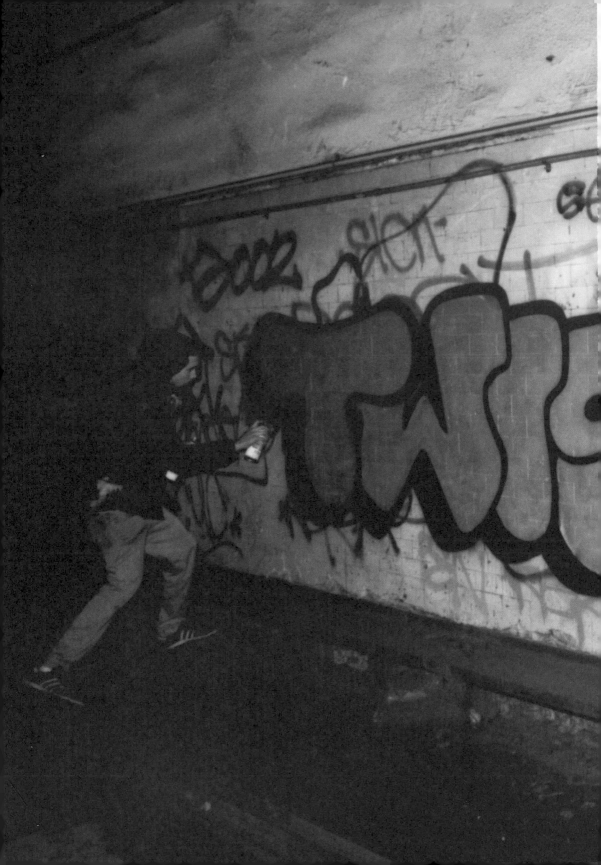

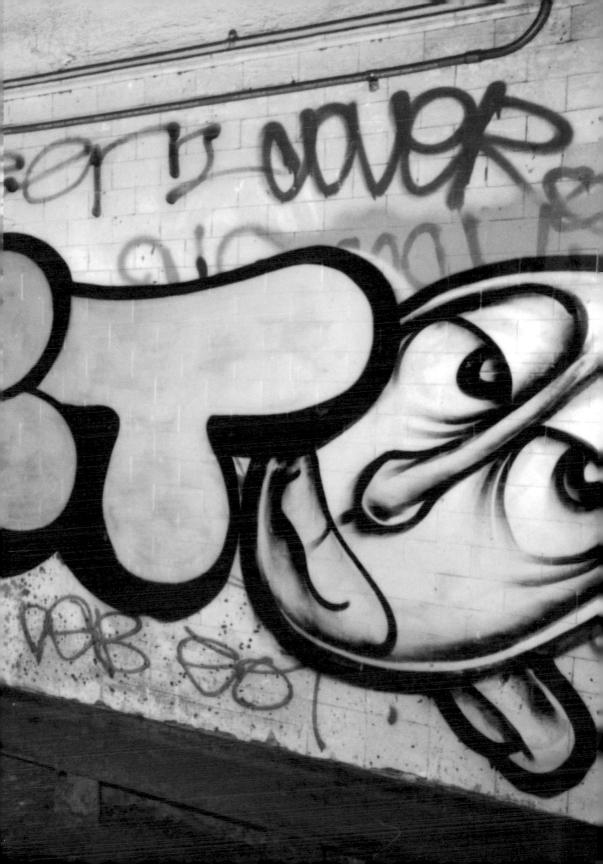

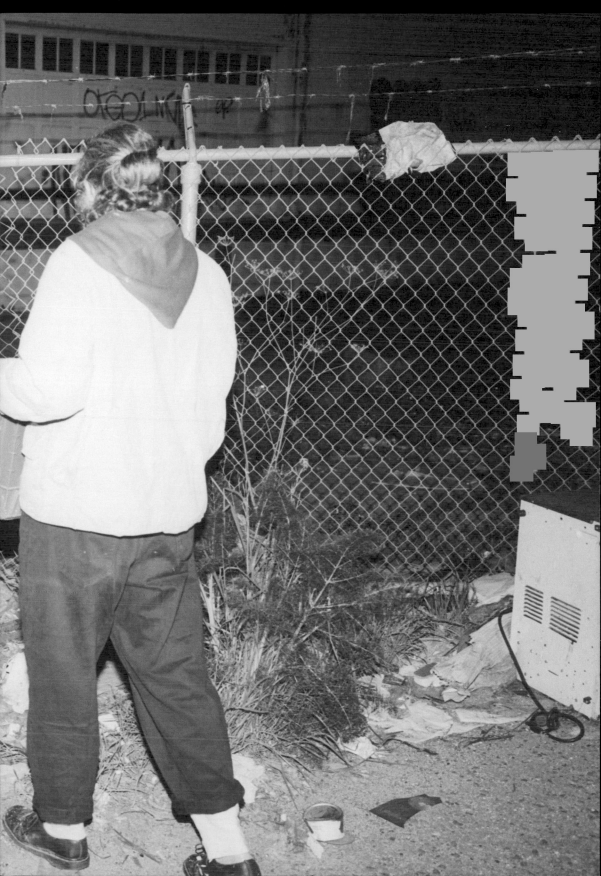

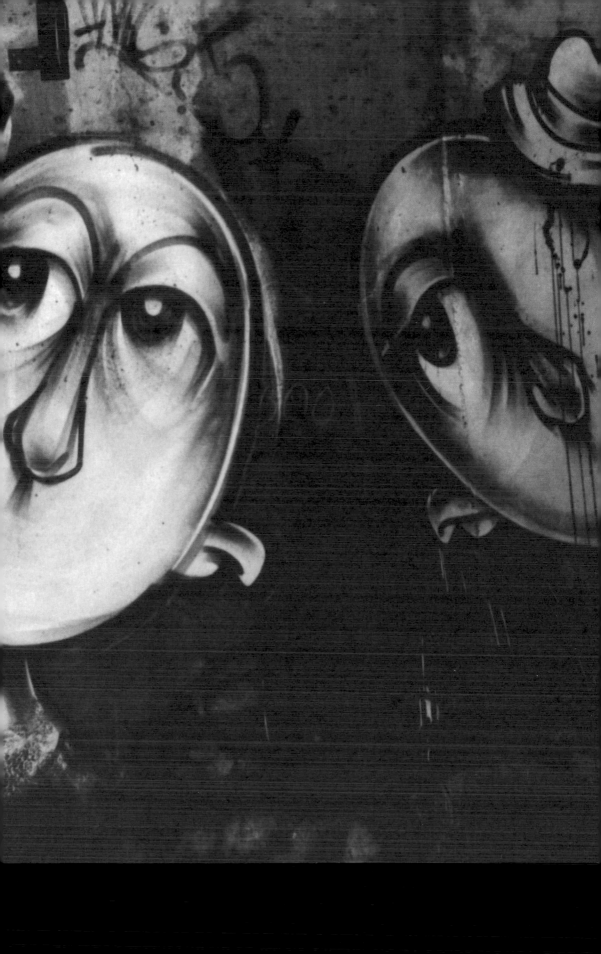

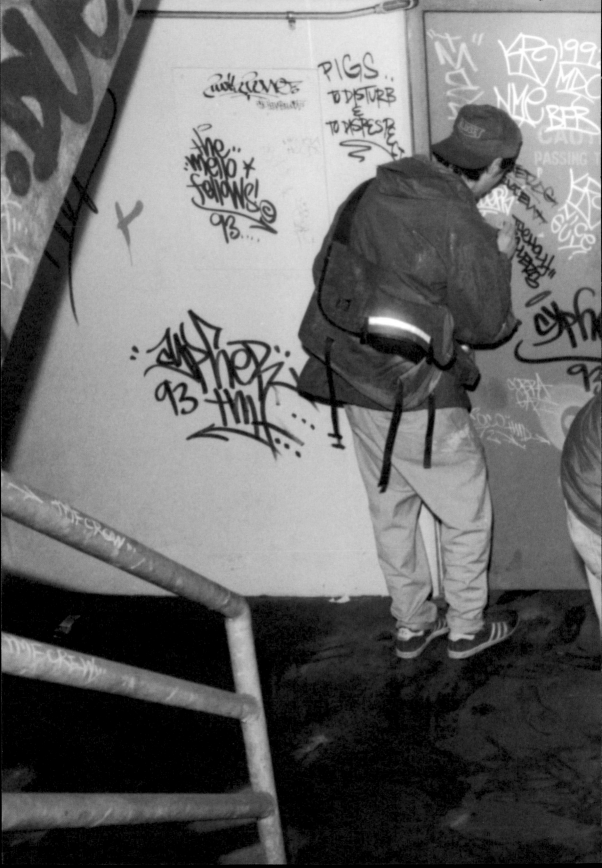

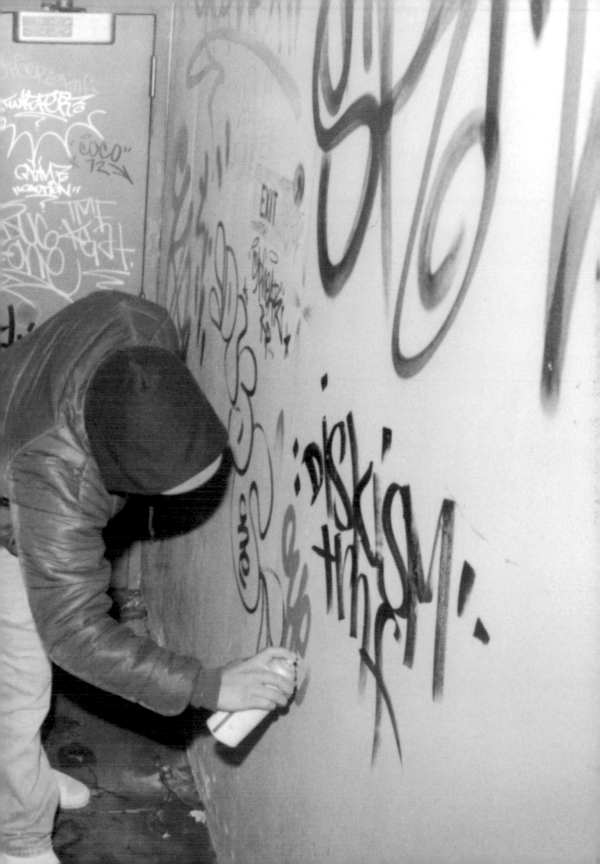

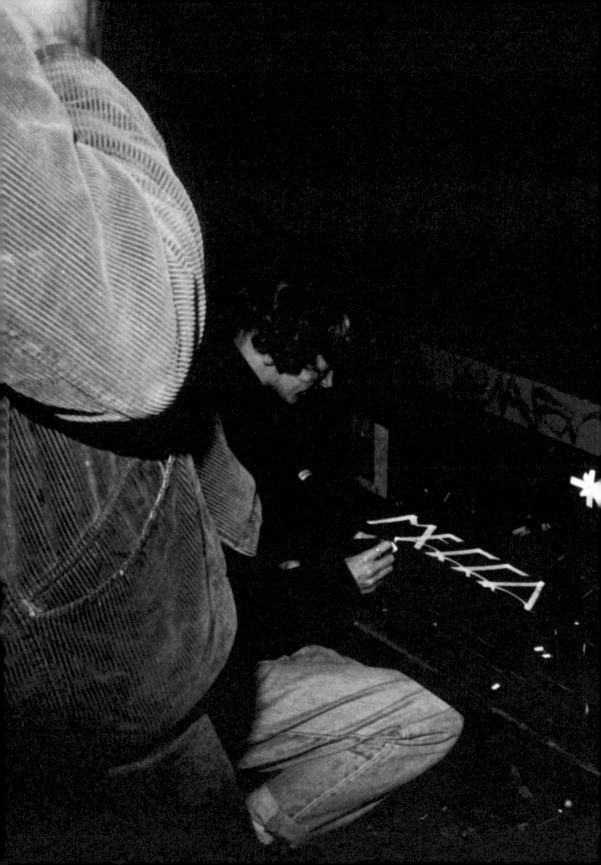

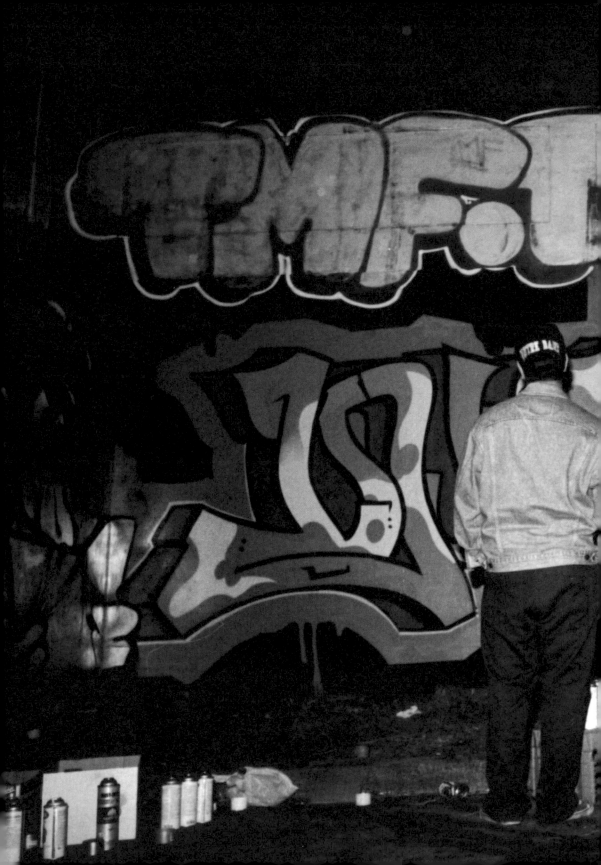

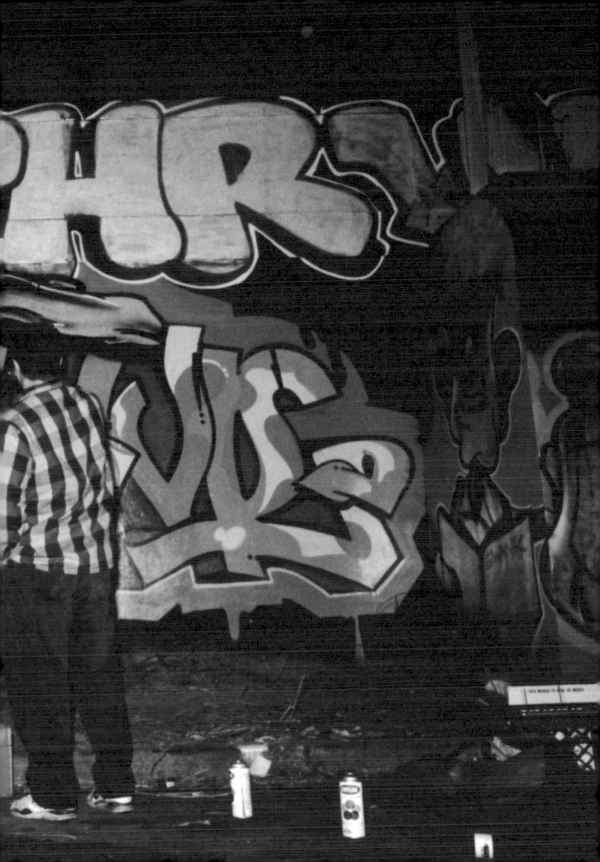

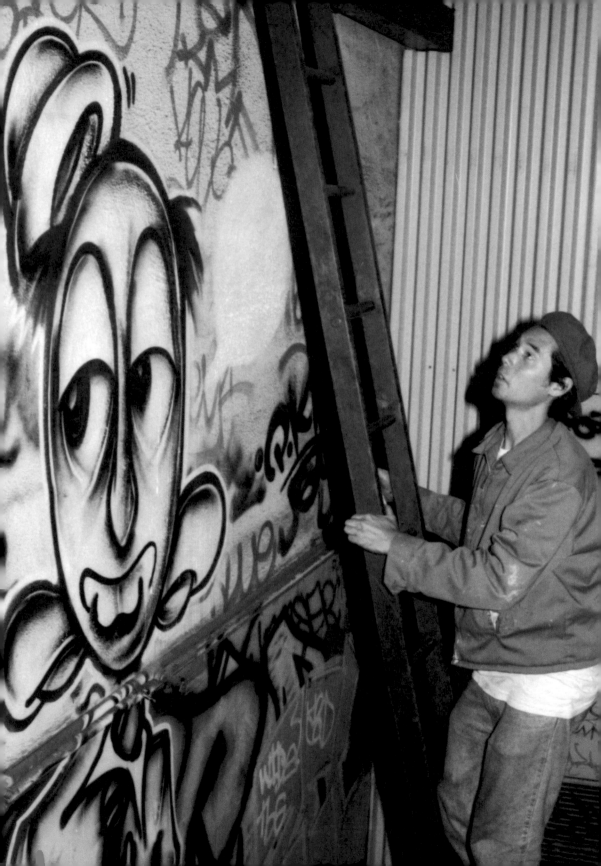

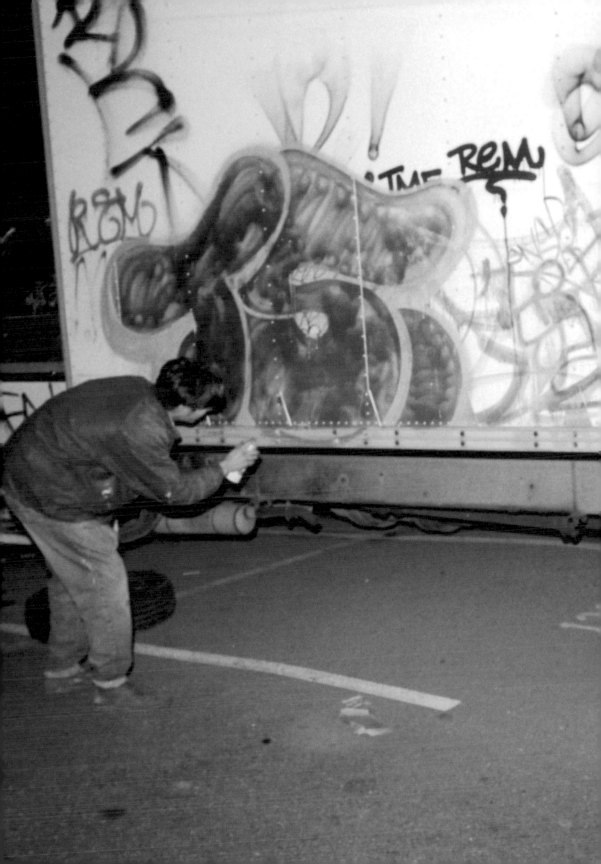

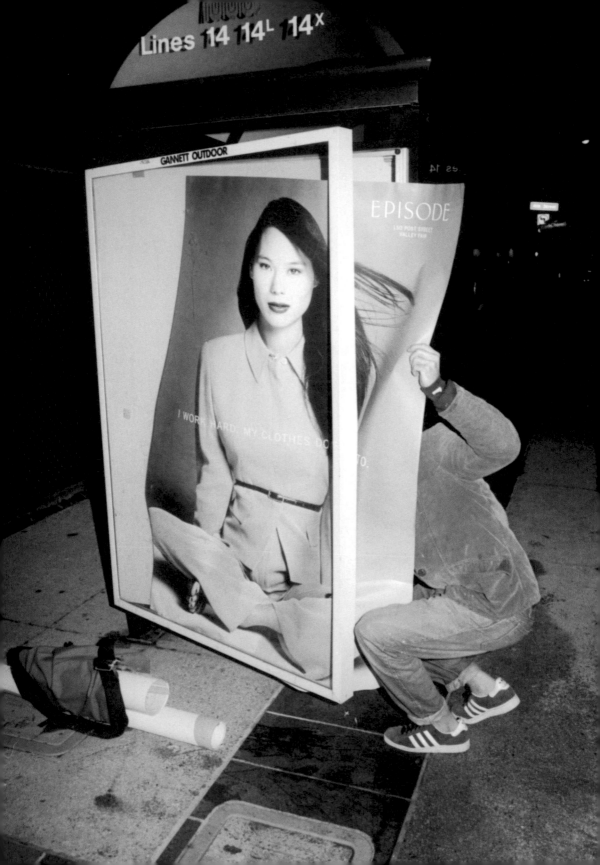

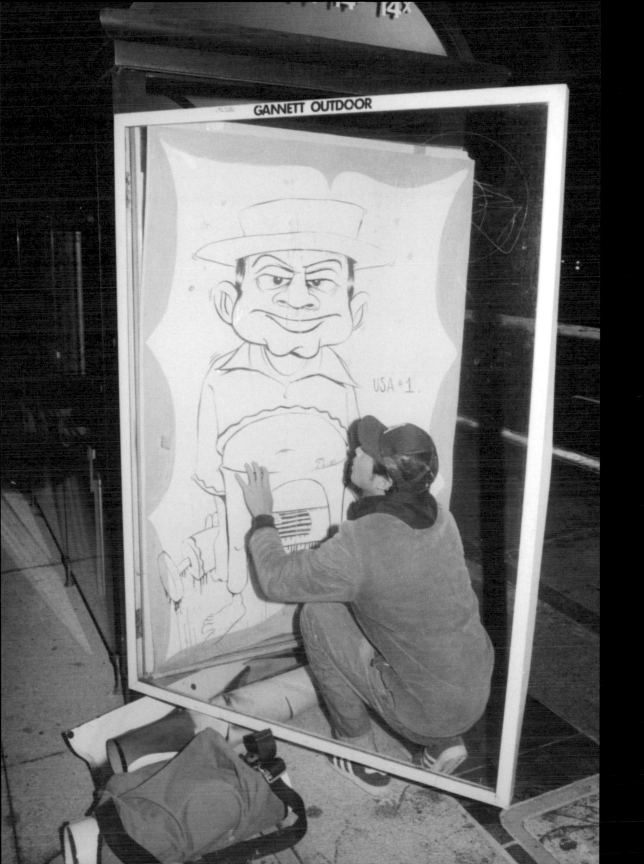

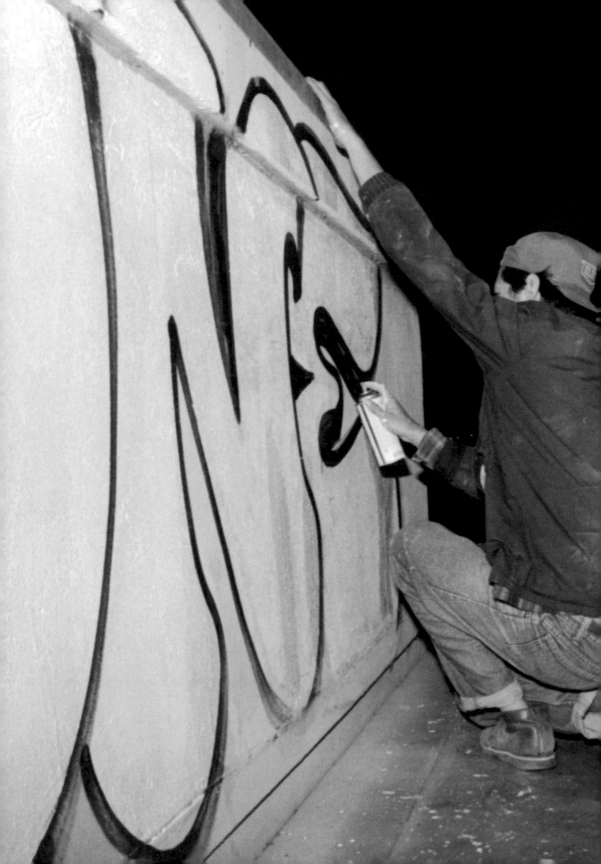

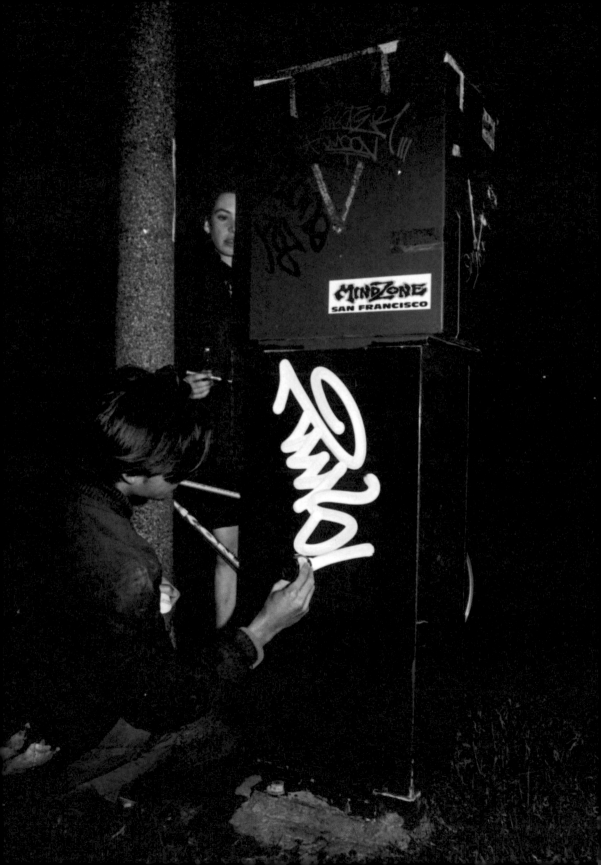

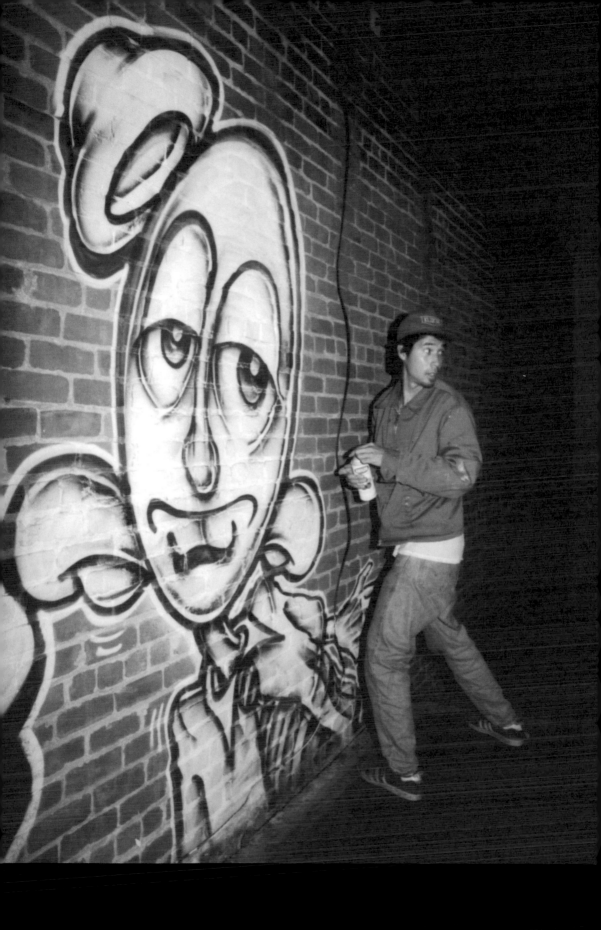

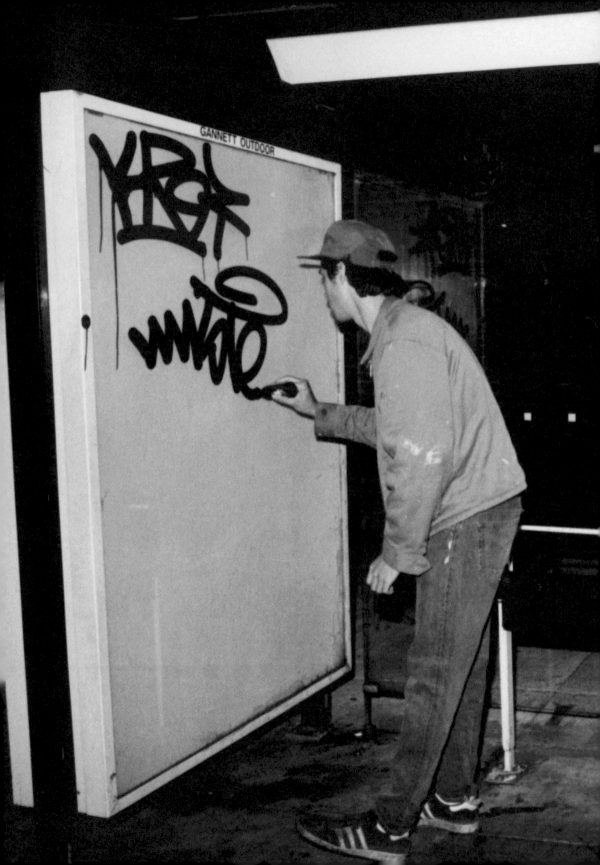

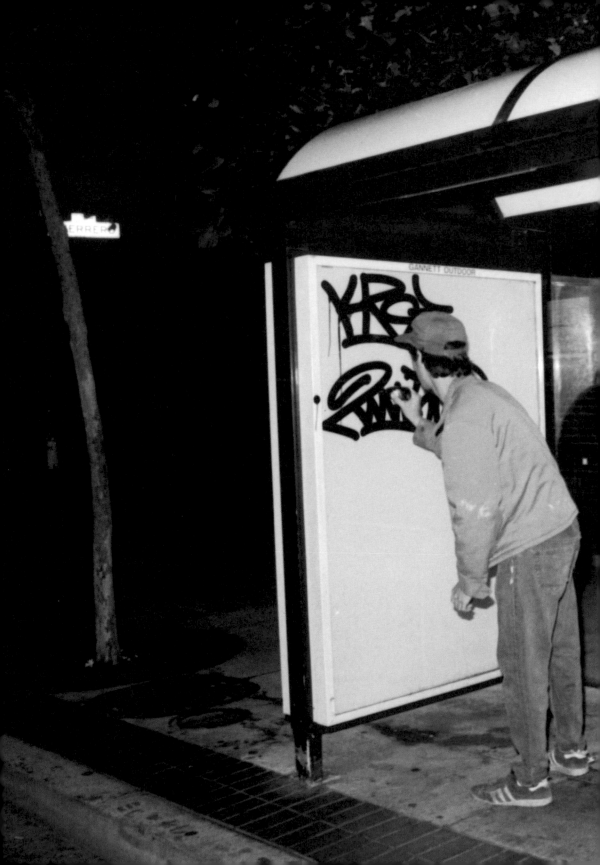

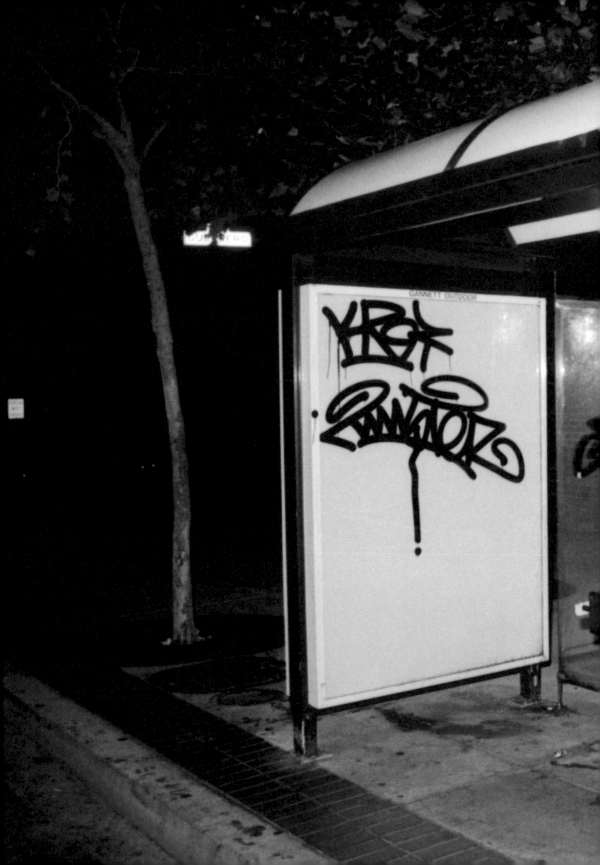

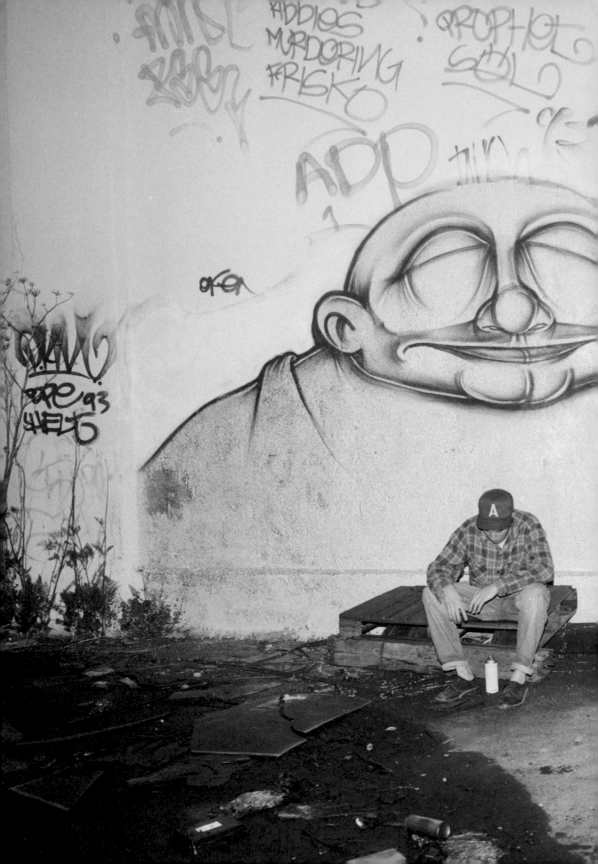

Barry McGee

Edited by Lawrence Rinder, with Dena Beard
With texts by Alex Baker, Natasha Boas, Germano Celant, and Jeffrey Deitch

University of California, Berkeley Art Museum and Pacific Film Archive
in association with D.A.P./Distributed Art Publishers, Inc.

Contents

EXIT

Barry McGee, September 24–December 9, 2012 (installation views); University of California, Berkeley Art Museum and Pacfic Film Archive. Photos: Sibila Savage.

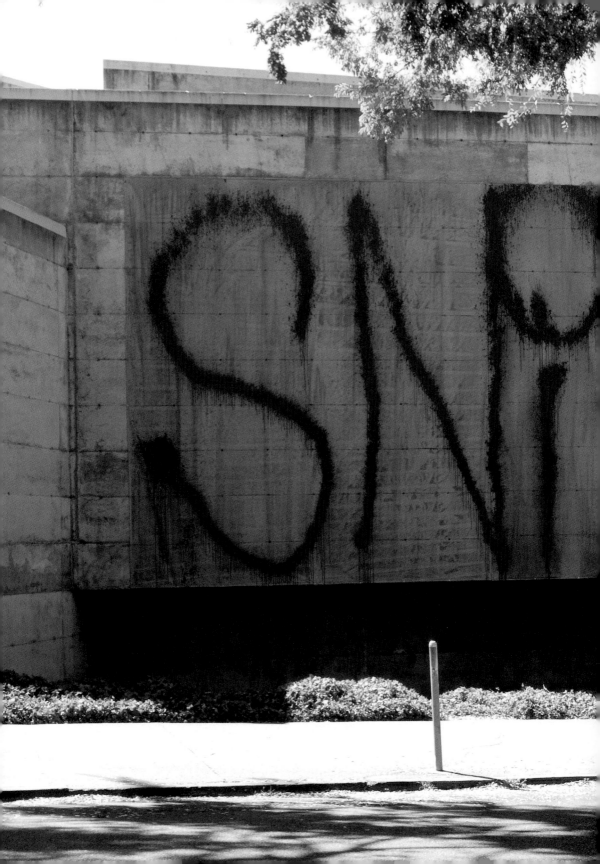

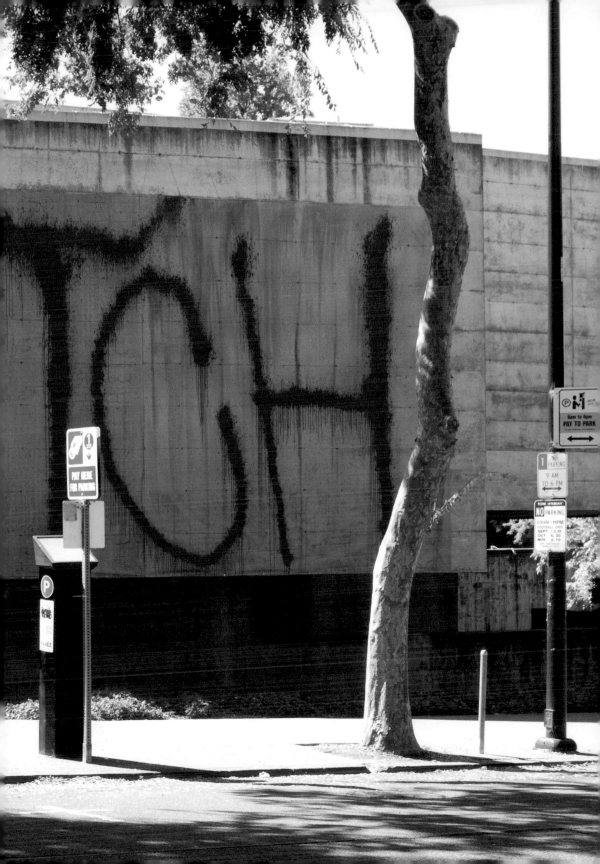

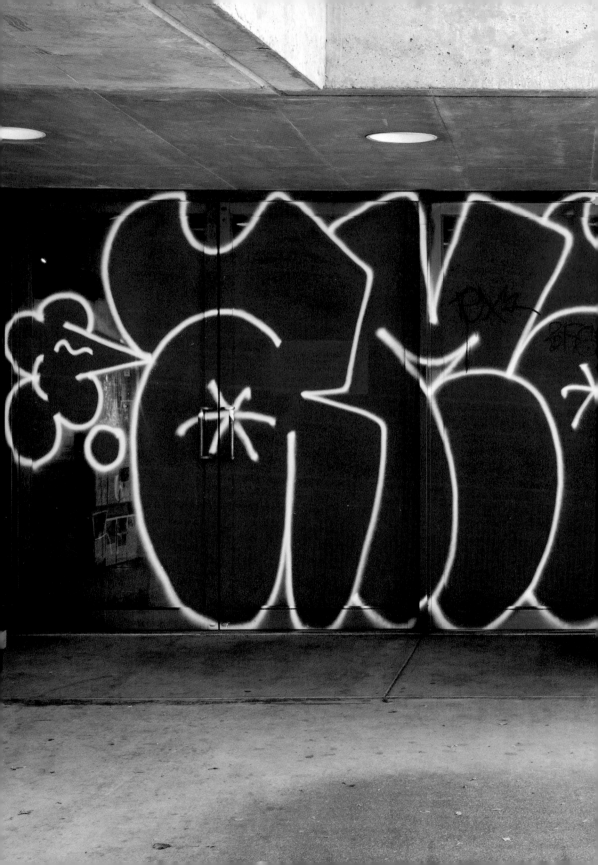

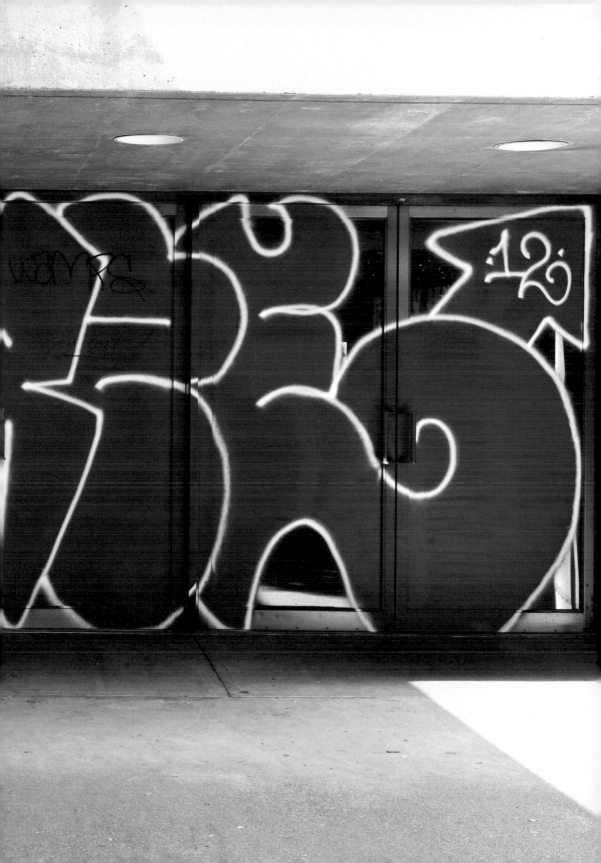

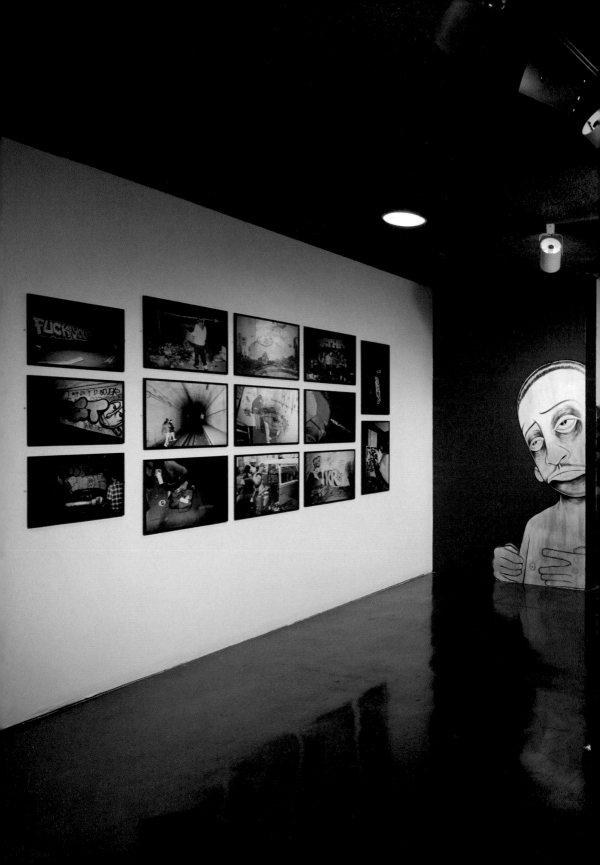

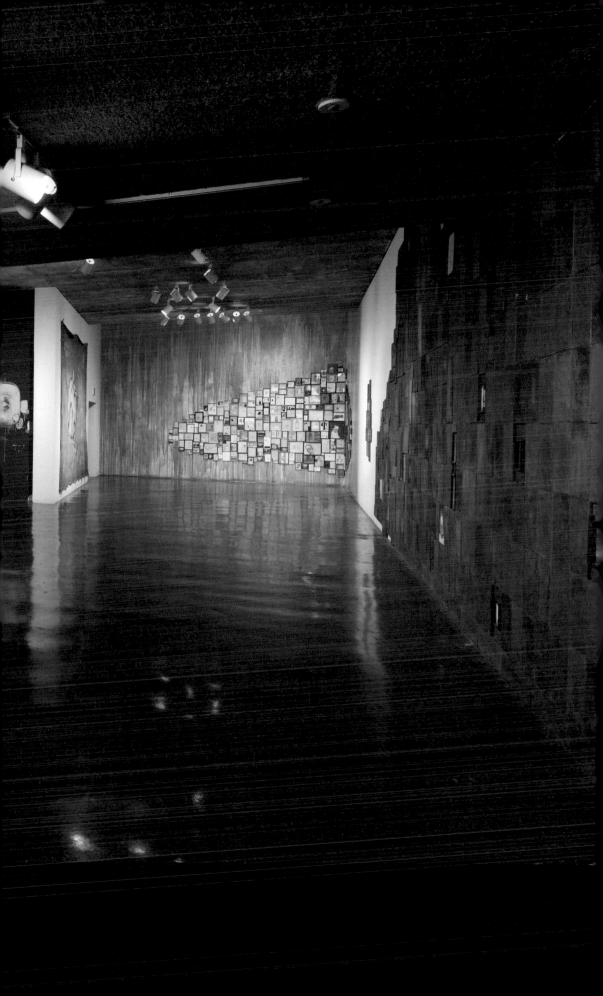

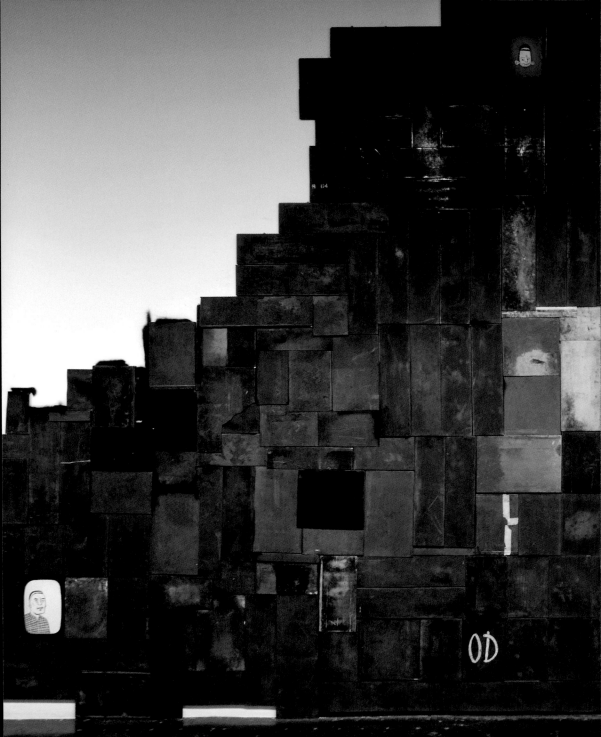

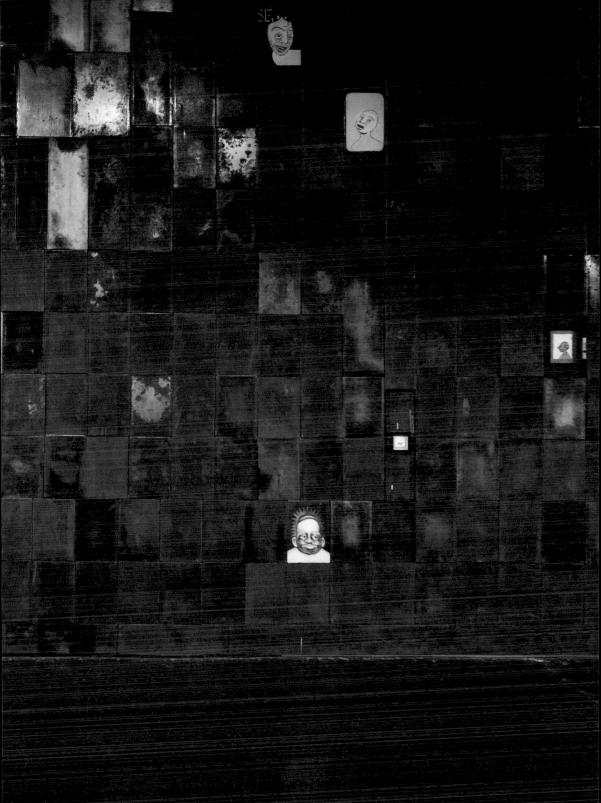

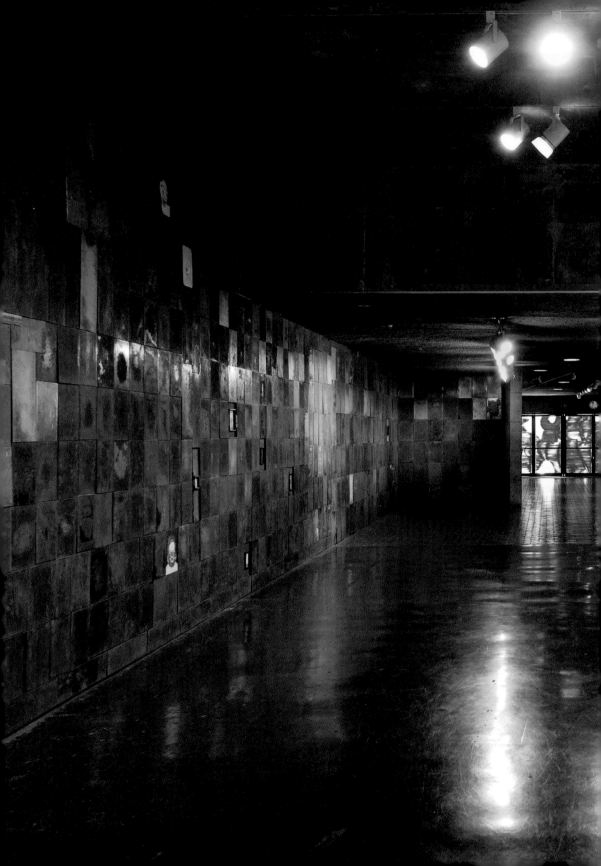

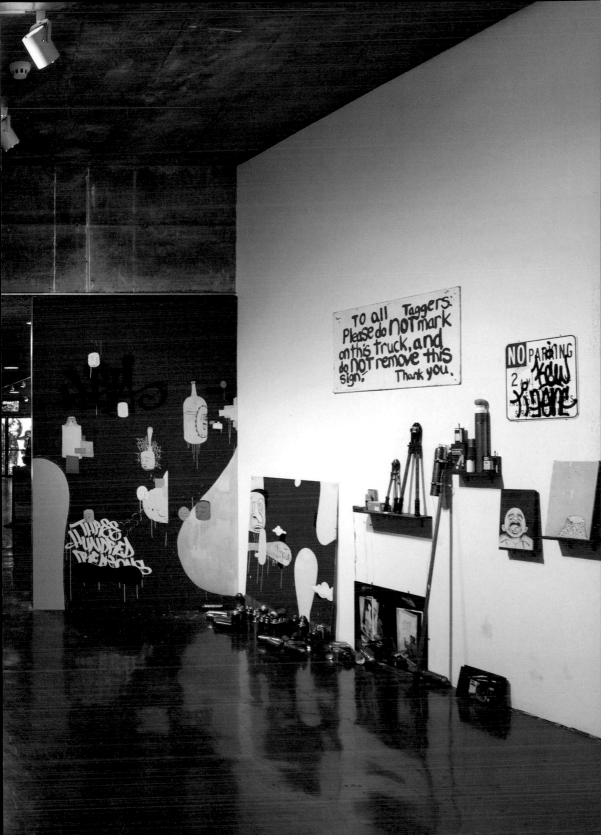

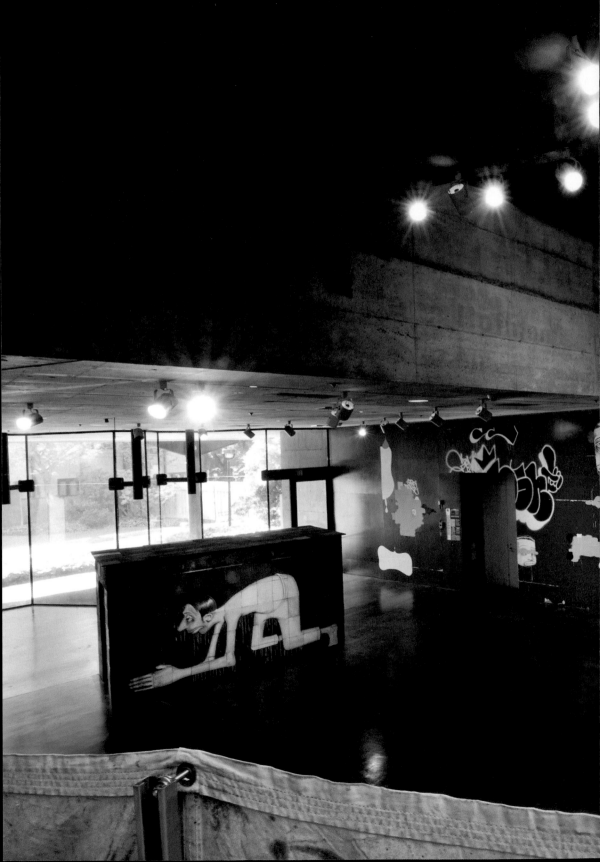

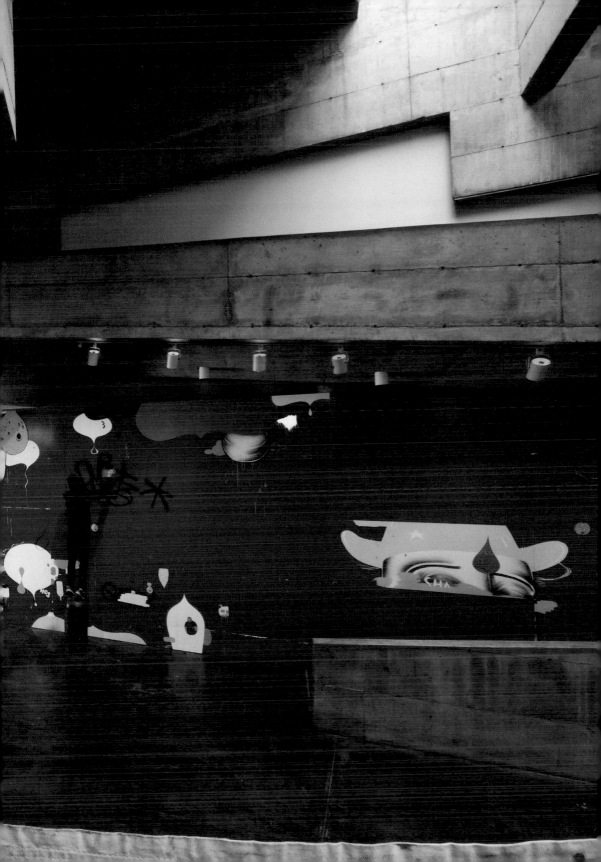

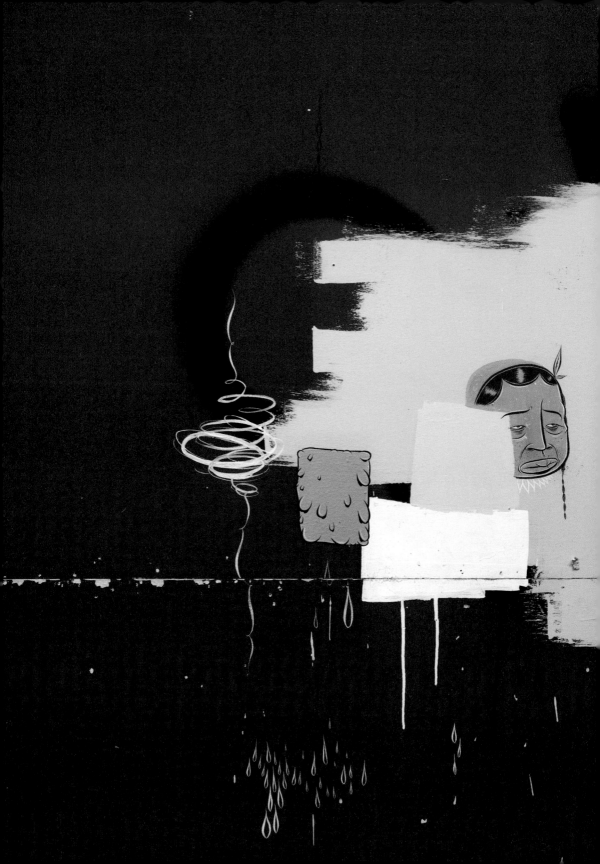

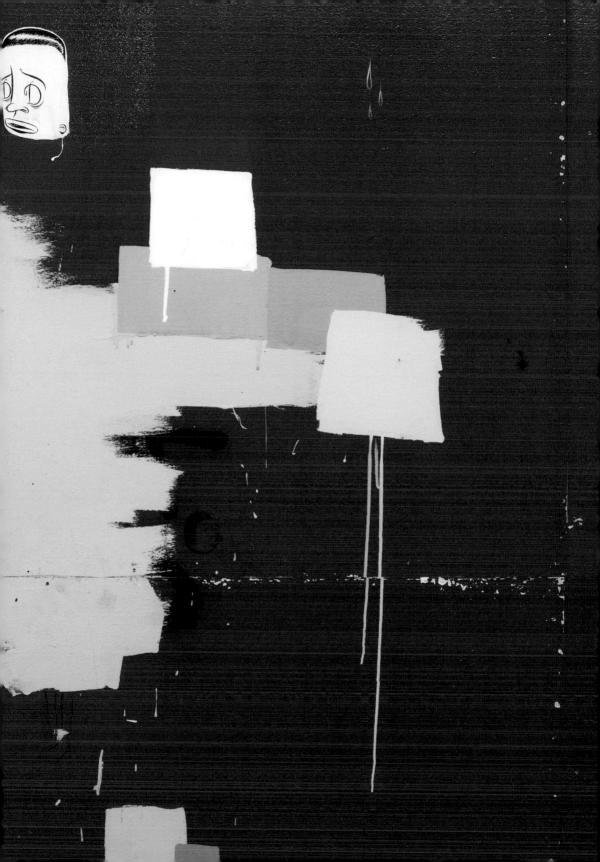

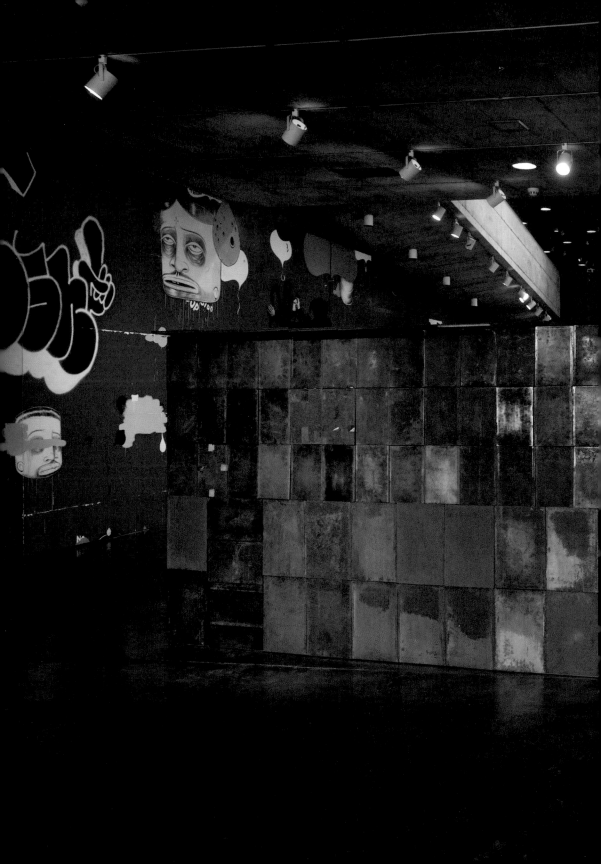

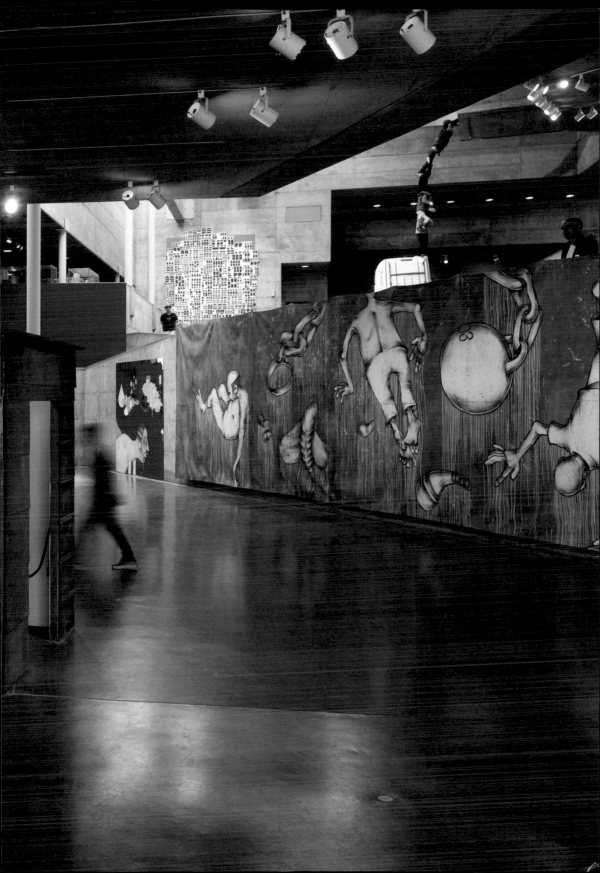

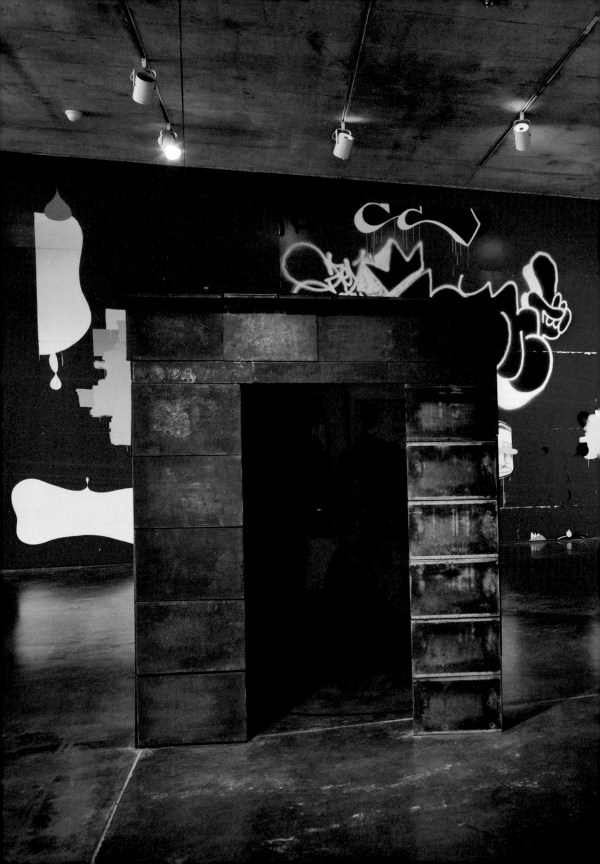

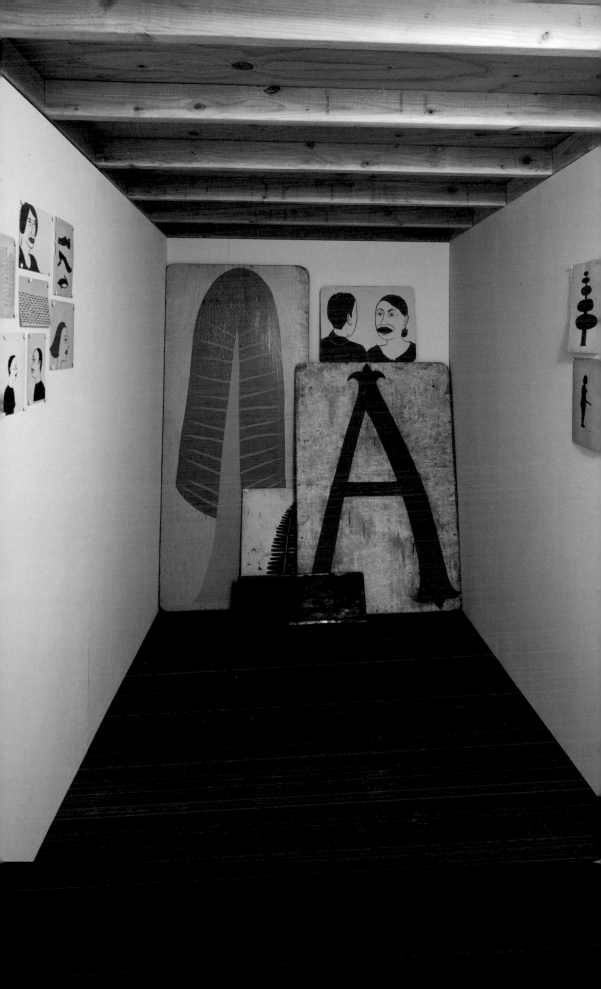

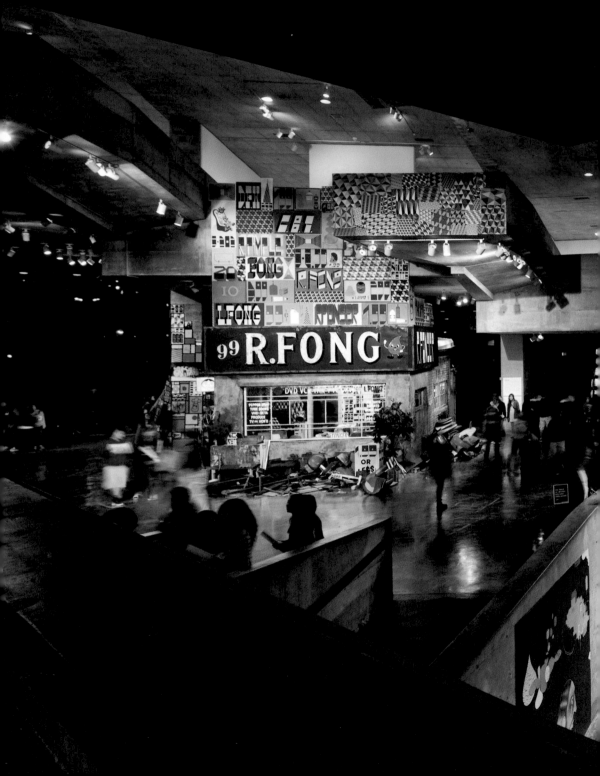

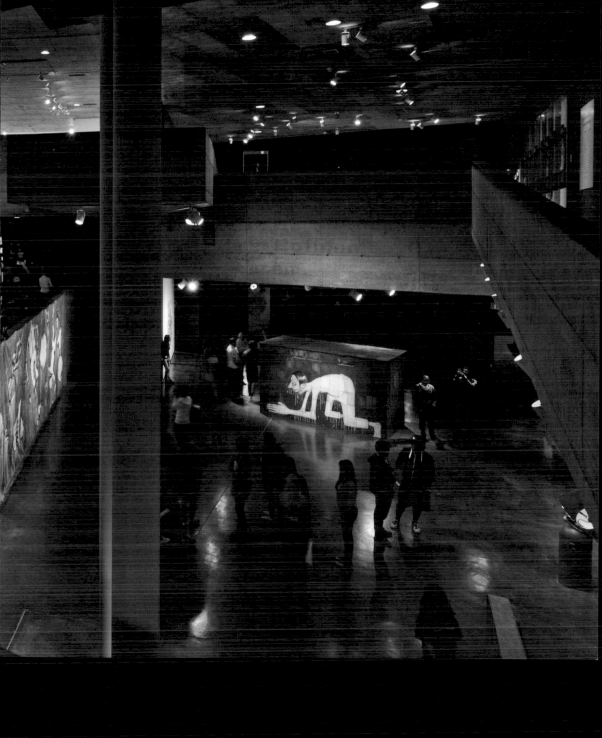

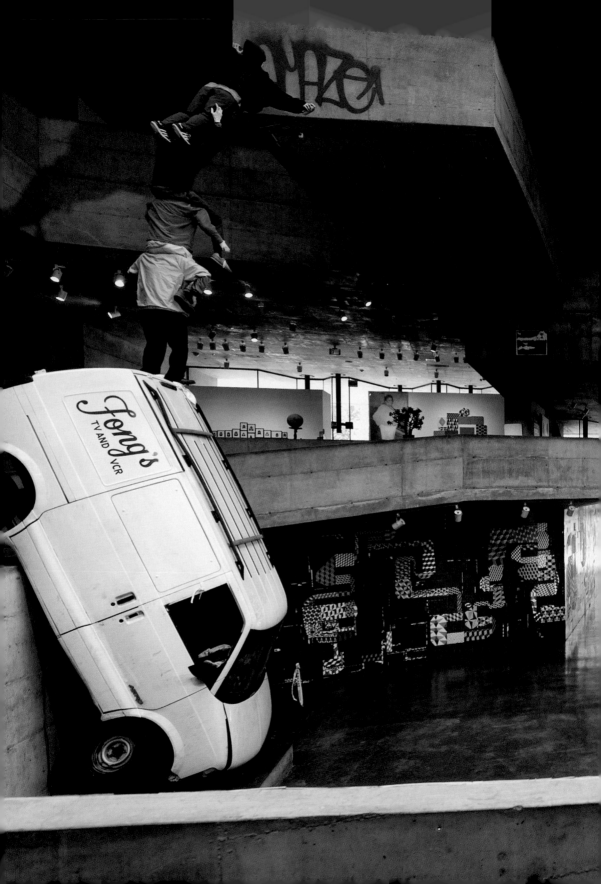

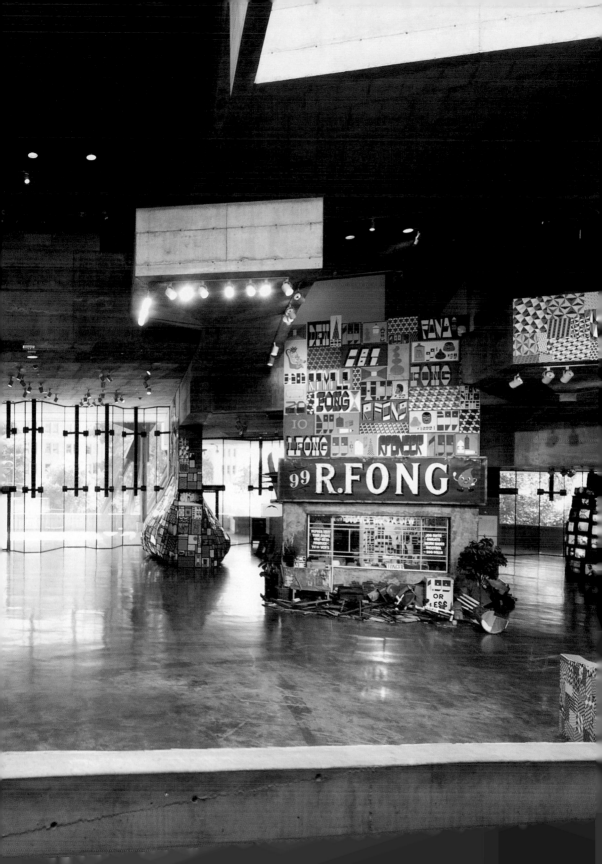

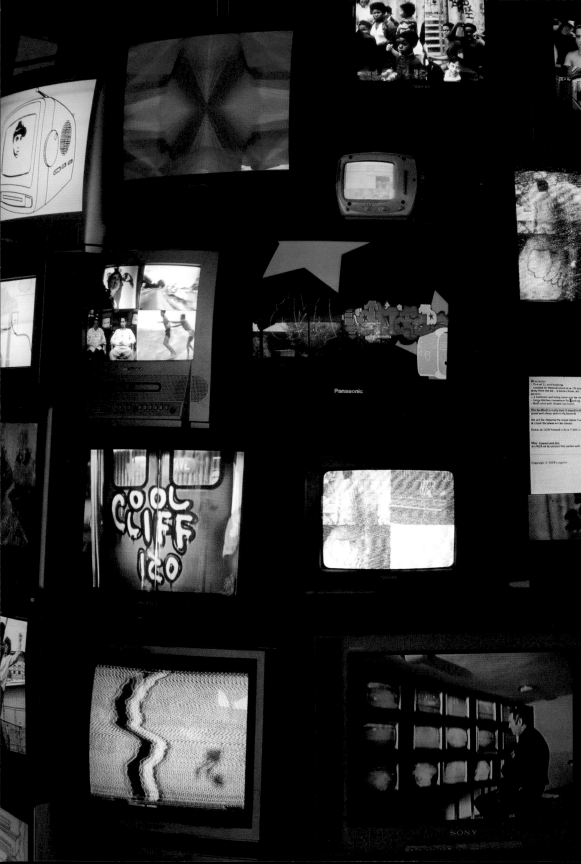

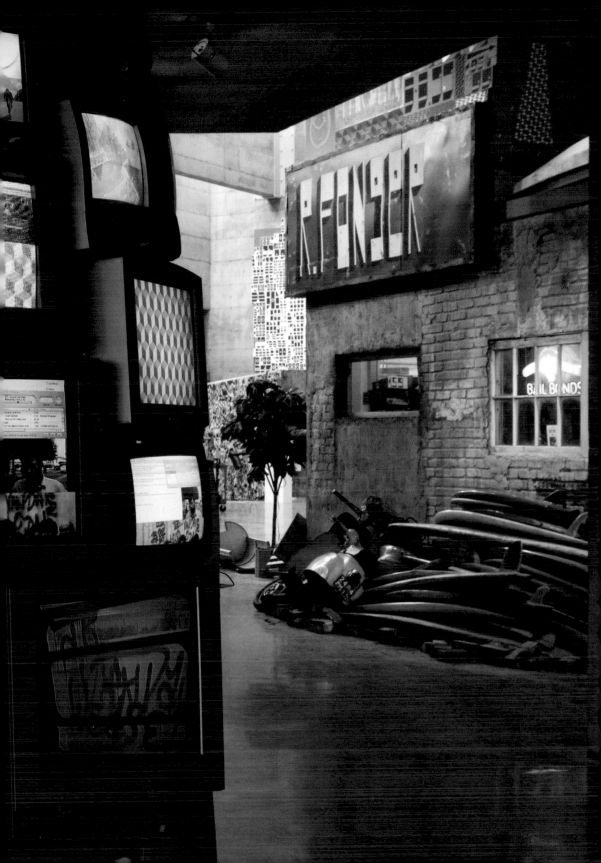

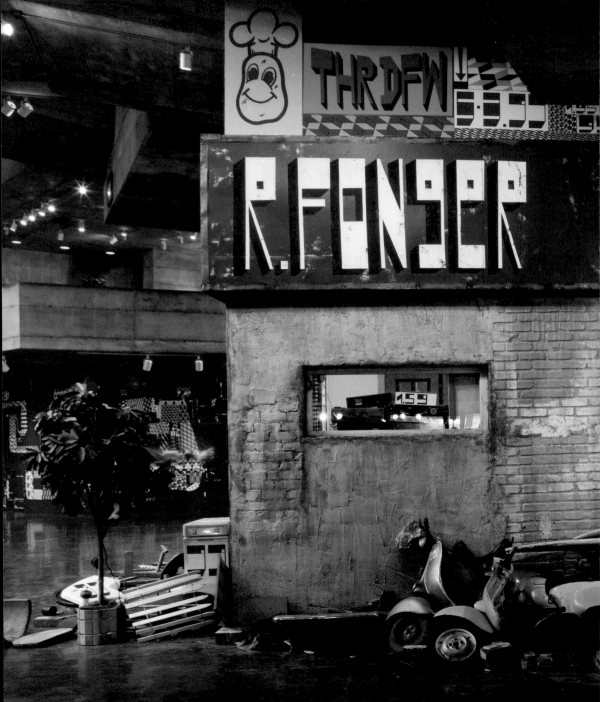

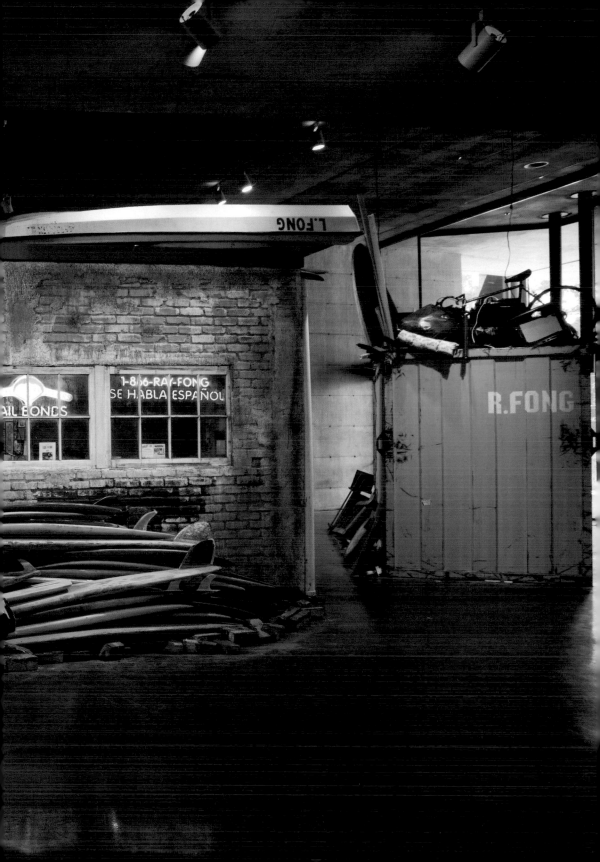

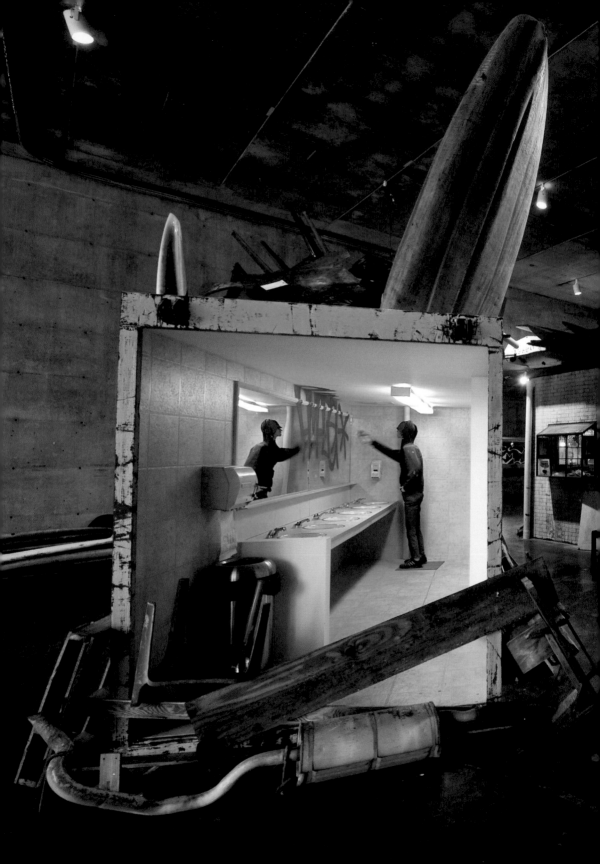

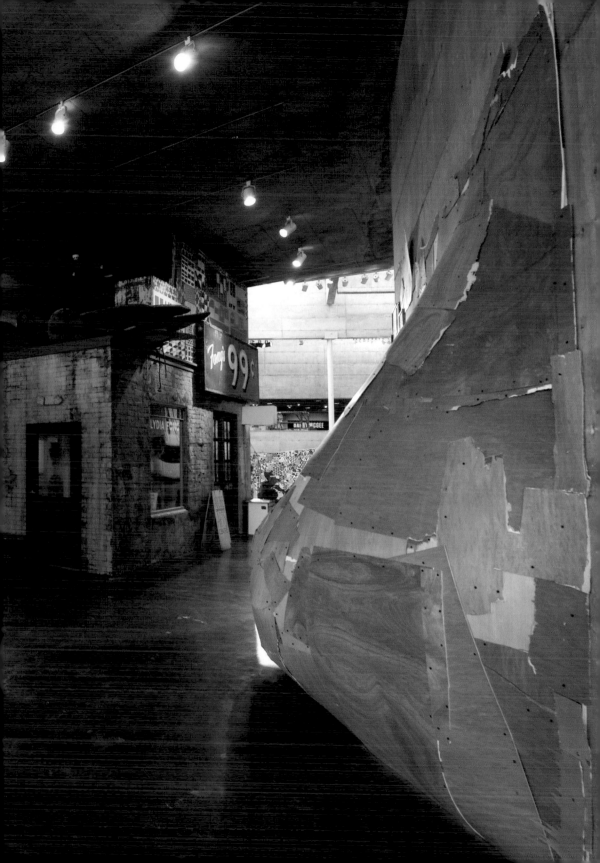

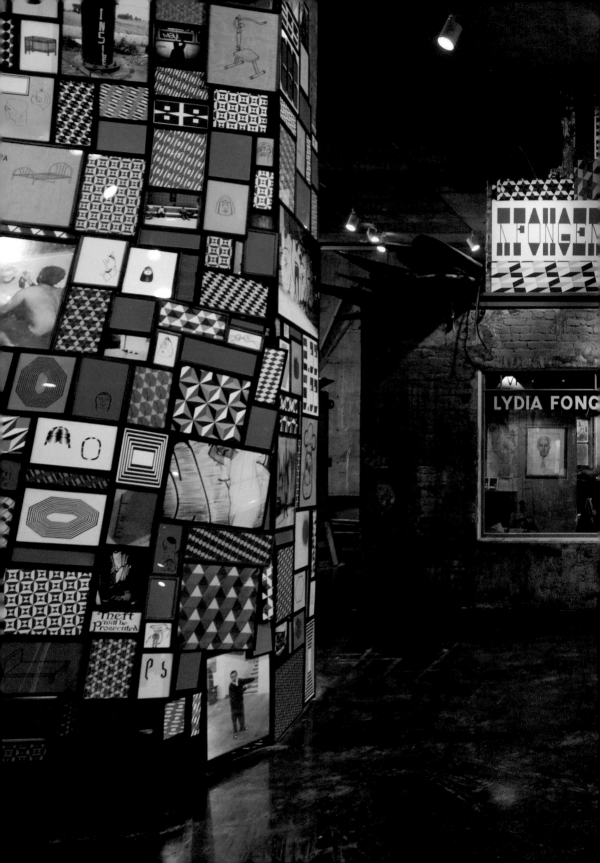

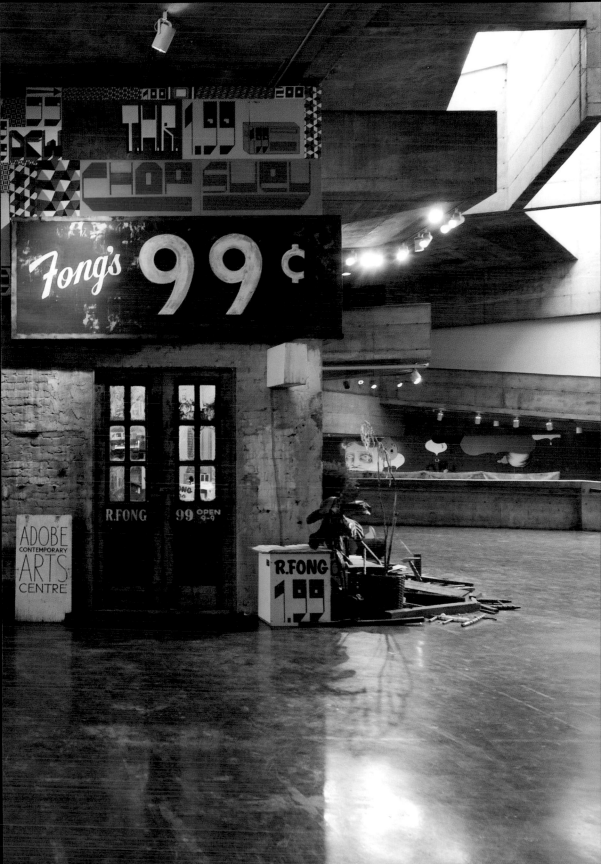

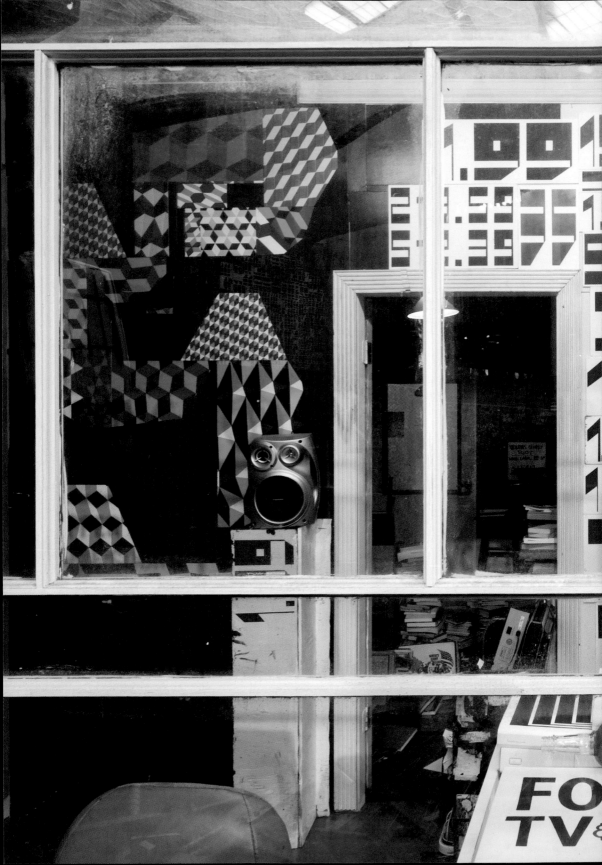

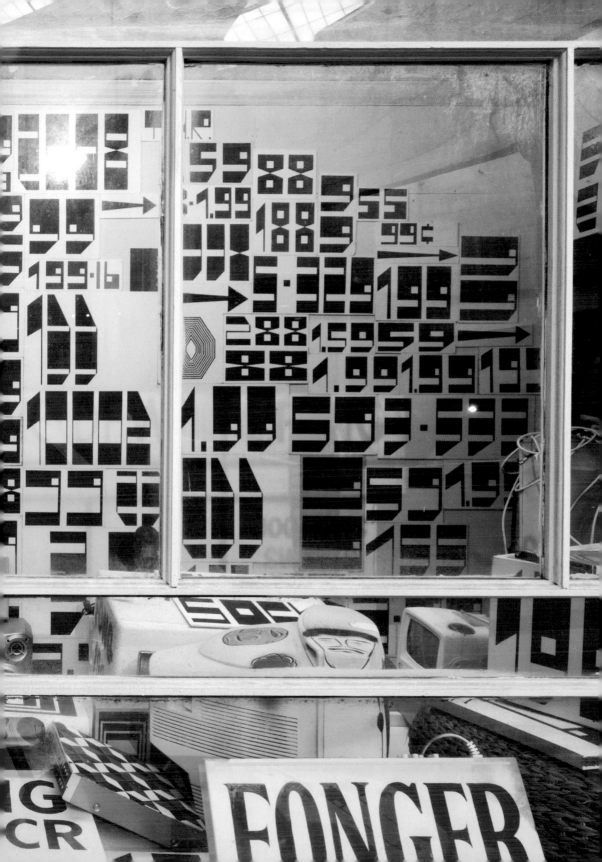

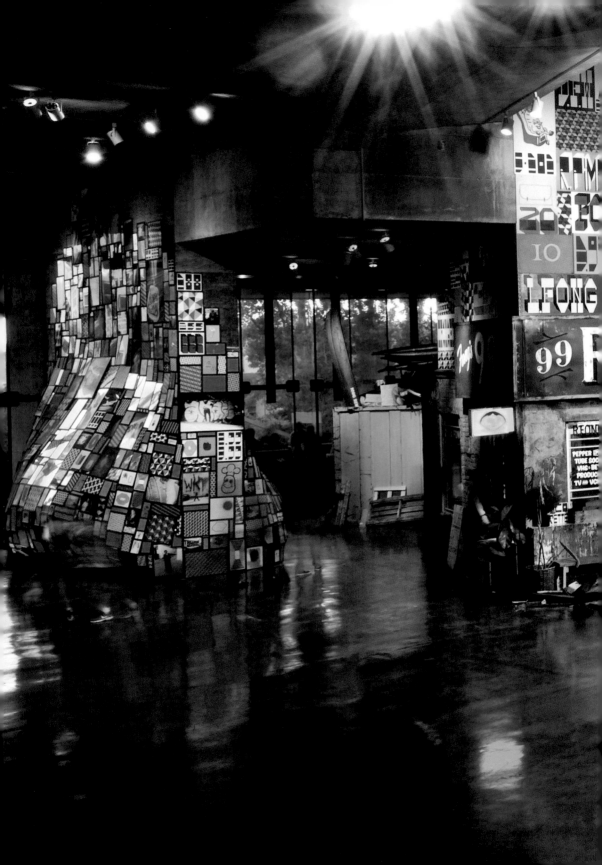

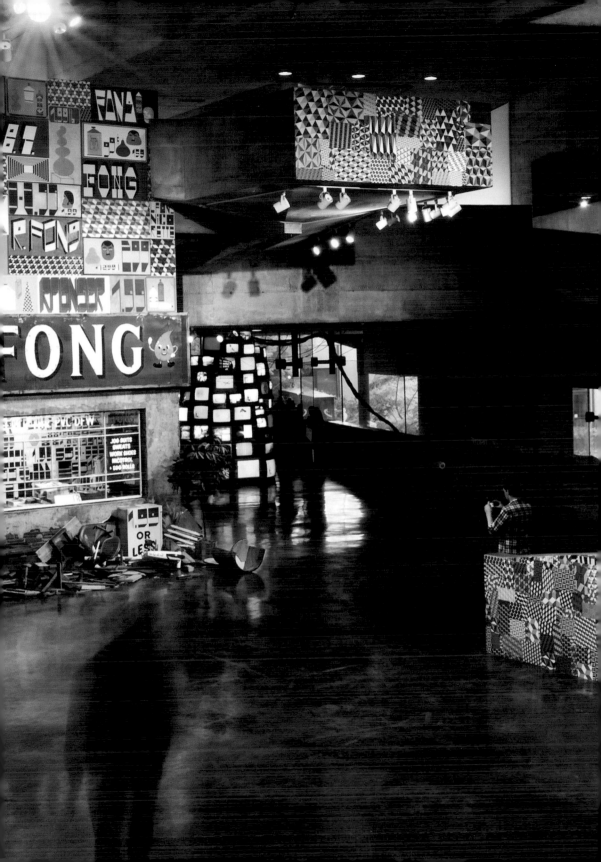

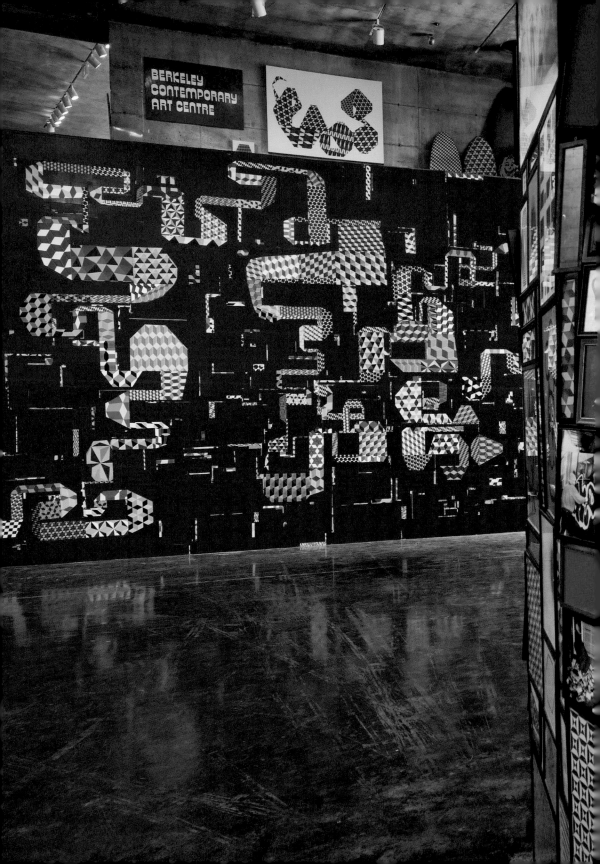

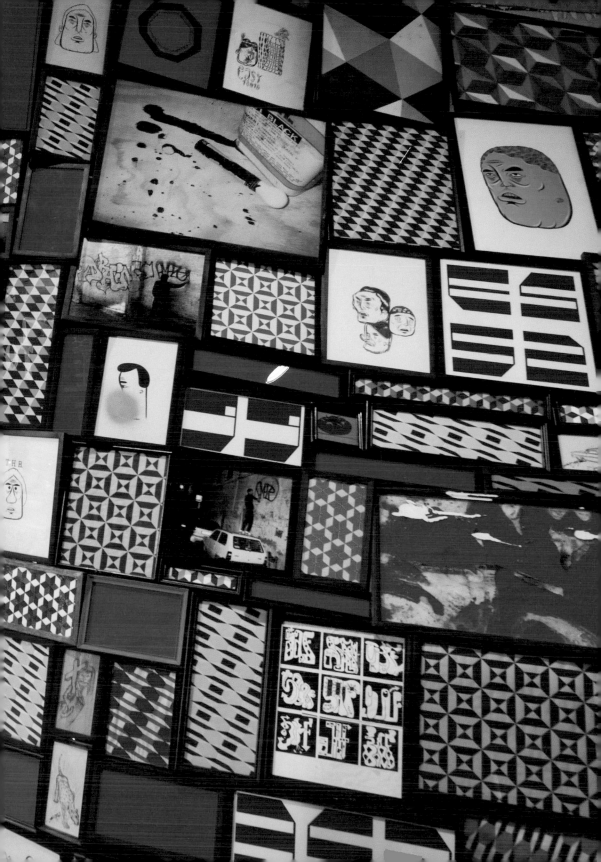

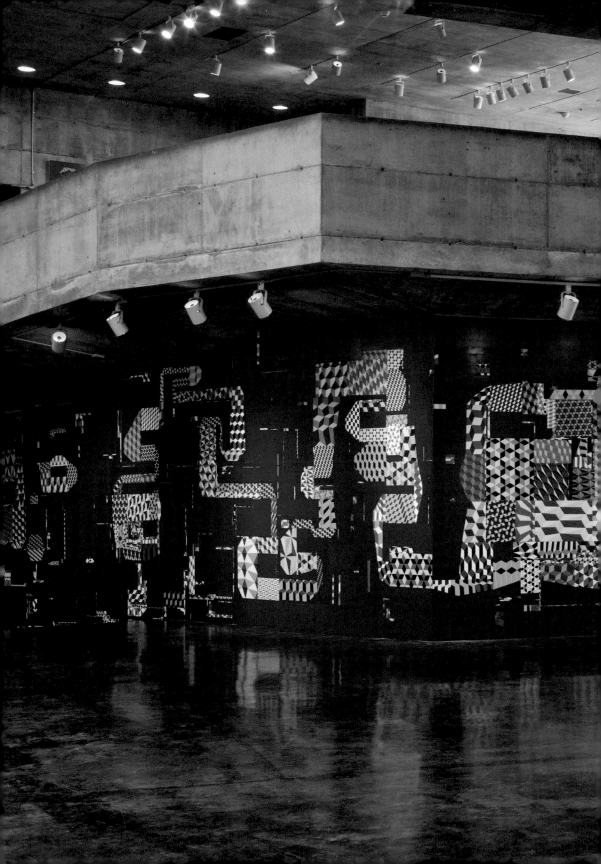

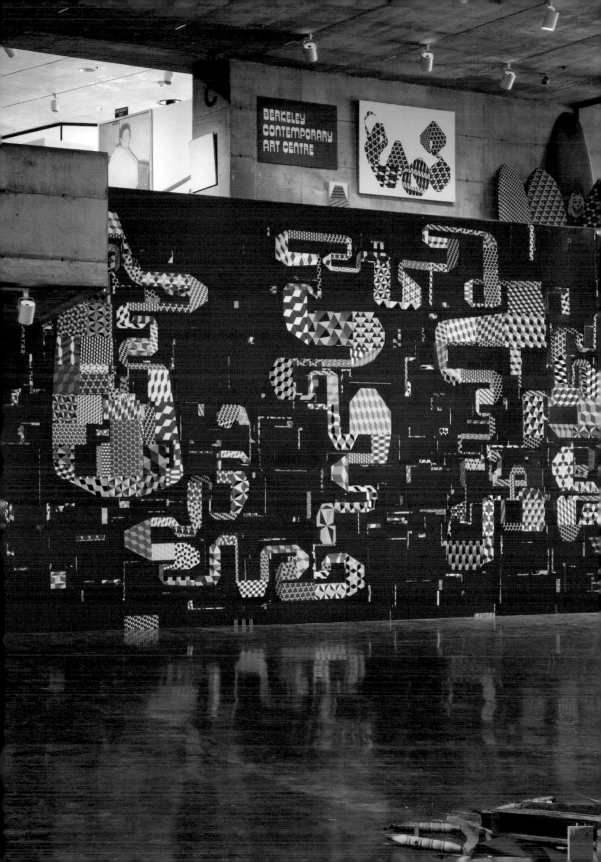

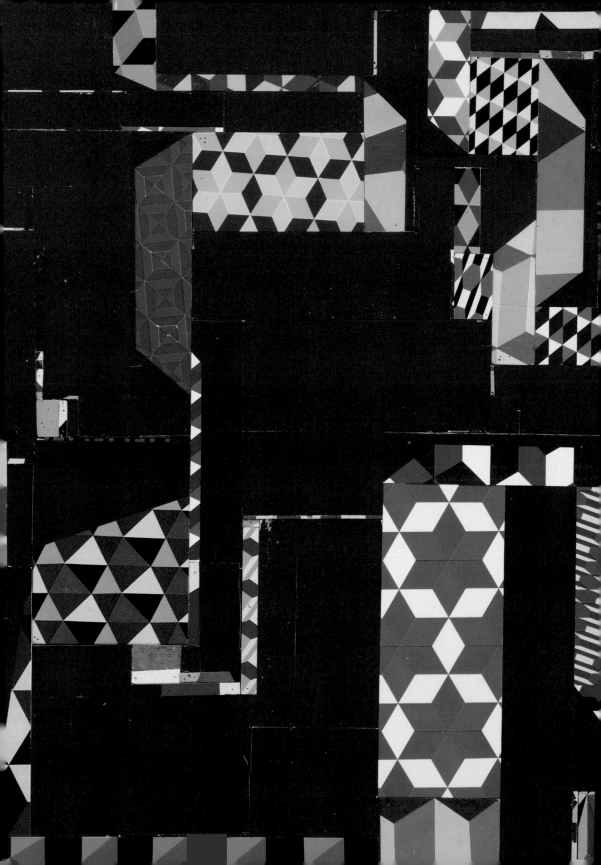

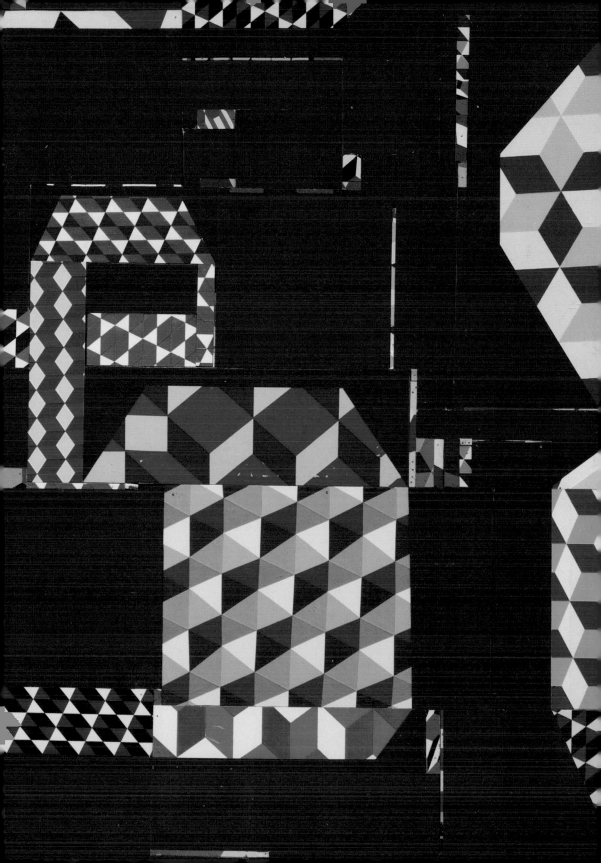

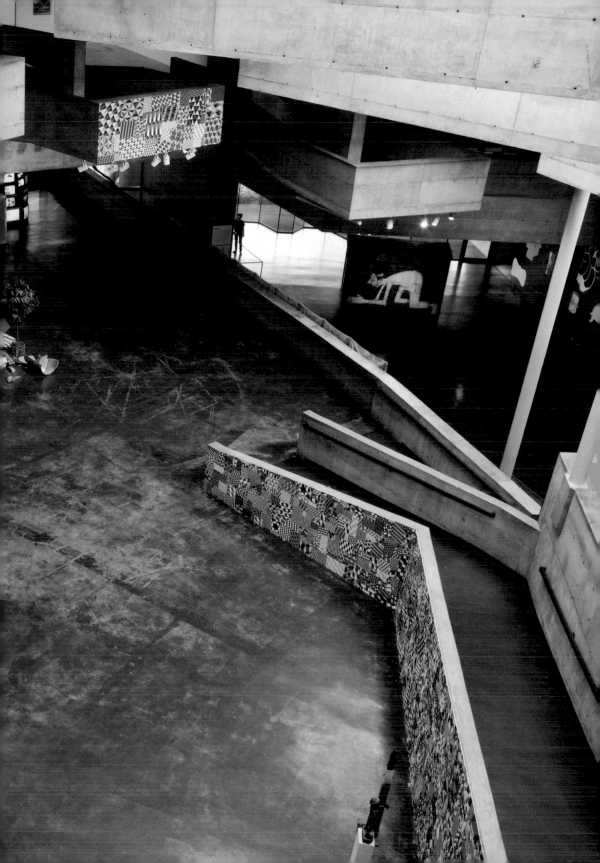

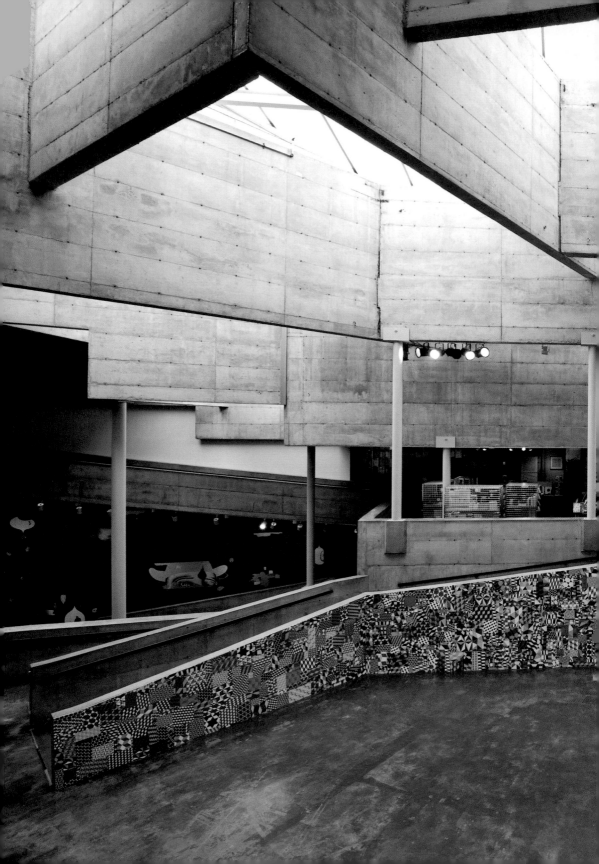

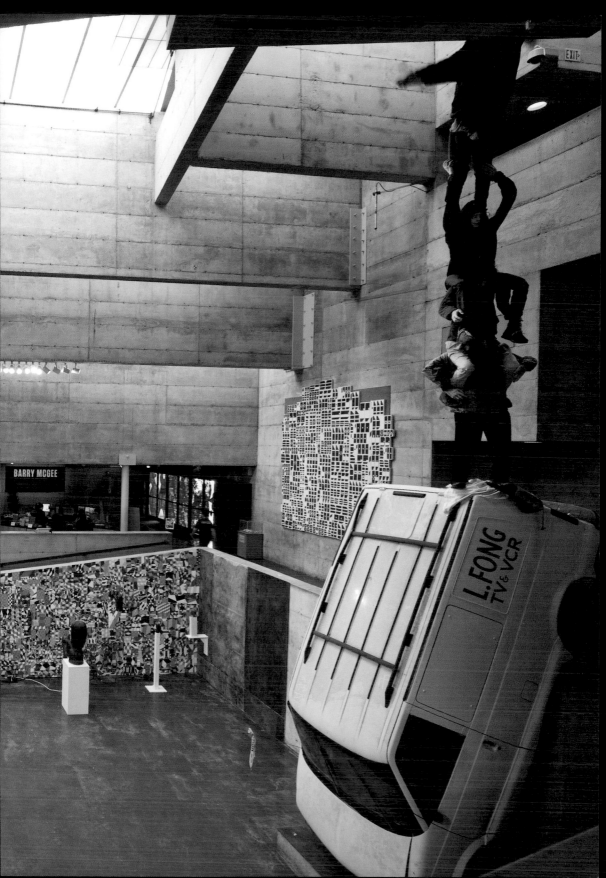

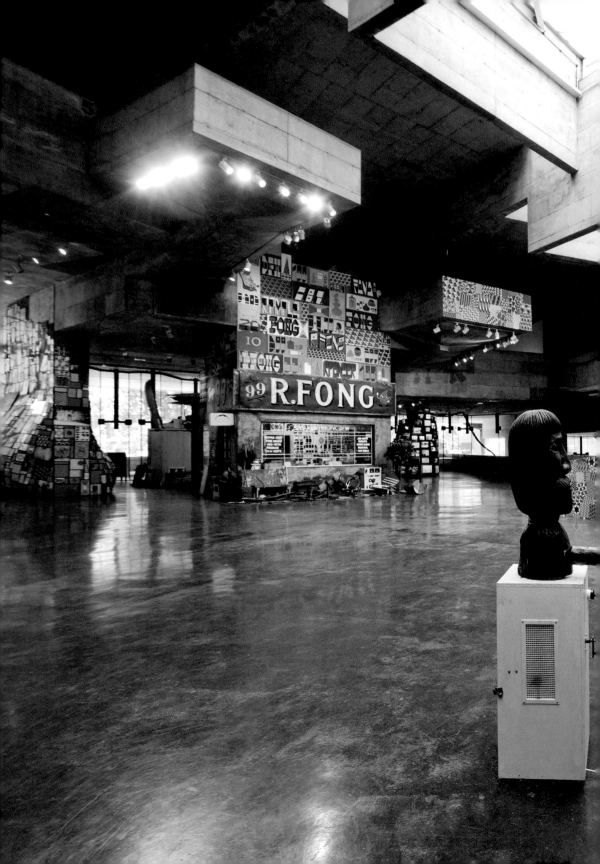

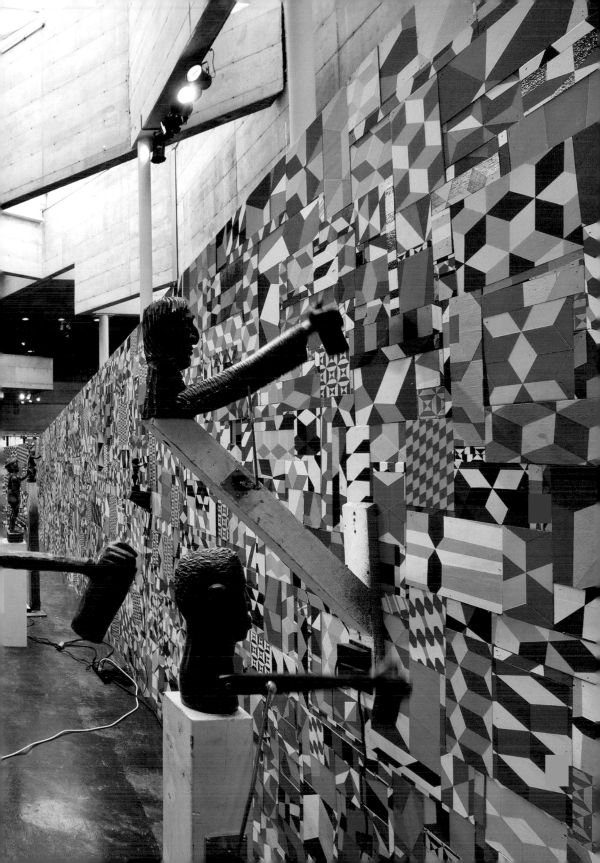

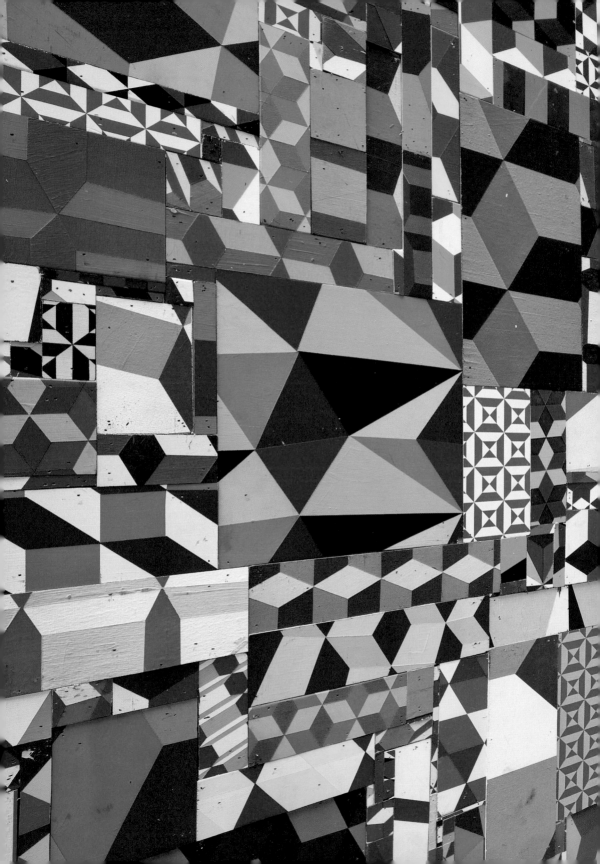

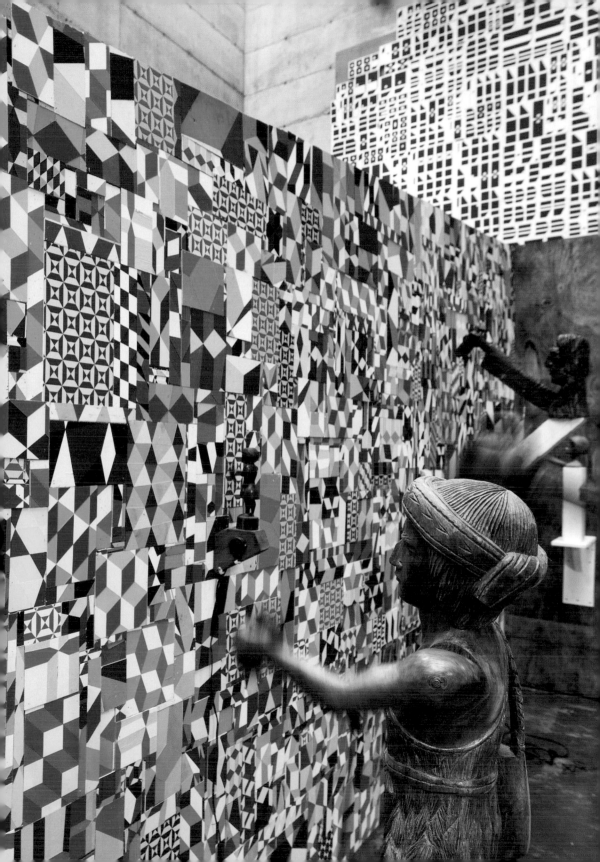

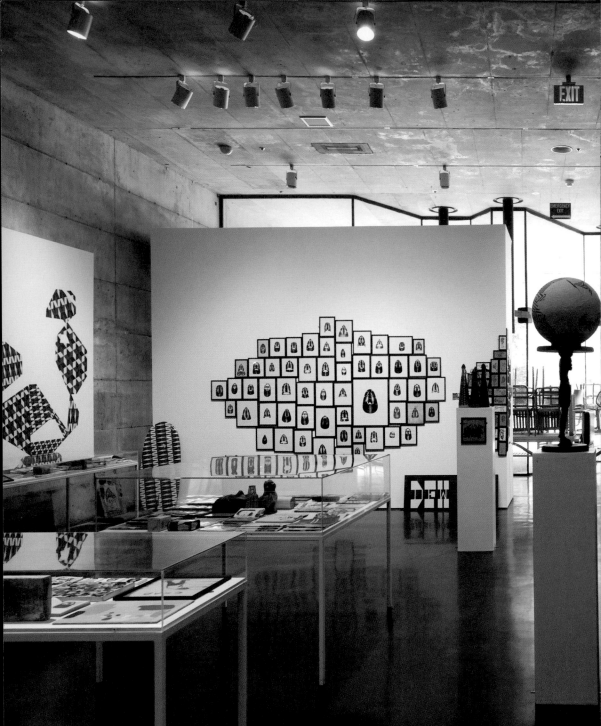

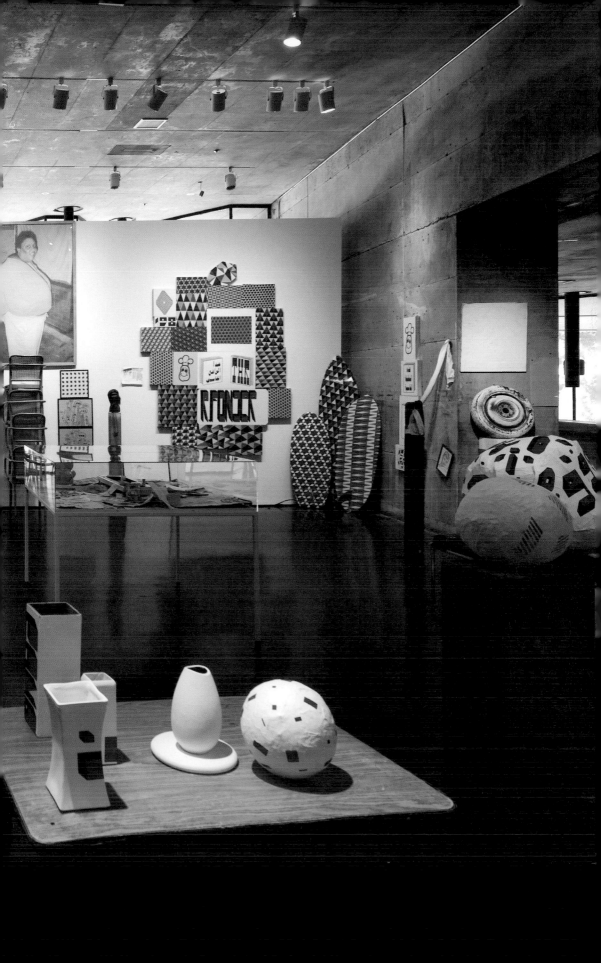

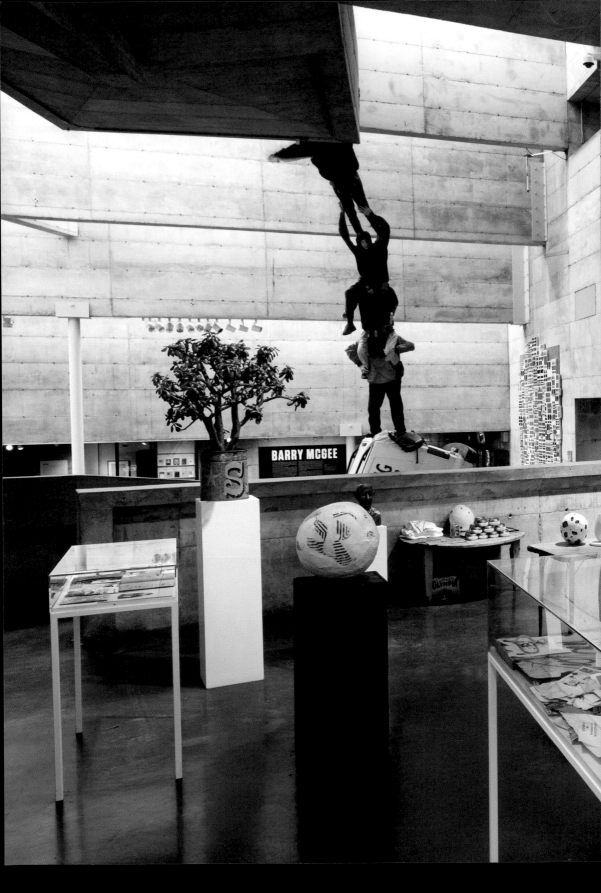

BARRY MCGEE

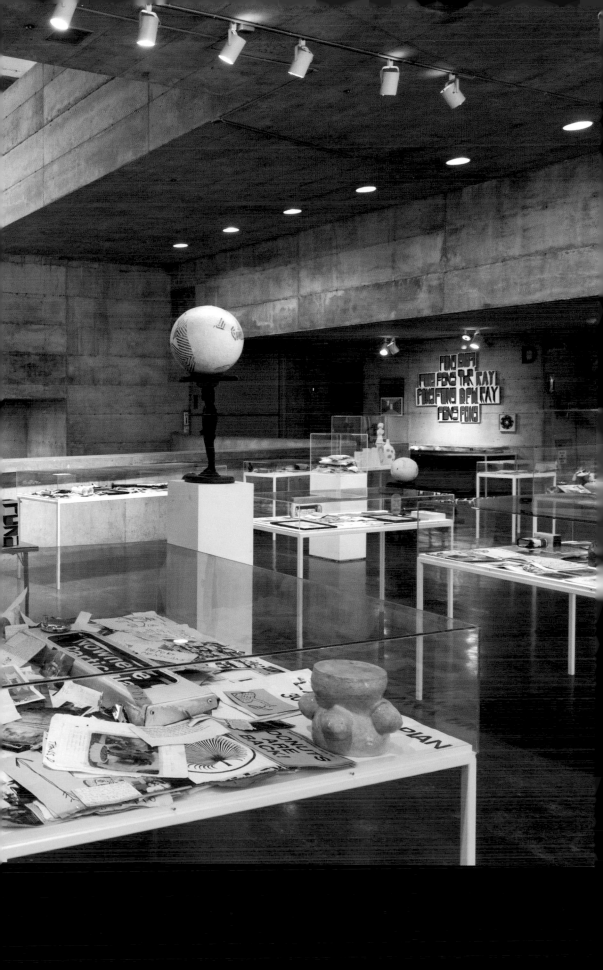

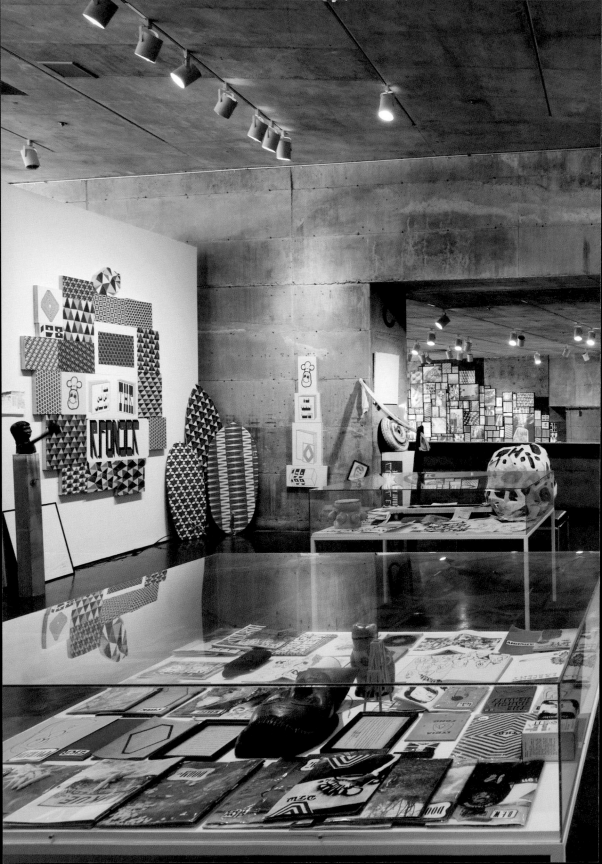

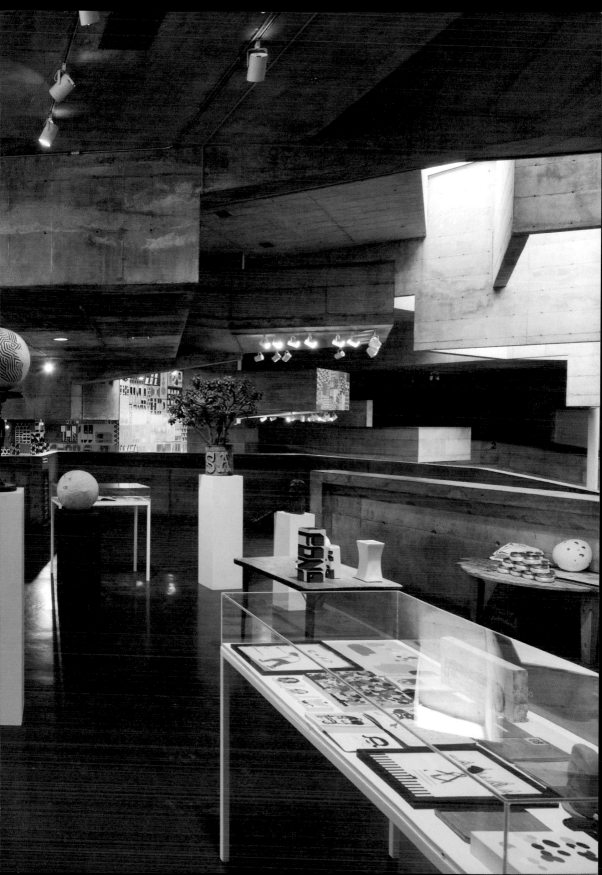

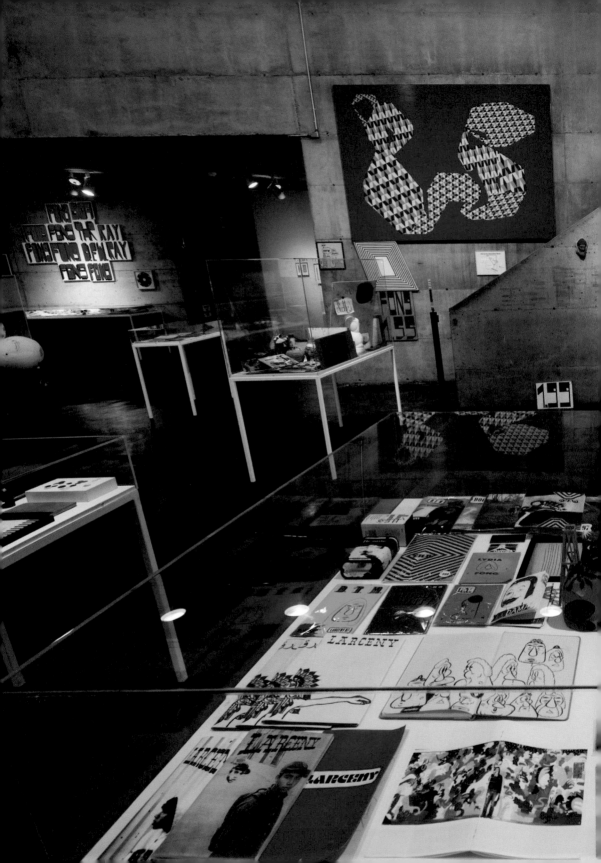

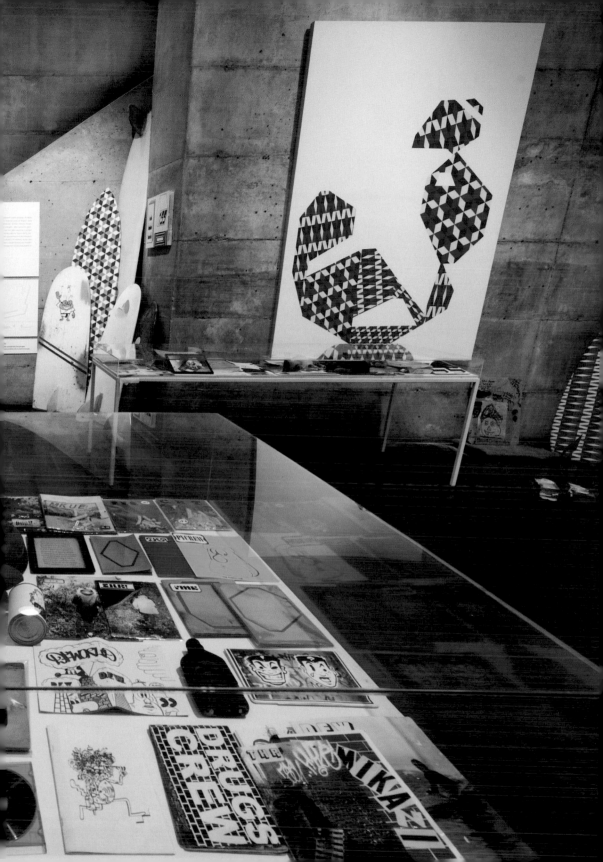

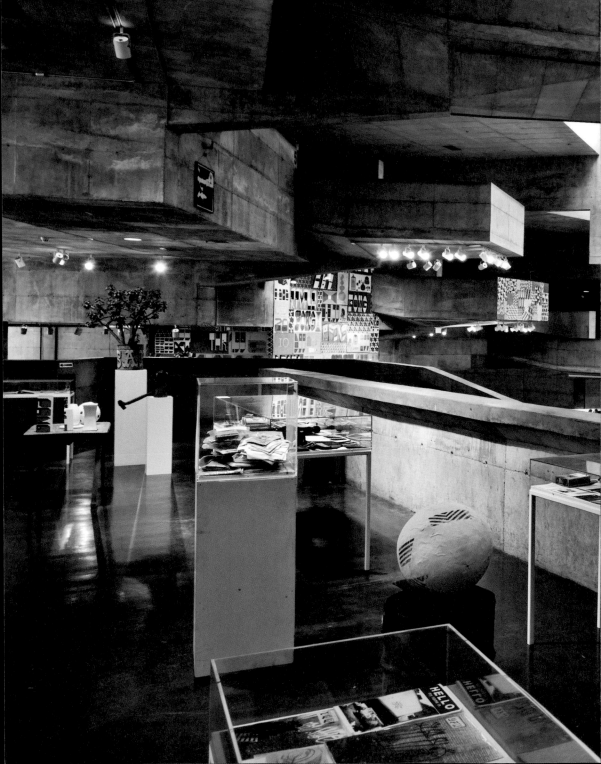

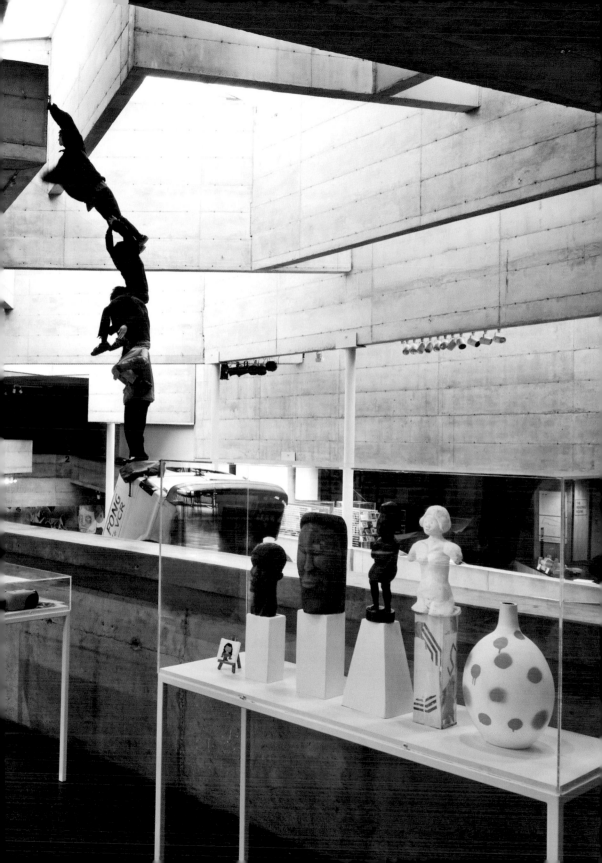

Untitled, 1989; etching; 35 1/2 x 24 in.; courtesy Barry McGee. Photo: Wilfred J. Jones.

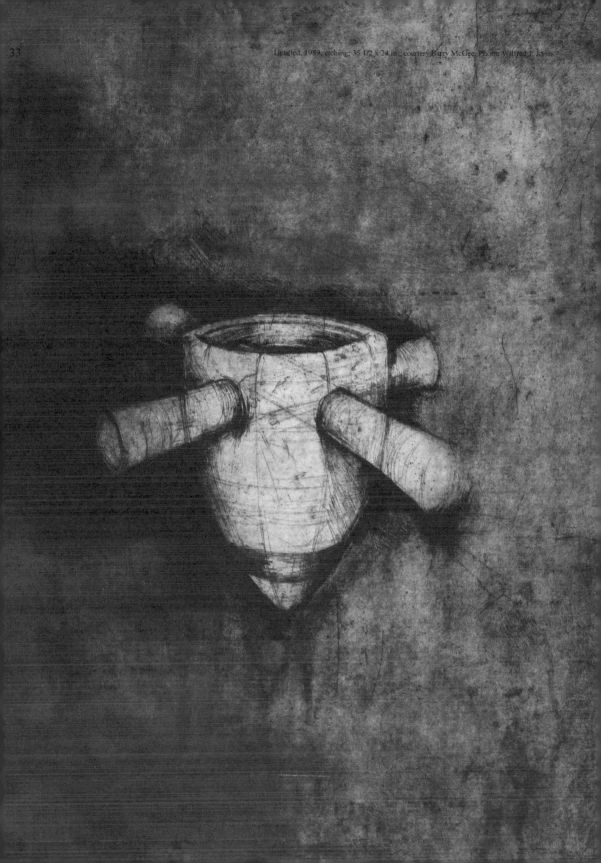

Barry McGee's distinctive style, collaborative approach, and celebration of the energy of the street have profoundly influenced a generation of international artists. Barry would be the first to say that his contribution is not singular, that he was just one of many who broke out of the confines of art schools, galleries, and museums in the 1980s and 1990s to make the city itself a living space for art and activism. Yet his work has been unusually bold, generous, and effective. His images and themes have resonated globally. From the tragic loneliness of a social outcast to the transgressive idealism of a youthful tagger, the characters in McGee's art can be found anywhere. Similarly, the two emotional poles of his work—compassion and vivacity—are universal. Barry's art cogently and beautifully cuts to this core of human experience.

McGee is self-effacing, sometimes working anonymously or shrouded by pseudonyms, and his work has often been ephemeral. This slippery approach to identity and imagery is deeply connected to the political motivations of his work, alluding to the possibility of a more collective, less materialist social condition. The Bay Area has provided an appreciative and welcoming community for McGee's dynamic, engaged, and progressive approach. However, there has not been a solo museum show of his work here since his seminal exhibition at the Yerba Buena Center for the Arts in 1994, nearly twenty years ago. So it is with a sense of belated—albeit happy—responsibility that the Berkeley Art Museum and Pacific Film Archive presents this midcareer survey of McGee's work.

For this exhibition, we have attempted both to bring together important examples of all the major periods of McGee's art and to provide him with an opportunity to develop new work. Of course, since much of his early artwork was made in situ on city streets and no longer exists, this important aspect of his art can only be represented photographically, as it is in this catalog, thanks to extensive archives of images provided by McGee and others. Our catalog writers have explored various dimensions of McGee's life and career. Alex Baker's essay is the first comprehensive history of McGee's art and sheds light on many fascinating aspects of his practice. Natasha Boas has collected diverse views on the San Francisco Mission School from a variety of art and culture personalities. Jeffrey Deitch contributed an invaluable commentary on his experiences working with McGee on some of his most important projects. We are also pleased to reprint in its entirety Germano Celant's illuminating 2002 interview with McGee that captures the artist's own unique voice and spirit.

McGee thrives on spontaneity, a condition that can be the bane of museum practice, so we are doubly grateful both to him and to our staff for meeting each other halfway. BAM/PFA's staff has displayed extraordinary resourcefulness throughout the process of putting together this unusually complex and ambitious exhibition. Chief Administrative Officer Richard Tellinghuisen has been invaluable in helping to realize some of Barry's most challenging concepts. Lucinda Barnes, chief curator and director of exhibitions and programs, has also been essential in keeping the project on track.

BAM/PFA Exhibition Designer Barney Bailey has been a supportive champion of McGee's ideas from the start. His ingenious solutions to the most challenging problems of presentation and display continue to amaze us all. Our crew of talented preparators including Gary Bogus, Laura Hansen, Michael Meyers, and Scott Orloff, also deserves thanks for their focus and determination to make this installation the best it could be. An exhibition with so many diverse works would test the mettle of the best of registrars; our

Registration staff, including Lisa Calden, Genevieve Cottraux, and Pamela Pack, remained calm throughout and managed to keep the artworks organized and safe. For a midcareer retrospective, the catalog is arguably as important as the exhibition, so we are especially grateful to Managing Editor Nina Lewallen Hufford for her patience and diligence and to Design Director Mary Kate Murphy for her consistently sage advice and guidance. The catalog itself has been marvelously designed by Purtill Family Business, who has worked with McGee before and who brought years of insight and enthusiasm to this project. Many of McGee's friends generously provided us with images and information; we are particularly indebted to Craig Costello for contributing invaluable photographs of his early collaborations with McGee on the streets of San Francisco. Special thanks are due to our two interns, Elisabeth Smith and Julianne Fraker, who provided editorial assistance during the production of this catalog. The public programs for the exhibition have been developed and overseen by our very capable Education staff, including Sherry Goodman, Karen Bennett, and Lynne Kimura.

An exhibition would be nothing without financial support and promotion. Our Development staff, including Sara Sackner, Elisa Isaacson, Sylvia Parisotto, Ben Castanon, and Kate Johnson, has done a tremendous job securing the necessary funding. Many thanks to our Communications and Digital Media staff, including Peter Cavagnaro, Grace Engels, and Dave Taylor, for making sure the world is aware of McGee's exhibition. Recently hired, Aimee Chang, our director of engagement, threw herself enthusiastically into this project, bringing tremendous experience and insight. There are many more staff members who have worked to make this show and its programs a success: we are particularly grateful to those working in the Business,

Security, Facilities, and Administration areas for all they have done on behalf of this exhibition.

For lending precious work to the exhibition in Berkeley and Boston, we would like to thank: Paul Benney and Jessica Lutes of OnSite Dance Company, San Francisco; Deitch Archive, New York; Peter Leeds, New York; Phillip Leeds, New York; Lindemann Collection, Miami; Collection of Jay Pidto and Lynne Baer, San Francisco; Cindy Sherman, New York; Collection of Robert Harshorn Shimshak and Marion Brenner, Berkeley; Collection of Taro, Costa Mesa, CA; Walker Art Center, Minneapolis; a private collection; and, of course, Barry McGee, San Francisco.

An exhibition of this scale relies even more than most on the generosity of funders. *Barry McGee* is made possible by lead support from The Andy Warhol Foundation for the Visual Arts and presenting sponsor Citizens of Humanity. Major support is provided by the National Endowment for the Arts, Ratio 3, Cheim and Read, the East Bay Fund for Artists at the East Bay Community Foundation, The Robert Lehman Foundation, Prism, Stuart Shave/Modern Art, and Cinelli. Additional support is provided by Rena Bransten, Gallery Paule Anglim, Jeffrey Fraenkel and Frish Brandt, Suzanne Geiss, Nion McEvoy, and the BAM/PFA Trustees.

Lawrence Rinder, Director
Dena Beard, Assistant Curator

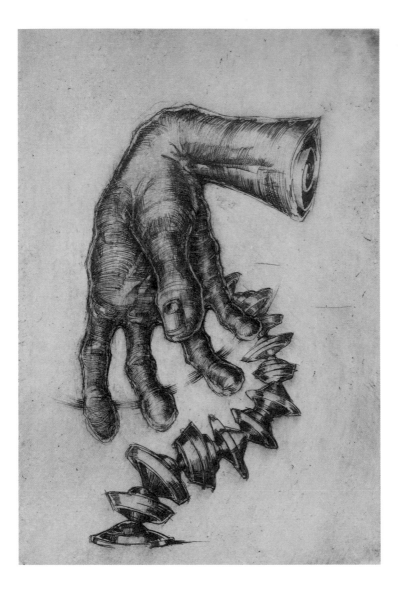

Untitled, 1989; etching; 5 3/4 x 3 7/8 in.; collection UC Berkeley Art Museum and Pacific Film Archive: bequest of Phoebe Apperson Hearst, by exchange.
Photo: Sibila Savage.

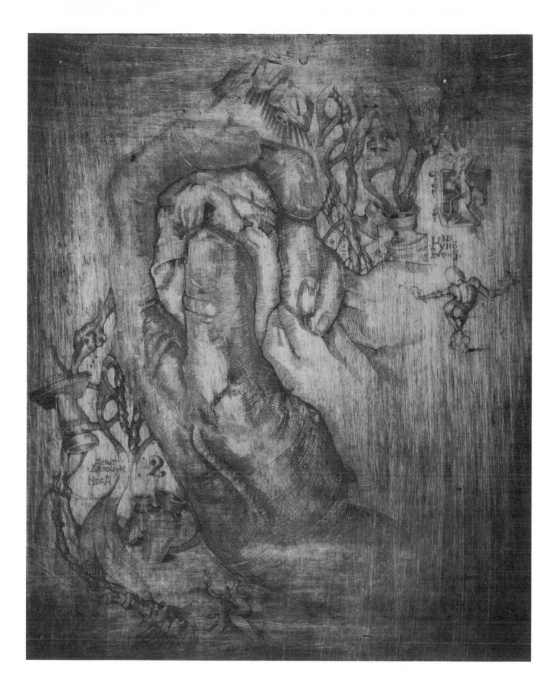

Untitled, 1989; etching; 9 5/8 x 7 7/8 in.; collection UC Berkeley Art Museum and Pacific Film Archive: bequest of Phoebe Apperson Hearst, by exchange.
Photo: Sibila Savage.

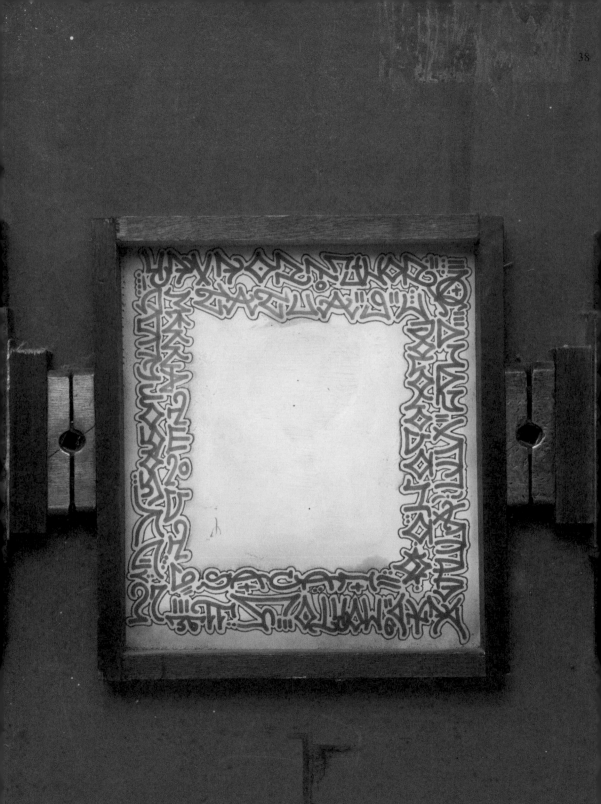

Untitled, 1992–93; ink and acrylic on paper in tin galley tray; 13 1/4 x 9 1/4 x 5/8 in.; collection Robert Harshorn Shimshak and Marion Brenner, Berkeley.
Photo: Sibila Savage.

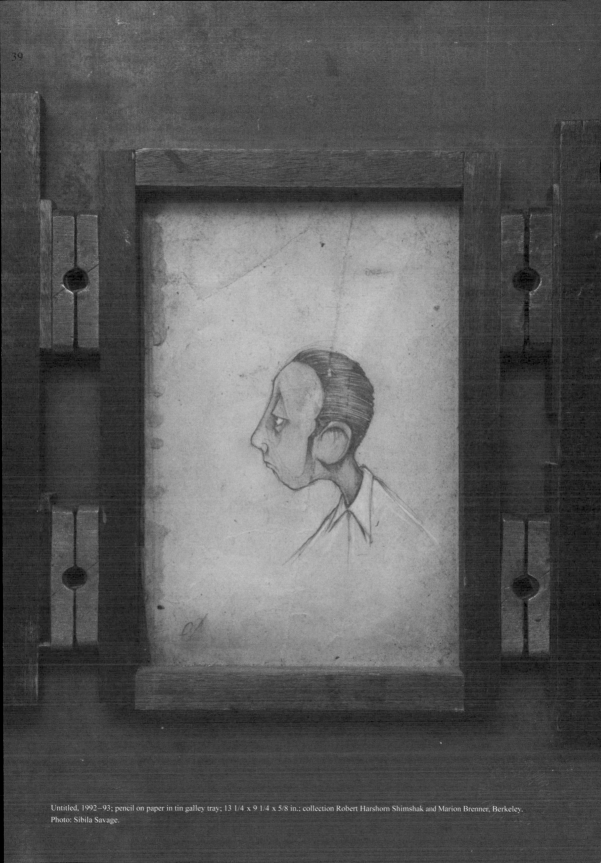

Untitled, 1992–93; pencil on paper in tin galley tray; 13 1/4 x 9 1/4 x 5/8 in.; collection Robert Harshorn Shimshak and Marion Brenner, Berkeley.
Photo: Sibila Savage.

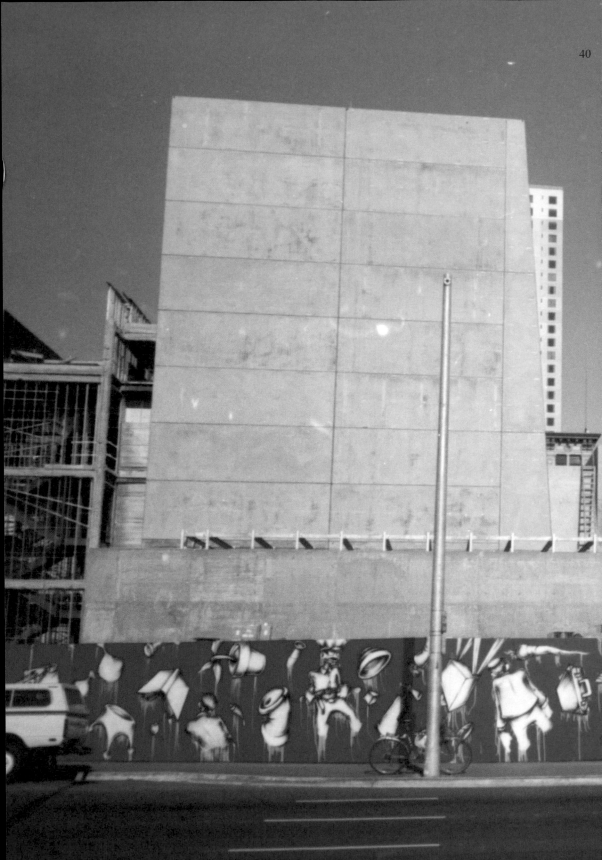

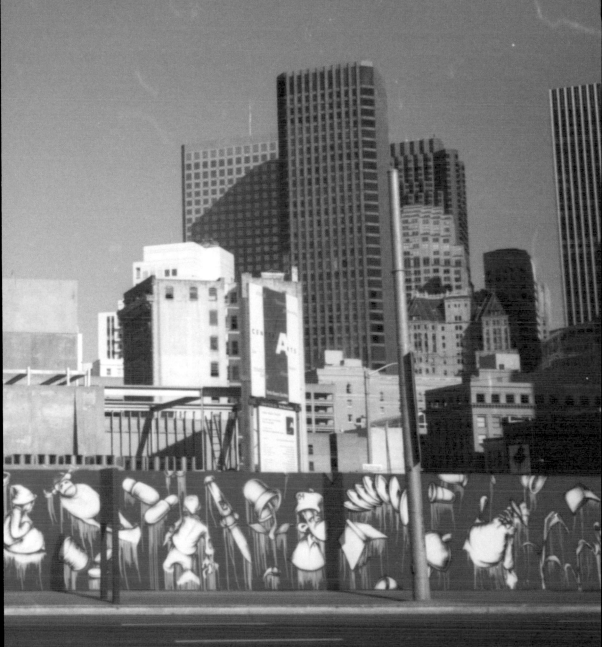

41 Untitled, 1992; acrylic house paint and enamel on wood; 8 x 240 ft.; site-specific painting commissioned by Yerba Buena Center for the Arts, San Francisco; courtesy Barry McGee.

I first worked with Barry McGee when I commissioned him to paint a gigantic mural on the construction fence sur- rounding Yerba Buena Center for the Arts in 1992. That became one of McGee's landmark early works, black-and- white figures of cops and workers and tools on a red back- ground. That success was on my mind when I heard about a grant opportunity from the enlightened philanthropy of Tom Layton at the Gerbode Foundation; he was making available five grants of $25,000 each for artist research and travel. I asked Barry where he'd like to go and he told me that he'd always wanted to visit Brazil. I wrote the grant and we got the money. This was still a time when the term Mission School hadn't been coined and Barry was still widely thought of as a graffiti artist. His three-month stay in Brazil was extended to around six months, and the exhibition that was part of the grant kept getting closer and closer. McGee did show up, and put up an extraordinary show, demonstrating his older style as seen on the construc- tion fence in combination with new ideas. These included dozens of newly outmoded type trays from a print shop, as wall covering and as something on which to paint. He showed his conglomerations of mixed-sized, framed, found, and original visual materials inspired by the communal input of church offerings in Brazil. Still ambivalent about his status as an emerging art star, Barry stayed outside on Mission Street during the whole opening. For the entire run of the show, youths in baggy pants kept coming to the front desk and asking, wide-eyed, if it were true that Twist had a show in the gallery.

Renny Pritikin, Chief Curator of Yerba Buena Center for the Arts, 1992–2007

pp. 43–47: *Barry McGee*, 1994 (installation views); Yerba Buena Center for the Arts, San Francisco; courtesy Barry McGee and Renny Pritikin. following: Untitled, 1993; acrylic house paint and enamel on found canvas; 130 x 170 in.; courtesy Barry McGee. Photo: Wilfred J. Jones.

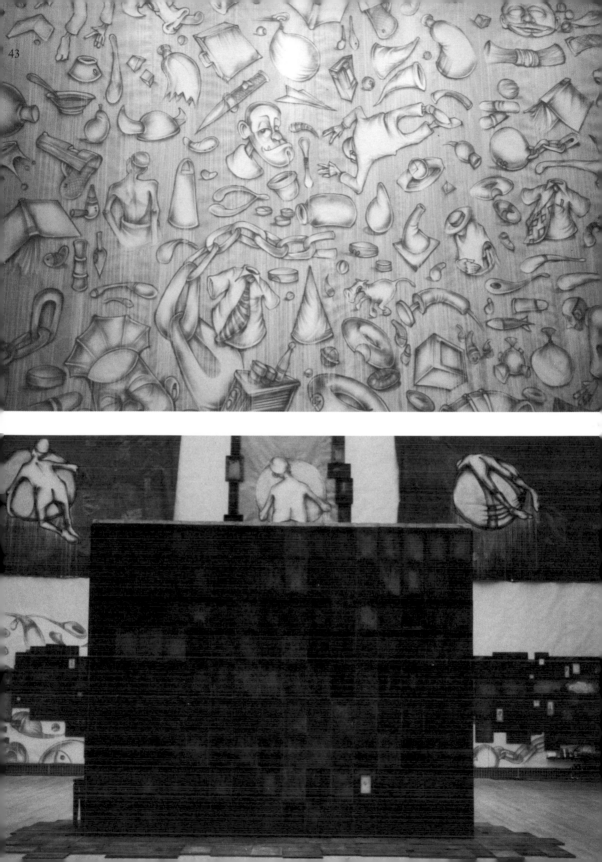

43

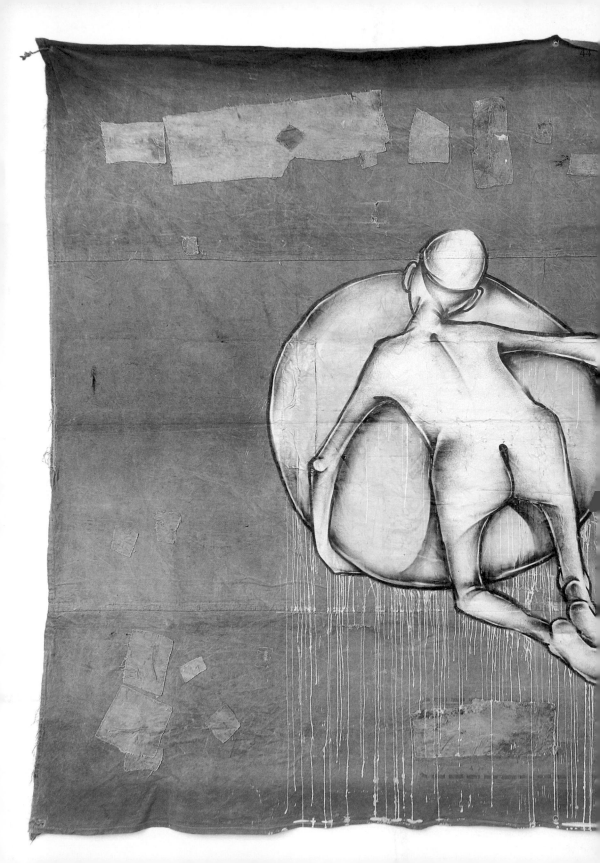

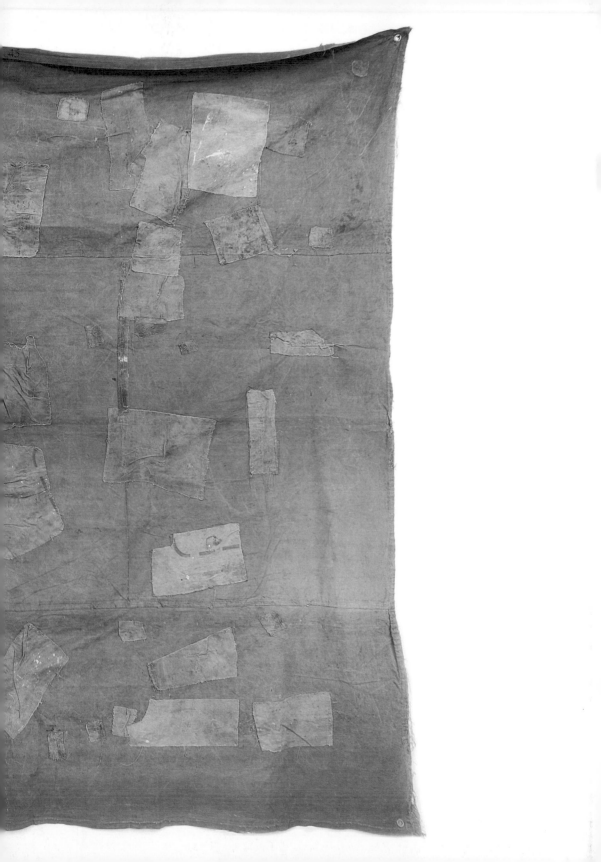

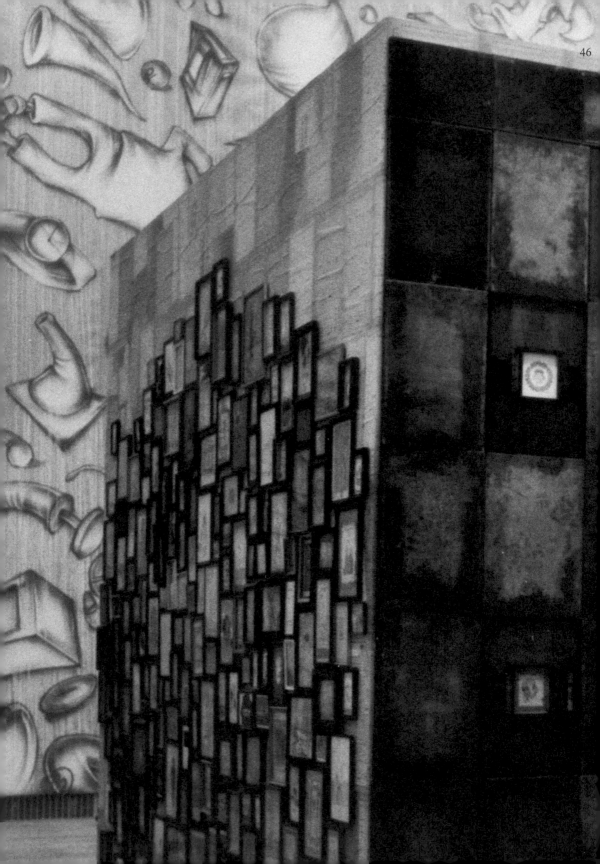

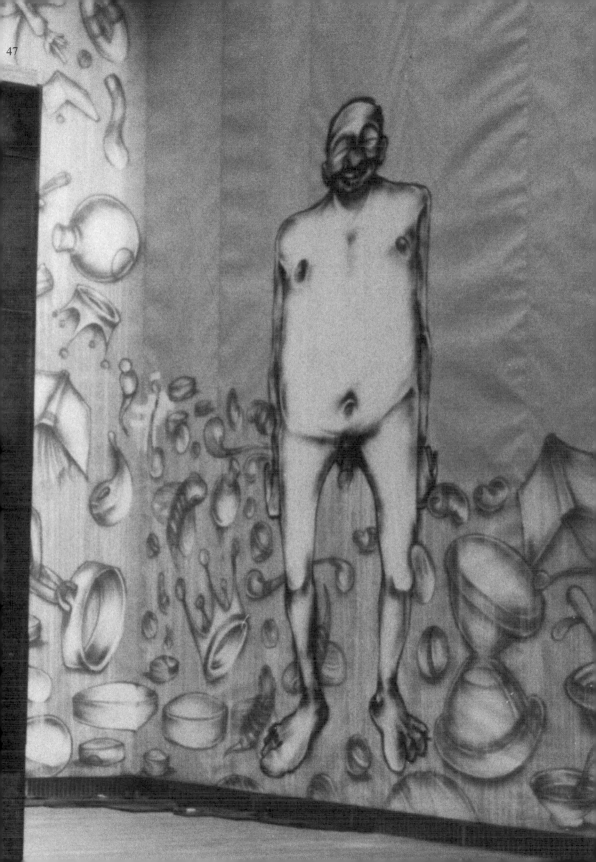

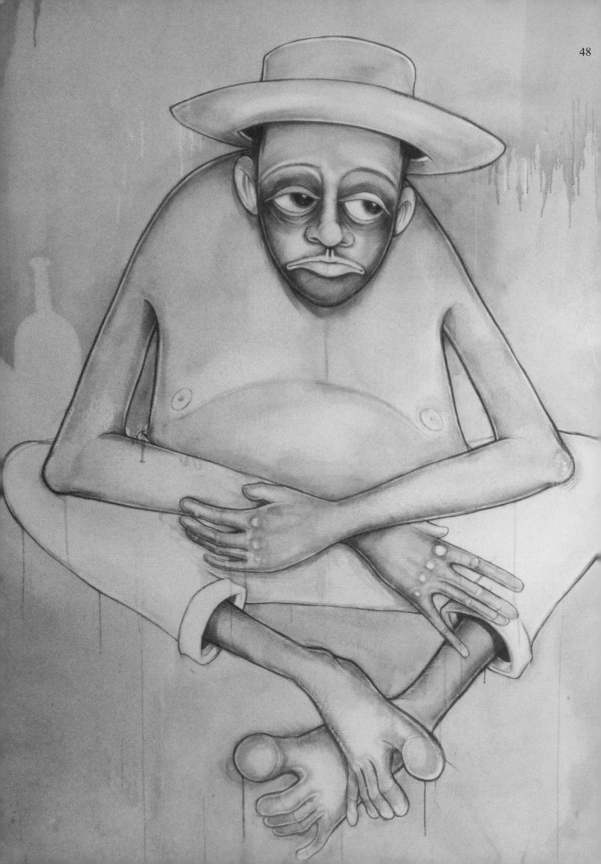

Untitled (detail), 1994; acrylic house paint and varnish on drywall; 10 x 16 ft.; site-specific painting at the Redstone Building, San Francisco, commissioned by Clarion Alley Mural Project; courtesy Barry McGee. Photo: Dena Beard.

Untitled, 1995; acrylic house paint, enamel, and varnish on canvas; 116 x 471 in.; commissioned by OnSite Dance Company, San Francisco, collection Paul Benney and Jessica Lutes. Photo: Sibila Savage.

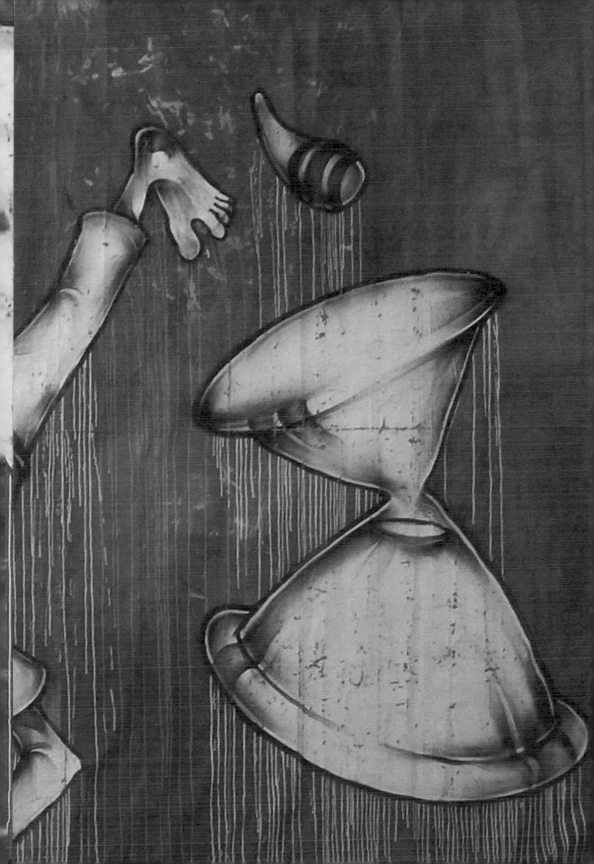

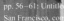

pp. 56–61; Untitled, 1995; acrylic house paint and enamel on tin galley trays and sheet metal; 8 x 64 ft.; site-specific painting at 1035 Howard Street, San Francisco, commissioned by Luggage Store with support from the Creative Work Fund; courtesy Luggage Store, San Francisco.

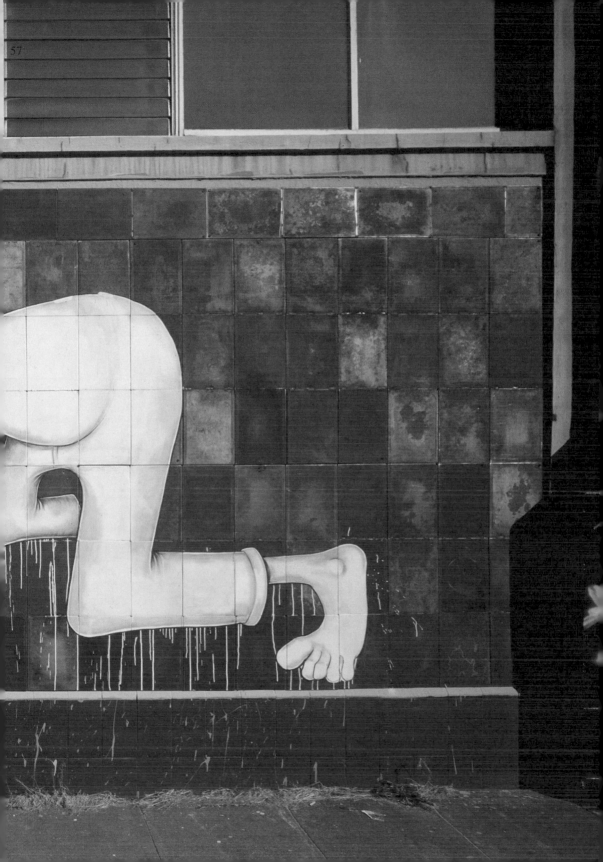

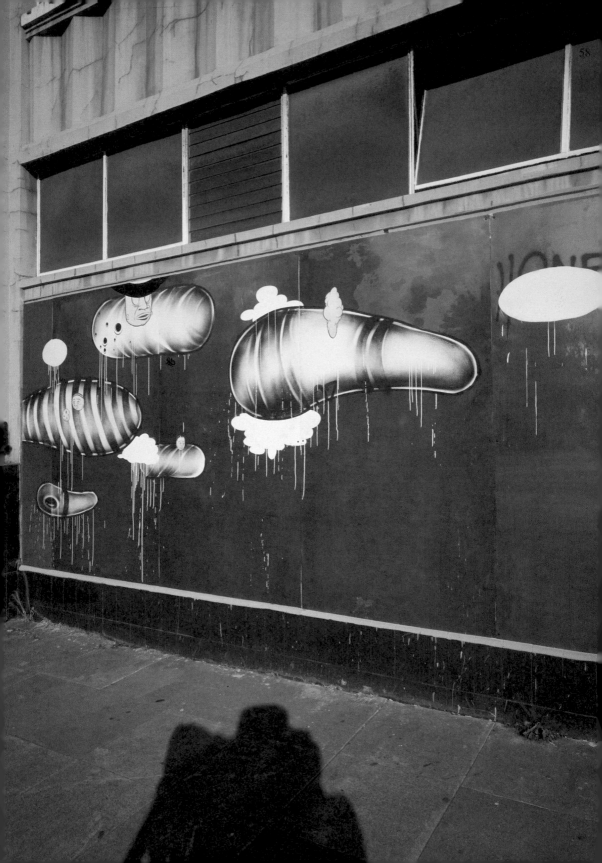

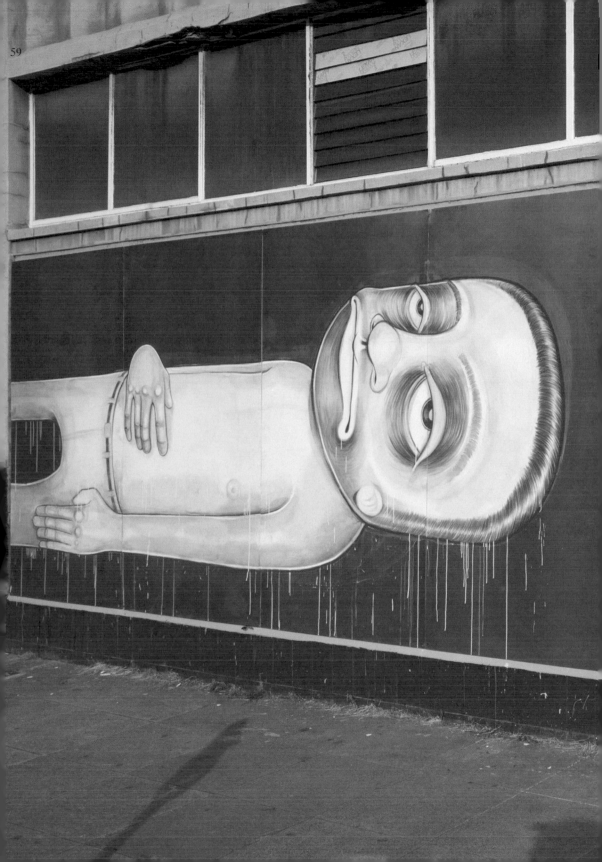

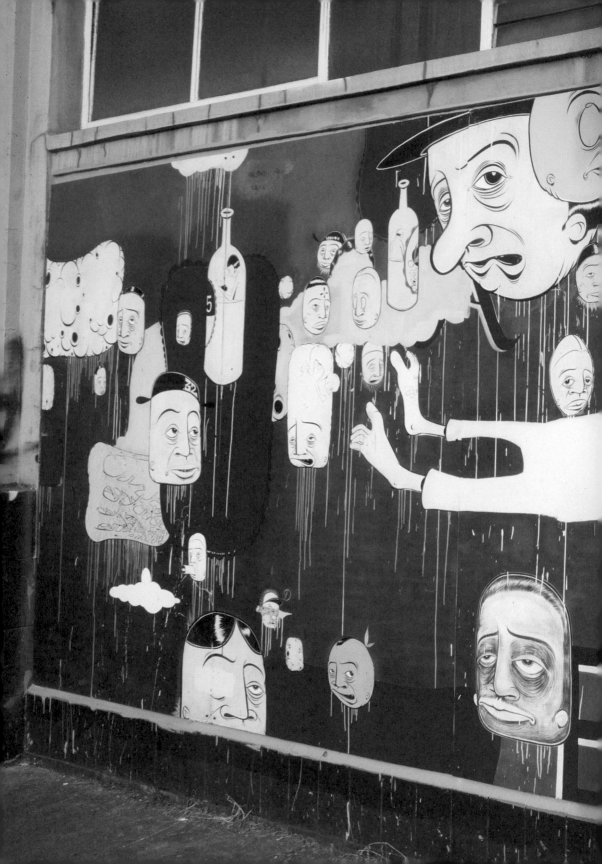

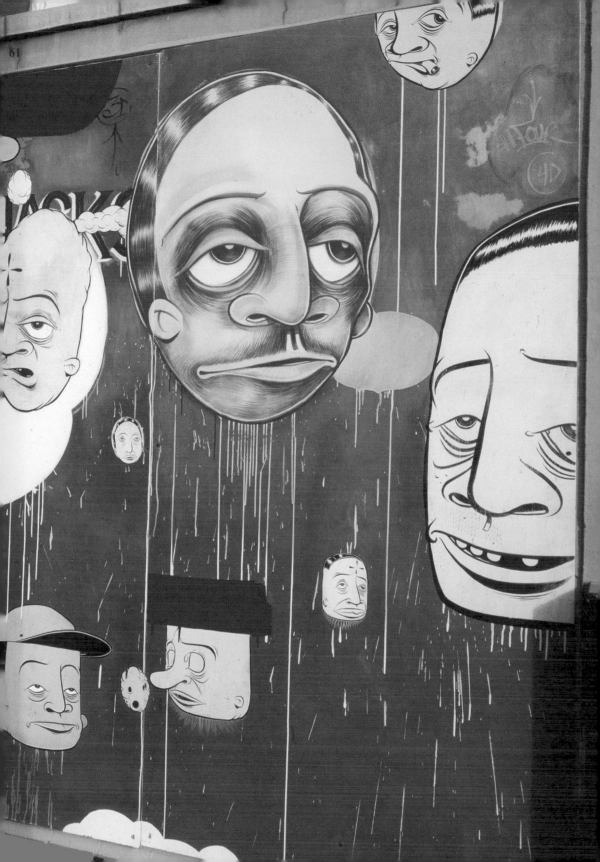

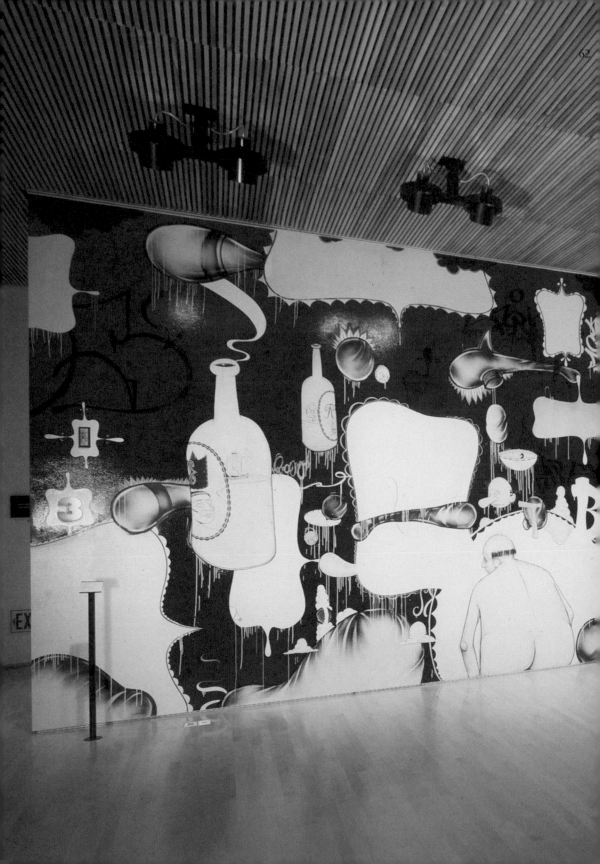

63

Untitled, 1996; acrylic house paint, enamel, and varnish on wall; 12 x 59 ft.; site-specific painting included in D-L Alvarez, Anne Appleby, Barry McGee:
1996 SECA Art Award, September 12, 1996 – January 7, 1997, San Francisco Museum of Modern Art, courtesy San Francisco Museum of Modern Art.

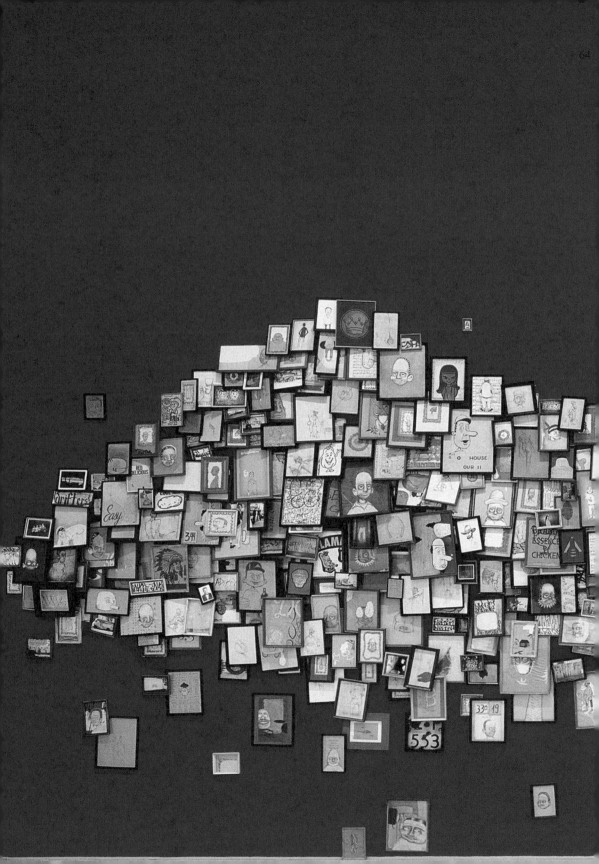

65 Untitled, 1999/2004, ink, graphite, acrylic, screenprint, and photographs on paper, frames, dimensions variable; installed in *Between Art and Life: The Contemporary Painting and Sculpture Collection*, July 1, 2004 – April 20, 2005, San Francisco Museum of Modern Art; collection San Francisco Museum of Modern Art, Russ Nash Fund and Louis Vuitton N.A. purchase.

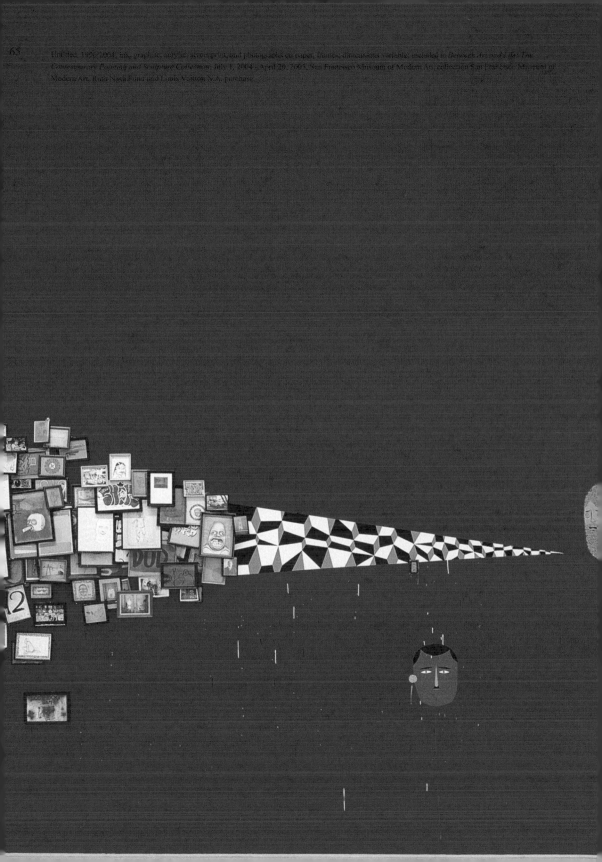

Untitled, 1995–96; house paint on tin galley tray; 16 ¼ x 10 ¼ x 5/8 in.; courtesy Barry McGee. Photo: Sibila Savage.

McGee creates works directly on "found" surfaces ranging from the gallery walls to steel printers' trays, from discarded bottles to scraps of paper mounted in thrift-store frames. Entangled in a sea of floating hardware, calligraphic markings, and fragmented body parts, his wall installations infuse a sublime poetic order on the inner city. These large-scale, site-specific works reference the ambivalent citizenry of the city through astute juxtapositions of figurative imagery reminiscent of Mad *magazine and Dr. Seuss illustrations, which address urban ills, overstimulations, frustrations, addictions, and trying to maintain a level head under the constant bombardment of advertising.*

From the press release for *Regards*, Walker Art Center, 1998

pp. 69–75: *Regards*, July 26–October 18, 1998 (installation views); Walker Art Center, Minneapolis; courtesy Walker Art Center, Minneapolis. Photos: Dan Dennehy.

69 Untitled, 1998; ink, graphite, acrylic, commercial screenprint, and photographs on paper, frames; 115 x 280 1/2 in. overall; collection Walker Art Center, Minneapolis, Miriam and Erwin Kelen Acquisition Fund for Drawings, 1998. Photo: Dan Dennehy.

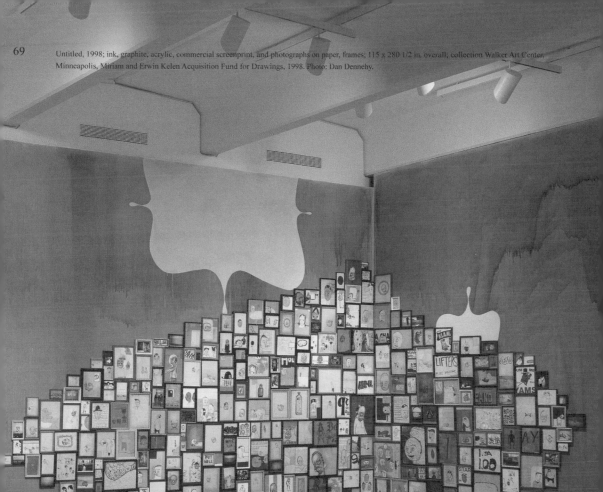

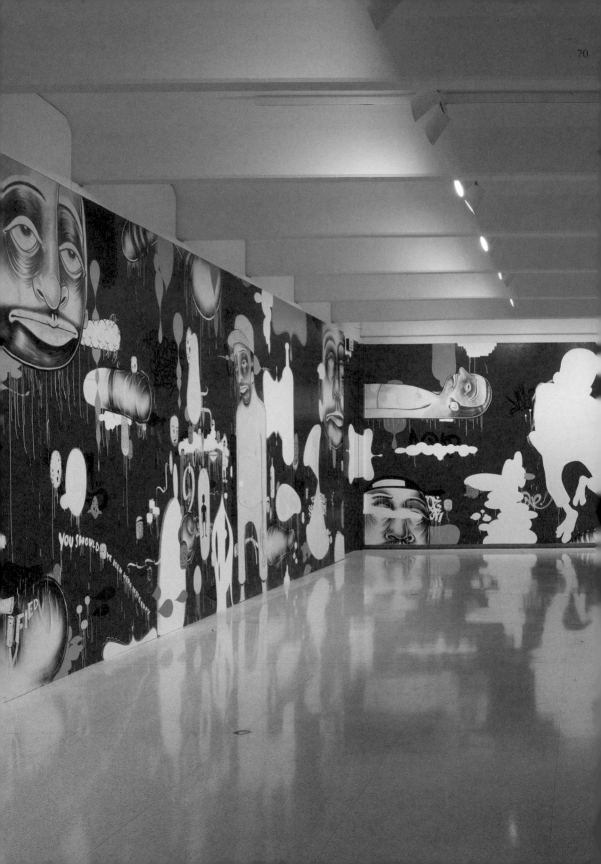

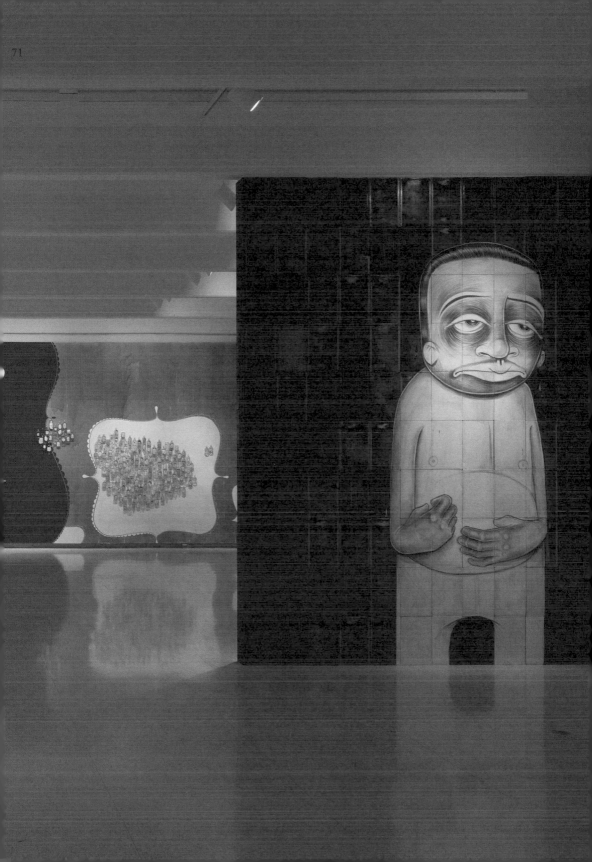

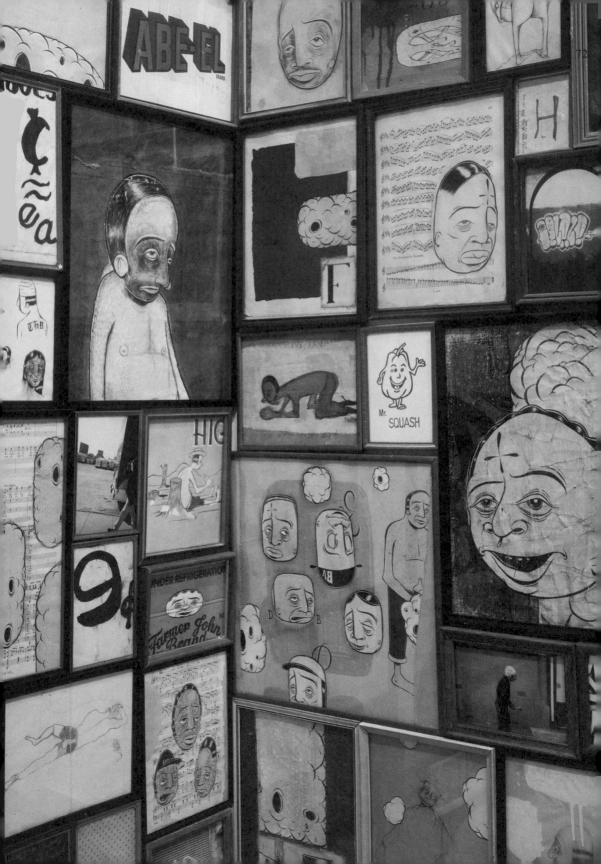

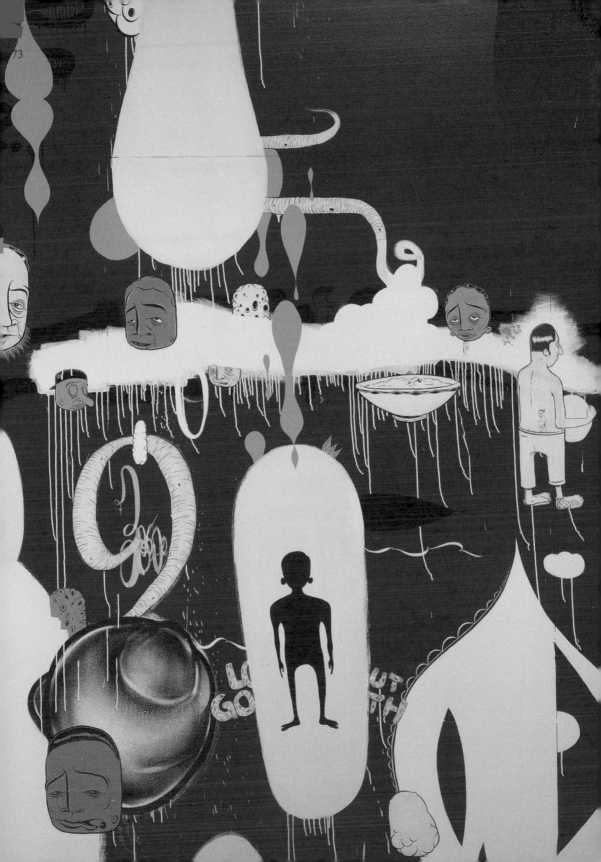

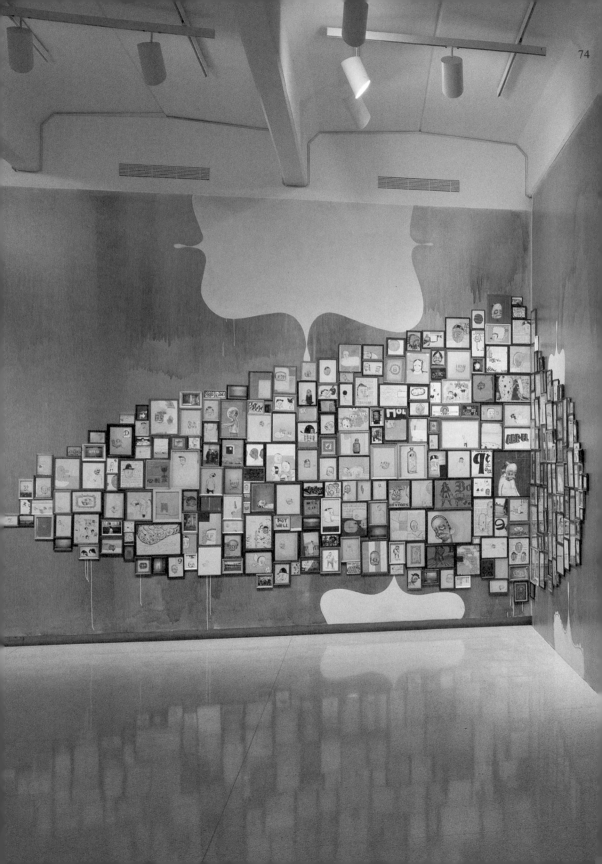

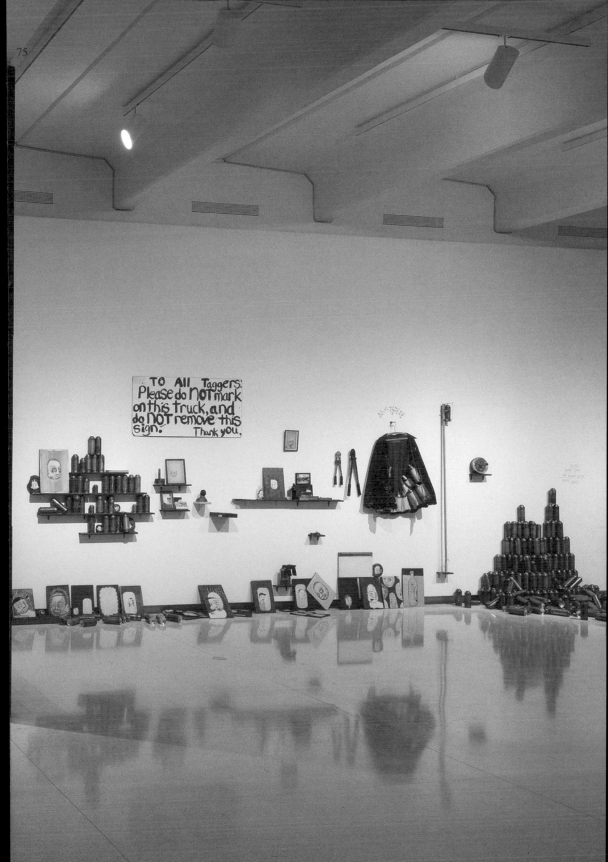

The Buddy System *is a floor-to-ceiling drawing and sculp-*
tural installation by Barry McGee that will fill the entire
gallery. McGee draws on a range of influences including
the Mexican muralists, tramp art, the graffiti artists of the
'70s and '80s and the San Francisco Beat poets to create a
unique visual language. The work has the strong immedi-
ately recognizable visual signature of the best graffiti art,
but is also enormously poetic and evocative. It communi-
cates the artist's strong empathy with people who have been
left behind by contemporary society.

From the press release for *The Buddy System*, Deitch Projects, 1999

pp. 77–81: *The Buddy System*, March 20–April 24, 1999 (installation views); Deitch Projects, 76 Grand Street, New York; courtesy Deitch Archive, New York. Photos: Tom Powel Imaging.

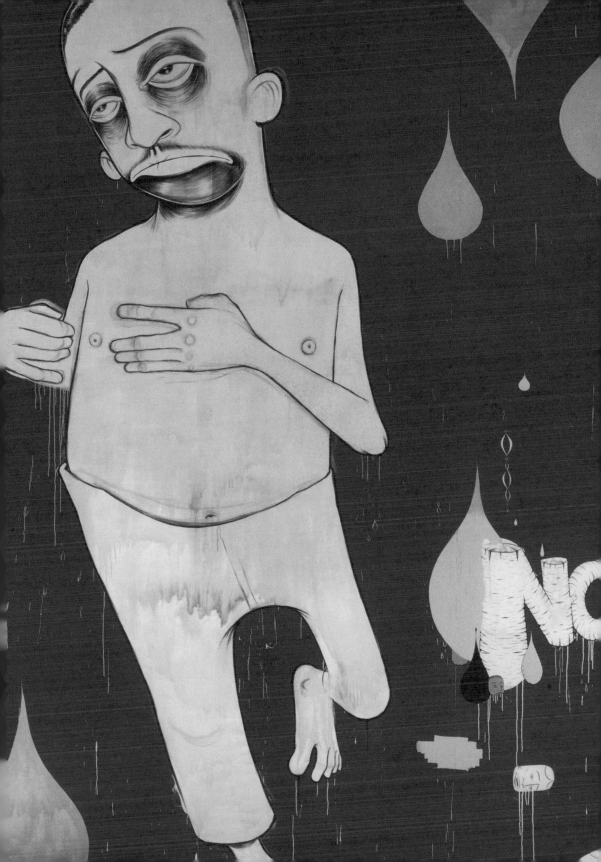

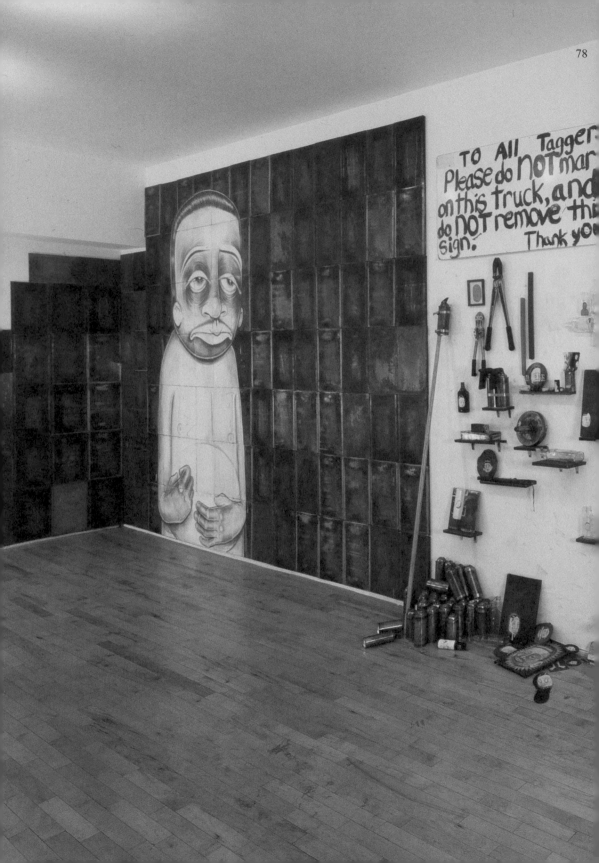

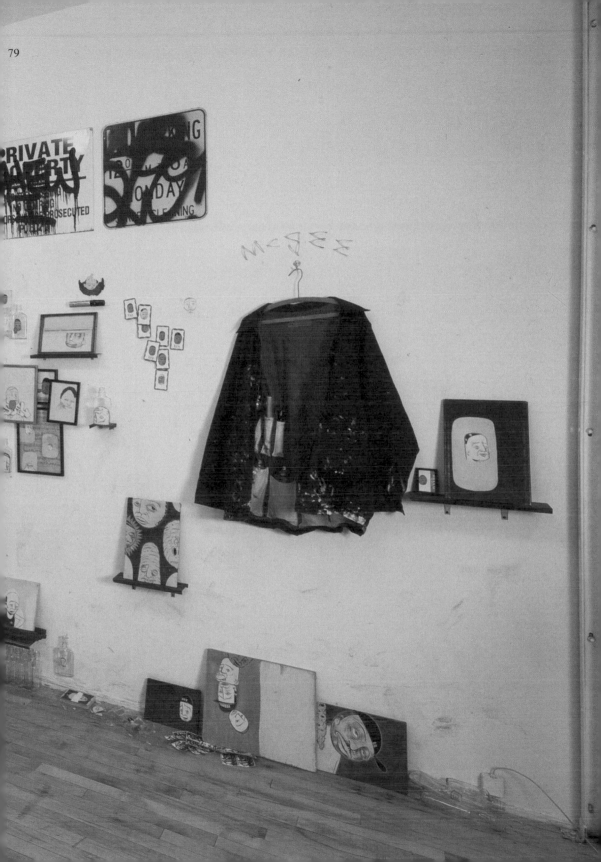

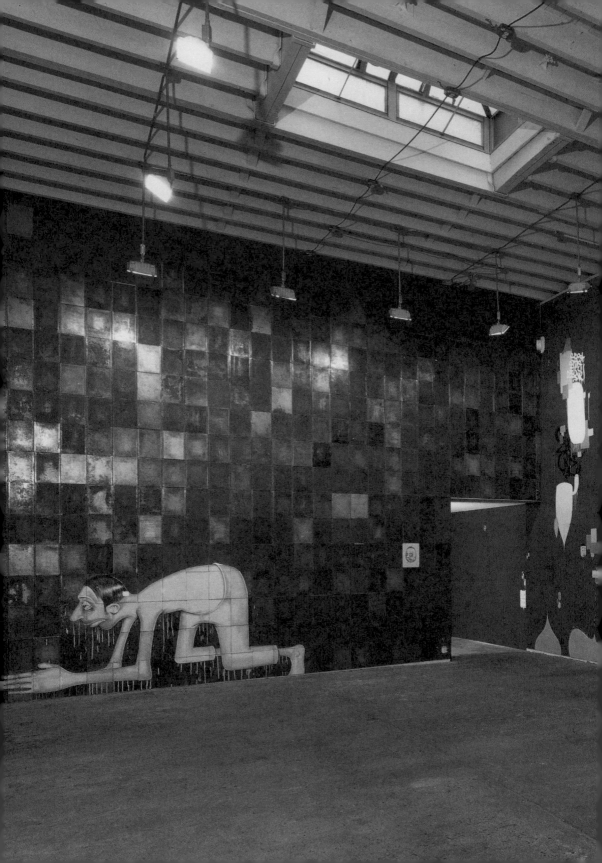

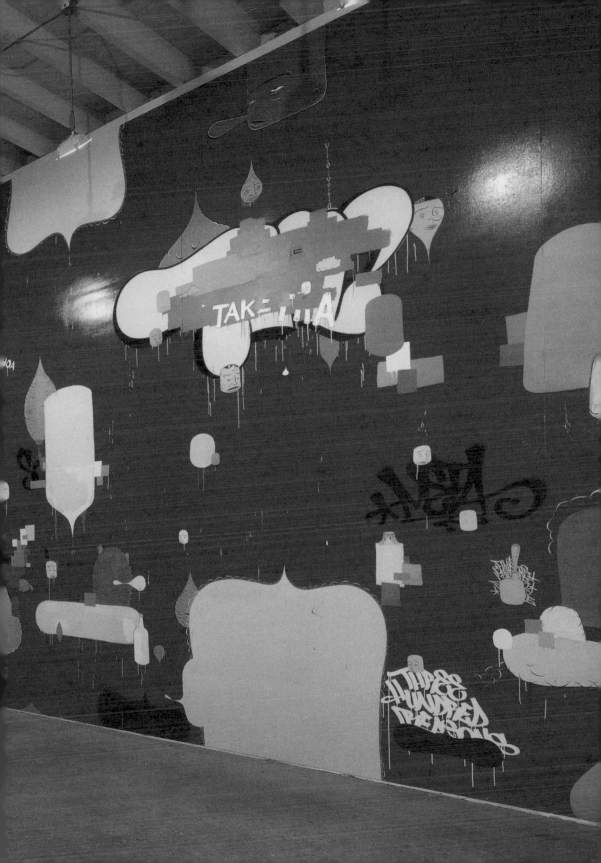

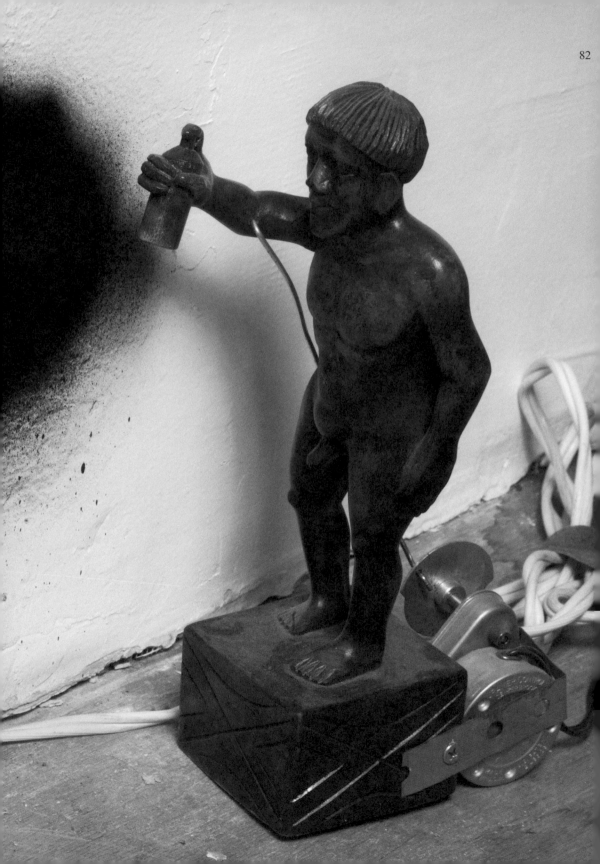

83 # Barry McGee: Chaos and Control

Alex Baker

Barry McGee has inhabited the two distinct worlds of graffiti and gallery-based art for over two decades. These worlds occasionally overlap like a Venn diagram, and at this moment in time there appears to be more convergence than usual, especially in the realm of street art, graffiti's dressed-up little brother. But, although he is partially responsible for the popularity of street art, McGee disparages the very concept. He advocates a kind of graffiti that even the art world does not like: tags and their larger, more elaborate cousins known as "throw ups," inscribed illicitly on urban surfaces. While he demands a return to hardcore graffiti vandalism kept safely in the streets where it belongs, in his gallery art McGee chooses to focus less on this non-aestheticized type of graffiti than on the context of its production, considering how it exists in the urban environment. Due to the responsibilities of age, he practices unsanctioned graffiti less and less; yet, he has cleverly convinced art institutions to allow him to graffiti their buildings. McGee knows full well that these works may not be "legitimate" graffiti by his standards, but such fine distinctions are beside the point for an often-irritated public that equates graffiti with vandalism. Context is everything, and McGee is perhaps the world's most context-sensitive artist.

Conscious of graffiti's plight in the early 1980s, when it was co-opted by the art world and graffiti writers were enticed to turn their spray cans from walls to canvases, McGee has been mindful of the exploitation of his practice as just another commodity for consumption. Much of his output in the gallery realm has been uncollectable—painted over at the conclusion of exhibition, discarded, or retained by the artist for later use.[1] But elements do circulate in a variety of markets, both official and

2

unsanctioned, from prestigious commercial galleries to eBay. McGee's work is frequently stolen from museum exhibitions or from outdoor commission sites, echoing the transgressive nature of graffiti writing itself. Wary of his increasing marketability, he has begun to turn away from working under the name Barry McGee or his tag name Twist, instead crediting work to the pseudonymous Lydia and Ray Fong.

McGee's gallery-based art explores the contradiction central to his daily life—reconciling graffiti with an artistic practice—but also addresses the question that the avant-garde has historically asked: how might art and life be reconciled? At once humorous, political, and difficult (especially for those who see private property as an inalienable right), McGee's art underscores the complexities of life in early twenty-first-century America, a country in the midst of wars, a financial crisis, unemployment, class stratification, and the ever-cheerful exhortation to keep consuming.

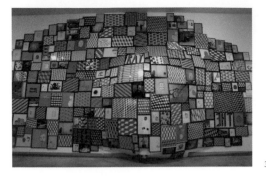

3

FOUNDATIONS AND PERMUTATIONS

Throughout his career, McGee has continued to surprise and contradict expectations. Initially renowned for his gallery-based murals featuring a cast of sad-sack, hangdog figures, he banished these trademark wall paintings in 2003 and switched to all-over op-art pattern painting as his signature backdrop. Along with the development of abstraction in his painting, his recent work is marked by an elaboration of his approach to installation. His installation environments now explore the anarchy of graffiti life, incorporating overturned cars and trucks and even spilling beyond the frame of the gallery or museum to include an exterior component. Yet McGee has followed these with more refined presentations that can be austerely minimal by the standards of his "more is more" aesthetic.

McGee's drawings and prints from the early 1990s reveal his tremendous skill as a draughtsman. With a limited palette of black, white, and shades of brown—and often on a very small scale—McGee evoked a powerful atmosphere of loneliness and despondency. His imagery at this time was primarily figurative, introducing the melancholy characters that were to dominate his practice for many years. Working at a letterpress shop, McGee had access to the metal trays that held type and began to use these as a surface for painting. He also reversed them and used the rusty backs as frames for his drawings and prints, exploiting these found objects to accentuate the desiccated mood of his images.[2]

First appearing in his 1994 exhibition at the Yerba Buena Center for the Arts, the wall cluster is perhaps the central unifying element of McGee's practice, and one that has steadily evolved over the last twenty years. In these works, McGee brings together drawings, paintings, photographs, letterpress trays, and found materials, often exhibited in thrift-shop or curbside-scavenged frames. McGee sees this juxtaposition of images as a kind of community where tension and tolerance exist side by side. Ideas for clusters are gleaned from keen urban observation:

I see a really good tag on a building, a man passed out in the middle of the street, a couple hugging, a cop arresting a panhandler. I'm interested in how all these things are happening in one block. It's beautiful, it's sad, it's terrible, it's going to be okay. The whole emotional range in one block.[3]

McGee uses a multiplicity of images in his wall clusters and these are variously juxtaposed over time. One cluster may contain familiar elements from months or years ago, with new components added to the mix, creating different narratives and relationships as time passes. A cluster might include any number of McGee's delicately drawn dispossessed male characters; logos for produce, depicting anthropomorphized vegetables like Mr. Squash; found scraps of paper with hand-scrawled messages; scavenged handwritten signs; photographs of urban despair and quirkiness; and photos of graffiti or taggers in action.

Discarded surfaces—signs, papers, and other detritus—are elemental motifs throughout the wall clusters and also infiltrate other aspects of McGee's work.[4] Sometimes these elements go from street or Dumpster straight into frames or onto walls, while at other moments they may be used as fields for McGee's drawings and then framed and arranged in clusters. McGee's wall clusters involve a process of repurposing, recombination, and accrual—the

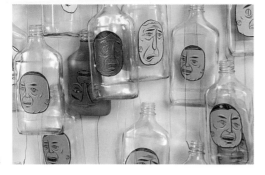

4

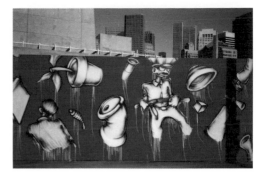

5

artist digs into an arsenal of found surfaces, putting them in dialogue with his own drawings, paintings, and photographs or other, more recent finds. Since 2007, the clusters have morphed into three dimensions, becoming "boils" (as McGee calls them) that protrude from the wall as if the mass were literally growing from within.[5]

McGee's wall-mounted bottle pieces, which emerged around the same time as the wall clusters, stem from a similar gesture of accumulation and juxtaposition. They consist of large groups of empty half-pint liquor bottles painted with a variety of faces and characters. Using his dexterous drawing ability, McGee creates an array of physiognomic traits that are derived from his extended repertoire of character types and his own observations of urban marginals. The ubiquitous down-and-out male character, one of McGee's signatures, references the artist's near-daily encounter with homeless people who also live in San Francisco's Mission District. For McGee, the characters are metaphors for graffiti, as both are "things that the city is trying to get rid of, or trying to hide, or pretending doesn't exist."[6]

The wall clusters and bottle pieces owe their presentation style to a seminal moment in McGee's life, a visit to an old Catholic church in São Cristóvão, Brazil, during a residency in 1993. There, McGee encountered overwhelming displays of offerings that included thousands of carved feet, legs, and arms "in varying degrees of execution with small inscriptions carved into each"; framed photos and drawings of family members and cherished items, such as cars; and piles of braided human hair. Each grouping of personal artifacts was allocated a separate wall. McGee was inspired not only by the vast yet considered arrangements,

but by the fragmented juxtapositions and disparities across the glut of offerings.[7]

While the wall-mounted bottle pieces have become less prevalent in the past five years, they, like the wall clusters, are foundational to McGee's exploration of part and whole: each element demands careful scrutiny, but only by observing the entire assemblage will the relationships across the work become evident. Such relationships are formal but also reality based and content driven, grounded in McGee's observations of a given street. As much as McGee has evolved over the years as an artist interested in abstraction, color, and form, he has always been invested in exploring the social realm based on his own experience of engaging with the city.

From the early 1990s until the early 2000s, McGee's large-scale wall murals painted in the gallery or museum context functioned as viewer-enveloping environments that evoked the street. The ground for the indoor murals during this period was almost always deep red, inspired by McGee's love of tagging red doors in San Francisco's Chinatown.[8] The red ground made its debut in 1992, in an official but outdoor context in San Francisco, in a mural commissioned for a barrier wall during the construction of the Yerba Buena Center for the Arts. At this time, McGee was in the thick of character-based graffiti, and his expertise in using spray paint to mimic the look of detailed line drawing was all the more pronounced against a field of red.

On the indoor murals, McGee could spend concentrated periods of time and explore variations in scale, detail, and medium. These works range from highly refined images rendered with near-single-hair brushes (figures, elaborate letterforms,

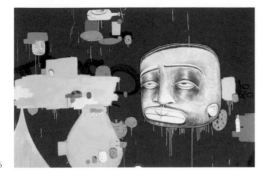
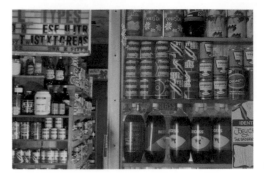

6

7

biomorphic shapes resembling wood or honey-comb), to large, cartoonlike thought balloons that might also resemble vintage address labels (with delicate filigree borders), to spray-painted tags, throw ups, and assorted characters and objects. Often interrupting the mural with gray and liver-colored blocks of latex, McGee evokes the fate of most graffiti in the contemporary city—obliterated by buff squads with mismatched paint. Like the wall clusters, the murals are visually packed; feed-ing off the disparity, energy, hope, and despair of urban life, they highlight the sensory overload of the urban experience. Wall clusters, bottle pieces, and other wall-mounted elements were often pre-sented in close proximity to the murals, but McGee created distinctions among these bodies of work, either by exploiting the existing architecture of the space or by using different paint colors as back-grounds for the framed clusters and bottles—a light brown furniture stain, for example.

McGee's talent for arrangement was evident in his early cluster-format works; however, in these the gallery wall still provided the backdrop. It was not until the fall of 2000, in the exhibition *Street Market* at New York's Deitch Projects, that McGee, collaborating with fellow graffiti writers Steve Powers (Espo) and Todd James (Reas), first upended vehicles and developed a more elaborate, three-dimensional installation practice.[9]

McGee first collaborated with Powers and James on *Indelible Market* earlier that year at the Institute of Contemporary Art (ICA), Philadelphia. In *Indelible Market*, McGee was still a wall-based artist: he installed a highly reworked version of the mural he had painted for his 1998 Walker Art Center exhibition, as well as a wall of metal type trays, a wall cluster, and a group of liquor bottles

painted with his signature down-and-out charac-ters.[10] It was Powers and James who took the leap from surface to installation environment in their customized re-creation of a bodega, or urban cor-ner store, using the salvaged architectural elements of a demolished New York store. A cacophony of hand-painted Espo and Reas signs, along with an assortment of found signs, were anchored to the roof of the bodega and to the gallery walls, mim-icking the visual noise of the cheap urban retail experience. Ironically reworking the idea of trans-forming image into product, Powers and James stocked the store with mock consumer items, iden-tified by their trademark tags and characters, and invented products, recalling the Wacky Packages stickers that Art Spiegelman pioneered for Topps chewing gum thirty years earlier. The bodega is one of those urban holdouts resistant to gentrifica-tion and corporatization—a fitting metaphor for the graffiti writer. The title *Indelible Market* suggests the hopes of the artists, McGee included, for the longevity and sustained resistance of graffiti and urban culture (symbolized in the bodega), as well as a critique of the market's voracious appetite for youth culture and street art.

Street Market, which opened at Deitch Projects about six months after the exhibition at ICA, was a much larger affair, almost carnivalesque in its aesthetic (the number of stores and signs grew dramatically from the ICA version) but also inflected by postapocalyptic overtones. To balance Powers and James's re-creation of what looked like an entire block of business establishments (the bodega was there, but so was a limousine dis-patching service, a liquor store, a check-cashing store, and a crack den), McGee brought in trucks. Graffitied, overturned, smashed up, and forlorn, the

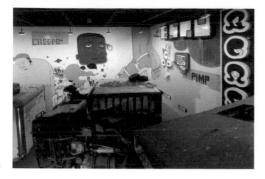

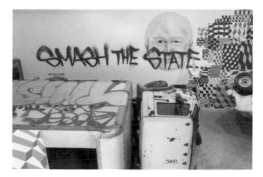

8

9

trucks resembled fallen elephants worked to the point of exhaustion or death. While Powers and James represented the urban strip, McGee chose the vacant lot and populated it with a herd of dead moving vans, vandalized beyond repair but occupied by an itinerant yet elusive bail bondsman, Robbie Pimple, conducting business in a derelict trailer. Adding to the visual surfeit of the exhibition, the trailer had another handmade sign adhered to its side emblazoned with the name "Lazcano," the last name of McGee's longtime collaborator, Josh Lazcano (Amaze). Pimple, one of McGee's aliases, came into being in *Street Market* and continues to make appearances in the artist's current work.

If McGee's earlier exhibitions conveyed a sense of tightness and control and an emphasis on walls and surfaces, *Street Market* inaugurated the beginning of McGee's embrace of the all-encompassing installation, developing a vocabulary of chaotic realism in three dimensions. In a series of shows between 2002 and 2004, McGee was increasingly engaged with installation.[11] Animated videos based on McGee's characters and other graffiti narratives joined the overturned vehicles; these were shown at first on a single junky television set and later on large stacks of TVs. Installations included DVD players covered in patterns and McGee characters and connected by tangles of electrical cabling, with no attempt to hide their chaotic jerry-rigging. Animatronic, life-size graffiti writers piggy-backed atop one another to tag hard-to-reach surfaces, an arm moving up and down to simulate the act of spraying. Another graffiti automaton, this one based on Lazcano, sprayed a tag in a bathroom inside a shipping container. Small, flat plywood cutout figures painted in McGee's highly expressive and detailed style also tagged walls in

jerky fashion, as did carved wooden African figurative sculptures. As he did with the television monitors, McGee left the wiring and mechanics of these robotic figures in plain sight. McGee's use of large-scale found objects such as automobiles and shipping containers, in combination with detritus and his own work, echoes the seedy installations of Ed Kienholz, whose pioneering 1960s works allegorized the dark side of American culture.

This proliferation of installation elements reached its zenith in the 2005 Deitch Projects exhibition *One More Thing*, which radically escalated the apocalyptic and overstimulating mood of *Street Market*. Here, all of McGee's previous experiments with sculpture, video, and found-object elements were amplified. For example, the viewer was confronted with not just a few vehicles but a three-story pileup. This anarchic scene was accentuated by other recent developments in McGee's practice such as the discombobulating op-art panel paintings. McGee also connected graffiti, urban chaos, and destruction with political critique in *One More Thing*, painting a portrait of then-Vice President Dick Cheney on the wall superimposed with the large graffitied words "Smash the State."

Feeling constricted by the museum or gallery setting, McGee began insisting that his exhibitions have outdoor components. For his exhibition at Brandeis University's Rose Art Museum in 2004, a graffiti-covered van was placed upside down in a Dumpster, greeting visitors before they entered the gallery. Such gestures reveal McGee's growing discomfort with gallery- and studio-based art and his desire to capture the rawness of graffiti and the urban abject; the contrast with the suburban purity of the Rose's university campus environment was striking. A few years later, McGee

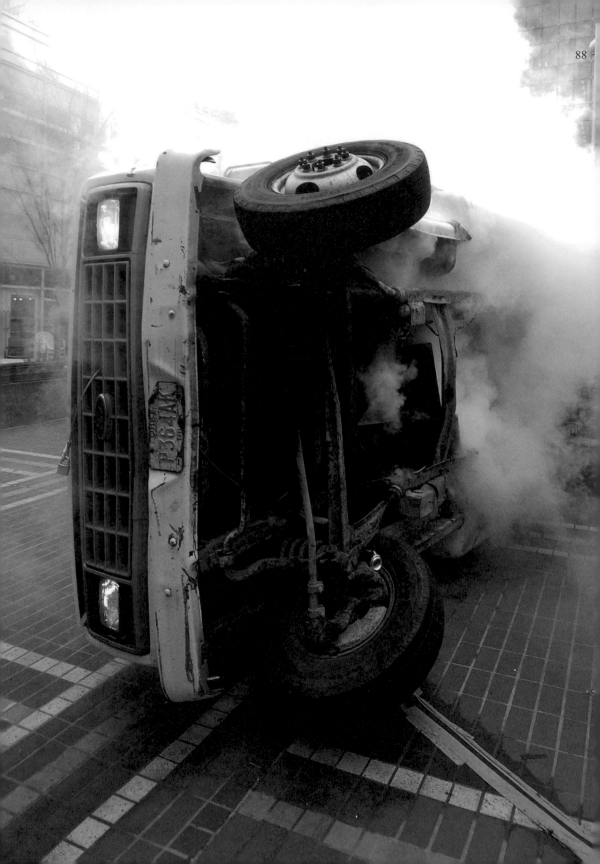

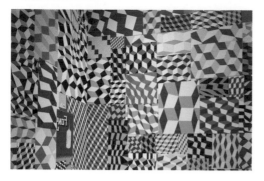

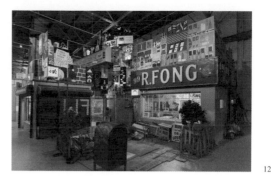

would take such gestures even further by actually painting graffiti on the facades of museum buildings, "vandalizing" institutions with their consent—institutional critique minus the self-conscious theory often associated with it. McGee's art has evolved in a building crescendo toward surfeit and the suggestion of museum and gallery space as a container near rupture. Moving steadily from surface to installation, the work eventually "spills" from the gallery, inhabiting spaces around and on the institution itself.

Since 2003, alongside his ever-expanding approach to installation, McGee has been developing a complementary geometric abstraction that accentuates and spins off from the installations' three-dimensional excess. These abstract paintings suggest a form of op art by way of 1960s populist Modernism (graphic design and interior architecture both come to mind). McGee acknowledges being inspired by geometric patterns on the front covers of old sheet music publications found in a Dumpster.[12] He calls these works tape paintings, a reference to the masking tape stenciling used to realize the orderly patterns. Diamond shapes, stepped blocks, and riotous Day-Glo colors are defining characteristics. Painted on panels, the geometric abstractions serve as all-encompassing wall murals, a replacement for his red-ground murals of the late 1990s and early 2000s. Patterning also finds its way into the more intimately scaled aspects of McGee's art strategy, as individually framed artworks juxtaposed within his ever-expanding approach to the wall cluster.

Over the last three years, McGee has embraced new modes of abstraction and image distillation, including concentric geometric forms and images derived from clip art. Like much of McGee's earlier

work, these new directions have an out-of-time sensibility, as if the images had been lifted from an old textbook on abstract motifs for graphic designers. McGee's op-art abstractions have been joined by more minimal, but still buzzy, creations in hexagonal, rhomboid, and other assorted geometric shapes formed by successions of concentric lines. These are often rendered on small panels and ganged together as groups in much the same way McGee has worked with clusters in the past, but they might also be juxtaposed in clusters with less similar works, such as face, pattern, and word paintings. Another recent development that stands in relief against the background of McGee's more detailed figurative and representational work are renderings of books, cans, and other objects as line-drawn icons. These simple paintings resemble obsolete clip art—images of familiar objects deployed as marketing tools in an old five-and-dime store.

McGee's evolving exploration of abstraction embraces letters, words, and numbers that refuse interpretation and become instead formal devices. Since graffiti is predicated on the formal attributes of letters and how each writer individualizes them, it is no surprise that McGee is a letterform expert. In his indoor gallery work over the last ten years, McGee has explored variations on a blocky, sans serif font with a drop shadow, often painted in red and black but sometimes in other colors as well. The block lettering is seemingly inspired by the old-fashioned graphic conventions of nondigital advertising—hand-painted signage. McGee's collaboration with Powers and James on *Street Market* and their shared interest in fictional commercial identities, aliases, and attendant letterforms gave rise to McGee's development of logos and signage for his own pseudo-commercial brand, Robbie

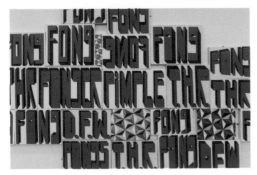

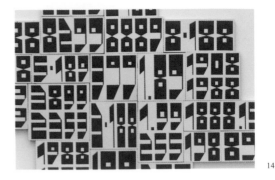

13

14

Pimple's Bail Bonds. Since then, McGee has created new aliases—Lydia and Ray Fong—who have their own signage styles, products (hair nets, shipping containers, Dumpsters), and, full circle back to *Street Market*, a mom-and-pop shop.[13]

The facade of McGee's Fong family shop, which was featured in the 2011 *Art in the Streets* exhibition at the Museum of Contemporary Art in Los Angeles, was an assemblage of competing signs painted in a number of different typographic styles, juxtaposed with his multi-colored op-art panels, iconographically rendered consumer items, and concentric linear abstract paintings. These competing images hovered above what appeared to be an actual old shop sign festooned with the name R. FONG. While the lettering on the shop windows and the front of the building indicated that tube socks, sweats, jog suits, DVDs, and VHS tapes might be for sale or rent inside, peering into the windows revealed no such merchandise. Instead, the viewer saw arrangements of what seemed to be large price-tag signs painted with vaguely retro yet futuristic numbers—many things seemed to cost ninety-nine cents, but some numbers morphed into abstract nonsense. Looking through another shop window, one gazed upon several surfboards enrobed in McGee's op-art patterns, a wooden ethnic folk-art character holding a spray can, a few zines littering the floor, a couple of small tables and stools covered in patterns, and more ninety-nine-cent signs scattered about amongst the clutter. The storefront installation showcases how letterforms have taken on the feel of concrete poetry in McGee's work.

Recent exhibitions of McGee's work in "white cube" commercial galleries give us further insight into the exchange between letterforms and abstraction, and reveal how McGee continues to build on his trademark wall cluster in new ways. In some instances, rather than juxtaposing photographs, drawings, and paintings for maximalist effect, the cluster has morphed into a more minimal arrangement of panels painted with cryptic monikers such as THR and DFW, the ubiquitous Pimple and Fong, and other letter combinations. Red and black (and sometimes olive-green) drop shadow texts are cleanly painted on white, occasionally punctuated by op-art panels. When these clusters are installed without the interruption of the trippy multicolored panels, the white grounds imbue the arrangement with a kind of purity.

Another direction that McGee has been exploring involves numbers rendered in a retro computer-generated style, such as those that added to the cacophony of the Fong shop. Installed in gallery settings, however, they exude a Minimalist quietude, and read not like signage but as abstraction. In a recent exhibition at Modern Art, London in 2011, for instance, a series of numbers—1988, 1888, 1908, 255, etc.—was painted in red on white panels and clustered in a group of about twenty. Over the past few years, letters and numbers have also migrated from walls onto three-dimensional objects, attaching themselves to the surfaces of irregularly shaped spheres. As viewers accustomed to the logic of language and mathematics, we attempt to make sense of these arrangements, but McGee defies our deciphering urges. What are THR and DFW? Who are Fong and Pimple? What is the significance of these numbers?

Across the room from a cluster of word and number paintings might be another wall cluster of concentric, linear abstract paintings, perhaps offering a clue as to how we might understand the

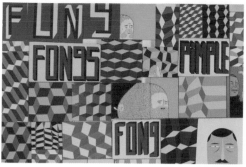

15

artist's arrangements of letters and numerals. The dialogue established across what might look like different bodies of work—abstract paintings on one hand and letter/word and number painting on the other—suggests that abstraction is the unifying element. McGee is looking at letters, words, and numbers as forms, not necessarily as systems of meaning. This should come as no surprise, as McGee's interest in the formal attributes of letters originated within the realm of graffiti, where what letters and words *look like* often trumps their meaning. Indeed, meaning is often beside the point when dealing with a name-based tag or throw up.[14]

INFLUENCES, CONTEXT, AND RESONANCES

McGee's suggestion that the creation of chaos is a political act—implicit in the Cheney portrait in the *One More Thing* exhibition—was formulated during his youth in San Francisco in the 1980s and early 1990s. Coming of age in a time of street protests, radical graffiti by communist and anarchist groups, and performances by Survival Research Laboratories (SRL), McGee absorbed the political possibilities of social disruption.

McGee began writing graffiti in 1984 under the tutelage of Zotz, who shared with McGee an interest in Italian motor scooters. It was around this time that McGee adopted the tag name Twist, apparently inspired by the title of a San Francisco scooter zine. From the mid-1980s through the early 1990s, McGee was inspired by the energy of a community of fellow taggers and the burgeoning hardcore music scene in San Francisco with its associated graffiti, as well as by the more politicized forms of protest graffiti perpetrated by groups such as the Revolutionary Communist Party, who would spray-paint aggressive statements on corporate and government buildings and freeway underpasses.[15] During the Reagan-Bush era, character-based graffiti was very popular and McGee explored this realm of creativity as well, often bringing together political statements regarding American foreign policy (the 1991 Gulf War, for instance) with spray-painted figures. McGee was participating in a larger dialogue about American politics that was particularly fervent in San Francisco during this time—"to some degree you felt like you could change the world"[16]—an attitude that informs his practice as an artist to this day.

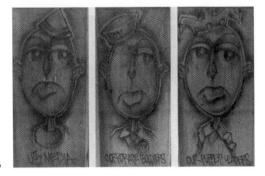

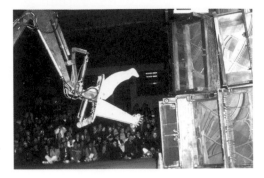

16

17

In the 1980s, ACT-UP (AIDS Coalition to Unleash Power) had a strong presence in San Francisco, where they used street protest and a savvy fusion of symbol and message conveyed by posters, stickers, and banners—even, at times, graffiti—to demand health care for, and an end to discrimination against, people with AIDS. The climate of dissent was also manifest in the Situationist-inspired subversion of outdoor advertising by both organized groups, such as the Billboard Liberation Front, and disgruntled individuals, who cleverly modified billboards to undermine the corporate control of public space. Such gestures galvanized McGee's belief in graffiti as an alternative to capitalism's ownership of visual expression in cities—the need to compete with the landscape of consumption.

As McGee has discussed in several interviews, San Francisco's Survival Research Laboratories also had tremendous impact during his formative years as a graffiti writer.[17] Founded by Mark Pauline in 1978, the organization appropriates aspects of machine and electronic technologies and diverts them from their usual applications in science, industry, and the military to the arena of public spectacle. SRL performances consist of interactions—battles really—among machines, robots, and special effects devices, presenting dark allegories that explore our dependency on warfare and destruction as a way of life. SRL borrows from the Situationists' belief in transforming the taken-for-granted aspects of daily life into subversive forms, and from Artaud's Theatre of Cruelty, in which audience members are shocked out of their comfort zones and into disturbing reality. The audience of a SRL performance is in constant danger, as fluorescent light tubes are catapulted into the air

like missiles from a rocket launcher and machines spit fire, grinding into one another like gladiators of the apocalypse. McGee recalls that an early experience attending a SRL spectacle in 1985 in a desolate area of San Francisco (the safest location for their violent performances) was a turning point, exposing him "to things that involve danger and can empower you."[18]

While it is in the context of graffiti writers working in the public realm that McGee feels most at home, he rose to prominence as a member of a loose community of artists who shared similar creative leanings. During the 1990s, a San Francisco aesthetic emerged, defined by a certain rawness, the use of found materials and recycled paint, an affinity for the old and well-worn, and a predisposition for narrative that often explored aspects of the hope and despair of urban life. Artists including McGee, his late wife Margaret Kilgallen (who passed away in 2001), Chris Johanson, and Alicia McCarthy have been grouped together under various headings (Mission School, the New Folk) to designate both a particularly local sensibility (informed by the ethnic and class realities, say, of the Mission District) and a marginality akin to folk or Outsider art (conveyed by a modesty of materials, although none was without some formal art school training). They eschewed the consumerism of the Bay Area's dotcom-driven economy of the 1990s and refused to embrace the penchant for slickness evident in other contemporary art. Digital techniques, prefabricated artwork made from high-end materials, academic theory, and media critique—which informed much of the art of the late 1990s and early 2000s—are refreshingly absent from the work produced by these artists.

93

Abstraction was evident in the work of artists like McGee, Kilgallen, McCarthy, and Johanson perhaps from the very beginning. McGee's indoor work of the mid to late 1990s featured biomorphic shapes, voids, drab green and gray color blocks, and other interruptions in figurative narrative that bring to mind erasure—all qualifying as abstract imagery. Kilgallen also explored abstraction with truncated letterforms (just the serifs exposed at the top) juxtaposed with thick striped and polka-dotted painted canvas elements, sewn together like a patchwork quilt. Her smaller drawings of rain-, tear-, dot-, and molecule-like motifs are all decidedly abstract. McCarthy was essentially an abstract artist from the very beginning, creating weave pattern paintings during the 1990s and early 2000s and, later, colorful rays intersecting at odd angles. Finally, Johanson, since at least 2001, has deployed both monochromatic painting and abstract energy bursts alongside figures, urbanscapes, and insightful and witty texts. Both Johanson and McGee have made the decision to take their earlier abstract tendencies in more articulated and all-encompassing directions, but the aesthetic logic that enabled them to make this move was present even in their less mature practices.

While McGee's initial evolution as an artist is often viewed within the context of San Francisco and the Mission School, his pattern paintings and the more subdued concentric line abstractions he has been creating more recently can be seen as part of an enthusiasm for psychedelic abstraction that has developed among young artists during the last fifteen years, chiefly on the East Coast of the United States. McGee shares a sensibility with these artists, many of whom are a generation his junior, although each has distilled abstraction in his or her own idiosyncratic way.

Fort Thunder (1995–2001), an informal collective of artists that was based in a large industrial loft in Providence, Rhode Island, has attained near-legendary status as the wellspring of a radical psychedelic aesthetic that permeated many realms of production including costume, sculpture, video, printmaking, and installation. Long before its art-world notoriety, Fort Thunder deeply influenced an up-and-coming generation of artists, many of whom embraced the experience of intense visual

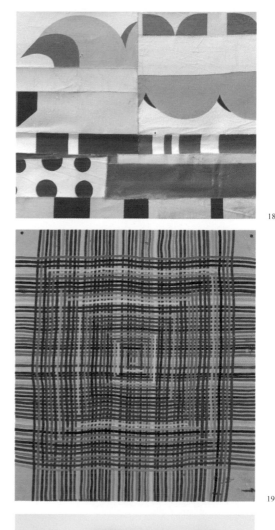

18

19

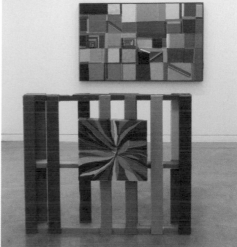

20

cacophony and took it in new directions. Residents designed and created their own living quarters; collaborated on elaborate stage sets for various musical performances, which were then destroyed during the course of the evening; hosted other extravaganzas like costumed wrestling events; and were responsible for an amazing output of screen-printed band flyers and zines, some of the most memorable of which were created by Brian Chippendale and Mat Brinkman. Several nationally influential bands emerged from the space, including Lightning Bolt and Forcefield, the latter of which also produced art installations. Forcefield members Jim Drain and Ara Peterson went on to work both collaboratively and individually, further exploring psychedelic abstract environments through geodesic sphere-shaped paintings, spinning ottomans, and rainbow pinwheels, all in outrageous polychrome.

Fort Thunder's anarchic spirit profoundly influenced students attending Providence's Rhode Island School of Design (RISD) during the mid-1990s and early 2000s, as well as young artists who had exhibited, visited, or performed at the space. Students, artists, and collectives-in-the-making who drew on this energy include paper rad, Andrew Jeffrey Wright, and Isaac Lin, who all work with psychedelic motifs, and Clare Rojas (Lin and Rojas both attended RISD).[19]

All of these artists shed light on McGee's engagement with abstraction, and reveal the ways that younger artists have influenced McGee. Rojas, now married to McGee, uses patterns alongside figuration just as her husband does, and is firmly situated within this generational zeitgeist. While never adopting the eye-popping color palette or formal density inherent in the work of her contemporaries, Rojas is still one of the most skilled and visible artists to explore abstract pattern painting in a range of scales. McGee shares with paper rad (2001–8), a Pittsburgh- and Northampton-based collective, a predilection for jarring op-art effects and an interest in retro animation techniques and outdated consumer technologies; these were the conceptual underpinnings of paper rad's practice, while for McGee they are more of a side note. Andrew Jeffrey Wright has collaborated and shown with McGee on several occasions. He explores recurring themes of the collective consciousness of his

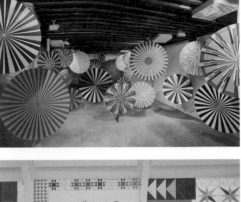

21

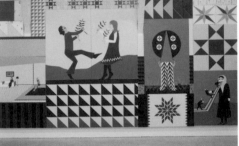

22

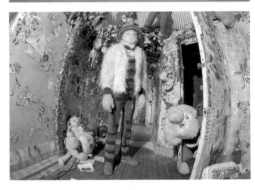

23

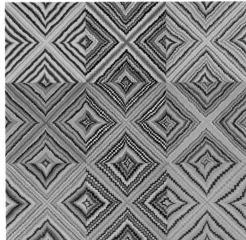

24

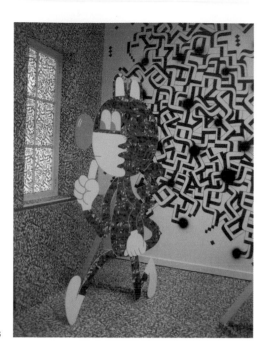

25

youth (punk rock, skateboarding, E.T., and graffiti, among a range of subjects), and often humorously evokes the world of illicit drugs through narrative cartoon drawings and abstract paintings of psychedelic energy pulsations. The latter are more loosely painted than McGee's taped stencil op-art paintings but are equally discombobulating, and underscore a shared visual vocabulary. Isaac Lin's dense and intricate paintings and drawings suggest calligraphic letterforms that buzz with energy. Lin has also taken abstraction off the canvas and into space—something that McGee excels at as well—creating entire room installations covered in dizzying printed wallpaper occupied by cartoon-character sculptures (viewable with 3-D glasses). Lin received his M.F.A. at California College of the Arts during the mid-2000s and has also collaborated with McGee, Wright, and Rojas in various capacities on exhibitions and zines. Lin's friendship with McGee and presence in San Francisco at a time when both artists were developing their respective takes on psychedelic abstraction suggests cross-fertilization.

BACK TO BASICS

In 2006, McGee began creating spray-painted graffiti throw ups on the facades of museums, art centers, and buildings procured by host institutions—all are commissioned works.[20] Such ventures are undertaken by McGee and Lazcano (Amaze), and occasionally with other assistants as well. The large-scale graffiti never feature McGee's tag name Twist; rather, they always read Josh, Amaze, or others' names, perhaps owing to McGee's discomfort in writing his own now that he no longer sees himself as a full-time participant in the graffiti culture: "I'm a middle-aged man with a family, home, dog, and all of the other trappings of a midlife crisis."[21] McGee sees Lazcano as a more authentic representative of graffiti, as he continues to write on a regular basis. Lazcano, who accompanies McGee on international travels, often regales McGee with graffiti tales when he returns from late-night adventures with various local writers. McGee is stuck installing indoors.[22]

Even though done licitly, by invitation, the graffiti interventions on museum buildings and sites secured by institutions express a graffiti purity that McGee's indoor installations lack. The throw ups, composed of only two colors and featuring a name (or names) without other representational elements, cannot be read as anything other than traditional, name-based graffiti. Owing to their prominent locations and their obvious resemblance to illicit graffiti, these works have the propensity to irritate and cause public alarm—which McGee relishes, although he still acknowledges that the throw up interventions are not actual graffiti because of the permission granted to realize them. It is important to remind ourselves that McGee's gallery practice,

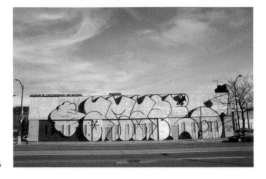

26

27, 28 >

as authentic as it might seem, is still an *explora-tion* of graffiti rather than the thing itself. The graffiti interventions indicate McGee's desire to free himself from the confines and expectations of his gallery-based practice. They also represent his continuing project of testing art world institutions and exploring what he can and cannot get away with, as graffiti, even if legitimately commissioned through proper channels, continues to disrupt the aesthetic and capitalist order of the contemporary city.

In 2010, for the exhibition *Viva la Revolución: A Dialogue with the Urban Landscape*, the Museum of Contemporary Art, San Diego commissioned McGee to paint two throw ups on buildings in downtown San Diego; these caused controversy and drew media attention before the works were even completed.[23] McGee, Lazcano, and other assistants finished the murals and then, much to the chagrin of the hosting institution and property owner, painted a third graffiti work on another side of the building without permission during the night. This mural, composed of hundreds of graffiti tags painted in bright red, paid homage to writers past and present but was removed because it violated the agreement that McGee would paint only two murals.[24] Furthermore, I imagine the aesthetic of the third work also tested the Museum of Contemporary Art and the building owner because it represented perhaps the lowest form of graffiti in the public's eye—the tag. McGee's illegal gesture threatened the two throw ups commissioned by the museum, but in the end negotiations allowed them to remain.

McGee has made his position clear that the political and social potential of graffiti lies in creating just this kind of noise in the system. Graffiti may convey overtly political messages (and

McGee has practiced this form of expression over the decades) but even simple name-based tagging reclaims space in the city for noncommercial messages. As McGee has argued, the outdoor visual sphere is essentially owned. In his view, it is the privatization of the contemporary city that is subversive, *not* graffiti, which is effectively an attempt to take back the public sphere: "Billboards are very subversive and advertising is very subversive whereas most of the stuff that is done on the street is closer to the truth. It's like the highest art there is."[25] Elsewhere he has declared graffiti a patriotic act, a way of salvaging long-held values like freedom of speech and expression.[26] McGee has also been vocal about his distaste for the aestheticization of graffiti as street art, its potential to become accepted—even co-opted—into the realm of capitalist consumption. He has acknowledged his role in the wider acceptance and commodification of street art, despite efforts to police his own boundaries by keeping graffiti and his gallery-based art separate. For graffiti to function critically, according to McGee, it must remain abrasive, and it must not aspire to art. That is why McGee advocates graffiti in its most elemental forms—the tag, the throw up—graffiti that generates disdain in the eyes of the general public as vandalism. McGee views graffiti as a form of resistance available to all, a desperate attempt at participation amidst the passivity of a consumer culture in which individuality is bought, not self-actualized. The notion of making things happen on your own terms rather than simply accepting the status quo, the do-it-yourself participatory ethos that undergirds movements from Situationism to punk rock to graffiti, has great liberating potential. As Cost (of the graffiti duo Cost and Revs) has remarked:

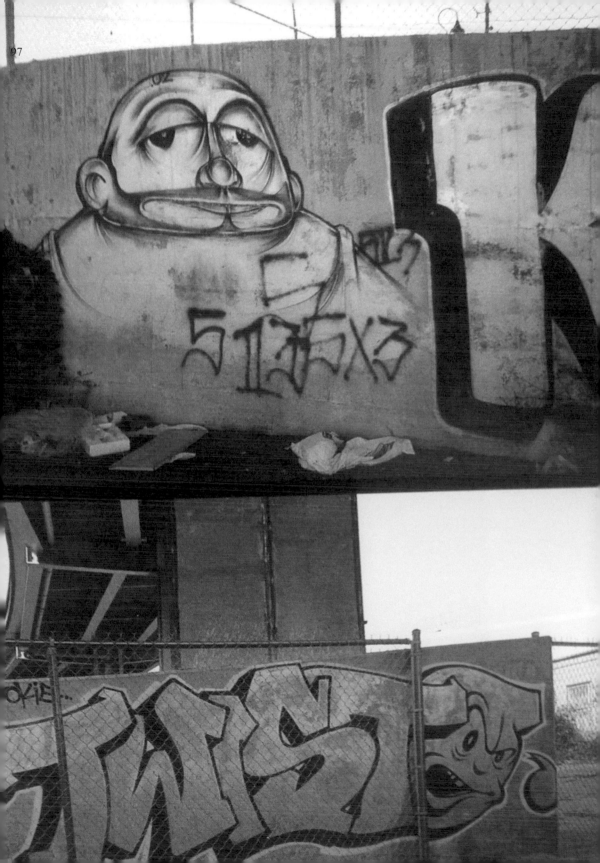

We don't have a choice in the matter, we have to do this stuff. It's not like we planned out a career. It's about putting our lives on the wall and letting people decipher it from there. I always say: "We're going all the way to the top with it. Or all the way to the bottom." And either one is fine. I don't want no middle ground—being an average Joe. Put me on the top of the pile or the bottom of the pile. Either is fine, just no mediocrity.[27]

As McGee reminds us, in the end all graffiti writers, past and present, articulate this sentiment in the act of writing: "I've got no other way to say I exist."[28]

Notes

1. For an interesting analysis of McGee's market, see Michelle Kuo, "Market Index: Barry McGee," *Artforum* 46, no. 8 (April 2008): 338–39.

2. As McGee's practice became increasingly installation based, the type trays were assembled into enclosed hut-like spaces, like the minigallery created in his 2002 solo exhibition at Fondazione Prada in Milan to present the drawings of his father, John McGee, and of his late wife Margaret Kilgallen.

3. John Eastman, "Artists of the 55th Carnegie International: Barry McGee," *Black and White*, May 30, 2008, http://blackandwhiteprogram.com/interview/barry-mcgee.

4. One such item, a sign that reads "To All Taggers: Please do not mark on this truck, and do not remove this sign. Thank you," recurs particularly often throughout McGee's installations.

5. To realize the boils, McGee creates a wooden armature covered in easy-bending plywood scraps, on which framed drawings are arranged en masse. What began around 1994 as patchwork wall arrangements of two-dimensional work have grown into a kind of installation architecture. McGee has also experimented with the boils as sculptures in and of themselves, without the addition of framed artworks. The most ambitious of these was a nodule-like growth he created for the 2009 Lyon Biennale. McGee would like to explore further the confrontational and phenomenological aspects of these protruding growths but must take into consideration institutional restrictions regarding public access and safety, as he explained to me in an e-mail on July 10, 2011.

6. "Germano Celant_Barry McGee," in *Barry McGee* (Milan: Fondazione Prada, 2002), unpaginated. Reprinted in this volume, 144.

7. See Barry McGee, conversation with Eungie Joo, in *Regards, Barry McGee* (Minneapolis: Walker Art Center, 1998), unpaginated.

8. Alex Baker, *Indelible Market: Barry McGee, Stephen Powers, and Todd James* (Philadelphia: Institute of Contemporary Art, 2000), unpaginated.

9. McGee, Power, and James explored the market theme until 2002. They revived it in 2011 for the *Art in the Streets* exhibition at the Museum of Contemporary Art, Los Angeles.

10. While McGee usually painted murals for institutions as site-specific works that would be painted over at the close of the exhibition, for the Walker he painted on plywood sheets so that he could retain the work for future use. The Walker panels were custom fit for the ICA's gallery, where McGee added new elements to the existing mural.

11. Exhibitions in this period include solo projects at the Fondazione Prada, Milan, in 2002; the Rose Art Museum, Waltham, MA, in 2004; and the Metropolitan Meat Market, Melbourne, also in 2004.

12. Andrew Paynter, "Twenty Questions with Barry McGee," *Theme*, Spring 2005, http://www.thememagazine.com/stories/barry-mcgee/.

13. McGee has taken up any number of alternative identities in both his graffiti and his gallery-based work. When writing on freight trains and engaging with the history of train workers and hobo graffiti, McGee signs his name "Burnin' Vernon." Changing identities might be seen as one way to combat the brand recognition of "Barry McGee" and "Twist." McGee comments: "Lydia and Ray Fong are more abstract, less associated with this popular trend of 'street art,' which is currently clogging the galleries." See Romain Dauriac and Guillaume Le Goff, "Barry McGee: Maux Urbains," *Clark Magazine* 36 (May/June 2009): 74.

14. McGee's fixation on letterforms is shared by artists of his generation who also have graffiti backgrounds. Two in particular stand out: Margaret Kilgallen and Steve Powers (Espo). One of Kilgallen's main inspirations was nineteenth-century typography, in particular a hand-painted serif-style font that once decorated American cities with the ubiquity of billboards today. At the end of her life, she was able to begin to leverage her love of the hand-lettered sign into actual commercial contexts, creating signage in her trademark style for businesses in San Francisco's Tenderloin neighborhood that could not afford to improve their commercial identity—a form of community-based public art. Powers has also explored the conventions of hand-painted signage over the past fifteen years, first, as illegal graffiti activity on abandoned storefronts (creating Espo markets), then as gallery-based explorations during the *Street*

Market era, and finally in several outdoor public-art projects in places such as Belfast, Northern Ireland; Coney Island, New York; and, most recently, Philadelphia. For the Coney Island project, a coproduction with Creative Time called *Dreamland Artist Club*, Powers and a group of artists worked with low-income business owners to make new signs for boardwalk amusements. Powers was directly inspired by Kilgallen's work in the Tenderloin.

15. Barry McGee, conversation with Raphaela Platow, in *Barry McGee*, ed. Lucy Flint-Gohlke (Waltham, MA: Rose Art Museum of Brandeis University, 2004), unpaginated.

16. "Germano Celant_Barry McGee," unpaginated.

17. Interestingly, Pauline began altering billboards around the time he started SRL, even donning a painter's uniform so he might perform his alterations undercover and in broad daylight. This trick has been adopted by graffiti writers such as Steve Powers (Espo), one of McGee's collaborators on *Street Market*, who painted New York storefront roll-down gates by day, posing as an employee of a public art outreach organization, Exterior Surface Painting Outreach; he even carried a false set of credentials to further the air of legitimacy. In Pauline's early days, he filled fire extinguishers with red paint and sprayed the word "Kill!" in large-scale letters on billboards. Pauline may have inspired the automaton taggers included in recent McGee installations who perch on top of each other, piggyback style, spraying monochrome clouds of black paint, or the huge letters of their graffiti crew, DFW, as if such feats were executed with a fire extinguisher. For an interesting interview with Mark Pauline that discusses billboard subversions and early SRL performances, see "Mark Pauline," in *Re/Search: Pranks*, ed. Andrea Juno and V. Vale (San Francisco: Re/Search Publications, 1987), 6–17.

18. McGee, conversation with Eungie Joo, unpaginated.

19. Wright, Rojas, and Lin have all been associated with Philadelphia's Space 1026, an artist cooperative influenced directly by Fort Thunder that was started by RISD and University of the Arts graduates in 1997. Fort Thunder and Forcefield's first exhibitions outside Providence occurred at Space 1026.

20. Commissioning venues and individuals include the Museum of Contemporary Art, Detroit, 2006; Fondation Cartier pour l'art contemporain, Paris, 2009; Museum of Contemporary Art, San Diego, 2010; real estate developer Tony Goldman for the Houston Street and the Bowery mural, 2010; and the Museum of Contemporary Art, Los Angeles, 2011.

21. Dauriac and Le Goff, "Barry McGee: Maux Urbains," 73.

22. Barry McGee, e-mail to author, July 23, 2011.

23. See Pedro Alonzo, "How to Start a Revolution," in *Viva la Revolución: A Dialogue with the Urban Landscape* (San Diego/Berkeley: Museum of Contemporary Art/Ginko Press, 2010), 109–13.

24. The short-lived San Diego mural was reconstituted in late August 2010, when McGee and Lazcano created a similar tag mural at Houston Street and the Bowery in New York. In a case of life imitating art, as the mural neared completion in the early morning, an SUV collided with a graffiti-covered van a few hundred feet away, flipping over on its side. See "Accidents Will Happen: Barry McGee Hits Houston Street," *The Art Collectors*, August 20, 2010, http://blog.theartcollectors.com/2010/08/30/accidents-will-happen-barry-mcgee-hits-houston-street/.

25. "Place: Margaret Kilgallen and Barry McGee," *Art:21—Art in the Twenty-First Century*, Season 1 (New York: Public Broadcasting Service, 2001).

26. McGee, conversation with Raphaela Platow, unpaginated.

27. Glenn O'Brien, "Cream of Wheat Paste: Cost and Revs," *Artforum* 32, no. 7 (March 1994): 119.

28. "Germano Celant/Barry McGee," unpaginated.

Captions

1. *One More Thing*, May 7–August 13, 2005 (installation view); Deitch Projects, 18 Wooster Street, New York; courtesy Deitch Archive, New York. Photo: Tom Powel Imaging.

2. Untitled, 1995–96; house paint on tin galley tray; 13 1/4 x 9 1/4 x 5/8 in.; collection of Taro, Costa Mesa, CA. Photo: Sibila Savage.

3. *Advanced Mature Work*, September 15–November 25, 2007 (installation view); REDCAT, Los Angeles; courtesy REDCAT, Los Angeles.

4. Untitled, 2005; acrylic on glass bottles, wire; dimensions variable; Lindemann Collection, Miami Beach. Photo: Mariano Costa Peuser.

5. Site-specific painting, Yerba Buena Center for the Arts, San Francisco, 1992; house paint on plywood; 8 x 240 ft.; courtesy Barry McGee.

6. Untitled, 1998 (detail); acrylic on plywood; 16 x 32 ft.; courtesy Barry McGee.

7. *Street Market: Barry McGee, Todd James and Stephen Powers*, October 5–December 2, 2000 (installation view); Deitch Projects, 18 Wooster Street, New York; courtesy Deitch Archive, New York. Photo: Tom Powel Imaging.

8–9. *One More Thing*, May 7–August 13, 2005 (installation view); Deitch Projects, 18 Wooster Street, New York; courtesy Deitch Archive, New York. Photos: Tom Powel Imaging.

10. Barry McGee and Josh Lazcano: Untitled, 2004; mixed media; site-specific installation included in *Beautiful Losers: Contemporary Art and Street Culture*, March 13–May 15, 2004, Contemporary Arts Center, Cincinnati; courtesy Contemporary Arts Center, Cincinnati.

11. *Barry McGee*, April 28–July 2, 2004 (installation view); Rose Art Museum, Brandeis University, Waltham, MA; courtesy Rose Art Museum, Brandeis University, Waltham, MA. Photo: Charles Meyer Photography.

12. *Art in the Streets*, April 17–August 8, 2011 (installation view); The Geffen Contemporary at The Museum of Contemporary Art, Los Angeles; courtesy The Museum of Contemporary Art, Los Angeles. Photo: Brian Forrest.

13. Untitled, 2008; 27 acrylic on wood panels; 74 x 120 x 1 in. (overall); courtesy Ratio 3, San Francisco. Photo: Wilfred J. Jones.

14. Untitled, 2011; 23 acrylic on wood panels; 64 5/8 x 79 1/8 in.; courtesy Stuart Shave/Modern Art, London. Photo: Todd White & Son.

15. *One More Thing*, May 7–August 13, 2005 (installation view); Deitch Projects, 18 Wooster Street, New York; courtesy Deitch Archive, New York. Photo: Tom Powel Imaging.

16. Graffiti on temporary walls around San Francisco Unified School District administration building, c. early 1990s. Photo: D.S. Black.

17. Survival Research Laboratories: *Illusions of Shameless Abundance: Degenerating into an Uninterrupted Sequence of Hostile Encounters*, May 28, 1989; performance at Fourth and Berry Streets, San Francisco; courtesy Survival Research Laboratories, San Francisco. Photo: 6th St. Studios.

18. Margaret Kilgallen: Untitled, c. 1999; acrylic on canvas; 28 3/4 x 98 in.; courtesy Ratio 3, San Francisco. Photo: Wilfred J. Jones.

19. Alicia McCarthy: *Made for My 97 Yr Old Grandma*, 2010; colored pencil, house paint, found wood; 18 1/2 x 16 1/2 in.; courtesy Jack Hanley Gallery, New York.

20. Chris Johanson: *This, This, This, That*, June 3–July 30, 2011 (installation view); Altman Siegel Gallery, San Francisco; courtesy the artist and Altman Siegel, San Francisco. Photo: Wilfred J. Jones.

21. Jim Drain and Ara Peterson: *Hypnogoogia*, November 4–December 23, 2005 (installation view); Deitch Projects, 18 Wooster Street, New York; courtesy the artists and Deitch Archive, New York. Photo: Tom Powel Imaging.

22. Clare Rojas: *We They, We They*, 2010 (installation view); Ikon Gallery, Birmingham, U.K.; courtesy Ikon Gallery, Birmingham, U.K. Photo: Stuart Whipps.

23. Adam Wallacavage: *Brian Chippendale and Matt Brinkman, Fort Thunder*, 1997; scan from color negative; courtesy the artist.

24. Andrew Jeffrey Wright: *Nine X-Waves*, 2009; oil, acrylic, and latex on masonite panel; 9 x 9 ft.; courtesy the artist. Photo: Adam Wallacavage.

25. Isaac Lin: *One of Us*, September 7–November 20, 2010 (installation view); The Print Center, Philadelphia; courtesy the artist and Fleisher/Ollmann Gallery, Philadelphia. Photo: Isaac Lin.

26. Untitled, 2006; enamel on masonry; 110 x 22 ft.; site-specific painting originally created for *Meditations in an Emergency*, October 26, 2006–April 22, 2007, Museum of Contemporary Art, Detroit; courtesy Museum of Contemporary Art, Detroit. Photo: Mitch Cope.

27–28. Images courtesy Barry McGee.

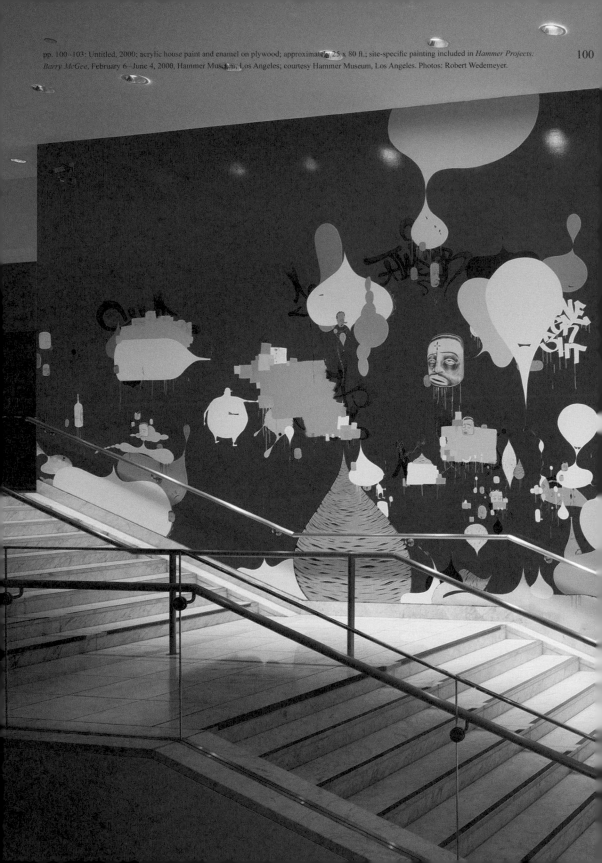

pp. 100–103: Untitled, 2000; acrylic house paint and enamel on plywood; approximately 25 x 80 ft.; site-specific painting included in *Hammer Projects: Barry McGee*, February 6–June 4, 2000, Hammer Museum, Los Angeles; courtesy Hammer Museum, Los Angeles. Photos: Robert Wedemeyer.

100

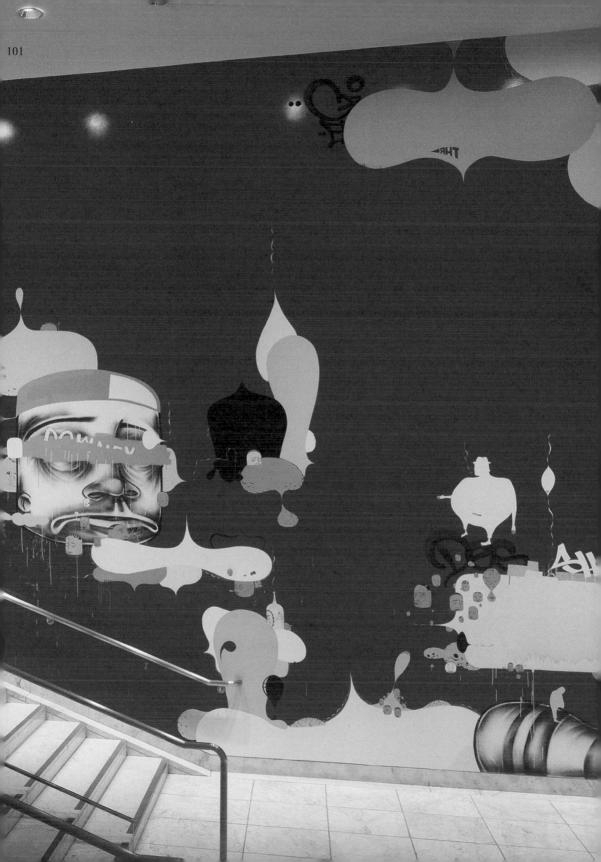

Todd James, Barry McGee, and Stephen Powers: Untitled, 2000; acrylic house paint and enamel on billboard; site-specific painting included in *Wall Power*, May 13–July 30, 2000, Institute of Contemporary Art, University of Pennsylvania, Philadephia; courtesy Institute of Contemporary Art, Philadephia. Photo: Adam Wallacavage.

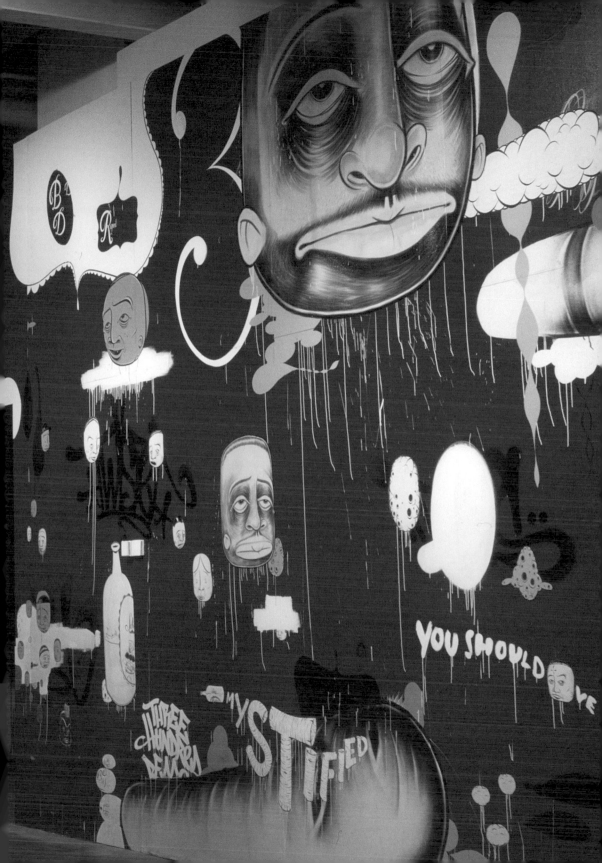

Barry McGee, Todd James and Stephen Powers have joined forces to re-create their version of an urban street inside Deitch Projects' 18 Wooster Street Gallery. A liquor store, a bodega, a check-cashing outfit, and a car service dispatch office line up beneath a cascade of illuminated signs. Battered trucks, bombed with graffiti tags lay upended on the gallery floor. James and Powers spent several months scouring the streets for discarded signs and storefronts, reassembling the debris into a startling fusion of urban reality and urban fantasy.

From the press release for *Street Market*, Deitch Projects, 2000

oppisite: *Street Market: Barry McGee, Todd James and Stephen Powers*, October 5–December 2, 2000 (installation view); Deitch Projects, 18 Wooster Street, New York; courtesy Deitch Archive, New York. Photo: Adam Wallacavage.

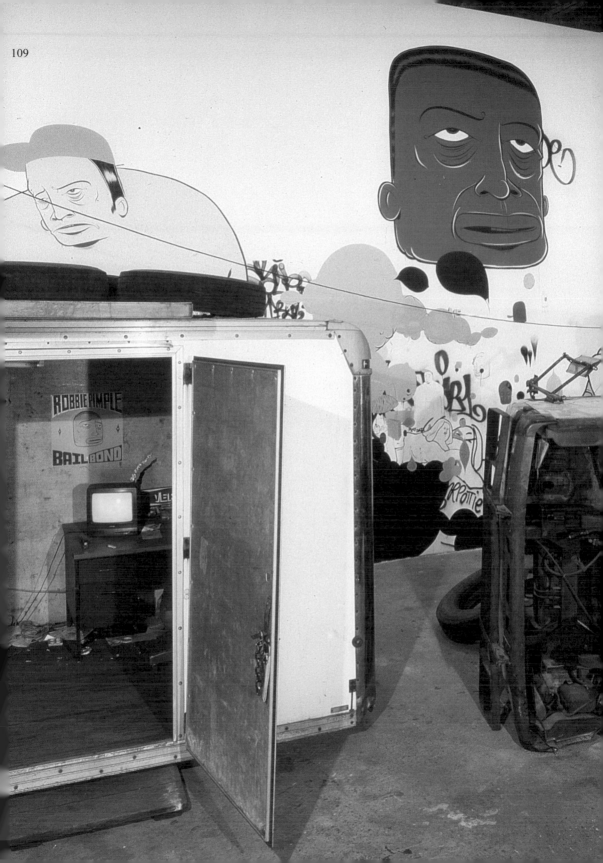

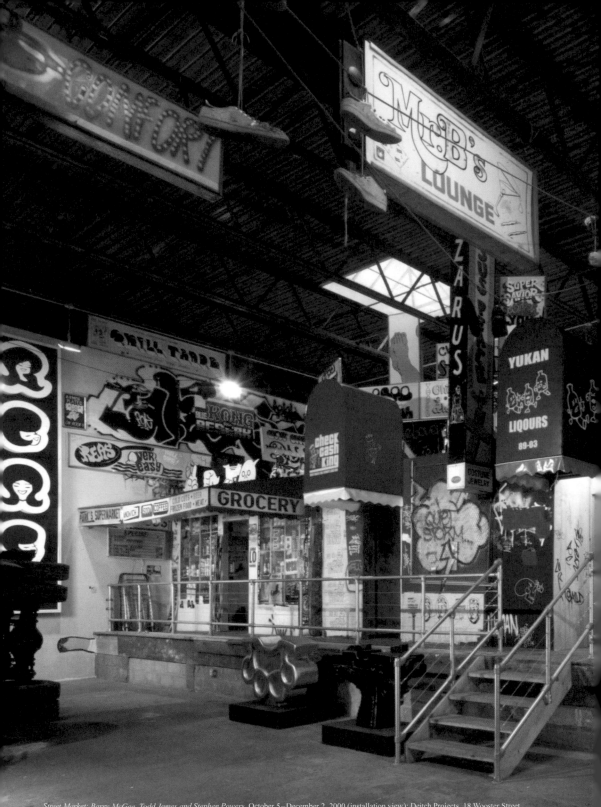

Street Market: Barry McGee, Todd James and Stephen Powers, October 5 – December 2, 2000 (installation view); Deitch Projects, 18 Wooster Street, New York; courtesy Deitch Archive, New York. Photo: Tom Powel Imaging.

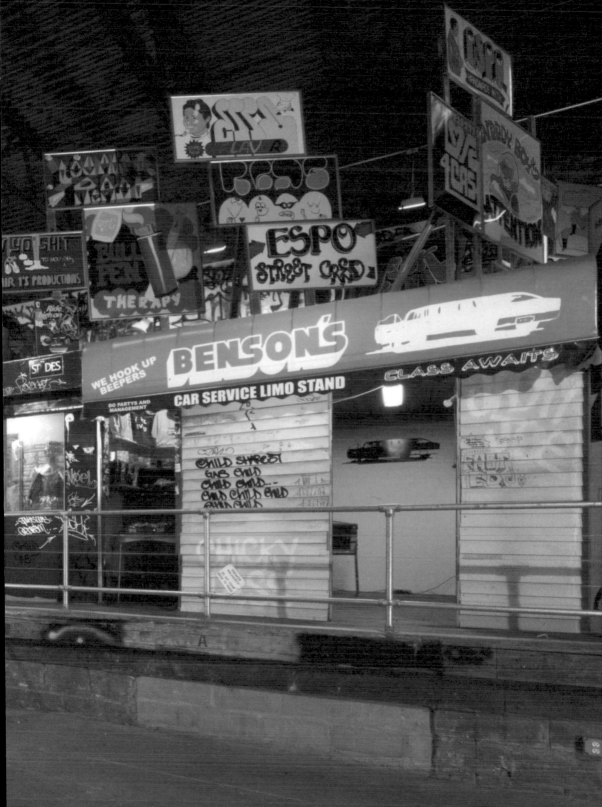

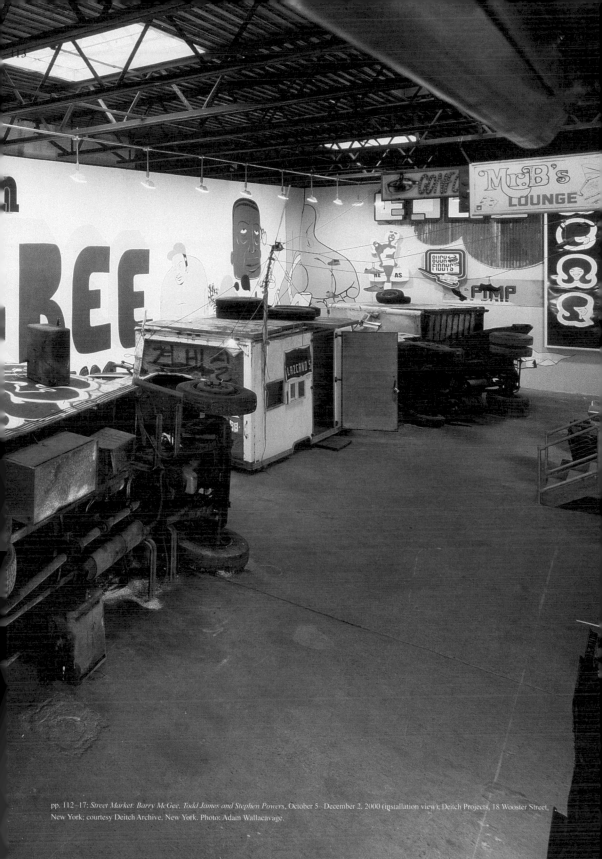

pp. 112–17: *Street Market: Barry McGee, Todd James and Stephen Powers*, October 5–December 2, 2000 (installation view); Deitch Projects, 18 Wooster Street, New York; courtesy Deitch Archive, New York. Photo: Adam Wallacavage.

115

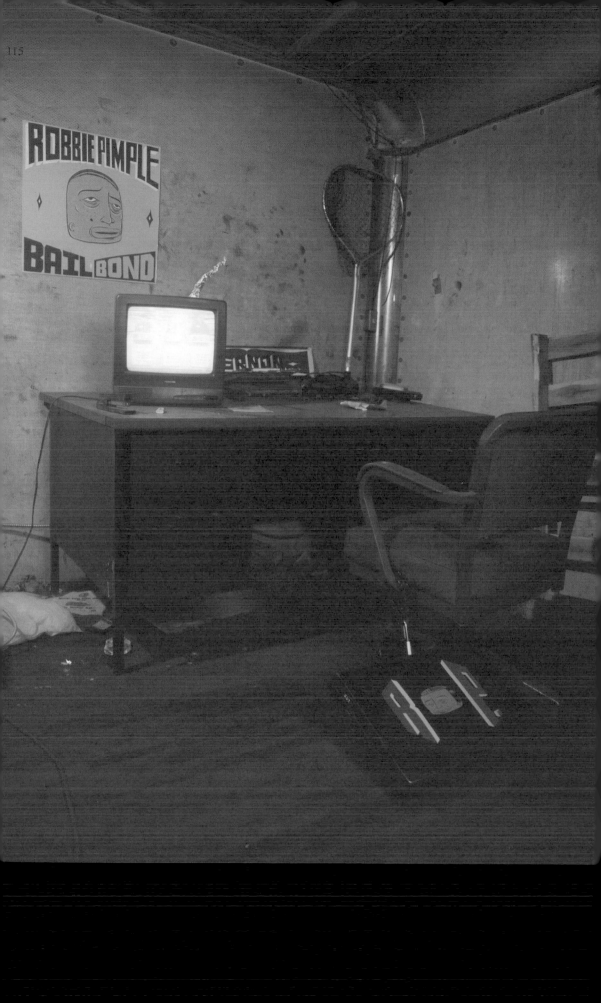

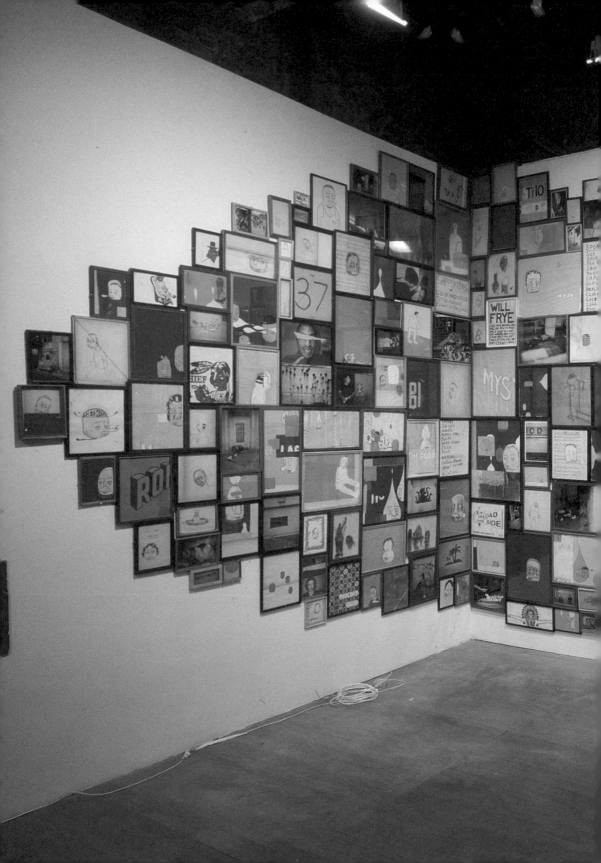

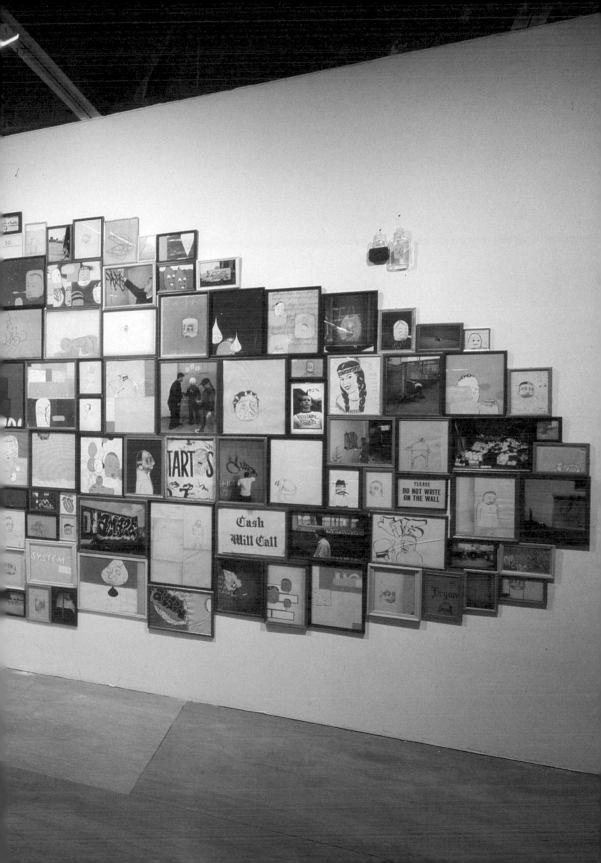

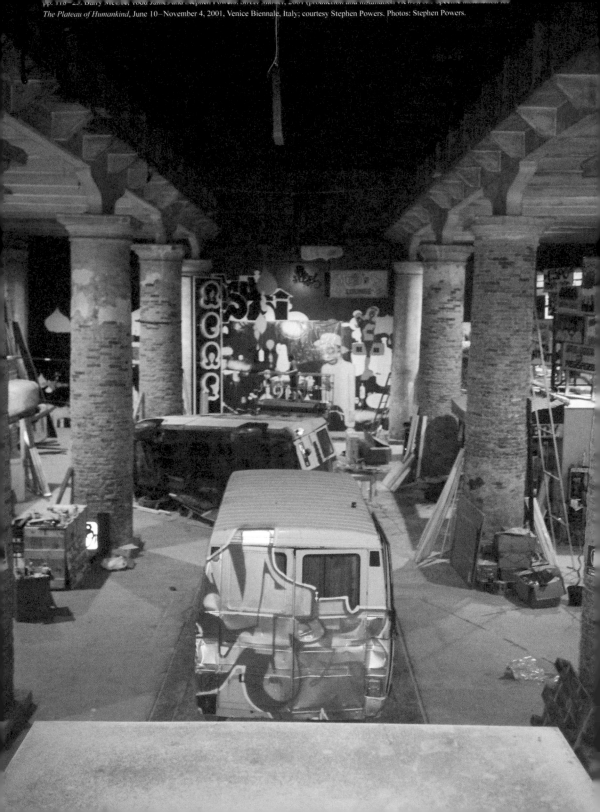

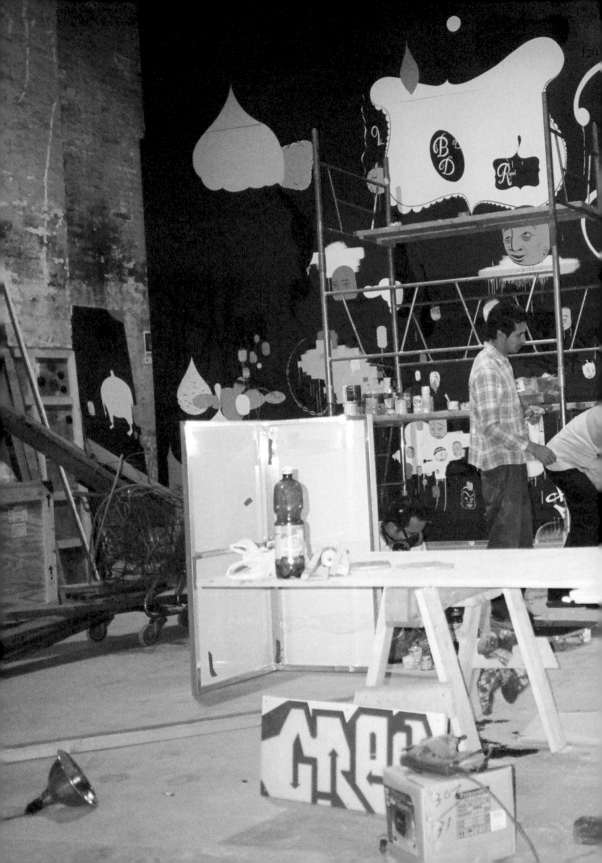

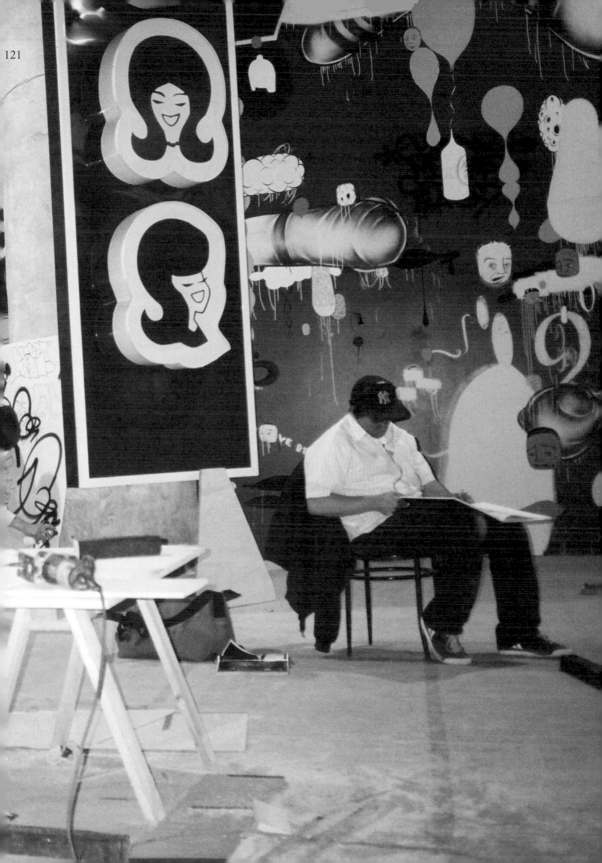

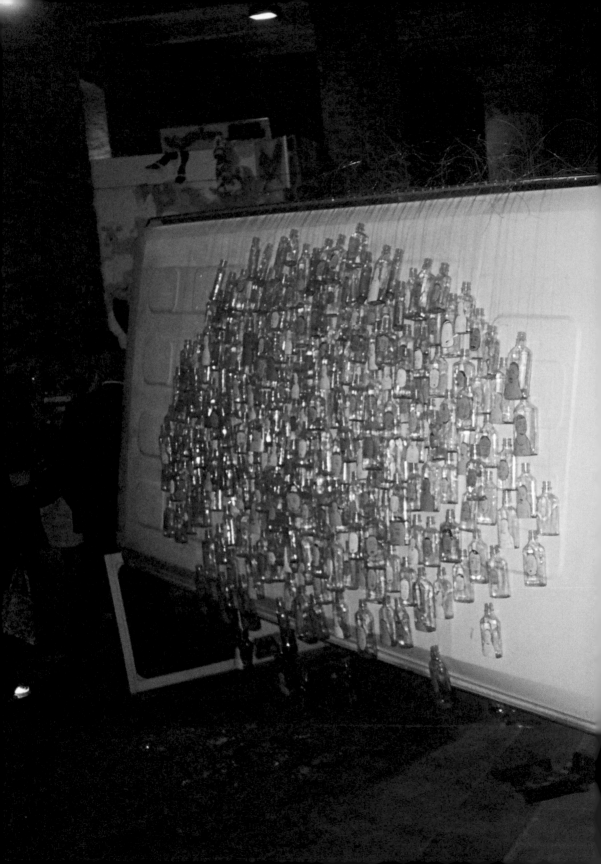

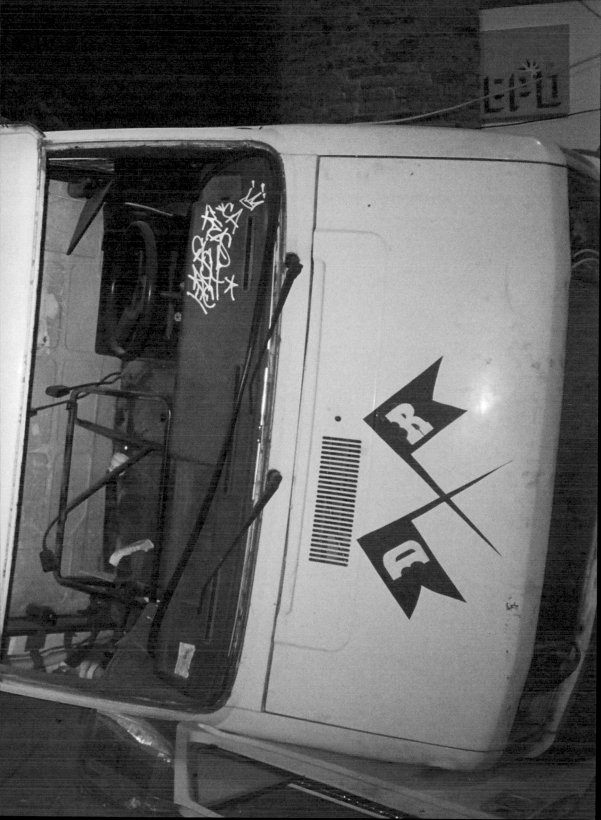

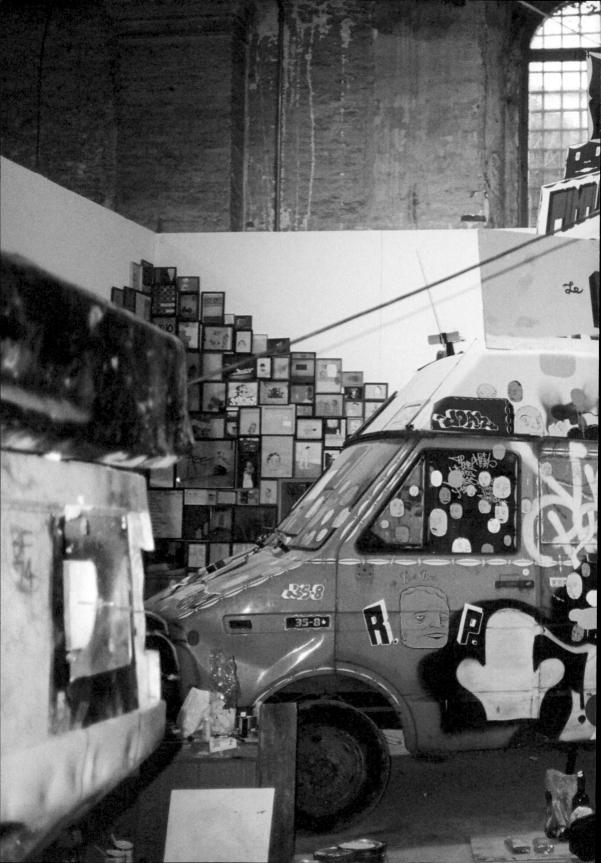

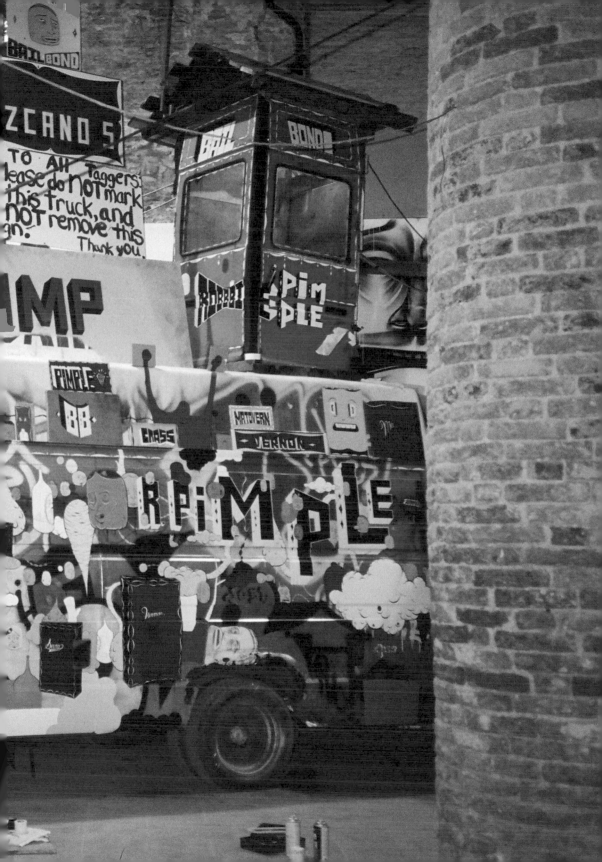

pp. 126–29: Untitled, 2001; enamel on glass; site-specific painting included in *Un art populaire*, June 21– November 4, 2001, Fondation Cartier pour l'art contemporain, Paris; courtesy Barry McGee.

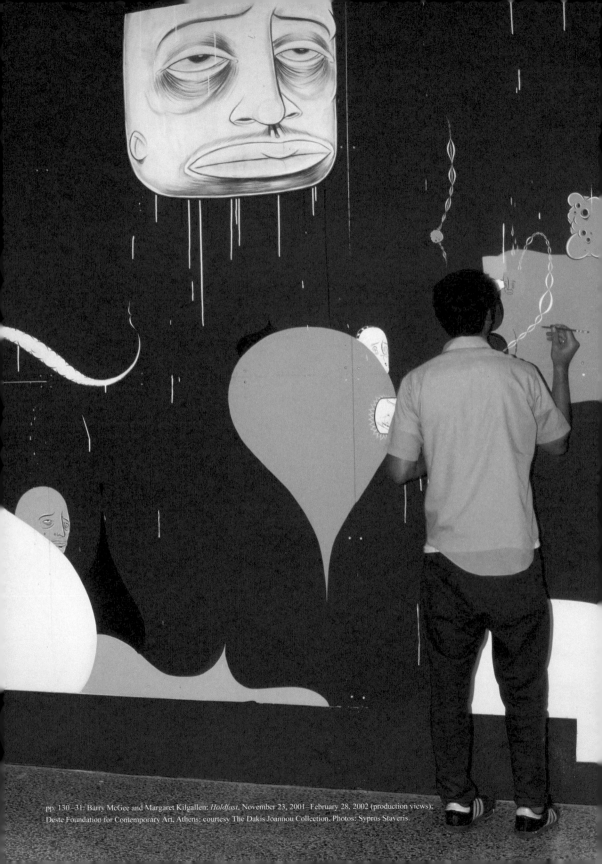

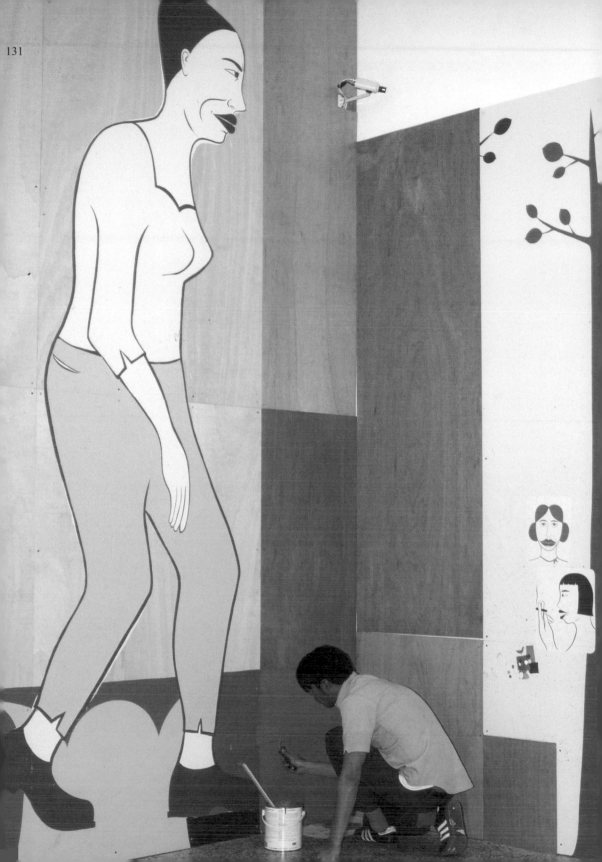

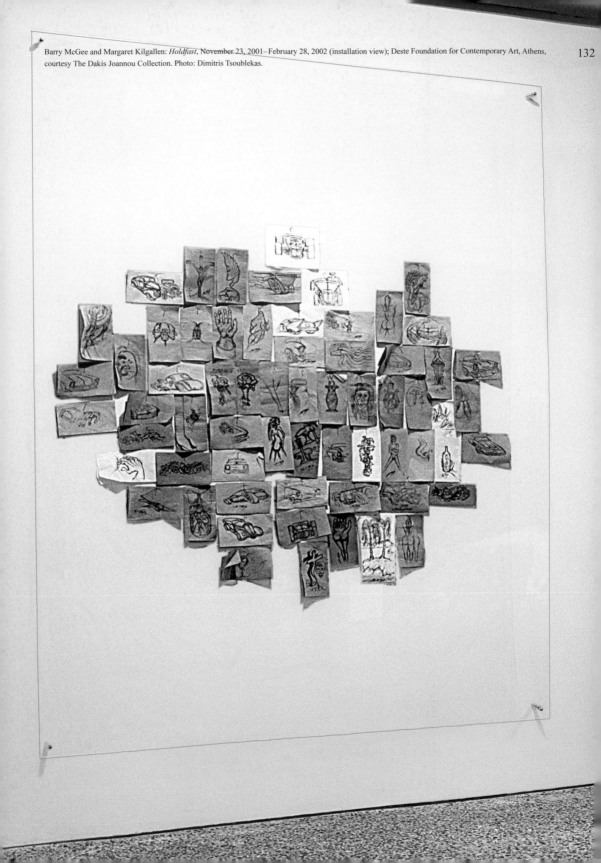

Barry McGee and Margaret Kilgallen: *Holdfast*, November 23, 2001–February 28, 2002 (installation view); Deste Foundation for Contemporary Art, Athens, courtesy The Dakis Joannou Collection. Photo: Dimitris Tsoublekas.

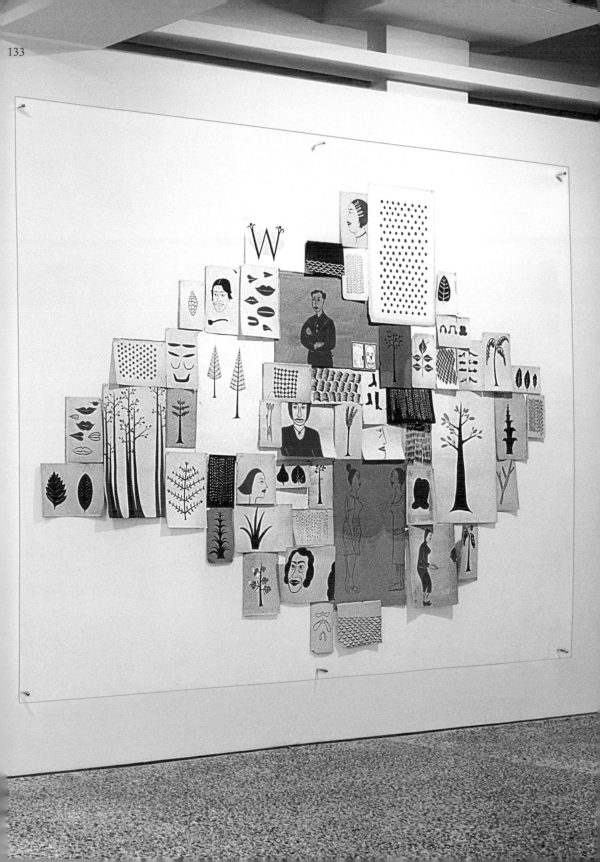

Intended specifically for the Fondazione Prada's space in Via Fogazzaro, this huge installation devised by McGee is entitled Today Pink *(2002). This is entered through an unusual and decidedly bewildering passage, which, when one emerges, turns out to be the back of an overturned truck. In the exhibition space one finds oneself in a chaotic scene, consisting of abandoned vehicles covered with graffiti, figures painted on huge metallic or monochrome walls, and fragments of lighter, fluctuating objects. This is a world rich in signs and symbols that contain references to life in today's cities and are linked to images of American culture such as the large, enigmatic figure of a Native American painted upside down on a wall made of rusty iron sheets. As in the aftermath of a road accident, two abandoned vehicles invade the space. On their bodies the artist has painted his familiar faces, which, with their sad eyes, are a reminder of bowed, resigned humanity.*

From the press release for *Today Pink*, Fondazione Prada, 2002

pp. 135–39: *Today Pink*, April 11–June 9, 2002 (installation views); Fondazione Prada, Milan; courtesy Fondazione Prada, Milan.

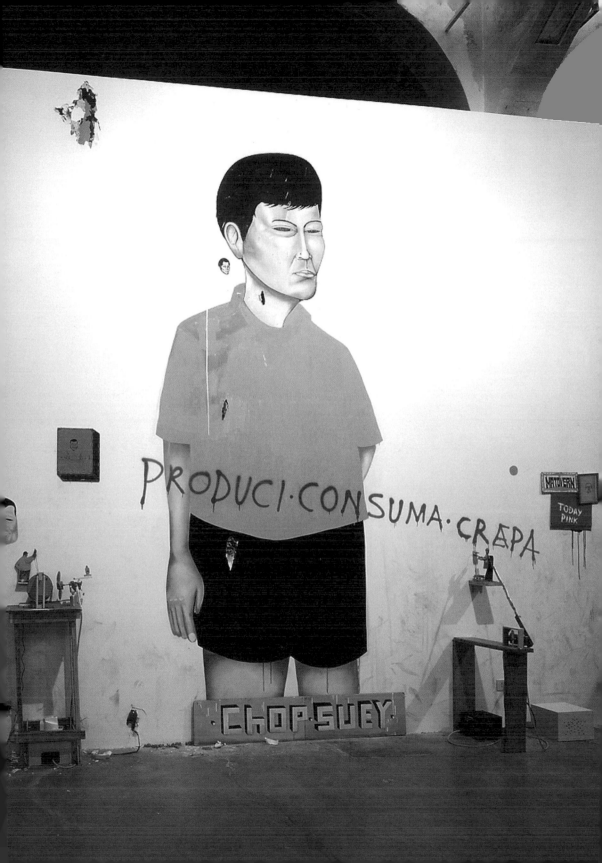

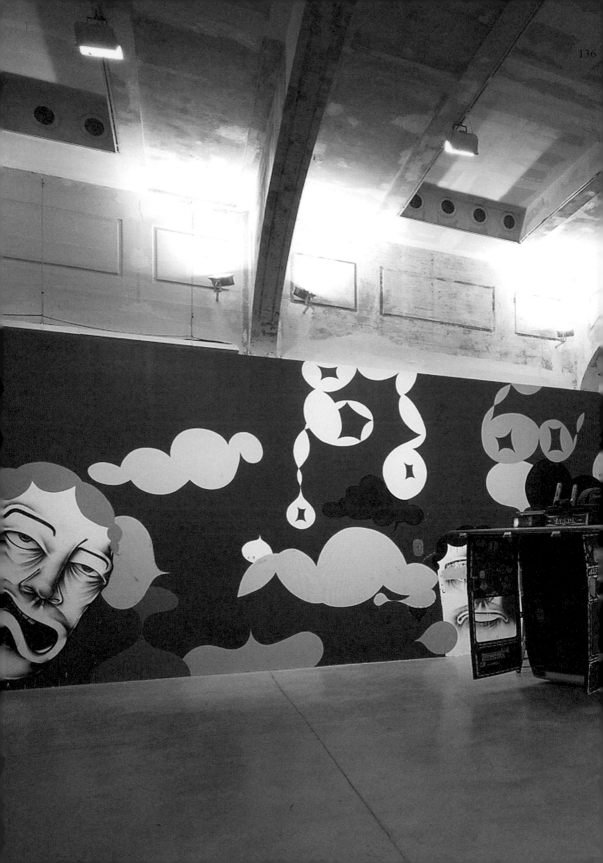

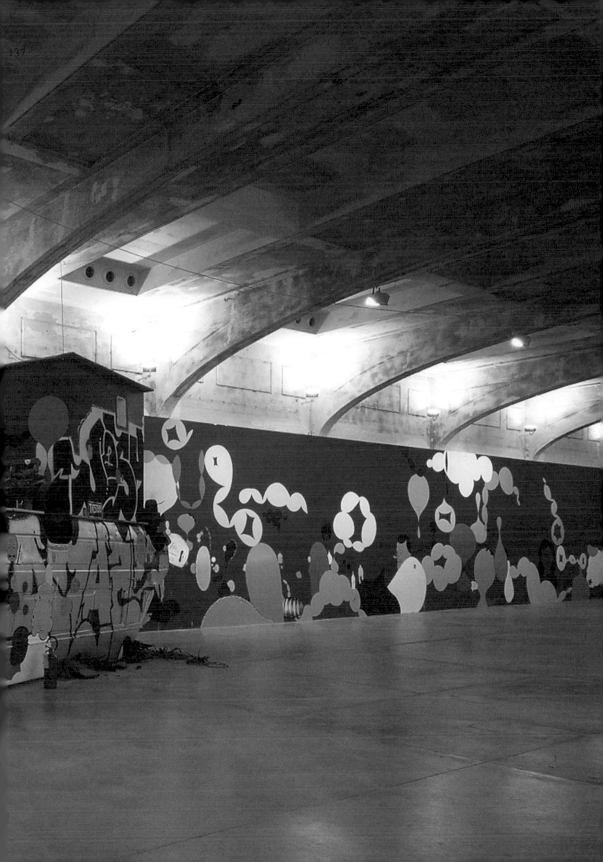

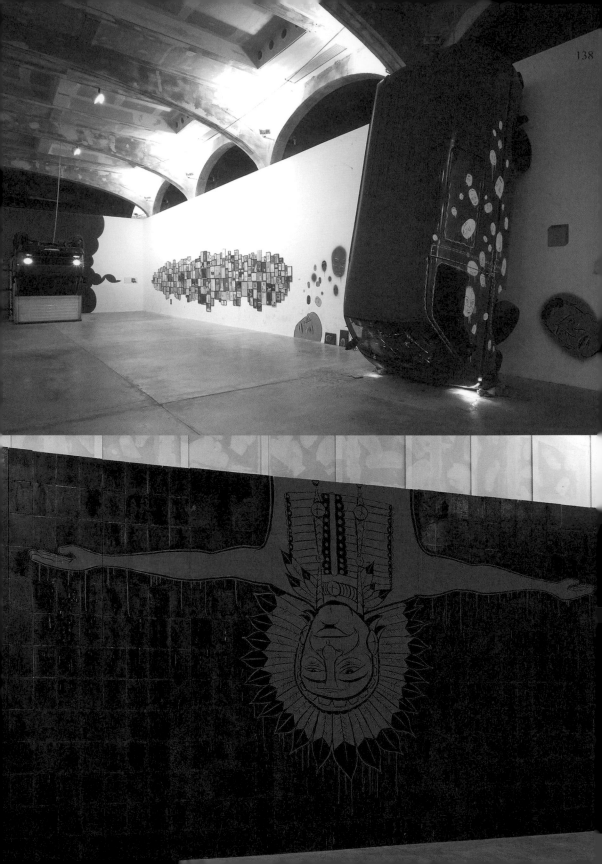

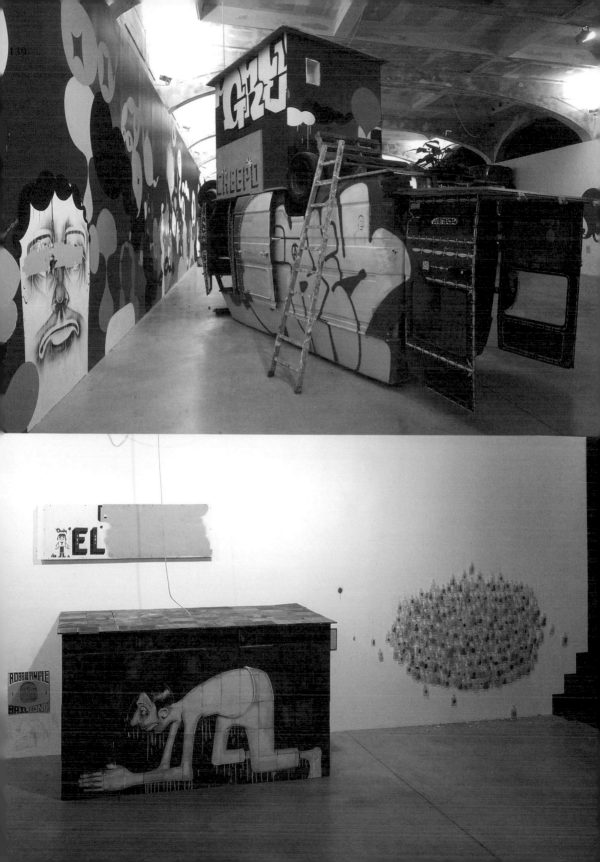

This 2002 interview with Barry McGee was conducted by Germano Celant, who was then senior curator of contemporary art at the Solomon R. Guggenheim Museum, New York, and is currently director at the Fondazione Prada, Milan. It was originally published on the occasion of McGee's exhibition at the Fondazione Prada in spring 2002.

Germano Celant: An artist's course is defined by his roots and his context, so I'd like to start by asking you about where you were born, your family, your adolescence.

Barry McGee: I come from a working-class family; my father repairs and customizes cars. He does all the painting on the bodywork and obtains spare parts, mainly for old Chevrolet cars. My father lived in San Francisco and used to stay out in Chinatown. He met my mother there; they got married and had four kids. When they got divorced, my brother, my two sisters, and I all lived with our mother.

Celant: But even though you then started to move around and travel, you never broke away from your family. I understand that your family now helps you to look after your daughter Asha.

McGee: It's true. Family dynamics are very interesting. In fact, I lived in the Mission District, a Hispanic area of San Francisco. In 1984, when I was sixteen, I got immersed in the life of the city, with its buzzing clubs and music. There were punk-rock groups like The Residents and The Dead Kennedys, but more than anything there was a really strong political climate. It was the Reagan era, and there were always organized protests and stuff like that against his policies. It was a way to feel in charge of your own ideas and your own life; it was all about how to react to make sure things changed. Lots of things went off in the streets; it was a way to be free and open: you could clog an intersection and make the city stop. To some degree you felt like you could change the world.

Celant: When did you come in contact with street expression like graffiti?

McGee: It was back in 1984. I used to ride through the city with my friends on scooters. There was one kid out there who would stop every now and then, take out a spray can and draw huge tags on the walls. He used to write "Zotz," and the O was a big cowboy face, or something. We'd be talking and he would go, "Hold on one second," and then he'd do a tag. He was my hero; I started copying him and noticing the images on the walls; for me they represented a different world of communicating. Writing on the walls had already been well established in New York— doing something that empowering was just great. It was Zotz who got me doing graffiti, and with him that my tag "Twist" was born. Graffiti was more or less everywhere, especially in punk-rock and hardcore clubs, in abandoned and desolate areas. I started to do graffiti in 1984, along with all the other kids; it was just another fun thing to do at the time. We did it at night, going round on bicycles and scooters; it felt like what true freedom must be like.

Celant: Today there is graffiti everywhere in urban cities, but I remember when a wave of tags and markers and spray-can images invaded the New York subways in 1977; it was something really strong and spectacular, there was an uncontrollable energy that changed both the way the subway looked and the way millions of people looked at surfaces, when they saw the train walls completely transformed and marked by strangers every single day. Then it started to become clear that the tags were repeated and recurrent, and that it

was possible to decipher a style and a whole way of writing or spreading color. The art world was intrigued right away, and succeeded in trying to identify and make some of the graffiti artists famous. Those names still are well known now—Futura 2000, Lady Pink, Keith Haring, Lee, and there are others. But for you, a generation on, what does graffiti stand for? How did you experience it, and how do you judge the fact that graffiti artists have come out into the open by entering the world of art?

McGee: For me, graffiti means making marks on surfaces using just about anything, be it markers, spray, paint, chalk, lipstick, varnish, ink. Or it can be the result of scratches and incisions. The aim is to maintain the energy created by disturbance or excitement in the street. To carry on pissing people off, challenging their ownership. No one single way to do this exists; everyone studies everyone else, on the walls, in magazines, via word of mouth, and then everyone invents their own way. There isn't just one style, or a constant form that's common to all. Kids come from all cultures and from different cities, a graffiti artist can join up with others. When a street artist comes to San Francisco from New York you know it right away. You can tell that there's someone new in the city; in fact everyone's well aware of his alias and his technique, so much so that sometimes his amazing penmanship and fearlessness really stand out. The kids can read walls and the writing on them like a history book: they can recognize the layers, the tags, the styles that have been made, and they know when that person's been in their city. They start recognizing identities, like a sort of visual language. Nonetheless, there's something mysterious about the whole thing: it's like being unknown but appearing everywhere; like everyone knows who you are but at the same time they've no idea who it is. I think it's really interesting when all this energy is unleashed on a city at the same time, becoming almost like a visible threat.

Celant: Then there's the illegality problem.

McGee: Certainly, but this is what makes the act a free one. It's pure chaos, claiming a territory that doesn't belong to you to state your own identity. It's like saying: "I've got no other way to say that I exist." And whoever protests that a building belongs to them doesn't understand that the idea of ownership has no significance at all to a thirteen-year-old who wants to express himself. In other words, it's a way of accessing art without having to ask permission. It's like an unauthorized public declaration: doing something without license. If you work out how much time is lost in meetings and discussions for completing a "public work," it's better just to do it without asking, otherwise the momentum and energy get lost and can fade and die.

Celant: A voyage, or encounter with different signals, stimulates growth. Where did your journey take you?

McGee: In 1988 I traveled in Central America with some friends for about a year, and in 1993 I lived for eight months in Brazil.

Celant: What were your experiences in these southern cultures, which are so "baroque" and exuberant?

McGee: The strongest emotion I've felt was in the small town of São Cristóvão, in Brazil, where I saw thousands of ex-votos in a church: legs, silver hearts, wooden inscriptions, small paintings, photographs, and other things. This directly influenced my way of displaying objects, like empty liquor bottles and drawings.

Celant: In the eighties, an awareness of human tragedy linked with AIDS left its mark in the art world; how was this catastrophe reflected on the streets?

McGee: AIDS left its mark on demonstrations and their visual components. Think of ACT UP (AIDS Coalition to Unleash Power), whose posters and pink upside-down triangles transformed the urban landscape; like graffiti, they were everywhere. And the writing on walls and buildings also reflected this political action, to the extent that huge writing used to appear overnight on the front of banks such as the Bank of America or other institutions that had objectionable policies toward certain communities. The same thing happened on public billboards, where the spray would cover up the commercial slogans and substitute other political messages.

Celant: Among the true street artists, besides the graffiti artists, we have to mention all those artists who

worked for decades outside the framework of public art, with its authorizations and licenses; I am referring to groups like the Survival Research Laboratories (SRL), whom you talk about in an interview with Eungie Joo in the *Regards* exhibition catalog (Walker Art Center, Minneapolis: 1998). I went to one of their performances in San Francisco back in the seventies; if I recall rightly, the group is led by Mark Pauline. Over a period of several days, SRL constructs enormous robots using bits of cars, cranes, tractors; they put them together into an arena, nearly always at night, and then make them fight until they are completely destroyed. The robots bellow out fire and oil, and during the fighting the scene becomes bloody and dangerous for the public, who are placed all around the combat area. In the space of one hour, wheels fly, along with boiling oil, pieces of metal saw, and other fragments; enormous tension accumulates and the atmosphere is intensely charged; then everything settles and the winner rises up like a giant over a heap of industrial wreckage. The recovery of the urban dimension in these operations is similar to the practice of graffiti, with the difference being that in this case it is three-dimensional and dynamic.

McGee: It's a very physical experience, and very frightening, because it takes place in a somewhat dangerous climate. The sculptures explode, spew out material—there is a clear risk that someone could get hurt. I came into contact with this kind of operation in the eighties, at a performance that took place under a freeway overpass. I was with a friend and we climbed over the arena fence where SRL had gathered together machines and robots that were burning and exploding into the air. I seem to remember there were also several effigies of American politicians. That construction really made an impression on me, even though it could have seemed part of the landscape. These guys really do whatever they want, dangerous things that have huge visual impact, with all the public standing around those machines that fight until completely destroyed. These kind of mad scientists also have a sort of fortress thing, and they're still making stuff underneath the freeway. It's completely crazy, sometimes you hear that they're organizing something in an industrial area. Even today, people gravitate around them. Pauline keeps on, he always has a group of people working with him. I remember a groundbreaking they

had for the Museum of Modern Art in San Francisco. Pauline had this big cannon thing, like a sort of sonic boom machine, that could break all the windows in the downtown area with just one sonic boom. The day of the performance there were a load of people chasing him for the damage caused: broken windows and glass. He's always causing trouble, you know, but he's an inspiration for me.

Celant: It's clear that you are attracted to abandoned urban areas, illegal actions, and spaces to which the homeless gravitate.

McGee: The American dream has nothing to do with criminality, but with a desire for independence and adventure, so escaping from any kind of control or definition also signifies not being identified, acting illegally, standing outside of every category of art and intervention on the streets. The fact of gravitating towards certain spaces in the city, like car cemeteries, abandoned subways, or waste-disposal areas under freeways is part of the attraction for something that has been left behind. It would seem that graffiti artists almost always use spaces where the homeless sleep, maybe because they are the cheapest places to live and in the worst neighborhoods. But the city usually ends up intervening, cleaning up and making it habitable; without even a minimum of tolerance, the homeless are kicked out, the graffiti is cleaned up, and the city speculates on the area. The public spaces where the first graffiti artists could leave their marks are declared private little by little, and the situation has become much tighter for the kids. It is hard for me to take in the concept of property and surveillance: to have a sense of ownership is problematic in today's climate. Everyone goes on about the damage caused by graffiti, but the argument is not valid; graffiti can be removed or you can paint over it with a roller. The idea of damage and destruction is ridiculous.

Celant: You keep on talking about kids and their direct, spontaneous expressiveness.

McGee: I love graffiti because it enables kids from every social extraction to do something that brings them closer to art, when they normally wouldn't be stimulated to be visually creative. Graffiti helps to develop an awareness of immediate expressive and uncontrolled

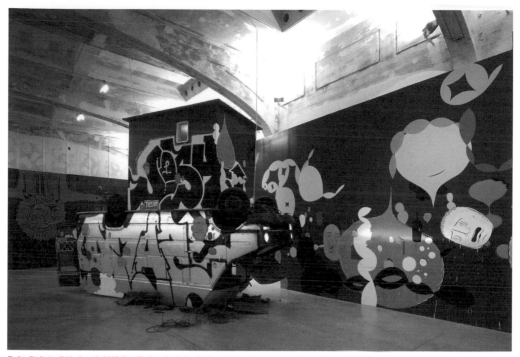

Today Pink, April 11–June 9, 2002 (installation view); Fondazione Prada, Milan; courtesy Fondazione Prada, Milan.

freedom. I want kids to have this possibility. It's an important introduction to form and writing, storytelling and color. All public spaces can be used, not just the arty galleries and museums. Graffiti communicates to the masses, not just to a select few; outside and on the streets the possibility of receiving it is open to all, while the territory of art is restricted to just a few. Writing on the wall is like a headline in a newspaper or a billboard that shows up overnight: it reveals the hand that has tagged it. It's a sign, whether it be right or wrong. It is free and surprising. Then, obviously, others intervene and change it, or it disappears under new paintings. Today, graffiti gets cancelled out more and more often.

Celant: In 1982, for the *Documenta 7* exhibition in Kassel, we invited several graffiti artists, such as Futura 2000, who had worked in urban subways; Lee, who had painted shutters and entrances; and Haring with his paintings on vinyl tarpaulin. Many others, including Lady Pink and Jean-Michel Basquiat, moved in the same circles. What do you think of this generation of graffiti artists, who achieved artistic success, compared to yours?

McGee: No one thinks that graffiti is linked to generations, but in fact it is. Compared to the eighties, the risks are greater today. The atmosphere is more intense, the stakes are higher. It's just like being persecuted. In the seventies and eighties, the artistic world took an interest, but nowadays it is trashed and the laws have become more rigid; now you can end up in jail. And everyone has started cleaning up the walls. The artists you mentioned went straight into the commercial galleries, painting on canvases. These days, awareness of graffiti is huge—in Europe it is enormous.

Celant: And Milan? Going round the city with me, Walter De Maria made me aware that Milan is also covered with graffiti in places that would be unlikely in New York or in any other American city, where this art is expressed in the suburbs and abandoned areas. In Milan, you also see graffiti in streets that are comparable to Park Avenue or Fifth Avenue, something that would be impossible in the United States.

McGee: In Milan I feel like I'm seeing San Francisco as it was back in the eighties. It is the same spirit: kids writing on the walls, on the windows, and I don't

think they're aware of the whole history of graffiti. It's amazing how this communication functions. In Europe the kids are still writing on the trolley cars. But it's also interesting to see how the kids travel: you find Americans and Europeans on the walls of all the cities, also because with the Internet they can easily get information and find out where to go, in which areas of the city they can paint and do their stuff. There's passion that still drives them to do an image, to put images on something and get away with it, get out of there and only have a photograph. Like in the Stone Age; it's just so interesting to me that this still drives a person to do graffiti. And they would risk anything in their life to do it, you know?

Celant: Have you left your mark in Milan? Have you spotted any good penmanship?

McGee: I've not done much, mainly because I'm doing a lot of stuff in the closed space of the Fondazione Prada. The styles you see here in Milan are different, and so are the words. Some European writing slants to the right, while the Americans tend towards the left. The trains have been converted into corporate billboards and are completely covered; it's the beginning of the privatization of "our" public spaces.

Celant: There's an incredible difference between working outside and inside. Is it difficult to pass from the public dimension to the private one?

McGee: I've always known that going from a wall to canvas was not the right translation for me. Given an entire wall inside, I could work endlessly. Given a single sheet of paper, I could be stuck indefinitely. With a space like this one in Milan I could keep going forever.

Celant: How do you collect the material for your installations, and why are you predominantly interested in the metal surfaces of trucks and cars or trays of rusty metal?

McGee: They are things I find in the city or in ruined buildings I love to explore, abandoned things and stuff like that. Anything you don't have to pay for, you know. For instance, in Italy there's beautiful wood here, completely different. Metal is the best surface for me; if I can paint outdoors, ideally I always look for metal objects and stuff like that: I like the way paint

just lays on the top, it doesn't get absorbed. As for the rusty metal trays, it goes back to the time I worked at a print shop for about eight years. It was a letterpress shop. I noticed the trays that held the lead type were quite amazing with the layered fingerprints and rust.

Celant: And your use of red?

McGee: In Chinatown in San Francisco the doors are painted red. They are great surfaces, they attract me a lot. Red is the color of life.

Celant: Your indoor works, starting with your first installations in the eighties, nearly always involve visually occupying the entire space. The wall is painted and covered with one single color onto which you trace figures or fluid signs, or instead you superimpose thick layers of sketches and bottles onto the wall. The figures you draw are invariably the same: men's faces with sad eyes and wrinkles, or human figures down on their knees; they almost always have the same expression, as though they are devoid of energy. A bowed humanity, whose faces are similar to photographs of lonely or drunken people who sleep on the streets of San Francisco. Their faces return again in bottles and on drawings.

McGee: This male figure is kind of like an everyman, but very specific to San Francisco, where there's a huge homeless population that everyone wants to be free of, a bit like graffiti. The subject has to do with graffiti and the homeless, [which are] kind of like outcasts, things that the city is trying to get rid of, or trying to hide, or pretending doesn't exist. With my work, I'm trying to reveal this.

pp. 145–47: Untitled, 2005; acrylic on glass bottles, wire; dimensions variable; Lindemann Collection, Miami Beach. Photo: Mariano Costa Peuser.

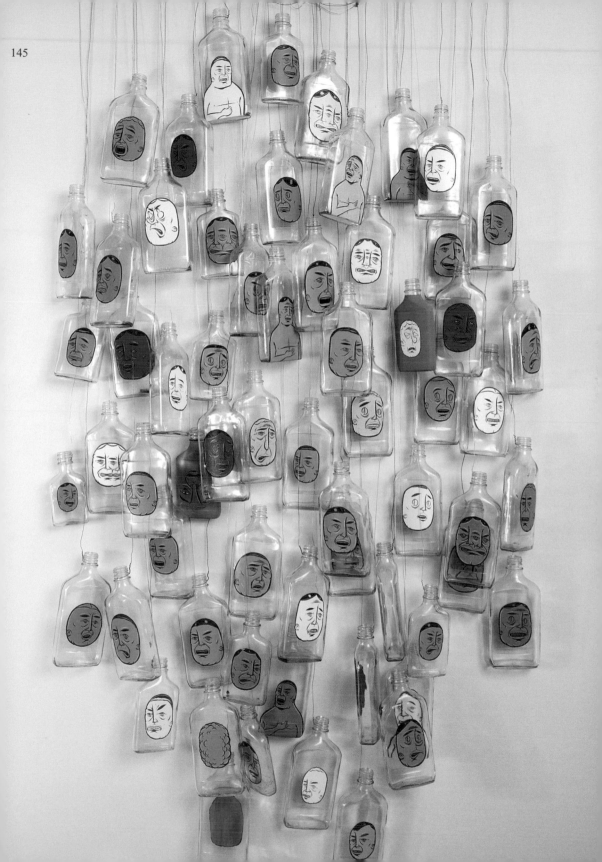

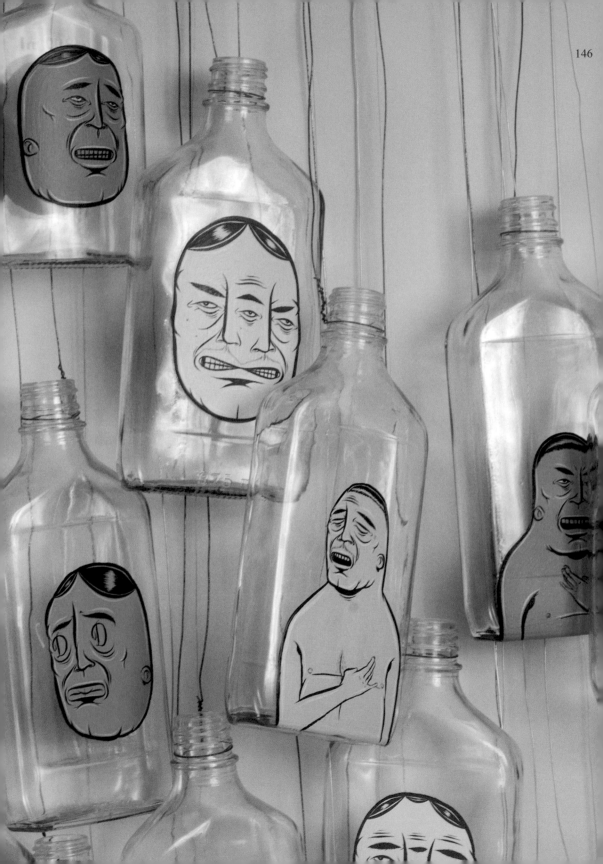

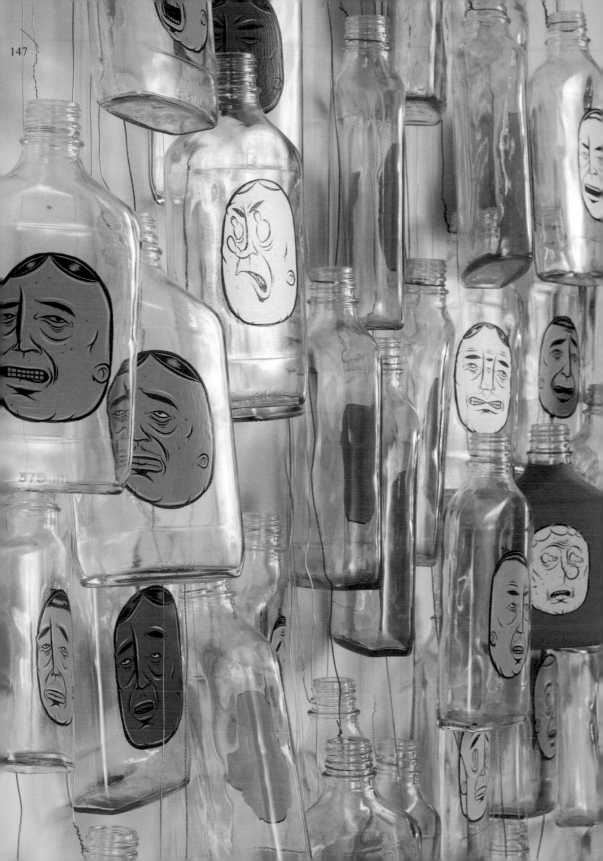

Since 1985, Barry McGee has been incorporating his own photographs into a slide show, which has evolved to reflect the changing imagery of his inspirations. Typically presented by the artist in rapid-fire style with occasional verbal interjections, the slide show is a kinetic visual essay that captures McGee's unusual eye for the language of the city street.

pp. 149–212: Untitled, 1985–2012; digital scans from slides; courtesy Barry McGee.

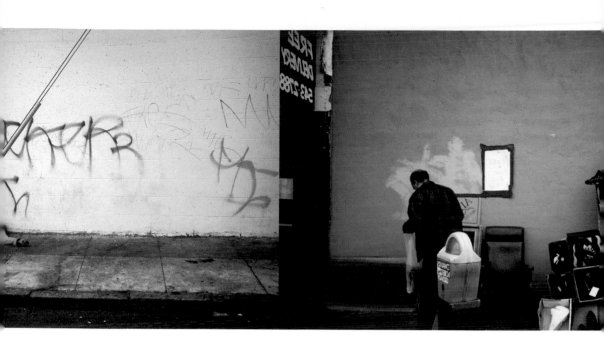

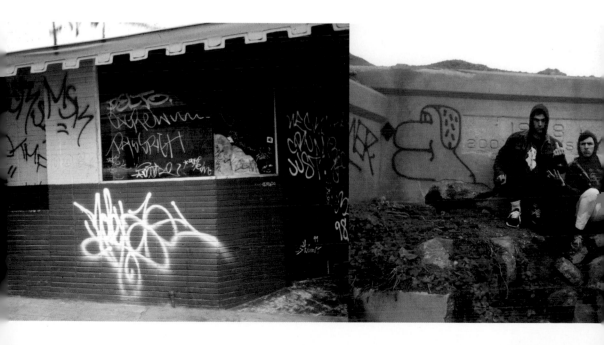

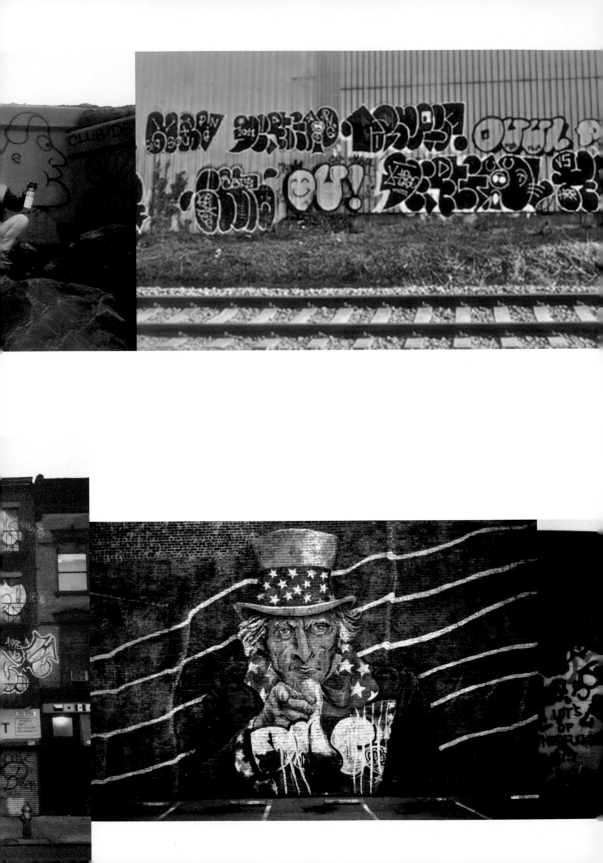

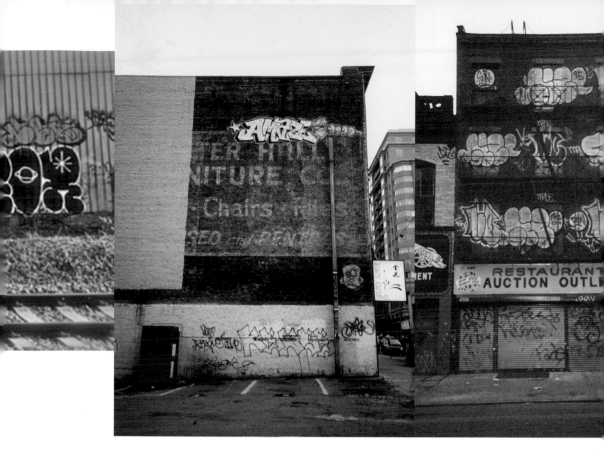

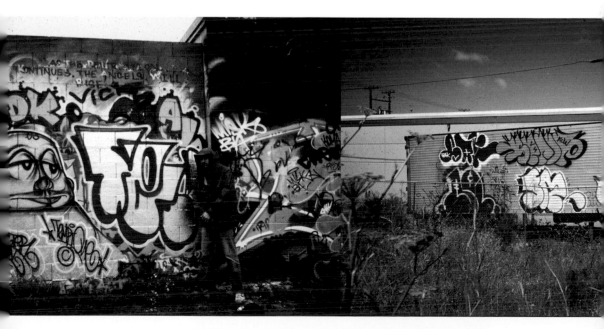

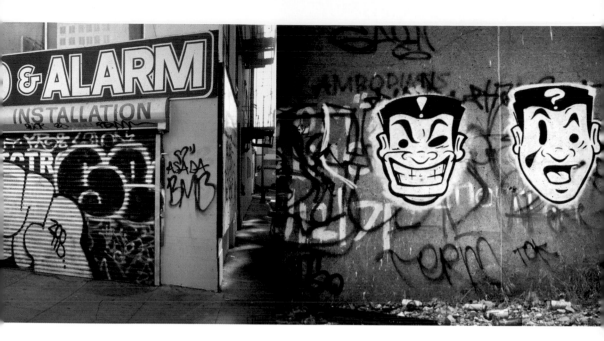

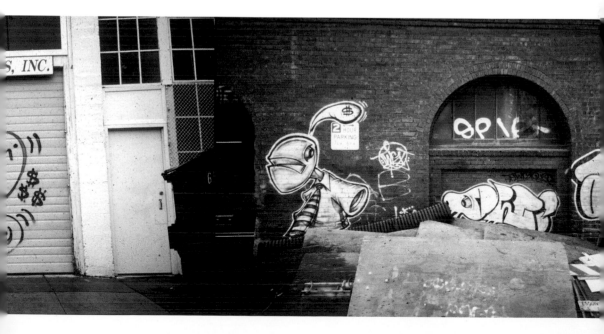

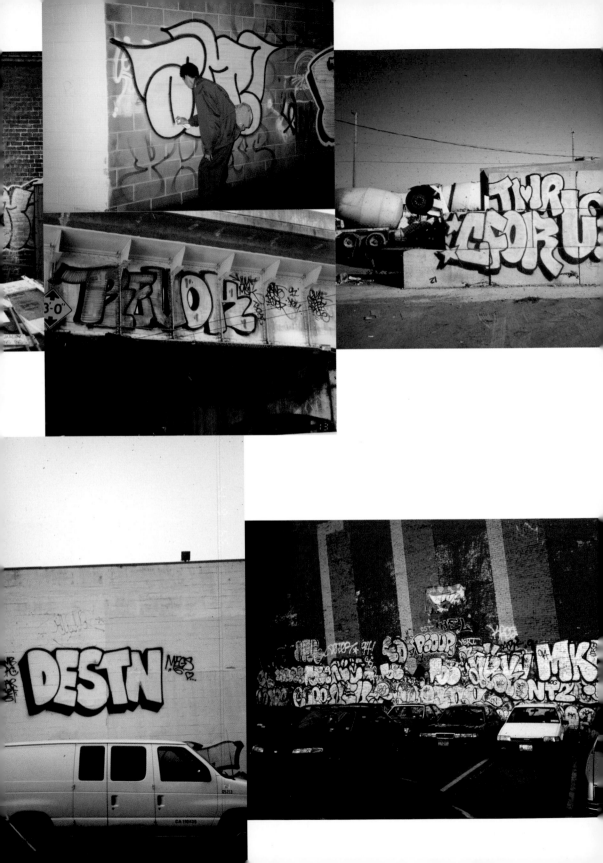

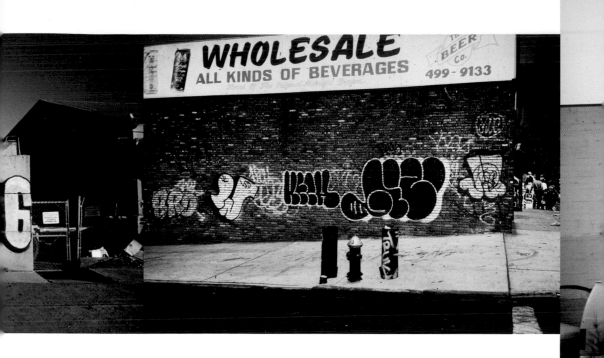

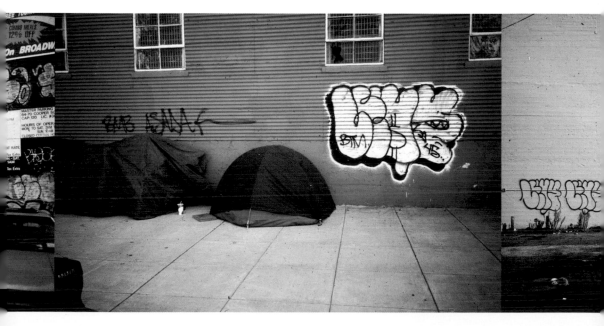

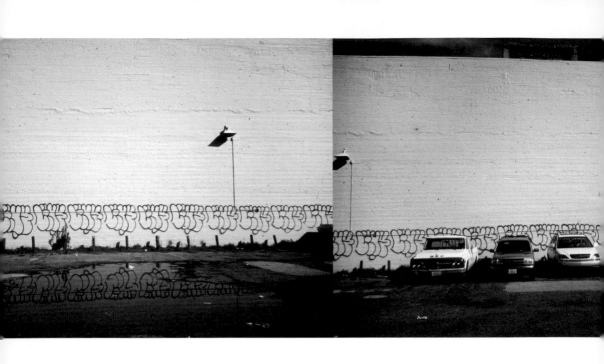

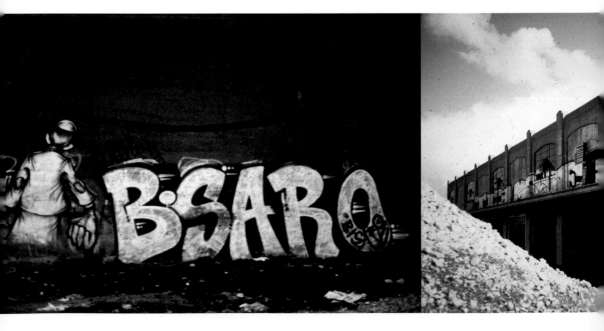

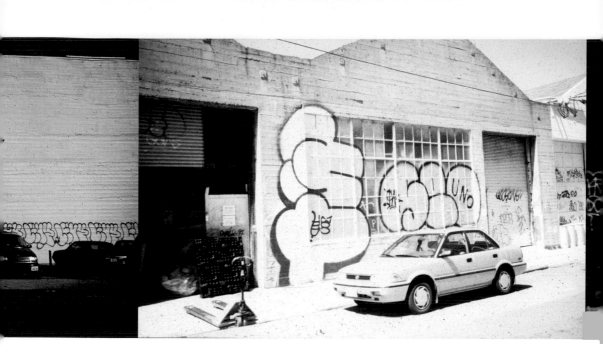

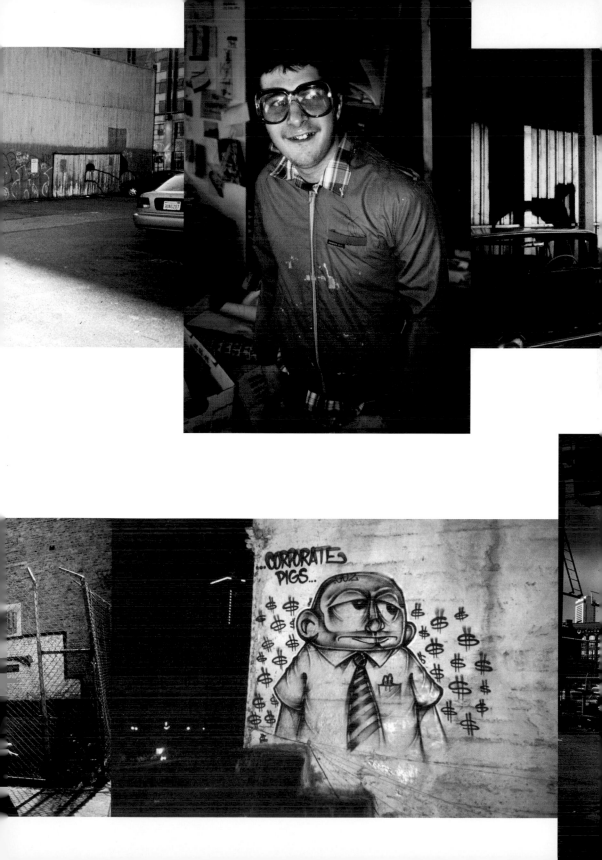

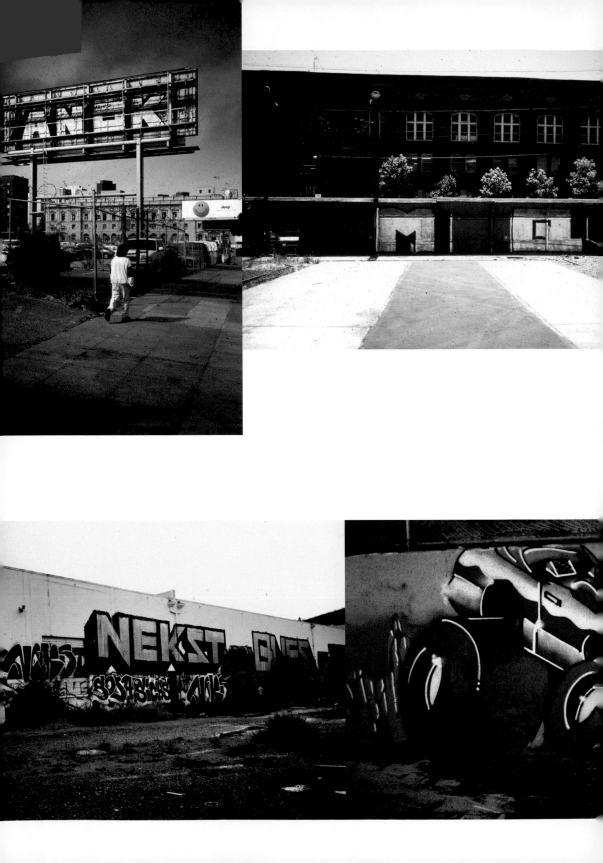

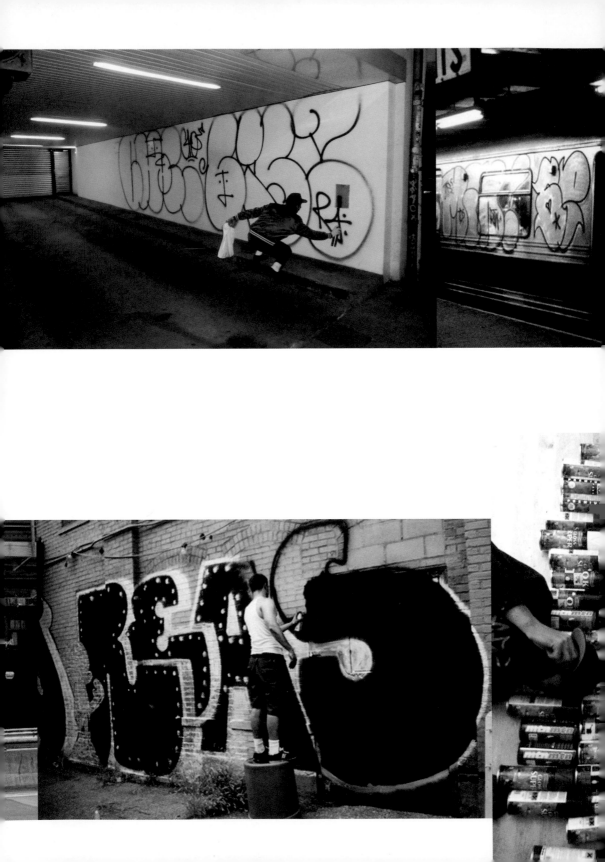

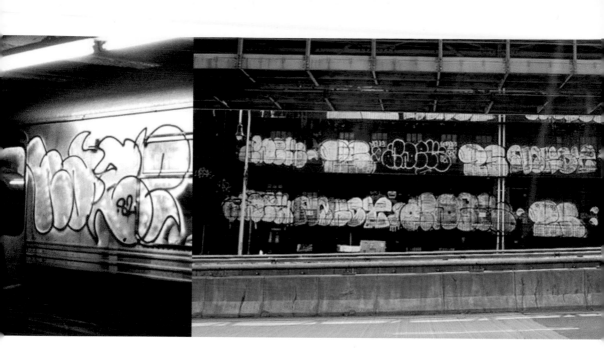

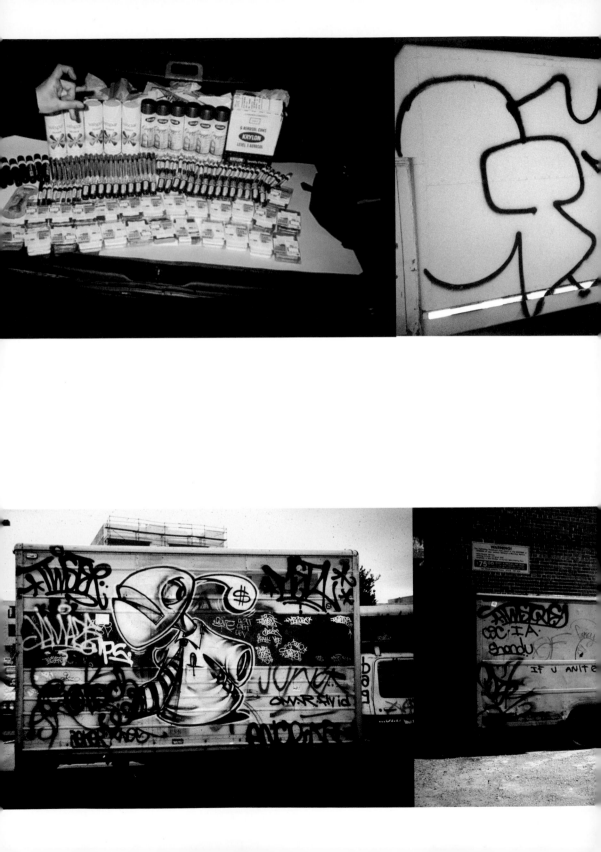

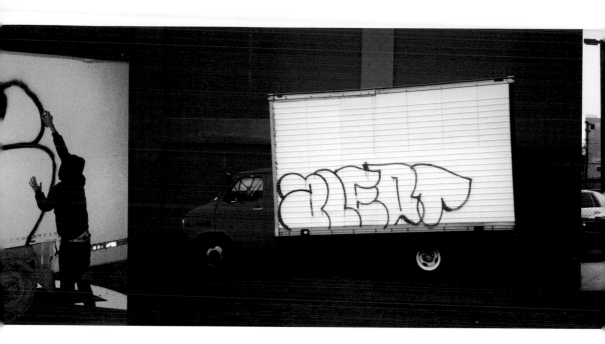

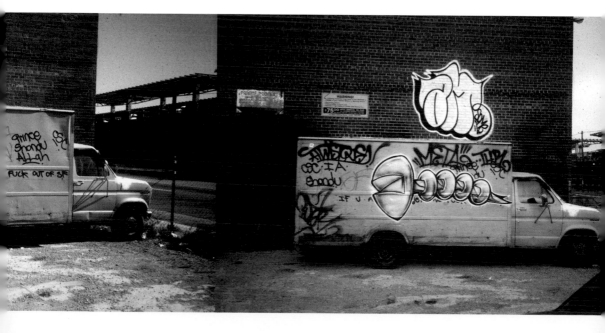

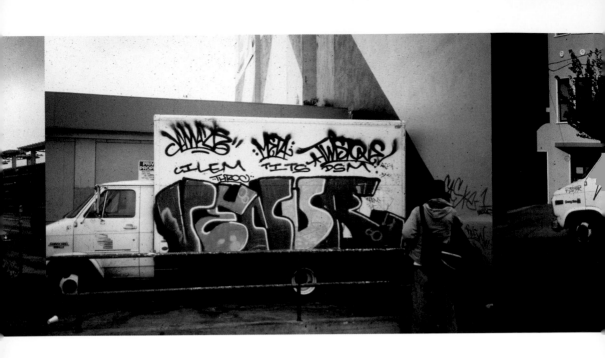

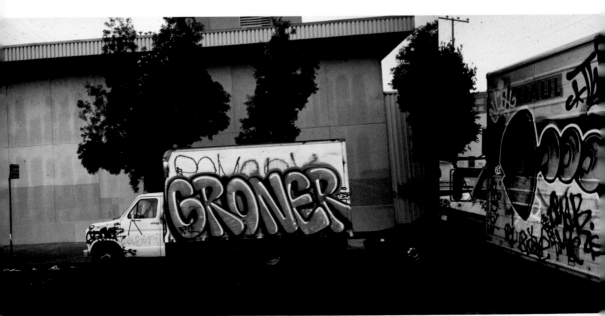

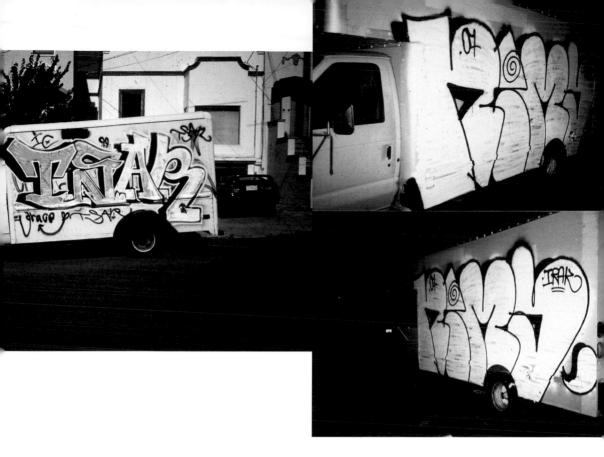
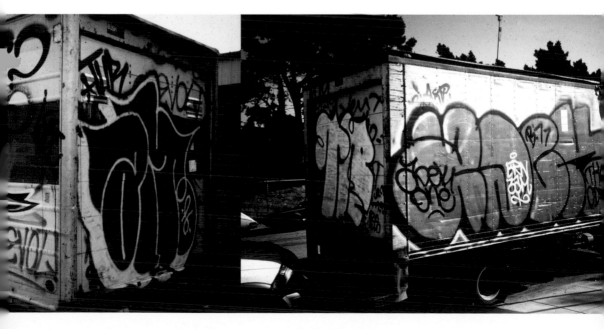

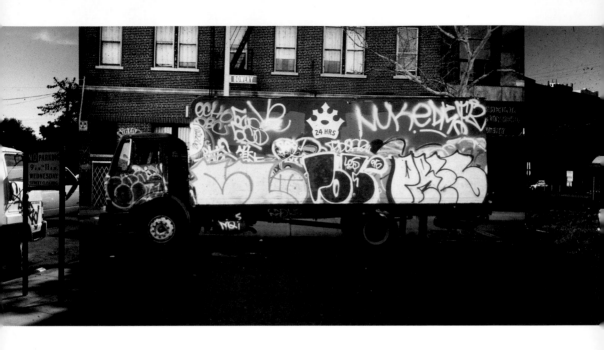

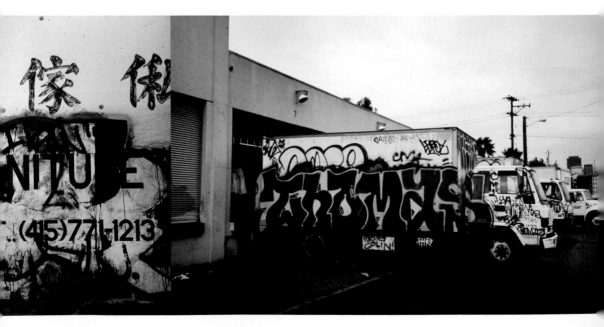

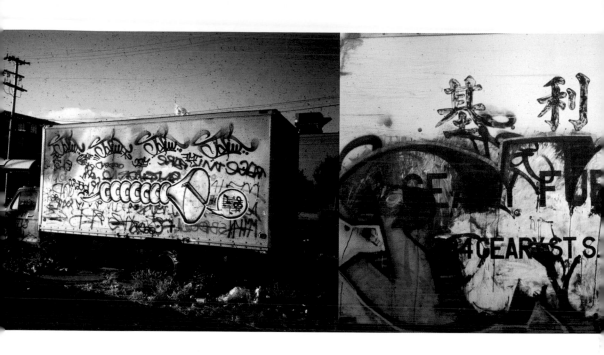
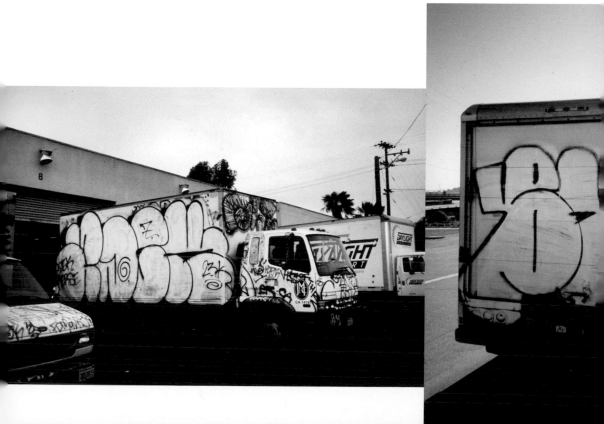

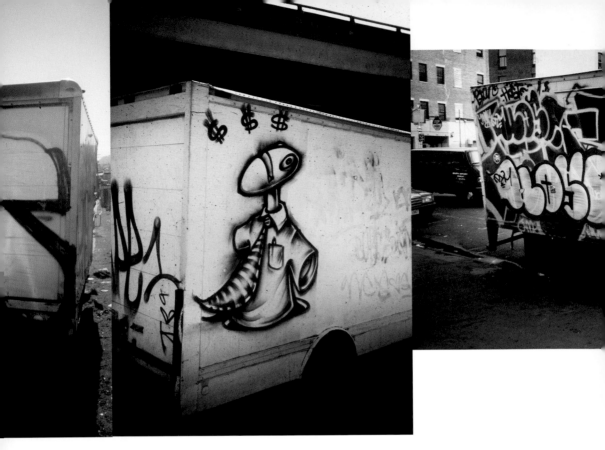

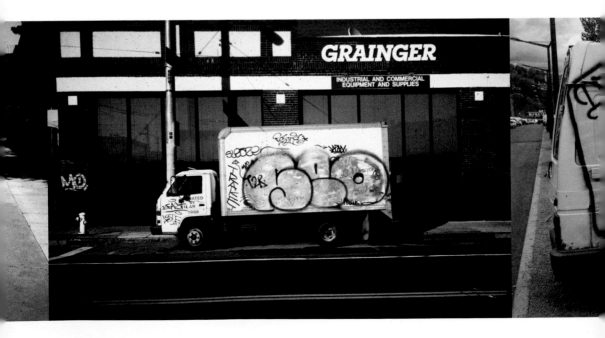

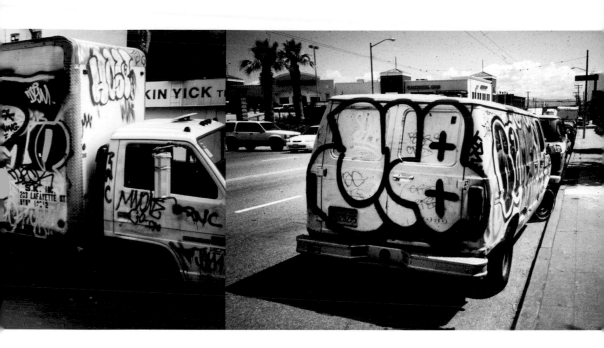

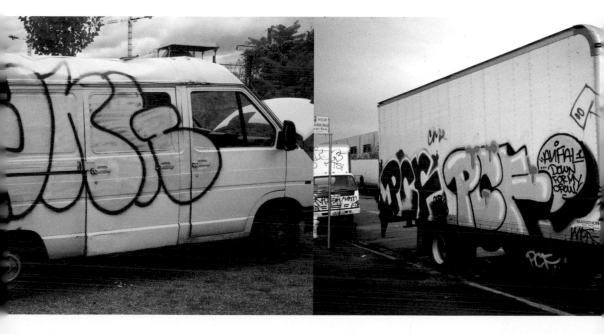

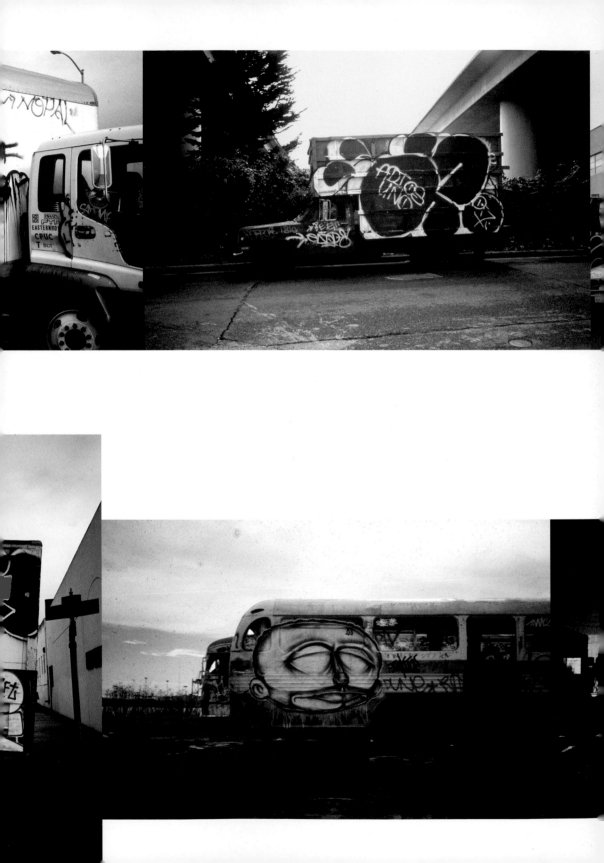

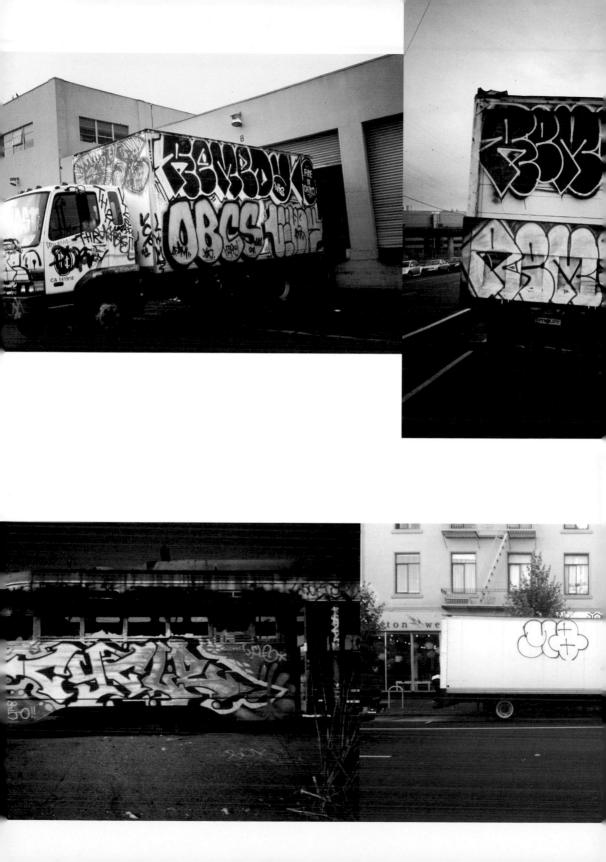

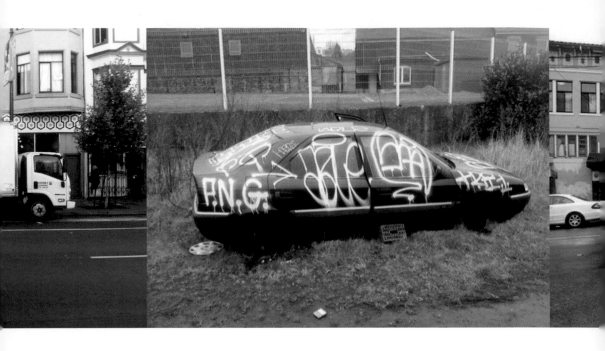

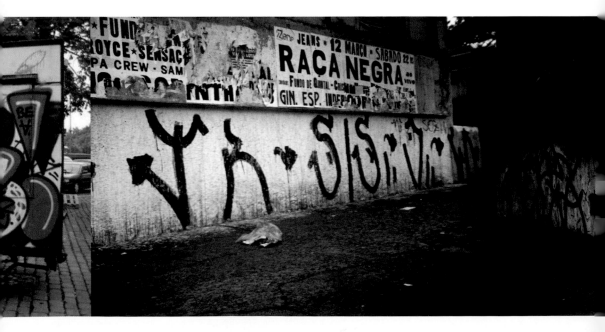

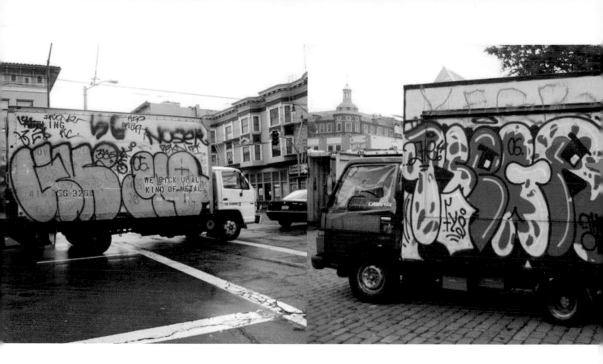

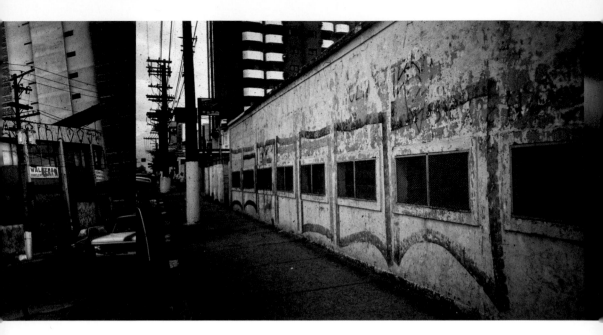

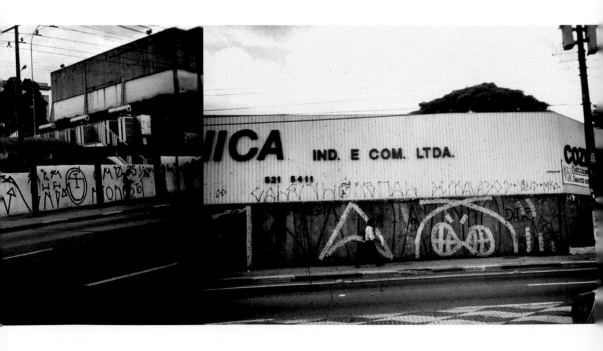

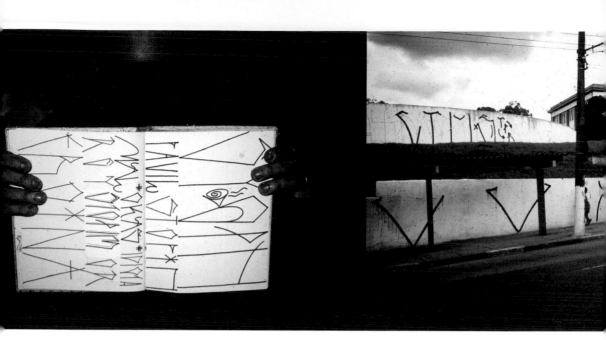

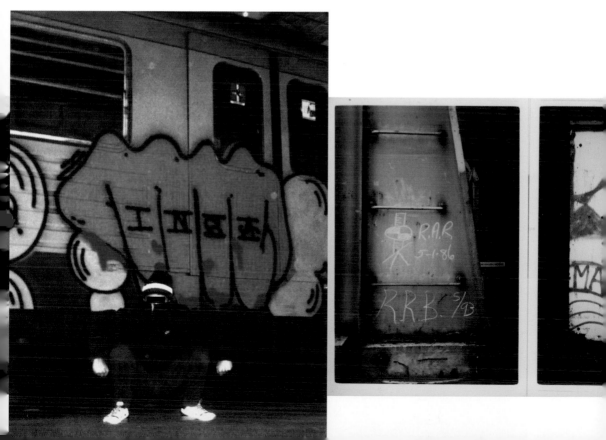

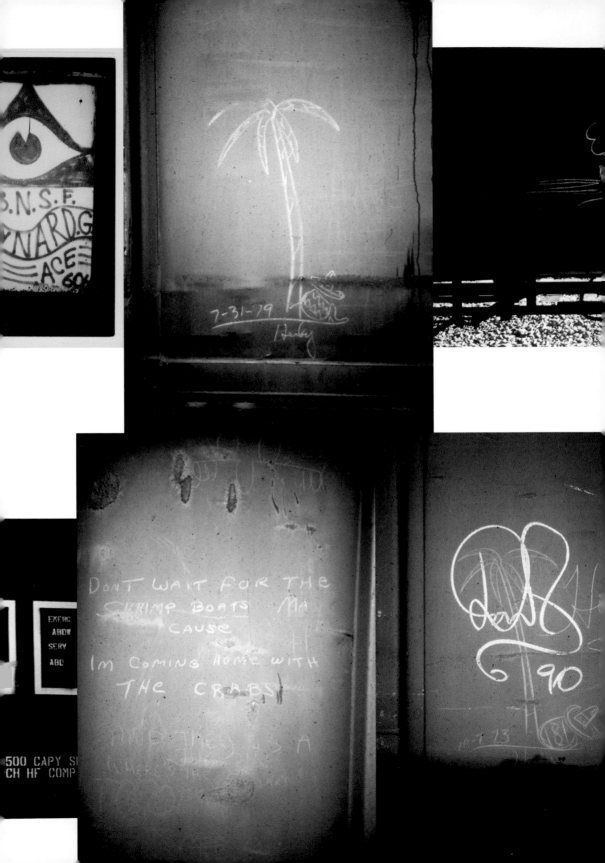

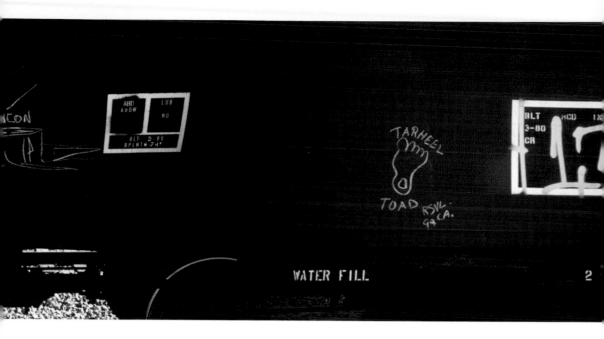

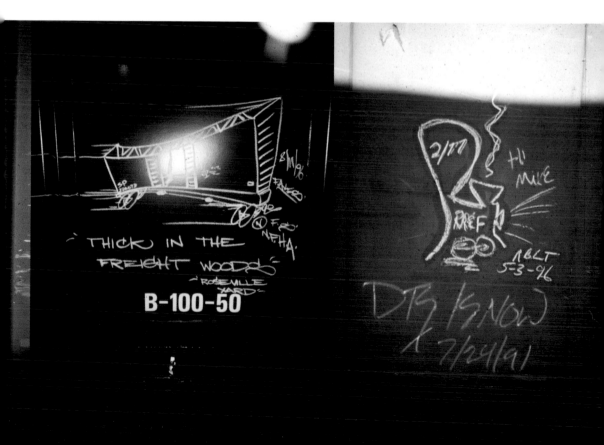

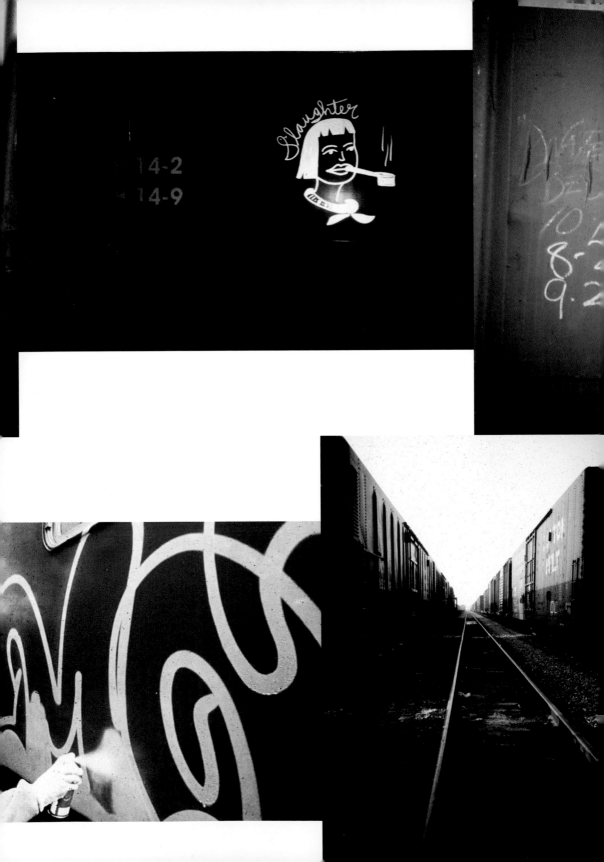

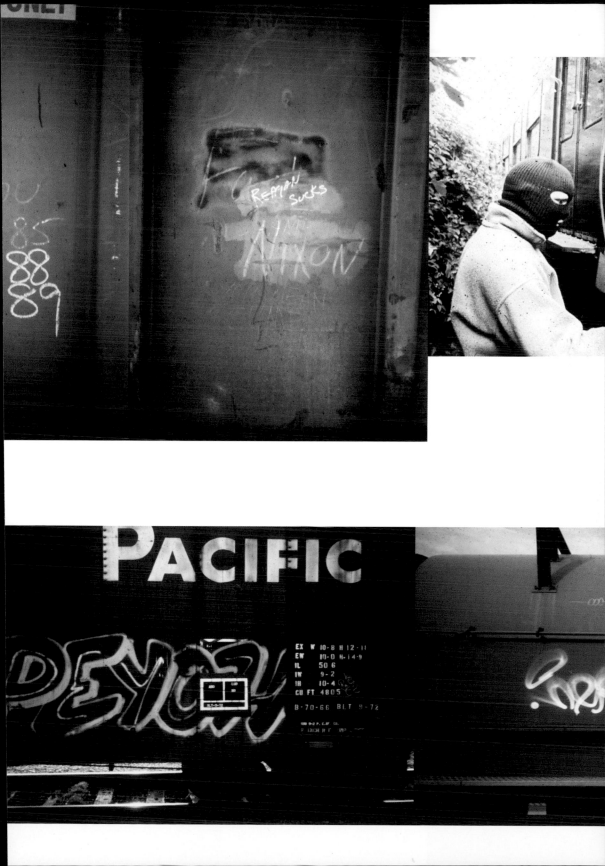

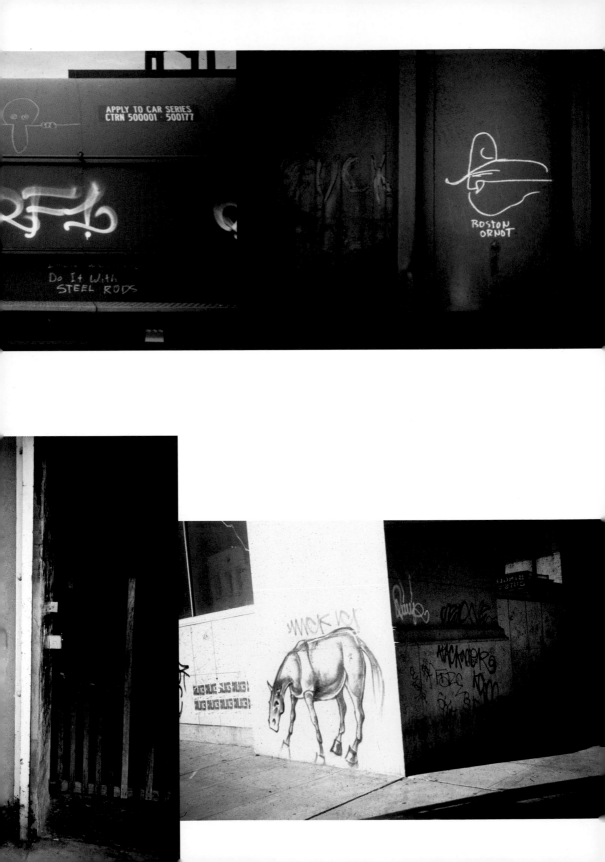

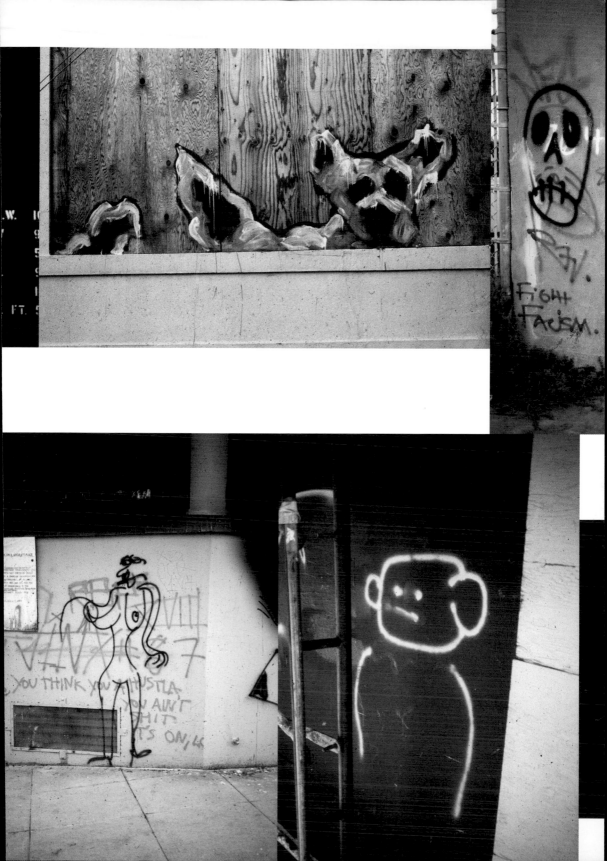

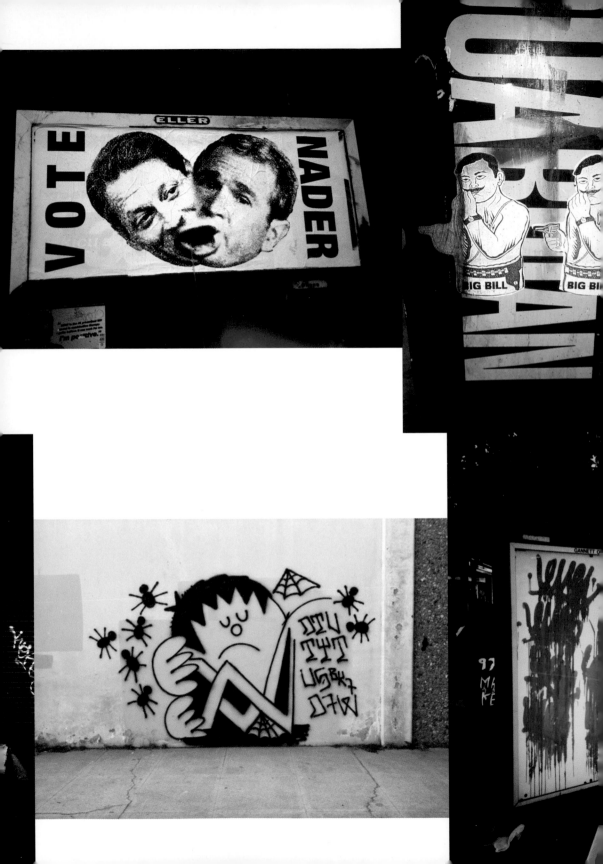

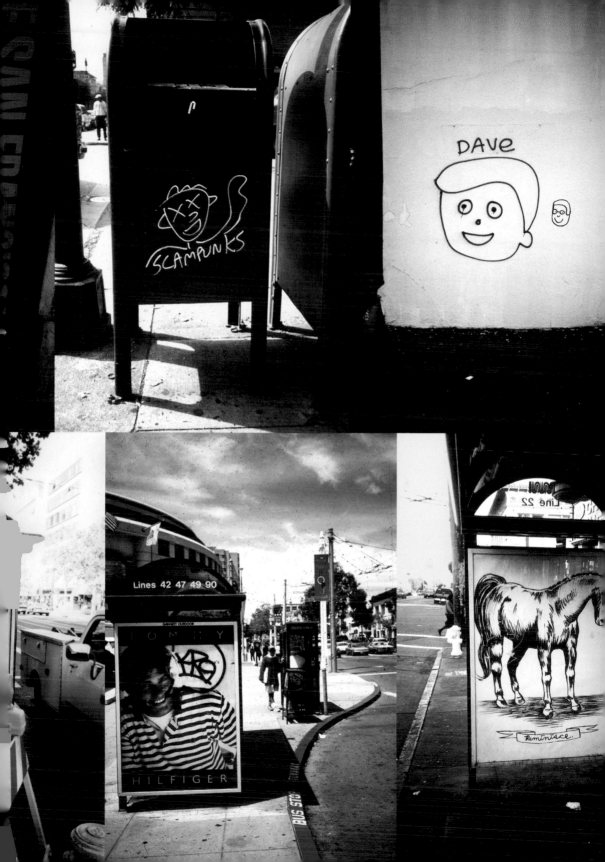

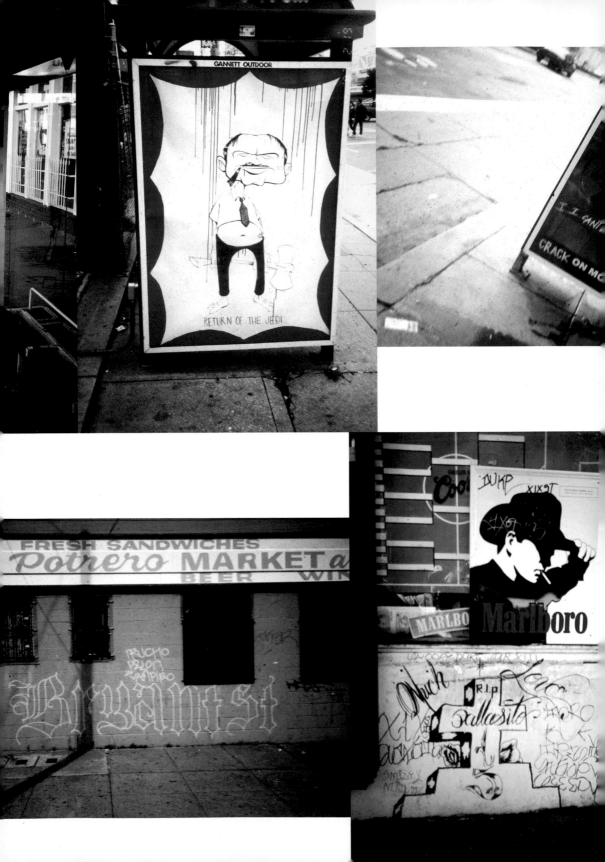

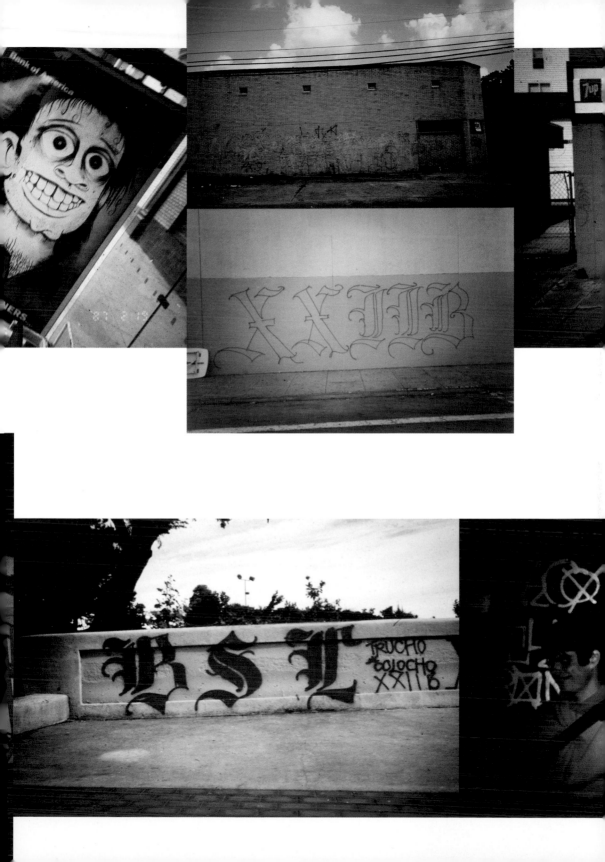

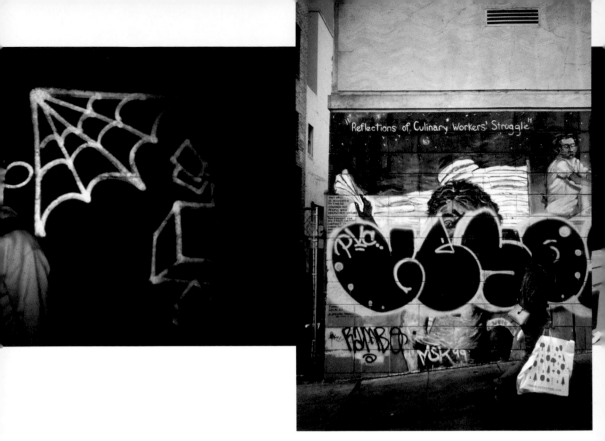

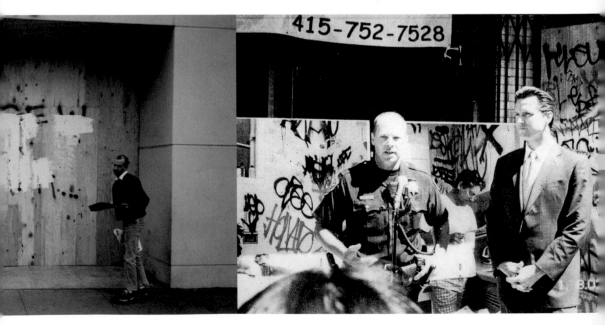

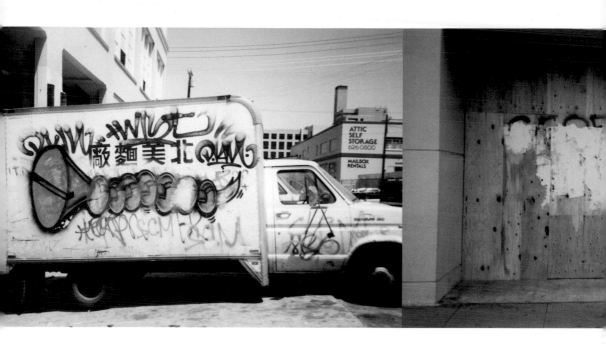

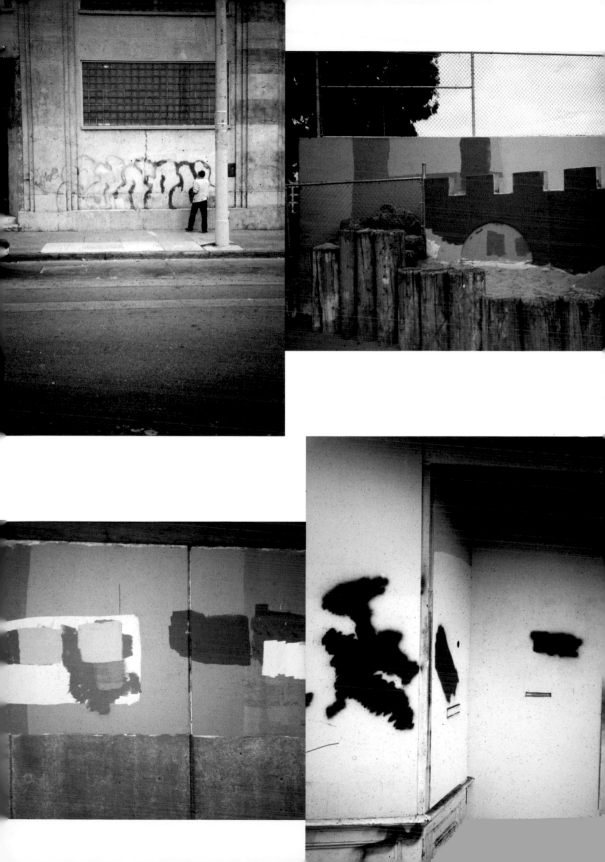

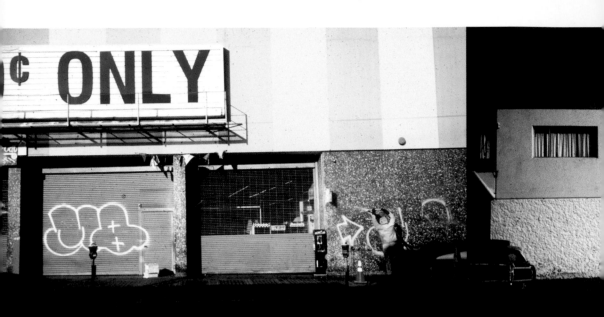

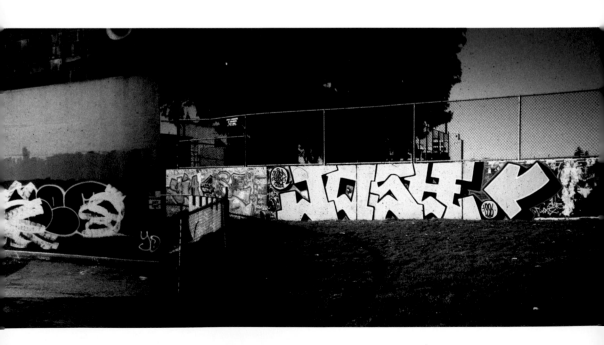

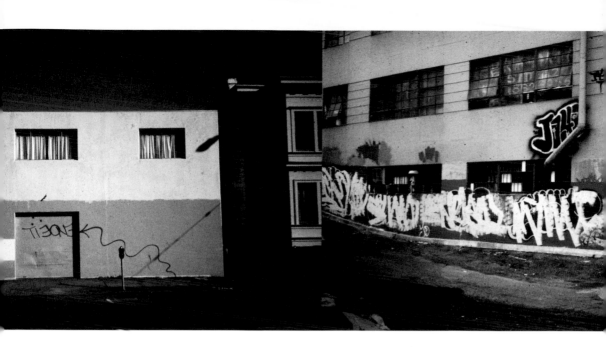

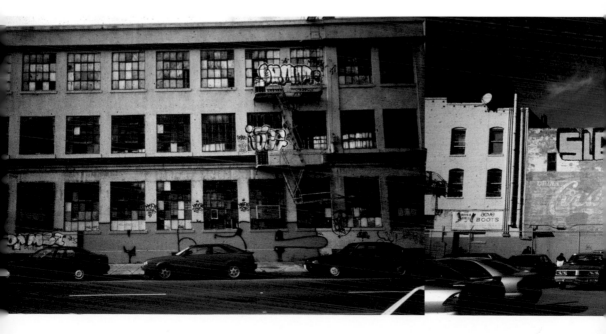

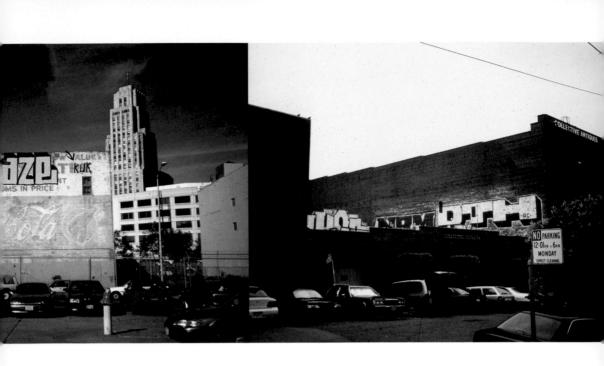

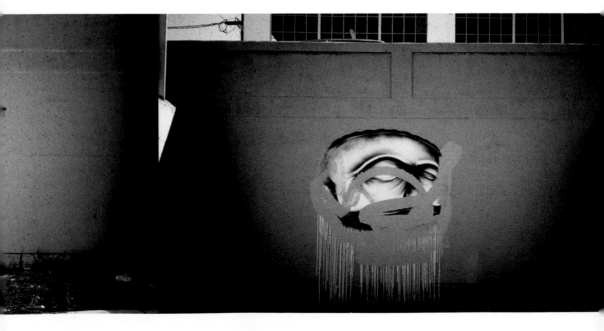

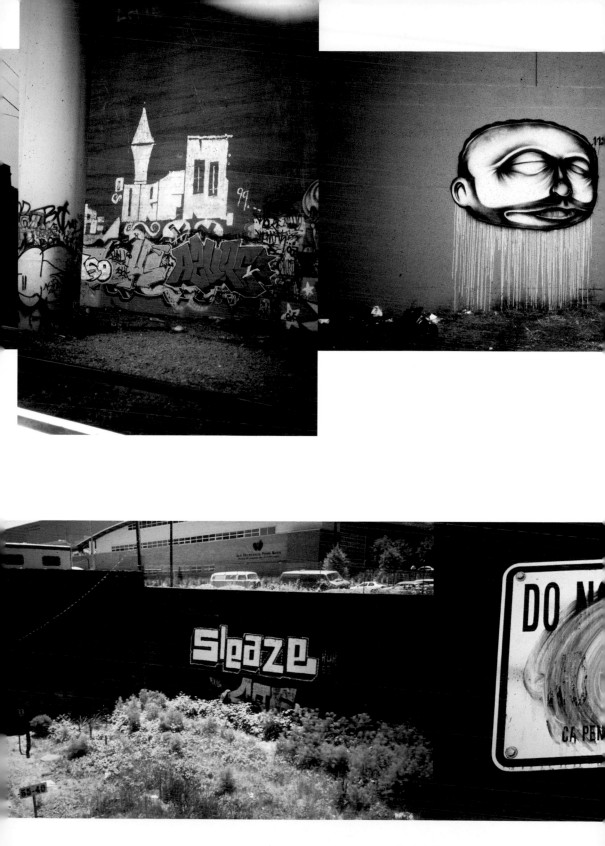

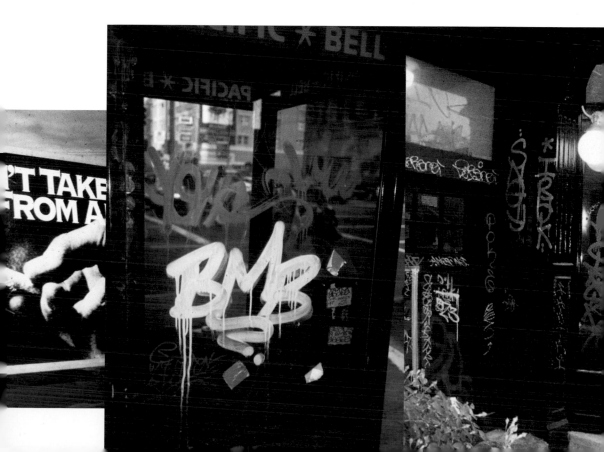

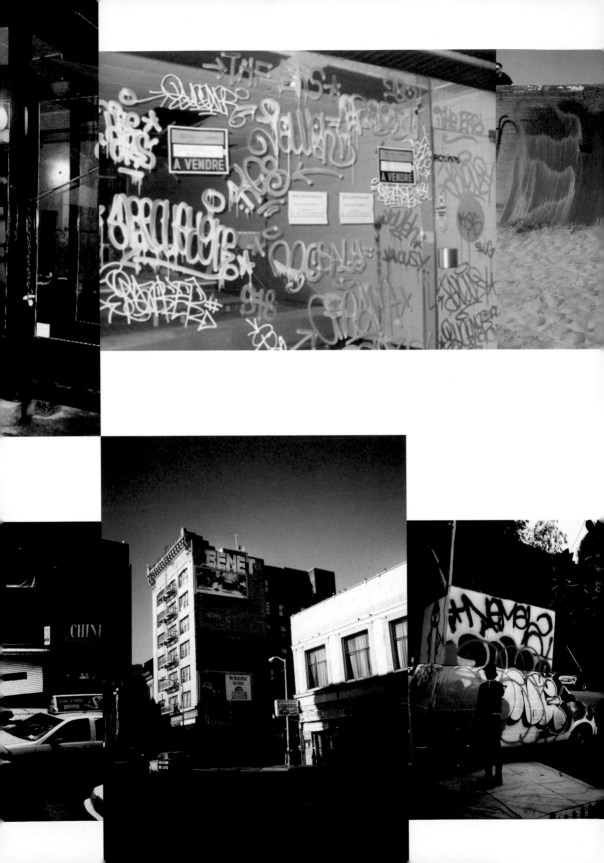

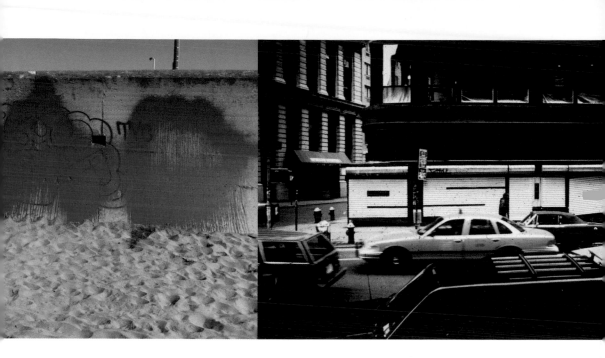
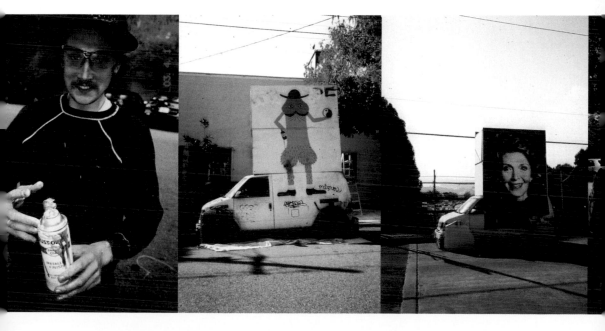

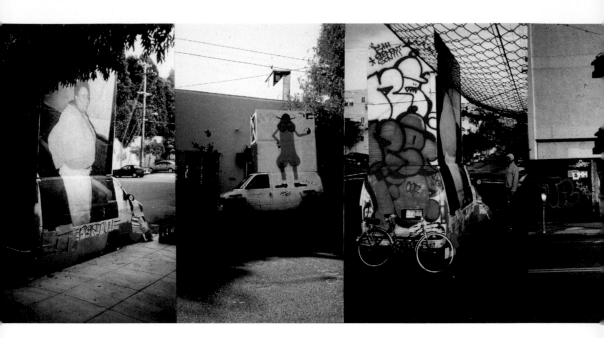

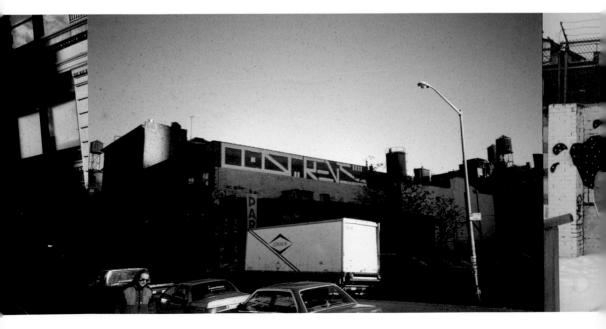

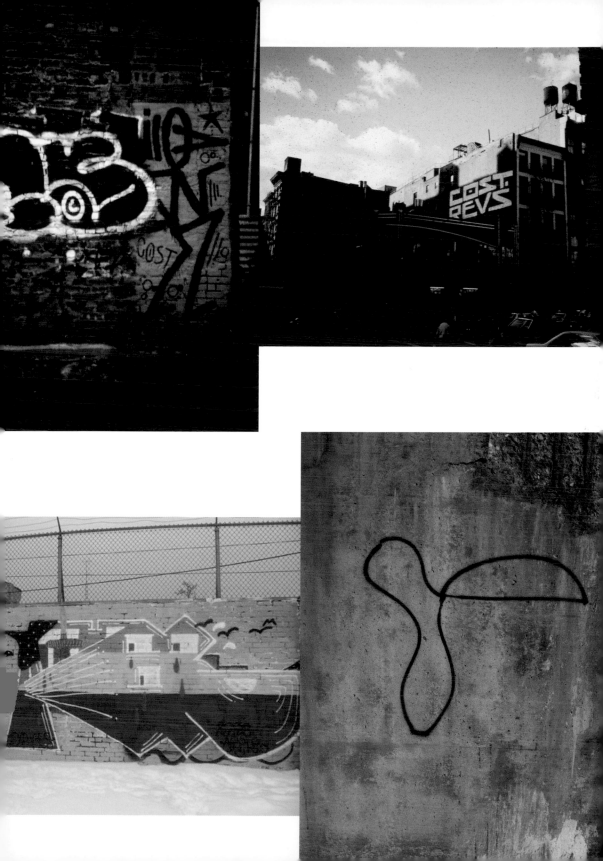

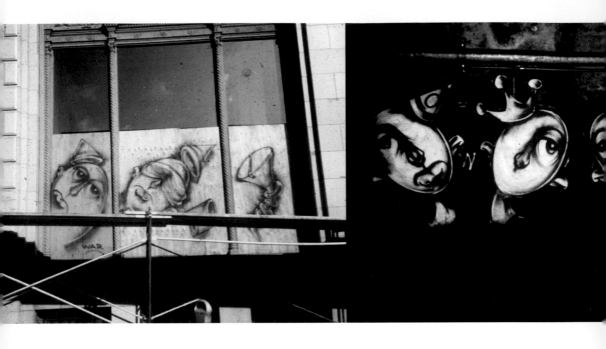

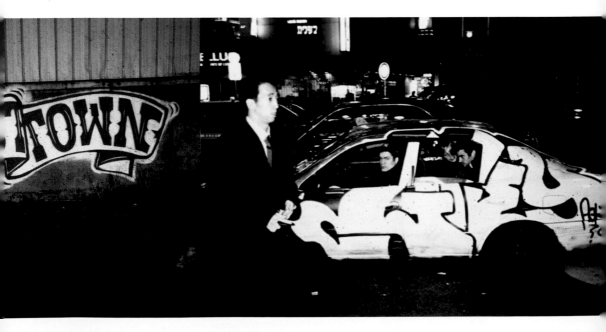

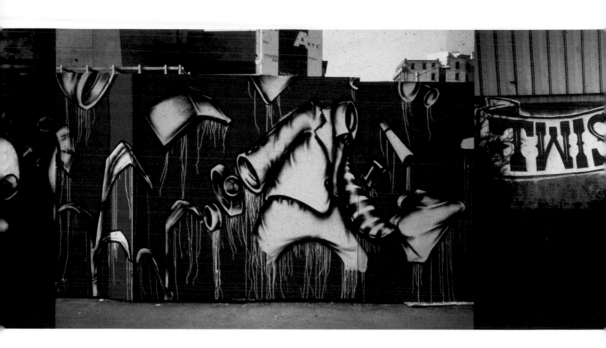

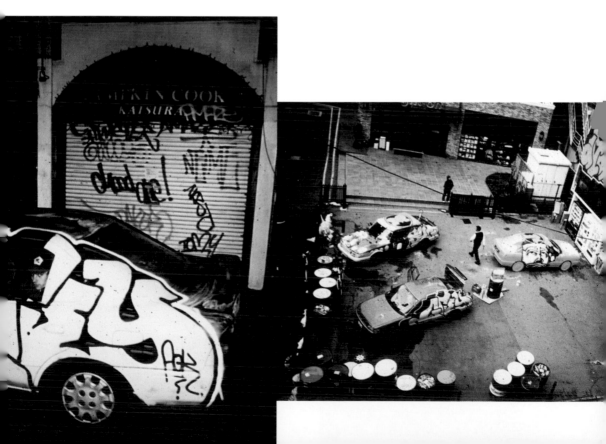

Was There Ever Really a Mission School? A Partial and Incomplete History

Natasha Boas

The art world has referred to a "Mission School" for a good decade now. Glen Helfand coined the term in the *San Francisco Bay Guardian* in 2002, identifying an artistic movement that he saw emerging out of a precise time and place—San Francisco's Mission District during the mid to late 1990s.[1] He pointed to a specific group of artists known for their collaborative and community-oriented ethos. At the height of this period, Barry McGee's mark could be seen widely in and around the city streets.

Today, the Mission School has been sanctified as an official art-historical movement. The San Francisco Museum of Modern Art's seventy-fifth anniversary exhibition in 2010 included work by Barry McGee and Chris Johanson with a wall text positioning both artists at the front and center of the Mission School, the "most significant art movement to emerge out of San Francisco in the late twentieth century."

Yet, in his essay "Learning at the Mission School," curator Lawrence Rinder argued that there may be "something misleading and too romantic about the notion that a neighborhood can demarcate a 'school.'"[2] And Renny Pritikin, the former chief curator of Yerba Buena Center for the Arts (the venue that organized the *Bay Area Now* exhibitions featuring artists from the alleged group throughout the 1990s), refers to the same constellation of artists, but by a different moniker, in his 2002 essay "Fellos": "Occasionally groups of friends who are artists living in the same city come together around similar aesthetics. On rare occasions the resulting work is good enough and lucky enough that national audiences and the national press discovers it." Pritikin continues, "Most recently, the graffiti/ skater movement centered around Barry McGee, Margaret Kilgallen, and Chris Johanson, among

others . . . can be seen as Urban Rustics and Digital Bohemians."[3]

The term Mission School persists, but not without some controversy. Since it has become almost synonymous with the work of Barry McGee, I thought it would be illuminating to ask a cross-section of artists, gallerists, and curators who were working in San Francisco during the 1990s: Was there ever really a Mission School? Going on two decades later, this is what they have to say.

Notes

1. Glen Helfand, "The Mission School," *San Francisco Bay Guardian*, January 12, 2002, http://www.sfbg.com/36/28/art_mission_school.html.
2. Lawrence Rinder, "Learning at the Mission School," *Parkett* 74 (2005): 190.
3. Renny Pritikin, "Fellos," in *Harvest: Futurefarmers 1995– 2002*, ed. Amy Franceschini (Hong Kong: Systems Design Limited, 2002), 104.

Alicia McCarthy, artist

I first had a mistrust of this question. But it's really important to hear the voices of the artists today on the subject. The funny thing about the article that Glen wrote—those same two lines that are repeated over and over—is that the four artists (Margaret, Barry, Chris, and me) who are supposed to define this "school" were not interested in being separated out or exclusive—they were a community and they would want to expand the list of artists.

Glen wanted to name something that came about from random parts that culminated in a time and place. This was a Bay Area–wide (not just Mission District–wide) group of artists, and one that was very tied into a history of Bay Area art history mostly from the thirties—we were very influenced the Bay Area Figurative movement: people like Philip Guston and then later by artists like Squeak Carnwath. . . . We were all connected to the San Francisco Art Institute in some way. We took part in a specific place and time in San Francisco.

John Weber, arts administrator

Interesting question. I'd say yes, there was. . . . I recall a ton of somewhat similar work that was like Barry's and Chris's. So many artists with lots of small, sometimes badly painted figures scampering around and muttering, and a lot of pleasingly cluttered drawings. There was sort of a yammering, angsty-but-festive mood to much of the work. The fact that it had a kind of home gallery at Jack Hanley's probably contributed to the "school" idea, but other group shows at SoEx [Southern Exposure] and New Langton Arts were part of the whole vibe for me. A lot of the work was fairly small scale, too, with a feisty, alt-indie, non-capital-intensive quality that I didn't associate with work in New York, Europe, Asia, Los Angeles, or Latin America at that time. Simon Evans . . . I loved his work the first time I saw it, for example.

None of this necessarily adds up to a school, but still, it felt distinctive and regionally specific, and still does a bit, although I think that the sort of "small figures on paper" thing can pop up anywhere now. Sensibility-wise, people like Amy Cutler or early Amy Sillman (her more figurative

things) who were not from the Bay Area shared a lot of the same feeling, and there are others. Barry's show at YBCA in 1994 still stands out as one of the best things I saw in the eleven years I spent in San Francisco.

Jack Hanley, gallerist

After pondering this Mission School issue a bit I do think there was/is a Mission School. Obviously I'm not referring to a building or a style but more in the sense of a New York School or Paris School, which mostly referred to the group of artists working in the same general place/scene and interacting/feeding off each other a bit. Stylistically, Pollock, Barnett Newman, Rothko, et al. hadn't much in common other than an immersion in their mutual art/painting issues, but their interactions and camaraderie at the Cedar Bar, etc. proved a fertile ground for innovation and support. Perhaps in a similar (if less monumental) way, the Mission geographically linked a scene and group of artists that interacted frequently and supported one another's art, bands, and survival. The sense of living in an outpost and in isolation from the dominant art centers of the respective times reinforced their importance in forming a support group with some shared concerns, both in community and aesthetics.

Bob Linder, artist

Two friends are walking down the street. One turns to the other and asks: Hey, was there ever really a Mission School?

No. 2 responds: You mean other than the constructed version? The version built by Yerba Buena Center for the Arts/SFMOMA to give San Francisco some kind of contemporary art identity? The similar San Francisco Art Institute and California College for the Arts versions or the graffiti version? The early Four Walls version, the Victoria Room or Scene/Escena version? The old Capp Street Project version? What about the Survival Research Laboratories (SRL) version? Or, better yet, the Bay Area Conceptual version, the overlooked Mission School, the Howard Fried, 16 Rose Street version? The Terry Fox, David Ireland, Paul Kos version? The Karen Finley version? The

118 Jones Street version, the Organizers of This Publication version? The 1943 Mission Street version, where I witnessed some wonderful, challenging, and awful performances from some of the most talented artists I know?

No, there has never been a Mission School.

Janet Bishop, curator
There was definitely something distinct and special that took root in the Bay Area in the 1990s. Since Glen Helfand used "Mission School," the term has stuck as a useful way of describing a fluid group of artists, many of whom were associated with skate/surf/graffiti subcultures, who embraced the scrappy DIY attitudes and community spirit of the San Francisco neighborhood where much of the work was first made and shown. Often embracing the grittier aspects of urban life through the use of found images, materials, and situations, the work tended to be both participatory and observational.

The movement took hold during the high-flying dot-com era, when this work stood out for reflecting a social conscience. SFMOMA began showing work related to the Mission School impulse when McGee, the artist most closely associated with the movement's beginnings, received a 1996 SECA Art Award, for which he painted a sixty-foot-long mural and displayed a cloud of hundreds of framed drawings and photographs.

Chris Johanson, artist
The Mission School as a painting thing does not really mean anything to me.

It was a neighborhood thing.

Johanna Jackson, artist
As for a Mission School, yes, for me there was one. There probably always is one, where artists are on top of each other as we were there and then. We were very isolated from the larger world, by location and by our super-left-wingness. This made us regional, and then laziness and shyness made us neighborhood-regional, and made it so we were one another's main inspirations. Looking back at the art made then, I can see how Barry's work looks like it

comes from the neighborhood. I didn't know him then. I saw his mural at the Justice League around 1996. It was so pretty and strong, it was the work of an artist who really owned his hand!

Ann Philbin, arts administrator
I am a fan of this group of artists from way back. We gave Barry his first big exposure in New York at the Drawing Center in the early nineties and Margaret's show came soon after. When I arrived in Los Angeles in 1999 to run the Hammer, Barry and Margaret were two of the first artists that curator James Elaine and I invited for the Hammer Project series. Indeed, Barry's wall drawing in the Hammer's lobby was a game-changer for the institution. Margaret's death was shattering to us and such a great loss to the world. It is still hard to imagine how this person could have forged such an indelible and unique vision in such a short life. I have been familiar with this circle of artists for many years but, to be honest, I never heard the moniker "Mission School" applied to them. If it existed as a named movement, I never knew it. But if it did, it was surely overseen by the benevolent, beautiful, and brilliant high priest and priestess, Barry and Margaret.

Kathryn Reasoner, arts administrator
I wasn't really paying a lot of attention to it until Margaret Kilgallen applied for a residency at the Headlands Center for the Arts. She moved into the house next door to me and Barry spent a lot of time with her there in 1997. Her wetsuit and their surfboards on the porch signaled when they were around. Margaret was less influenced by other artists than by old letter text (she was a bookbinder), hobo art, the poignant messages on handmade signs, effluvia from the street, etc. I think she ended up influencing Barry and the others in their circle a great deal.

Ruby Neri, artist
My opinion is that yes, there were people in San Francisco at a specific time who were doing work that was in a similar vein. Barry had a lot of

influence on the artists working in the early nineties, but there were others as well. Barry was instrumental in bringing what he did on the street into the gallery. He worked at a printing shop then and used lots of their cast-off material in his work. He also found objects from the street, and then combined these objects with his street work/sensibilities into an installation environment in a gallery setting. I think of this way of working when I think of what people call "Mission School."

D-L Alvarez, artist
The art scene in San Francisco that shaped my sensibility was not an influence of style, in the sense that art historians use the word "style," but the generosity of permission. I'm talking pre-dot-com, when rents were cheap and people experimented wildly, leaping from writing fiction to playing in bands to graffiti to activism to running a gallery. It was a communal embracing of the idea as medium. The Mission itself was a neighborhood where artists turned unwanted space into places where people could try out new projects in evenings that were a word-of-mouth fusion of art opening/poetry reading/spontaneous DJ-ing/guerrilla theater/drug-laced potluck/orgy/political fundraiser. You saw a lot of the same friendly faces at each event, and the familial atmosphere encouraged you to take risks that would be impossible in a city that was under heavier art-world scrutiny. Being slightly off the map in that regard is the greatest gift for a creative individual still finding her or his footing. That was my Mission School.

Darryl Smith and Laurie Lazer, arts administrators
With respect to the question I would prefer to look past the brand as such and first acknowledge the gathering storm of awesome art making with an attention to the folkloric as practiced by fringe dwellers, dreamers, outsiders, outlaws, critical and compassionate beings that found a nexus in San Francisco beginning in the early nineties.

 Graffiti—the embodiment of its spirit—the reverence of the hand, the absolute freedom of the line, the never-ending wave . . . Exhibitions like *Folklore* with Barry McGee and Brett Cook-Dizney

in 1993, *Be Bleeding Ink* with Ruby Neri and Alicia McCarthy in 1995, *Widely Unknown* with Margaret Kilgallen, Terry Hoff, and Frederick Hayes in 1996, *Off the Hook* curated by Thomas Campbell in 1998—these were shows presented at the Luggage Store that exemplified this "school."

 That many of these artists hung out, found affordable space to live and work, and had their work presented in a number of significant venues (that would emerge in parallel: Adobe, Jack Hanley, Four Walls, ESP, Kiki, The Bearded Lady, and Collision Gallery) in the Inner Mission—possibly, most likely, contributed to its gentrification by the very naming of such . . .

Marialidia Marcotulli, curator
San Francisco was very raw during the late eighties, early nineties. In the lower Haight, Miles Bellamy opened Upaya, where artists were convening out of art school. Later Michael Damn opened The Victoria Room in the Tenderloin, Julie Deamer was running her space Four Walls in the Mission, and there was Gallery Sixteen in lower Potrero. By the mid-1990s, the original "school" crew was quite active in their careers, showing in Japan, Manhattan, South America, and Europe. Randy Moore in 1997 curated Barry's and Margaret's individual solo shows at John Berggruen Gallery's fourth-floor space. Yes, there was a "school" of sorts happening in the nineties, and many of the artists during that time were merging the skateboarding, surfing, music, graphic design, and the outsider pieces all together in one place through film, photography, collage, murals, paintings, zines, and attitude.

Julie Deamer, gallerist
I believe there was something going on in the Mission District at that time that is deserving of a little myth making, but I wish the period could be remembered or historicized for more than a style. Style is the easiest thing to excavate from a certain place and time but what remains most meaningful to me about that period was the experimentation and wide appreciation among artists for genuine creative expression. It's a cliché to say this but that

was the only time in my life I knew I was at the right place at the right time. Or, maybe that's just because anywhere is magical when you're in your twenties; I'll never know.

David Ross, curator
It was not a "school" in the art-historical sense, but it was very much a scene and Barry was at the center of it, as was Margaret. Every once in a while San Francisco is recognized by the national art press for something indigenous, and this was one such instance. Margaret's tragically young death added an element of powerful reality to the scene, and, if anything, Barry's work became even more intensely life affirmative in the ensuing years. But whether it was a "school" or not is probably the wrong question. More important was the sense of possibility that a certain group of artists seized upon and made their own.

Thomas Campbell, artist
The media generally makes up slogans or titles to help make things eatable for readers. I'm sure the people in what they called the Mission School (Alicia, Chris, Barry, Margaret) didn't come up with the term . . . but shit . . . media helps and media hurts and you can't really stop it. . . . Regardless, people paid and are paying attention to these amazing stuff-makers, which is cool.

Aaron Rose, filmmaker/curator
In my opinion, yes! Even though most of the artists involved still deny it to his day. The first time I came to San Francisco from New York, I most certainly noticed a unified aesthetic among a lot of the artists in that neighborhood. It wasn't organized or anything, but there most certainly was a "look."

Kal Spelletich, artist
Schools, clubs, sloganeering, marketing propaganda, a posse that feeds off of each other or has a common philosophy or goal. Hell, I dunno, I always tell the youngsters and my students, two or three people are a movement, get your posse together, you will need them! So yeah, create your own scene, don't depend on anyone else to do it for you. If you are in the club it can be great, if not it is like a party that all the cool kids are invited to but not you. It is a little funny that this particular club/school was formed or named, but not by the people in it. . . . All in all, I suppose it is good to try and identify movements and groups, it helps those who are included career-wise to be identified as being in a movement. And helps society to figure out/frame culture. "I don't care to belong to any club that will have me as a member" (Groucho Marx).

Randy Colosky, artist
By the time I migrated to San Francisco in 1993 from North Philly, I noticed the outsider vibe started to show up in more respectable places in people's work, like Manuel Ocampo's show at Annina Nosei Gallery in New York. And then Pettibon started surfacing beyond the Black Flag records in L.A. Your question of was there ever a Mission School is really a yes/no question, so I'm not going to answer it, but I will tell you in my experience the aesthetic ascribed to the Mission School had been fermenting all over the country, in Philly, Chicago, and cities in the Midwest long before. By the time I started working for Chris Johanson in 2002 it was pretty much second nature for me to understand his aesthetic and how to transfer that into constructing the pieces I worked on for him.

Julio Cesar Morales, artist
I really wish there was no Mission School—you can blame it all on Glen's article in the *San Francisco Bay Guardian* and on bored curators! I would say that Alicia McCarthy was first to develop the rainbow-type palette of colors and Chris Johanson, with his assemblage/found material artwork—Chris had not even hooked up with Jo Jackson yet—but it also took hold during the dot-com boom and really the only connection is that all these artists associated with the so-called movement lived in the Mission. They did not share a common living manifesto but rather a sense of friendship and excitement about outsider art, punk rock, and surfing.

Bob Carillo, surfer/curator

It's more about the kids creating art and living by threads in the Mission District before the dot-com boom which allowed them to get away with certain things, like creating street and gallery art. It was an economic survival situation for them. They can claim the Mission but really, hey—it was claimed by the Latinos many moons ago . . .

Tommy Guerrero, skater/musician

Isn't Mission High School on Eighteenth and Guerrero? Other than that, I have no idea what that means. I dislike that term/idea . . . but what I don't know could fill a black hole.

Clare Rojas, artist

The Story of the Blind Men and the Elephant:

Once upon a time, there lived six blind men in a village. One day the villagers told them about an elephant in the village. They had no idea what an elephant was and decided they would all go and touch it.

"Hey, the elephant is a pillar," said the first man, who touched his leg.

"Oh, no! It is like a rope," said the second man, who touched the tail.

"Oh, no! It is like a thick branch of a tree," said the third man, who touched the trunk of the elephant.

"It is like a big hand fan," said the fourth man, who touched the ear of the elephant.

"It is like a huge wall," said the fifth man, who touched the belly of the elephant.

"It is like a solid pipe," said the sixth man, who touched the tusk of the elephant.

A wise man was passing by while the blind men were deliberating. They said, "We cannot agree on what the elephant is." The wise man calmly explained to them, "You are all right."

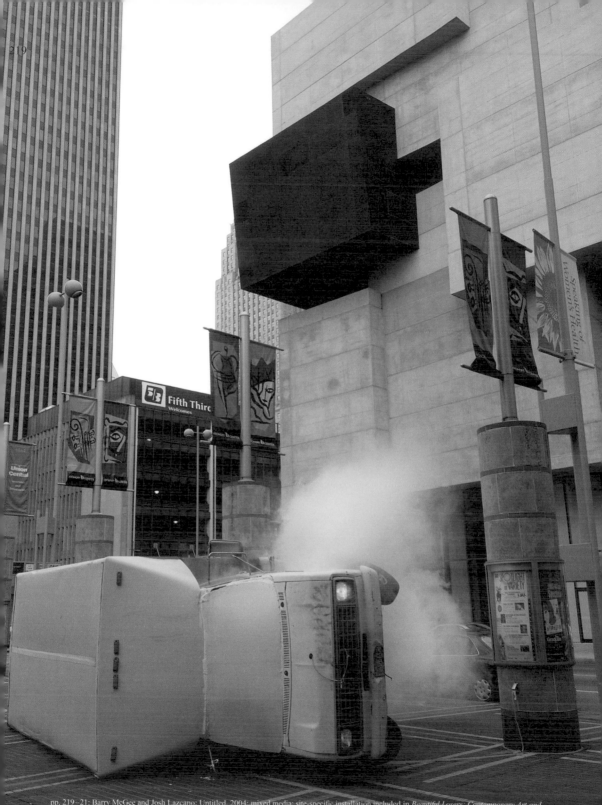

219

pp. 219–21: Barry McGee and Josh Lazcano: Untitled, 2004; mixed media; site-specific installation included in *Beautiful Losers: Contemporary Art and Street Culture*, March 13–May 15, 2004, Contemporary Arts Center, Cincinnati; courtesy Contemporary Arts Center, Cincinnati.

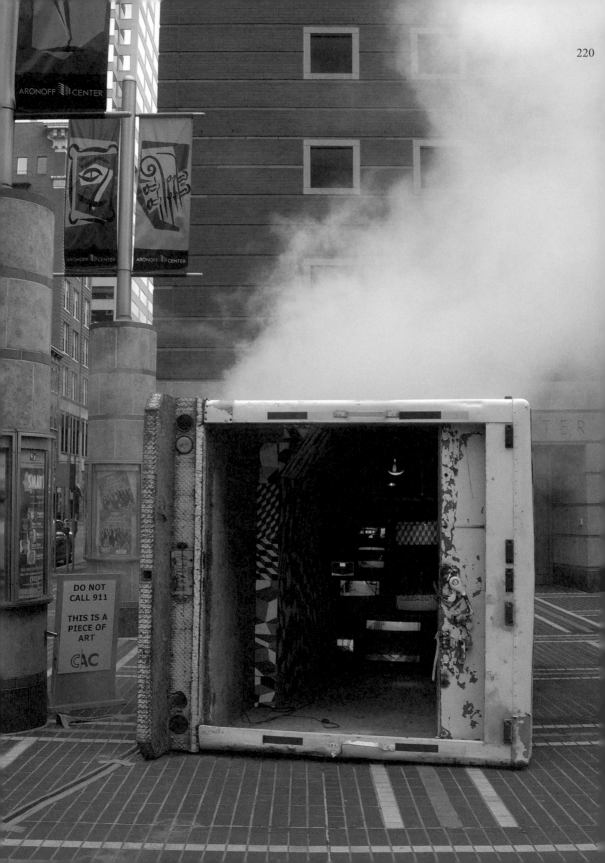

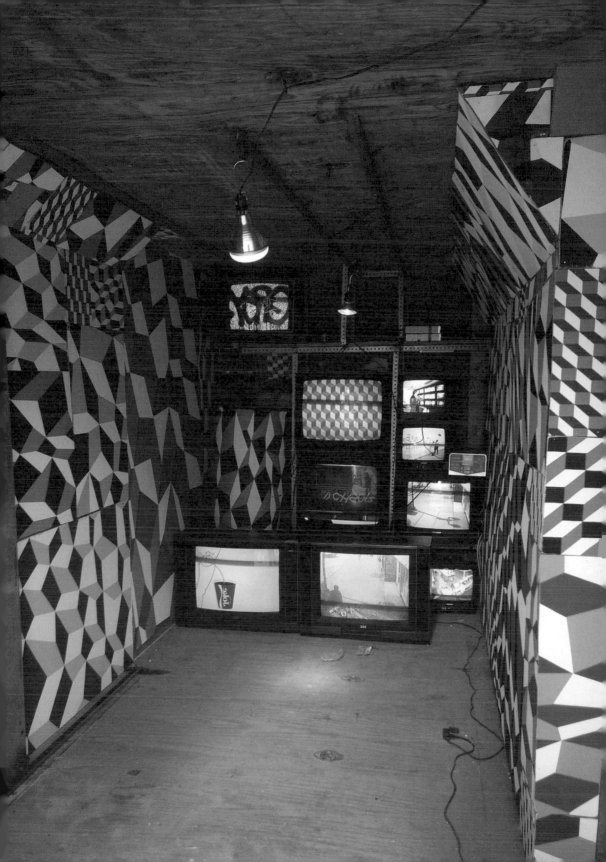

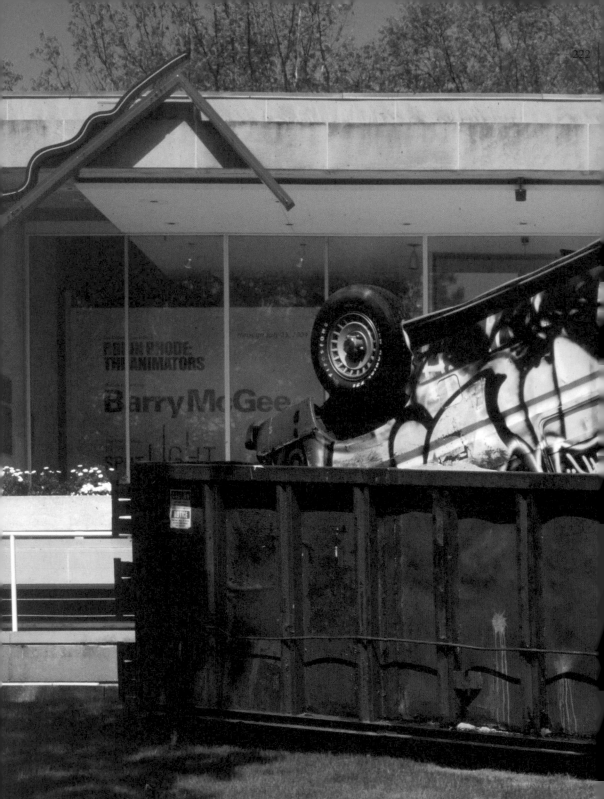

Untitled, 2004; mixed media; site-specific installation included in *Barry McGee*, April 29–July 25, 2004, Rose Art Museum, Brandeis University, Waltham, MA; courtesy Rose Art Museum, Brandeis University, Waltham, MA. Photo: Charles Meyer Photography.

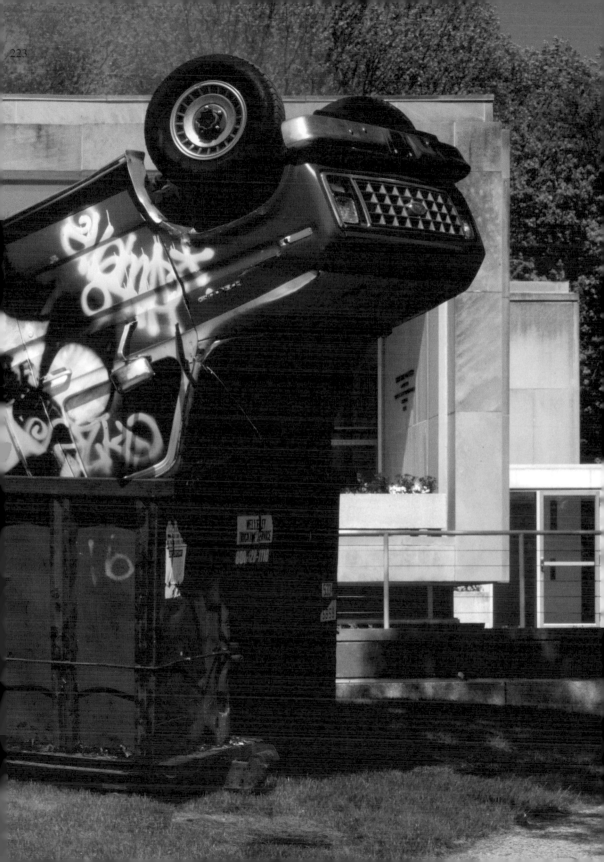

In Australia for his Kaldor project in 2004, Barry McGee chose the site of the old Metropolitan Meat Market in North Melbourne for The stars were aligned...

He transformed the space into an apocalyptic circus where a mix of autobiography, political comment, urban overload and total anarchy battle for supremacy. His over-the-top audiovisual installation was the kind of thing your average viewer might cross the street to avoid: 11 oddly angled defunct trucks and vans piled on top of each other with their doors flung open, headlights flashing and wheels still turning; banks of monitors screening op-art harlequin shapes and surveillance camera footage of street gangs like dim transmissions from some deep-ocean diving bell. The walls lined with painted boards and ad-hoc accumulations of totemic objects. Writhing mechanized mannequins poised to graffiti mirrors and booze bottles painted with McGee's abject outcasts completed this image of the underside of contemporary consumer culture. At the National Gallery of Victoria across town, McGee painted a mural over the glass waterwall at the front of the building, which served as a kind of alternative billboard for the event.

From the press release for *The stars were aligned…*, John Kaldor Projects at Meat Market Gallery, 2004

pp. 225–29: *The stars were aligned…*, October 28–December 5, 2004 (installation views); John Kaldor Projects at Metropolitan Meat Market, Melbourne; courtesy Kaldor Public Art Projects. Photo: Gerry Sommerfeld, National Gallery of Victoria.

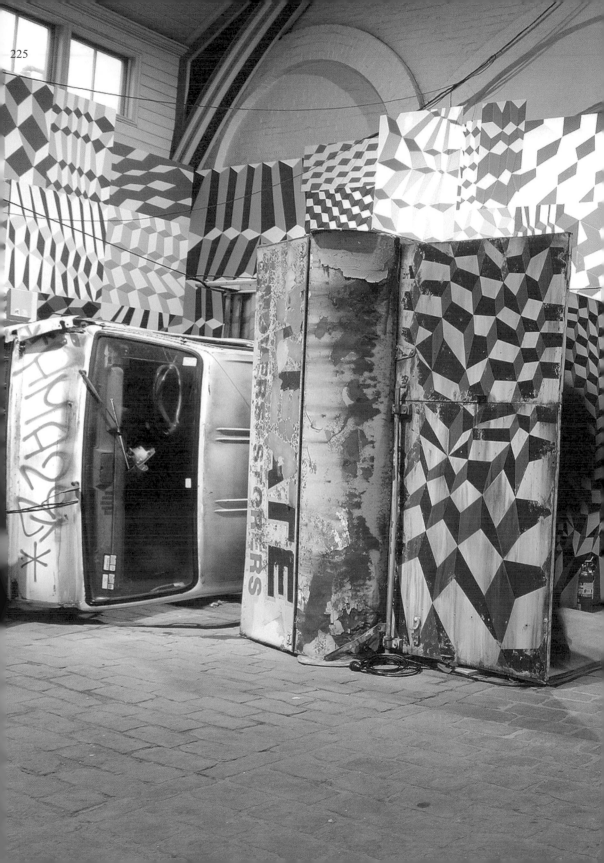

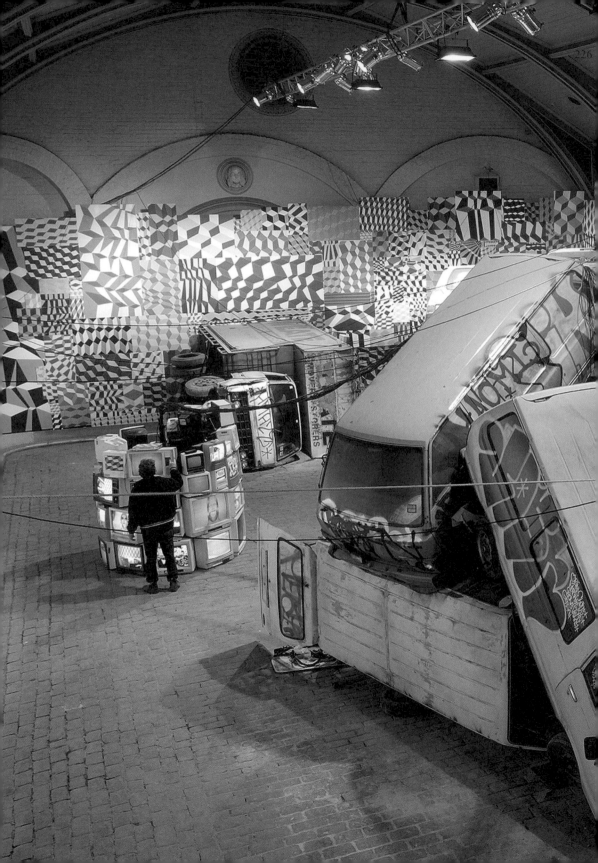

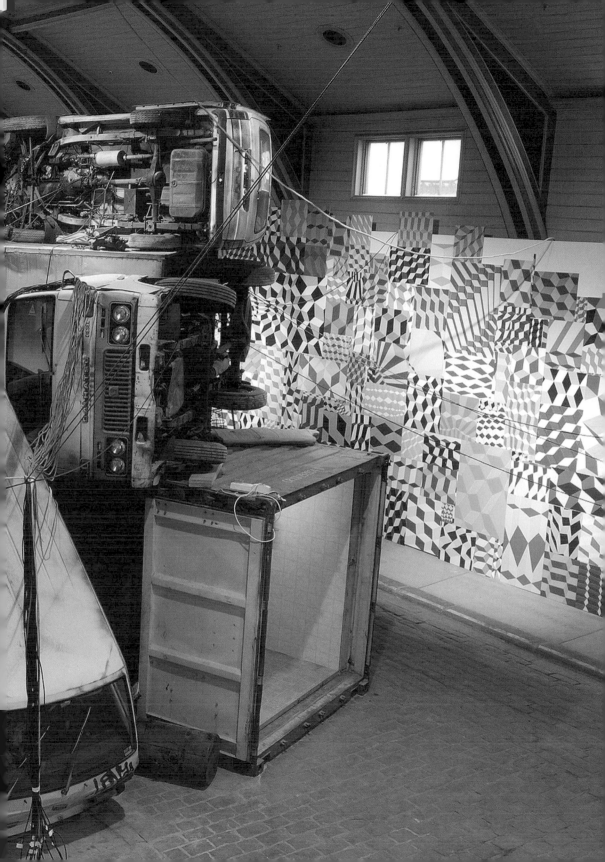

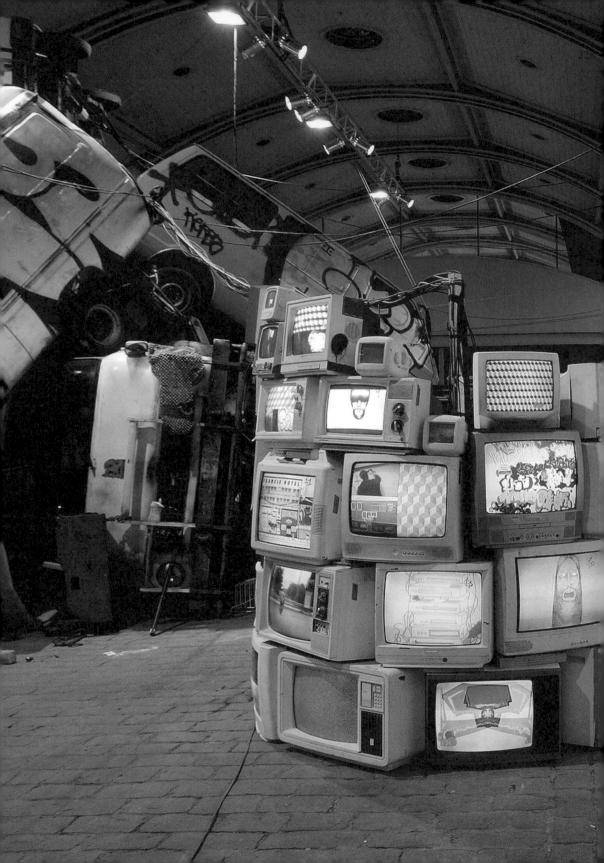

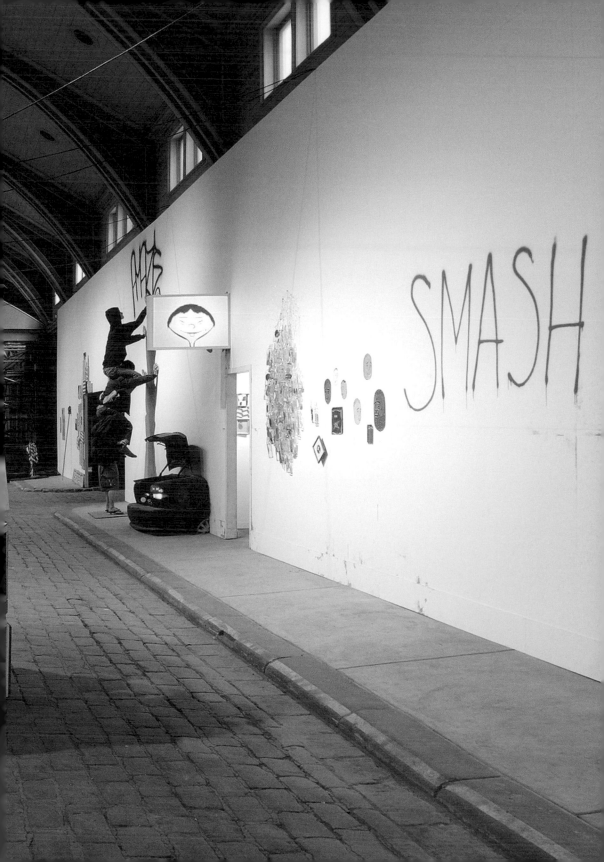

pp. 230–33: *Things are really getting better*, January 22–March 28, 2005 (installation views); Museum Het Domein, Sittard, The Netherlands; courtesy Barry McGee and Stijn Huijts.

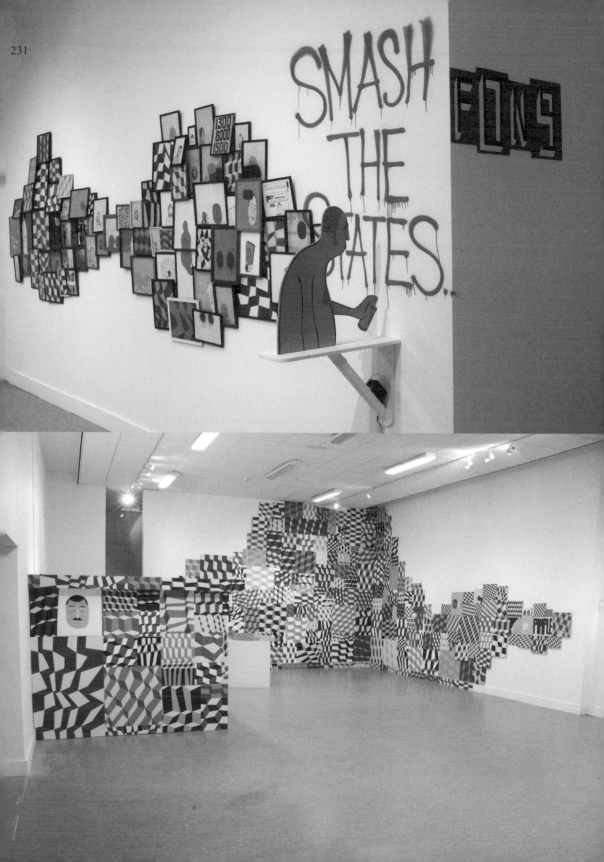

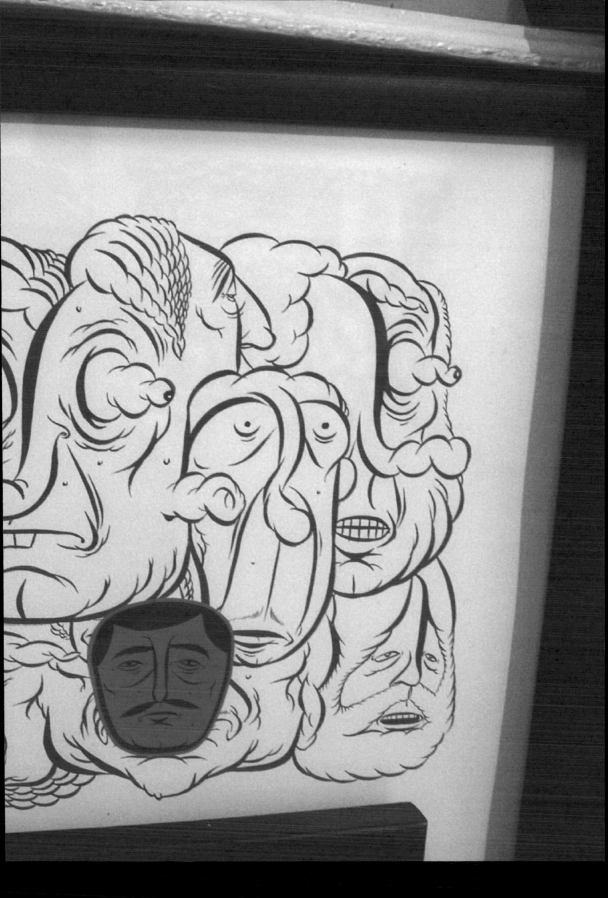

Jeffrey Deitch

It started with a story about an exhibition opening. Annie Philbin, then the director of The Drawing Center around the corner from my SoHo gallery, Deitch Projects, told me of her astonishment when she opened the door for their January 1996 *Wall Drawings* exhibition opening. Expecting to see the small group of downtown artists and writers who usually attended their openings, she was amazed to see a crowd of several hundred scruffy young men milling in the street, many of them holding skateboards. She learned that some of them had traveled by bus for hours to see the work of one of their heroes, Barry McGee.

I had been fascinated by Barry's wall in the exhibition and was even more intrigued after hearing about how this unexpected audience was so inspired by his work. Barry's wall fused elements of Mexican murals from the 1930s, traditional American sign painting, Wild Style graffiti, and Old Master drawing. Like the songs of Bob Dylan, it drew on "old weird America" while creating a vision that was completely new. As I asked friends about Barry, I found that although he was showing in the mainstream New York art world for the first time, he already had an enormous underground following. Known by his tag name, Twist, he was admired by his fellow surfers, skaters, and graffiti artists for creating the most innovative art that had been seen on the street in years.

The Wild Style graffiti that emerged in New York in the 1970s became one of the most influential international art movements since Pop Art, with variants of the style appearing on walls, trucks, and freight cars all over the world. The style was so ubiquitous, however, that its popularity seemed to stifle innovation. Into the mid-1990s, most of the graffiti in New York looked pretty much the same

as it did in 1980. The most surprising innovations in graffiti began to come from outside New York where the possibilities were more open. The strongest new vision was coming from Barry McGee in San Francisco. The mixture of counterculture and subculture in San Francisco's Mission District, where Barry was living, fueled a fresh approach to art. His work incorporated Beat poetry, hobo mythology, punk rock, Mexican American handicrafts, and other elements of San Francisco street culture. Barry was able to bring a poignant, humanistic quality to art on the street. His work galvanized a community that had become accustomed to graffiti that emphasized form over content.

I asked The Drawing Center staff if I could get an introduction to Barry McGee and was told that I should not even bother. Apparently, numerous galleries were writing to him with invitations to show, but Barry would never respond. I was told that he wanted nothing to do with the commercial side of the art world. I sent a letter to an address that I was given but, as predicted, there was no response. This disdain for conventional art-world careerism made me even more intrigued. As I learned more about Barry's work and his influence, I became determined to meet him. I had been involved with the work of Lee Quinones, Futura 2000, Dondi, and other artists who had defined the golden age of New York graffiti and had waited fifteen years to find a street artist with a new vision. I was not going to give up on trying to connect with Barry.

I had begun working with Shahzia Sikander, a Pakistani artist whose work also had its first New York presentation at The Drawing Center. Shahzia had been invited to participate in a wall painting exhibition at the Forum for Contemporary Art in St. Louis, a show that would also include the work

of Barry McGee. Shahzia would be traveling to St. Louis to install her work and told me that Barry would be painting his wall at the same time; she was happy to speak to Barry and ask him if I might be welcome to come and talk with him. Shahzia called shortly after her arrival at the Forum to tell me that she had spoken to Barry and that he would be pleased to meet me if I came to St. Louis. I got on a plane the next day.

Barry was up on the scaffold when I arrived in the gallery. Shahzia introduced us and Barry climbed down and shyly said hello. We moved to a nearby cafe where the conversation started awkwardly but became more engaged as I talked about my projects with some of his graffiti heroes. Barry had timed his visit to St. Louis to coincide with a graffiti jamboree. Fifty graffiti artists from around the country had converged in the city to paint an enormous wall. It seemed that half of them were crashing in the small apartment that the Forum had provided for Barry during the installation. Along with several of the visiting artists, Barry and I took a fascinating graffiti tour of St. Louis. The tags and images that would seem random to most observers turned into a compelling personal narrative through Barry's interpretation. By the end of my visit, Barry had agreed to an exhibition at Deitch Projects.

The Buddy System, our first project with Barry, was scheduled for March and April 1999. We closed the gallery for two weeks so that Barry could move in to install the show. The first day of the installation Barry arrived in the late morning and began laying out some of the components of his installation: boxes of drawings and photographs in old frames, spray cans with the paint buffed off, and stacks of metal type trays from a print shop that had gone out of business. We had covered the largest wall with thin wooden door skin as a painting surface for Barry. He started by painting a ground coat of blood red. Each day Barry arrived later in the afternoon. By the end of the first week, he did not arrive until after the gallery staff had already gone home, preferring to work through the night. Each morning we would wade through the piles of debris in the gallery space and look with amazement at what Barry had created. Barry liked to work out of view of the gallery staff, but that did not mean that he worked in isolation. In addition to the remarkable images that appeared each morning, the gallery would be filled with empty beer bottles, pizza boxes, and cigarette butts. Barry's circle of artist friends would converge each night to listen to music and hang out while he worked. The schedule set the pattern for all of our subsequent projects with Barry. The impromptu social club that came together every night during Barry's installation became almost as interesting as the exhibition itself.

Barry had asked if he could bring his "assistant" from San Francisco, Josh Lozcano, to help with the installation and I readily agreed. Josh, whose tag name is Amaze, arrived with Barry on the first day but I never saw Josh doing any work in the gallery space. "What is your assistant doing?" I asked Barry. "He's getting the word out," Barry responded. I did not really understand until I began seeing Twist tag stickers on every mailbox downtown. Josh was also getting the word out about his own visit to New York. The day before the opening, a gigantic fifty-foot-long Amaze throw up appeared on the side of the building next door to the gallery. Josh's giant tag remained there for ten years, welcoming visitors to our neighborhood until the building started to collapse and had to be torn down.

Amaze had in fact done an amazing job of "getting the word out." I was expecting a large crowd at the opening but I was unprepared for the people camped on the sidewalk days in advance and the thousand or more enthusiasts clamoring to get in when we opened our doors. In 1999, very few of the people who followed Barry's work used the Internet. They learned about Barry's projects through a low-tech, but very effective, communications system of tags on the street and zines and flyers that were circulated from person to person. Josh had made sure that everyone who followed the art on the street knew that Twist was in town.

We ordered cases of Thunderbird and Night Train, the cheap, rotgut wine that the winos in Barry's drawings drank, discarding the bottles on the street for Barry to recycle into artworks. We assumed that our opening crowd would drink though the entire stock, but the wine was so bad that we had a half-dozen cases left over. We hired a mariachi band to bring the sound of the San Francisco Mission District to New York. I am not sure if Barry even entered the gallery space. He

spent the evening on the stairs in front of the gallery next door, surrounded by fans asking him to contribute a tag or a drawing to their black books. He was still there at the end of the opening when we closed the gallery. He must have tagged more than a hundred books.

The enthusiasm of Barry's following was remarkable, but it was the exhibition itself that was truly extraordinary. Barry had gone beyond an installation of works and had created his own artistic world. In addition to embracing the history of graffiti, the work embodied Barry's engagement with Pop Art, Minimalism, Social Realism, and other chapters of modern art history. In the main gallery space, Barry's vibrant mural featuring a poignant everyman figure was installed opposite a grid of metal type trays. On top of the metal panels, Barry had painted an exhausted dog-person who appeared to stagger onto the floor. On the back wall was an accumulation of empty Night Train bottles with sad faces delicately painted onto them, each one imbued with a completely different personality.

Barry had installed a grid of spray cans buffed down to the metal in the entrance to the gallery. It referenced Andy Warhol's rows of Coca-Cola bottles as well as the tough metal grids of Carl Andre. In the storefront was one of his signature accumulations of drawings, photographs, and old-fashioned found imagery from fruit cartons and other commercial sources. These organic, free-form grids of framed images, growing out from the center, have come to define Barry's aesthetic vision. These works present a structure of visual thinking, a grammar of juxtaposed images that map Barry's artistic syntax. There is an intriguing visual rapport among the images that Barry retrieves from dumpsters, the photographs of taggers and bums lying in the street, and the meticulous drawings, usually of old men's faces, that Barry spends weeks creating. The disparate images form a surprisingly coherent narrative that fuses Barry's formal language with his profound humanity.

We returned to the gallery the day after the opening to find the storefront next door completely bombed, painted over with fifty or more tags. This is where Barry had stayed on the steps for hours tagging black books while the rest of us were at the celebratory dinner. It appeared that his fans had stayed even longer. When we opened the office we found a hysterically angry fax from our neighbors. We quickly dispatched a crew to clean the glass and repaint the facade.

The response to Barry's exhibition was overwhelming. Teenagers arrived by bus from Canada and the Midwest. Many of our visitors, including a new group of young collectors, arrived by skateboard. I realized for the first time that an entirely new audience was developing, one whose interest in art began with their participation in progressive popular culture. It was skateboarding, surfing, street fashion, and independent bands that drew this new group of people to art. They followed the full range of progressive culture, ignoring the traditional boundaries between art, music, film, and fashion. Barry's work inspired this audience by speaking to their own life experiences.

Some detractors felt that a gallery exhibition would dilute the authenticity and "street cred" of Barry's work, maintaining that street art should remain on the street. I would argue that Barry's exhibition actually had the opposite effect, opening up a platform in the mainstream art world for the progressive vision and social engagement of his community. Starting with *The Buddy System*, Deitch Projects became a kind of clubhouse for international street artists and the people who were inspired by their work. Every day for the next ten years, visitors from around the world came to see work and gather information about Barry and other artists who were drawn to the gallery by his exhibition.

One significant cultural conflict did remain between the art world and the world of the streets. This was the tradition in the graffiti community of "racking," stealing spray paint and markers. It is a matter of pride among many graffiti artists that all of the paint they use is stolen. This attitude developed partly out of necessity when stores began refusing to sell spray paint to teenagers. The week after the opening, the pilfering began. Unseen hands were pulling Barry's painted bottles, drawings, and paintings off the wall. We stationed gallery watchers in every room, but they were no match for the graffiti renegades who were skilled in the subtleties of shoplifting. After the first round of thefts, Barry painted some replacements and FedExed them from San Francisco, but as the pilfering continued, there

was no choice but to accept this as part of the game. About halfway through the exhibition we were contacted by someone who claimed to have bought one of the key works in the show from the person who had stolen it. We had been heartbroken when this work had disappeared; it was small, but exquisite, and had been installed in the center of one of the walls. The new owner did not want money for it; he just wanted to return it. We assumed that he was just a proxy for the thief, probably another artist who eventually felt guilty seeing the gaping hole in Barry's composition. We were overjoyed at this unexpected and miraculous recovery. It was emblematic of the direct and personal way that people connected with Barry's work.

Barry had been characterized as a graffiti artist, but *The Buddy System* demonstrated that graffiti was just one of the numerous influences that contributed to his singular approach to art. Unlike many artists who went from art school directly into the gallery system, Barry's work is not conceived as part of a career strategy or a critical commentary on the work of other artists. His work is lived rather than strategized, emerging out of his own life experience. Part of the foundation of Barry's work is his multicultural background, growing up in the industrial city of South San Francisco with a Chinese American mother and an Irish American father. The repetitive structures of his bottle accumulations and his groups of panels probably have some connection to the factories he passed every day as a child. The overturned cars and trucks and the piles of discarded electronic parts in Barry's exhibitions could have come right out of his father's auto body shop. His orderly grids of geometric patterns could have come from his sister's co-op bakery. Barry's numerous artistic aliases, like Ray Fong, Lydia Fong, and B. Vernon, reflect his multicultural identity.

Barry is famously modest and is not socially outgoing in a conventional way, but he has one of the tightest and most extensive network of friends and collaborators of any artist I know. A project with Barry leads to an immersion in his extended community, including family members and friends from all over the world. Through projects with Barry, I connected with a vibrant community of artists with whom I developed additional projects: Chris Johanson from San Francisco, Os Gemeos from Brazil, Stephen Powers from Philadelphia, Jim Drain and Ara Peterson from Providence.

Probably the best known and most loved of all our gallery projects, *Street Market*, presented in the fall of 2000, came out of Barry's network of artist friends. I had traveled to the Institute of Contemporary Art in Philadelphia earlier that year for the opening of *Indelible Market*, curated by Alex Baker. It was a fascinating re-creation of a bodega as a joint artistic project by Barry, Todd James, and Stephen Powers. Inspired, I asked the artists if they would be interested in working on a larger version for Deitch Projects, re-creating an entire urban street. It would be an enormous task, but they were all up for it. The result was beyond what I ever could have imagined. The artists created not only their own version of a Bronx or Brooklyn street, with the typical variety of storefronts, but their own versions of all the products that one would find inside them. There was a riot of signs above, an auto parts yard to the side, and overturned trucks bombed with graffiti on the street below. It was a fascinating fusion of the visions of three artists with the visual language of the New York street. Barry's contributions, which included an astonishing wall mural with faces, tags, and fluid abstract shapes, were visible and semivisible throughout the installation. The exhibition opened with the hip-hop artist Thirstin Howl III performing on top of one of the overturned trucks with his crew. Steve Powers proudly told me that some of the toughest thugs in the city, as well as Robert De Niro, were in attendance.

Street Market was an exhilarating mashup of art and gritty urban reality. The bodega, Yukan Liquors, Benson's Car Service Limo Stand, Check Cash King, the Auto Thug rim shop, and the other businesses were uncannily convincing and at the same time disconcerting. Visitors would hang out in front of the shops as if they were on a real street, rather than on a stage set or at an art exhibition. The project could be described as a participatory assemblage, an experiential collage, a visual analog of a tough DJ mix of urban sounds.

The great curator Harald Szeeman, who at the time was organizing the 2001 Venice Biennale, came to see *Street Market* and was fascinated. He said that he would love to bring it to Venice but did

not think that there would be enough money in the budget for a project this ambitious. I told him not to worry—we would make it happen. Our whole crew moved to Venice for a month to create an Italian version of the project in a cavernous space at the end of the Arsenale. The artists activated the work by inviting some of the ubiquitous Senegalese peddlers of counterfeit Prada bags to bring their wares into the exhibition. Ironically, Miuccia Prada was so taken with the project that she invited Barry to create a major exhibition at her foundation in Milan.

Barry's work is characterized by both painstaking detail and outsized ambition. His projects can be as big as life itself but he needs to spend weeks on the delicate drawings that might be only a small, but essential, component of the overall installation. For Barry's next show at Deitch Projects, rather than creating an entirely new body of work, I proposed that he build on the previous two years of museum exhibitions and public projects. He had reworked and expanded his exhibition at Brandeis's Rose Art Museum for a John Kaldor Project in Melbourne, Australia; Barry would reassemble and amplify the ambitious Melbourne project for New York.

In Barry's exhibitions, there is always "one more thing" that he tries to do. He stays up all night prior to the opening completing a meticulous portrait with his fine brush or carefully arranging the debris spilling out of an overturned van. *One More Thing*, which opened in May 2005, was the perfect title for this exhibition, which included the full range of Barry's work. He replaced the gallery's glass facade with a gray plasterboard wall that framed the back of an overturned truck. The entrance was marked by a small red and yellow illuminated sign depicting Barry's surrogate, Ray Fong, as a child. Visitors entered through the back of the truck into Barry's artistic world. The first wall was an accumulation of heads with anxious expressions, painted in misregistered red and green Day-Glo as in a printing mistake. A mountain of stacked and overturned cars and trucks was surrounded by Barry's new formal signature, hundreds of illusionistically painted geometric panels. A tower of old television sets playing Barry's animations dominated the platform. Enormous clusters of painted panels, drawings, photographs, and found objects were installed on the mezzanine. Behind the overturned trucks was a fearsome portrait of Dick Cheney with "Smash the State" spray-painted across it in blood red. Underneath the stack of cars and trucks, upended as if in the aftermath of a bombing, was a shipping container containing an animatronic version of Josh Lozcano spraying his Amaze tag in a men's lavatory. Five animatronic taggers stood on one another's shoulders atop an overturned car to tag a section of wall twenty-five feet above the floor.

The tenor of the exhibition was tough but also embodied the sense of childlike wonder that characterizes much of Barry's work. It combined bombastic sculptural images with sensitive painting and drawing. It featured emblematic imagery as well as experiential installations that had to be explored. One of the most engaging elements of the show was a ladder that descended through a hole in the floor into a basement room where the walls were covered with Barry's father's obsessive drawings on napkins from his local Starbucks. On the floor were dozens of old DVD players painted with Barry's signature geometric patterns, connected through a forest of wires to the TV sets upstairs.

Barry's exhibitions are never really over, as elements of each show fold into the next. New concepts and imagery extend from previous innovations. Barry is now developing work that fuses his geometric and figurative styles with abstracted letters and numerals. The new paintings are more emblematic, with a structure pushing into the center rather than expanding out through the space. Elements from past exhibitions reappear in new contexts. In his most recent shows, surfboards painted with smurf-like figures and geometric patterns lean against a wall, ready to be thrown into the van for an early morning drive to the beach. The work is never confined to the gallery. It continues to spill out onto the street, mixing into the experience of life. Next door to my former New York gallery, a haunting image of a twisted screw that Barry painted in 1999 resonates from a brick wall three stories above the street. The exhibition is long over, but the work remains.

239

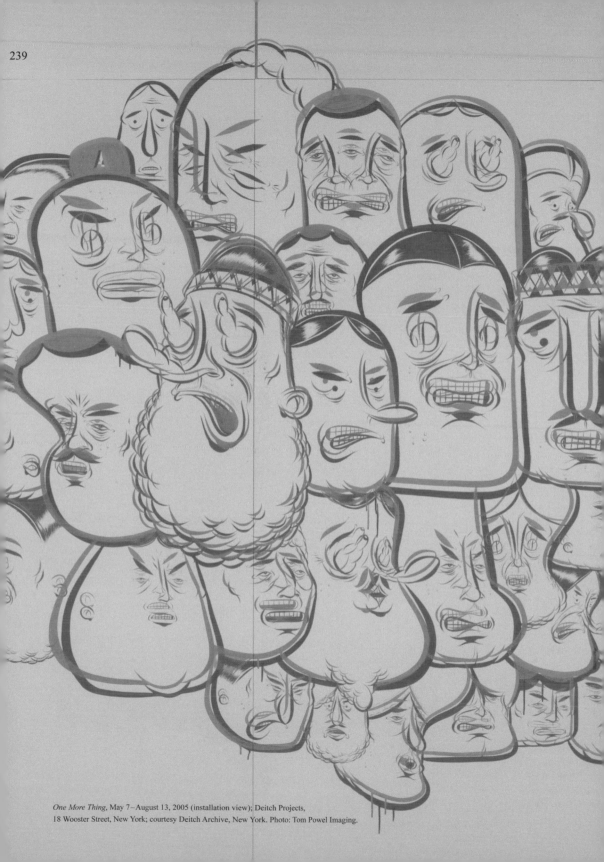

One More Thing, May 7–August 13, 2005 (installation view); Deitch Projects,
18 Wooster Street, New York; courtesy Deitch Archive, New York. Photo: Tom Powel Imaging.

The vitality and chaos of the street are always present in Barry McGee's exhibitions. The visitor is greeted by overturned trucks, overflowing dumpsters, and dozens of discarded Thunderbird and Night Train bottles. Animated drawings flickering on piles of television sets surrounded by hundreds of geometrically painted panels create a cacophonic environment. McGee brings his own world into the gallery: his community of friends (an important presence in the exhibition through photos, drawings, mannequins, and their active participation in the installation process itself), the haunting presence of hobos and outcasts, whose sagging faces appear on the walls or cover empty bottles, the cast-off material from the street where graffiti artists go out to leave their marks.

From the press release for *One More Thing*, Deitch Projects, 2005

pp. 241–61: *One More Thing*, May 7–August 13, 2005 (installation views); Deitch Projects, 18 Wooster Street, New York; courtesy Deitch Archive, New York. Photos: Tom Powel Imaging.

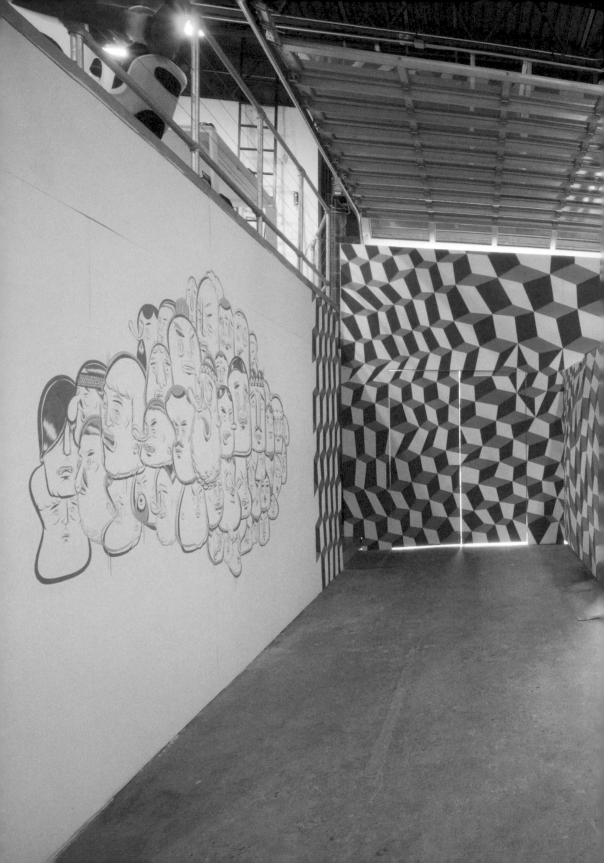

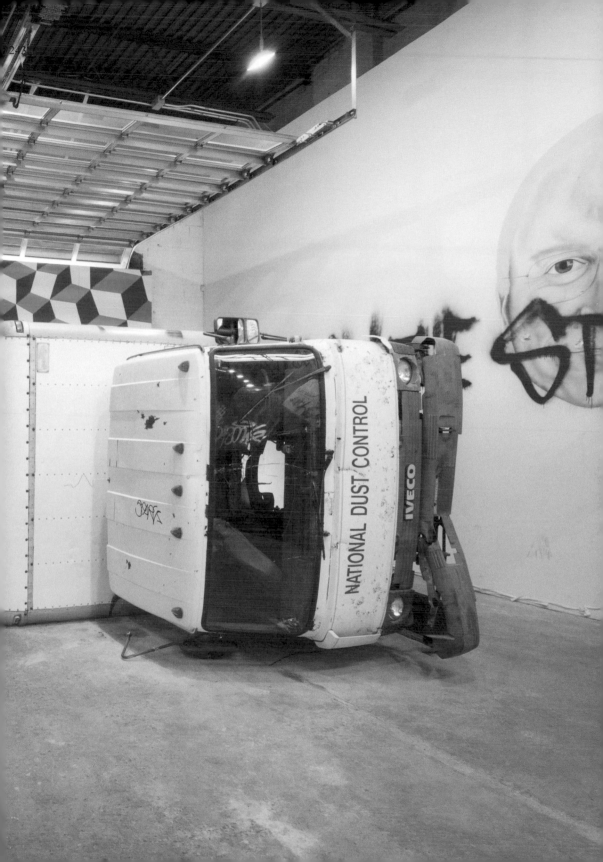

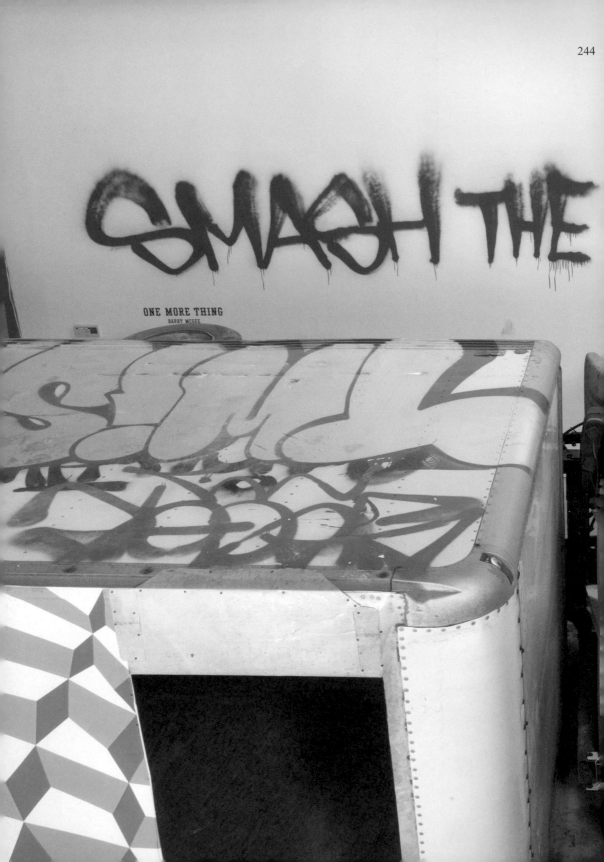

245

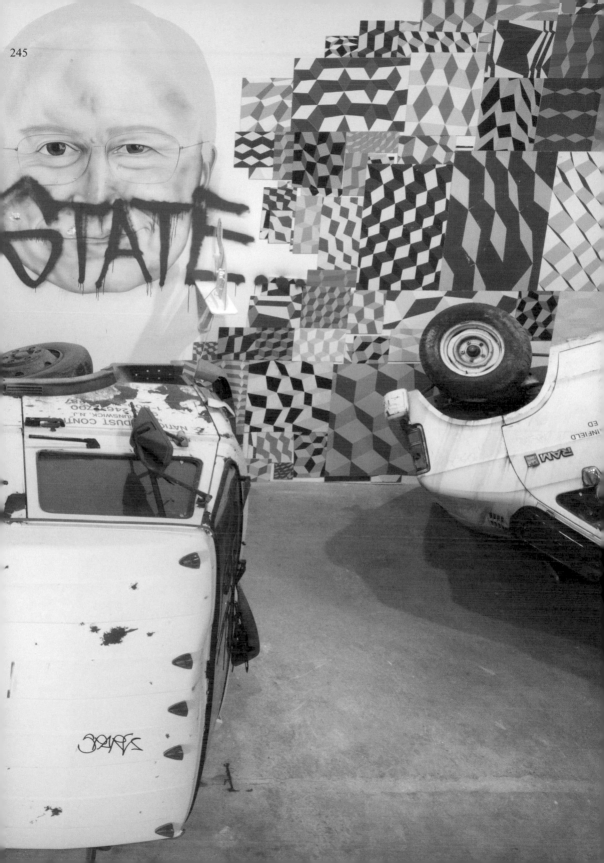

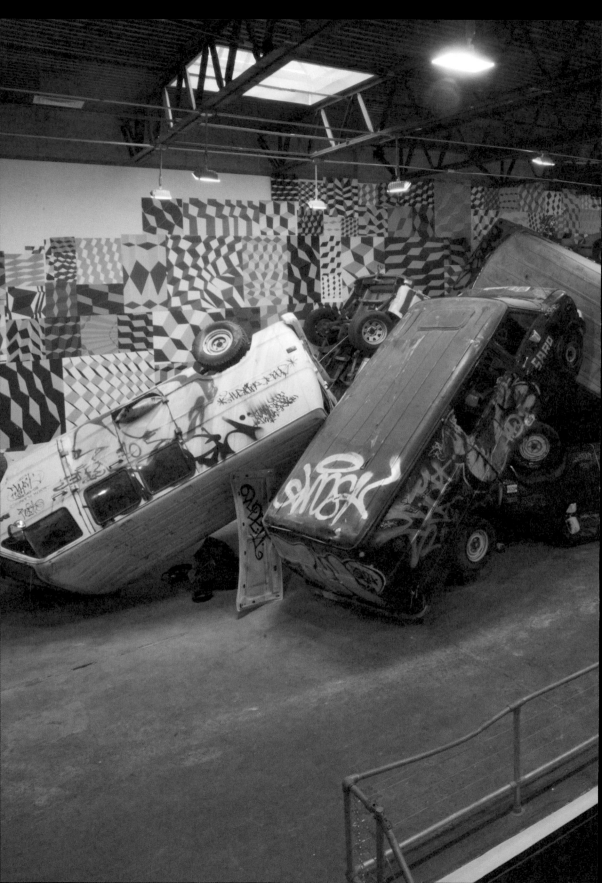

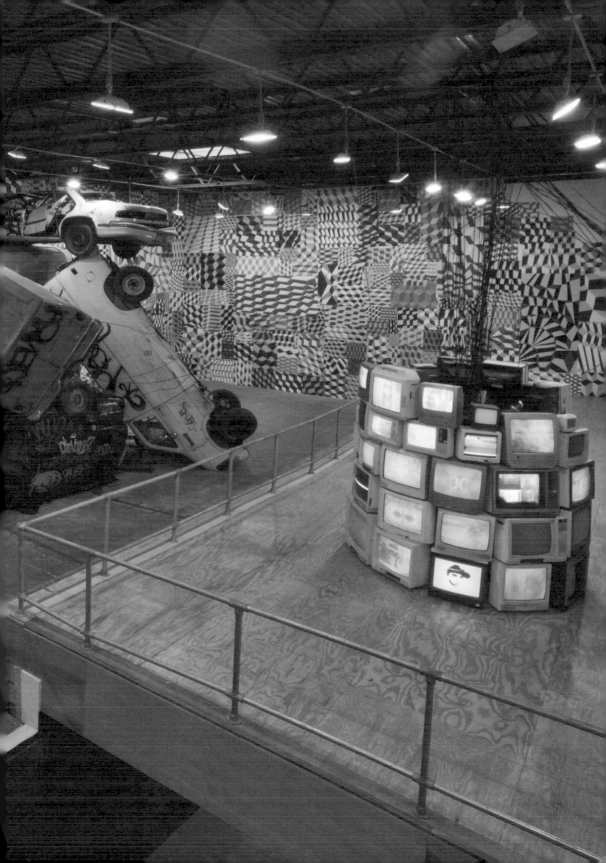

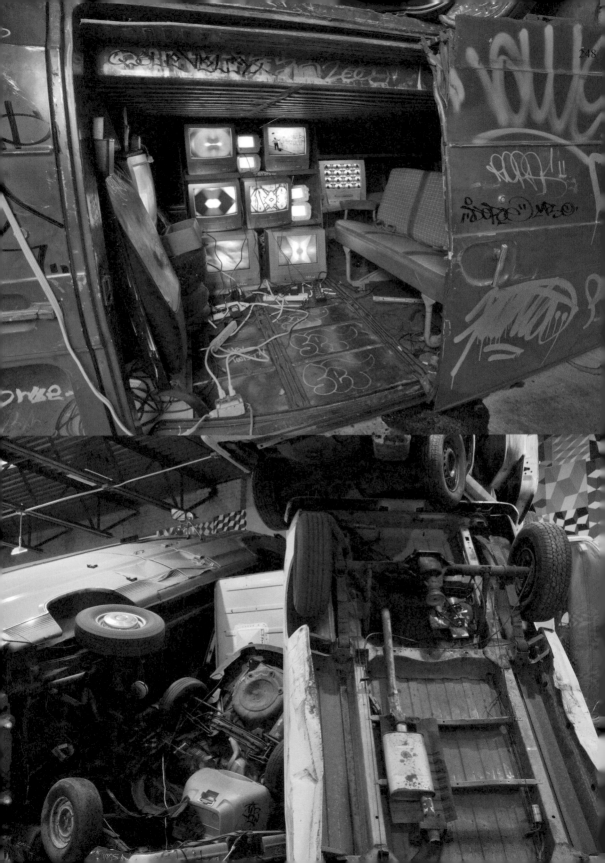

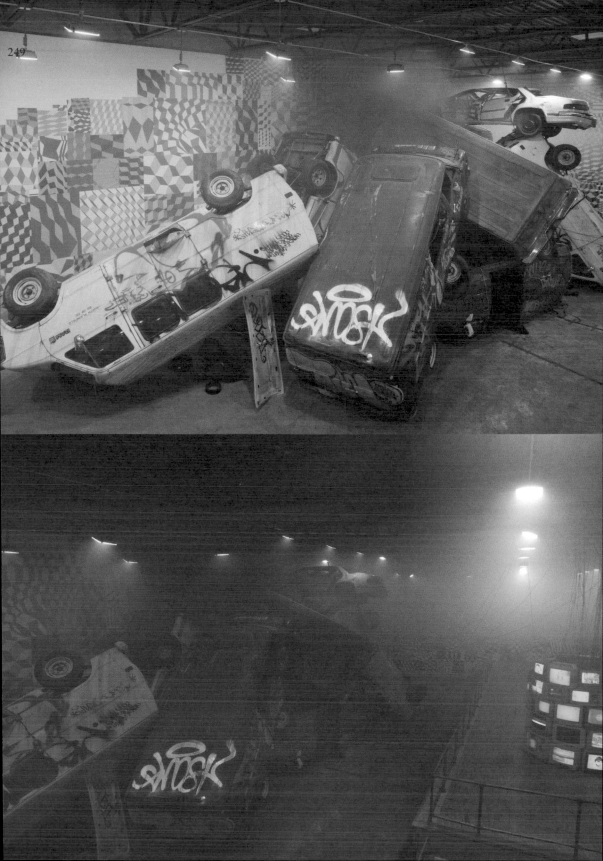

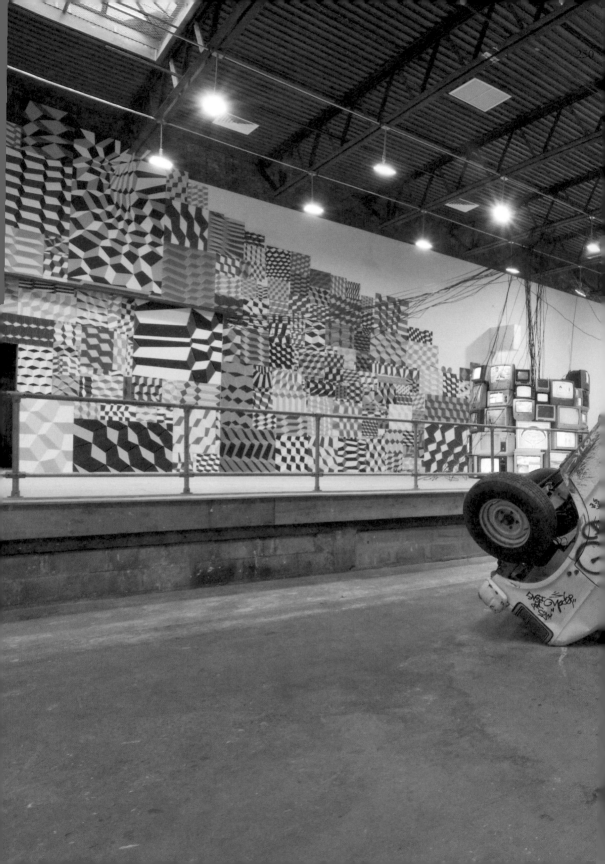

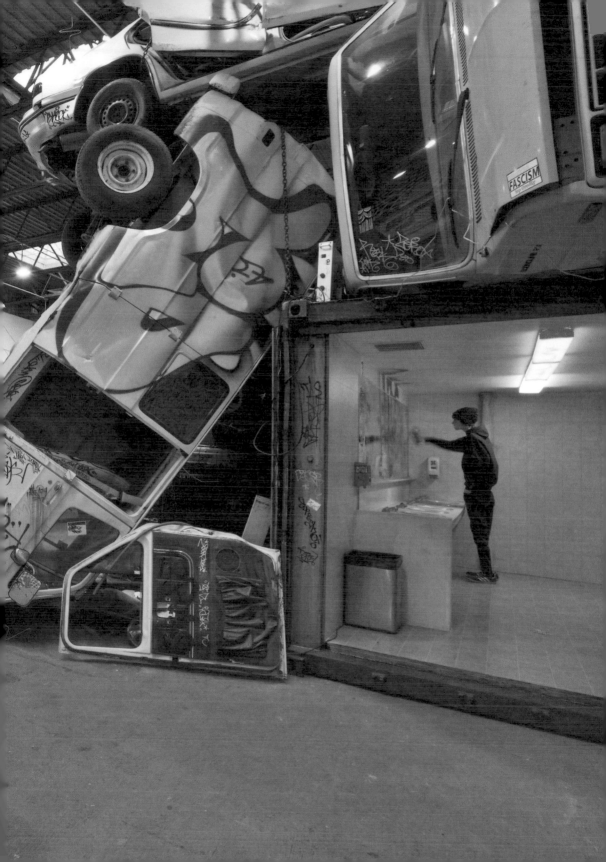

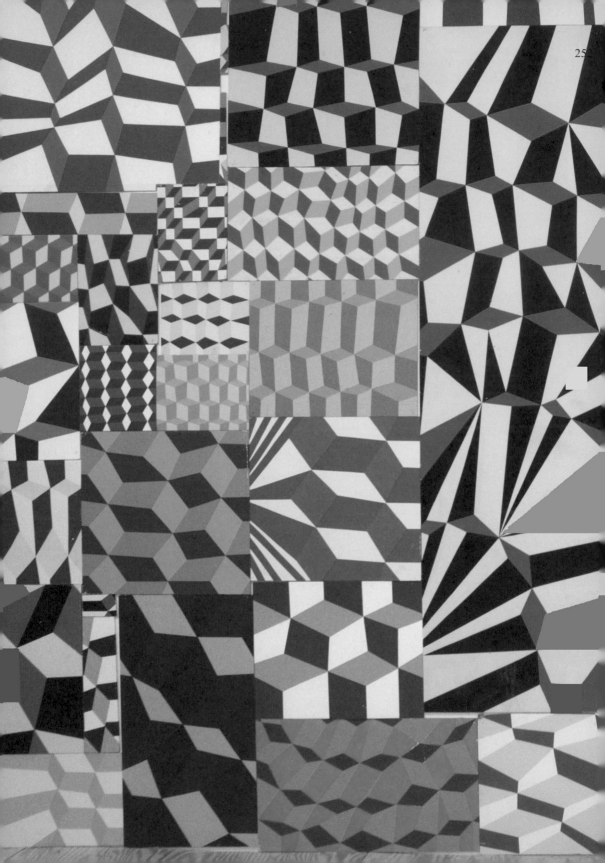

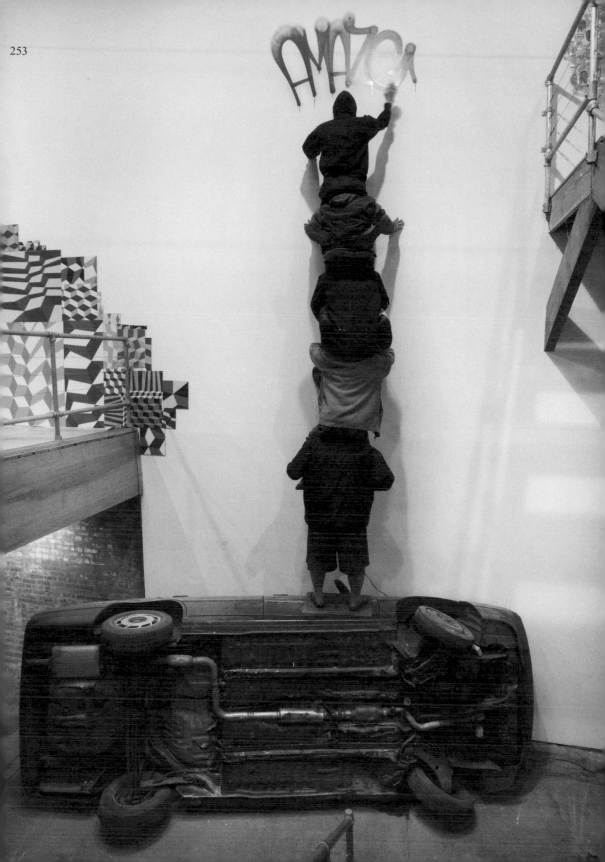

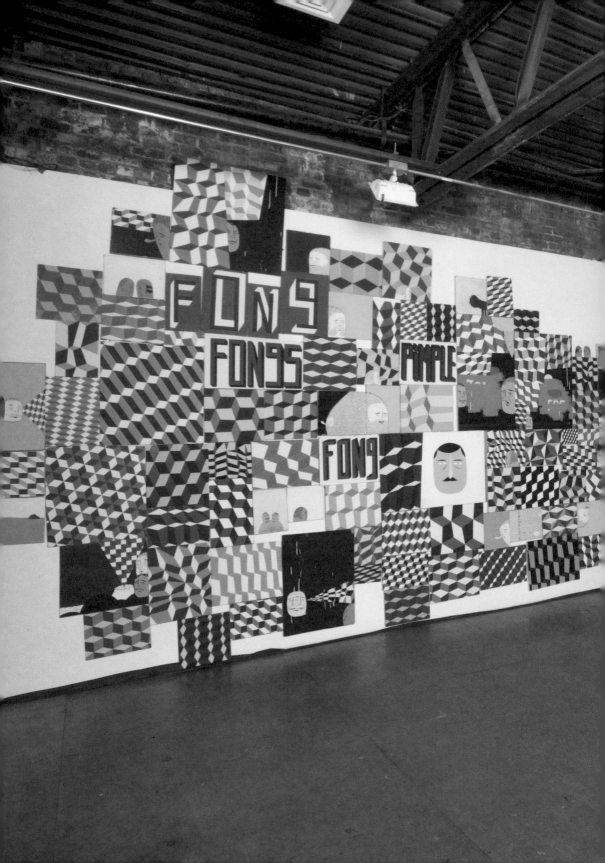

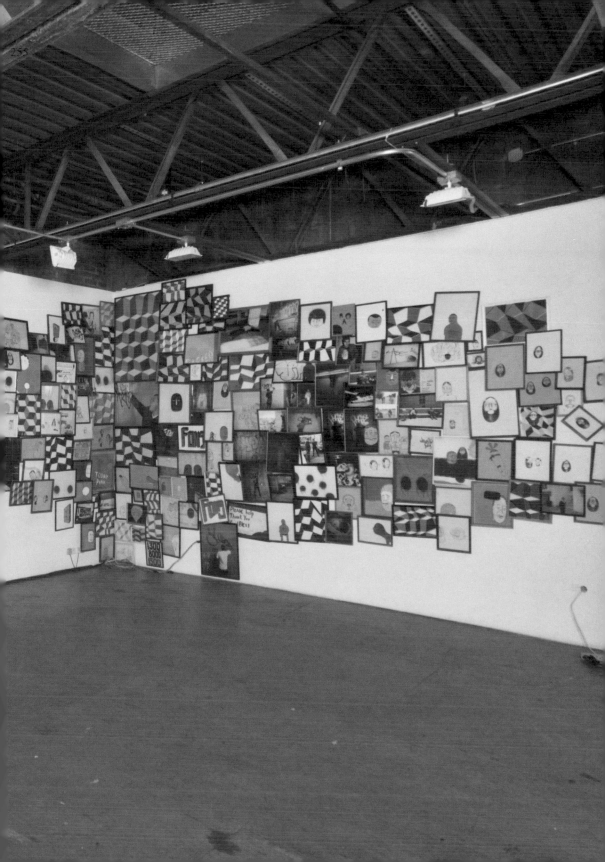

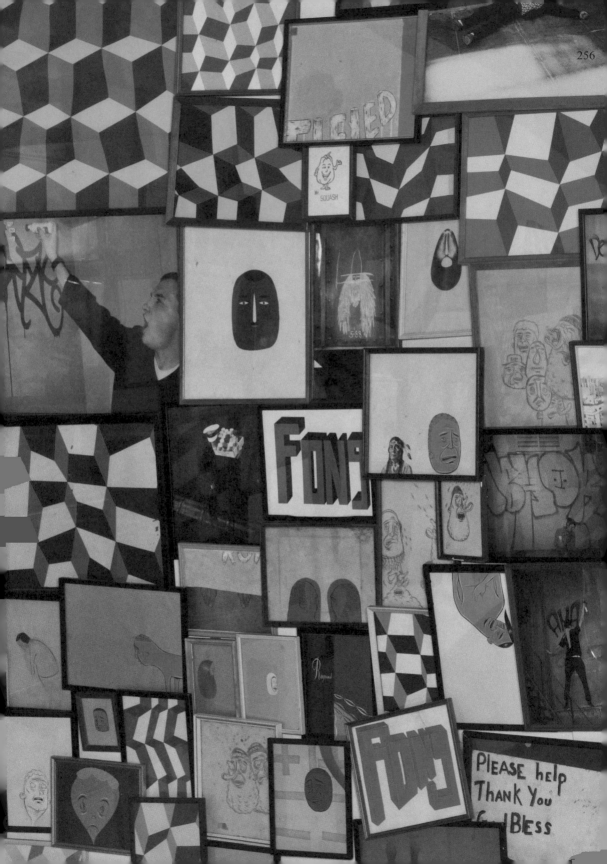

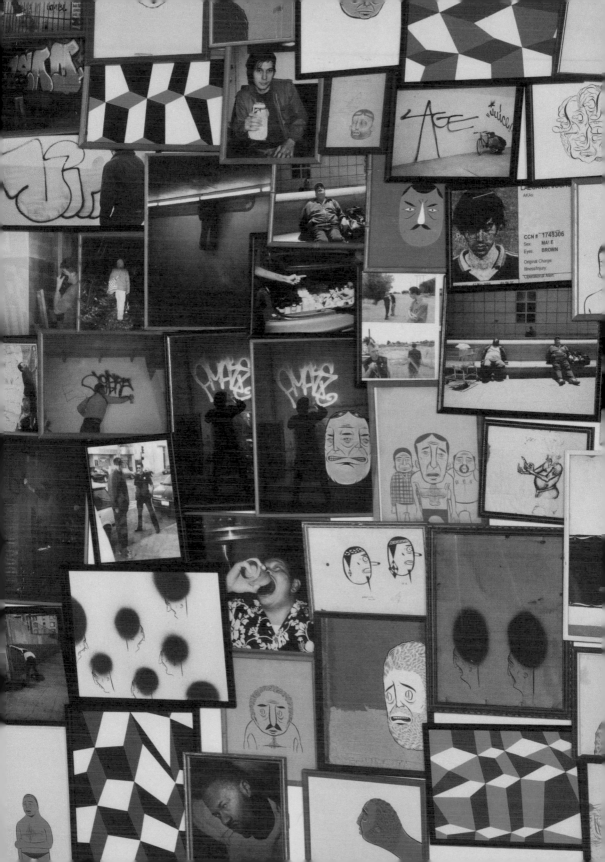

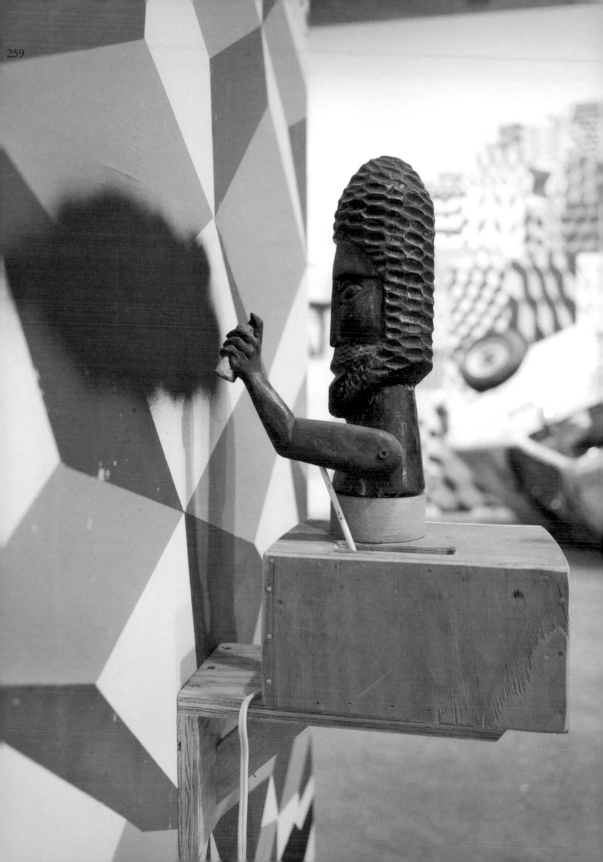

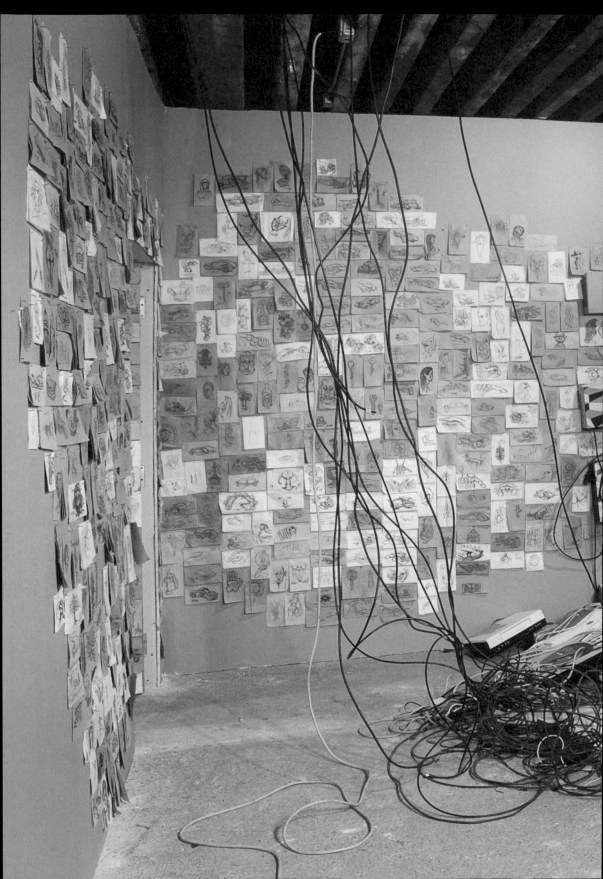

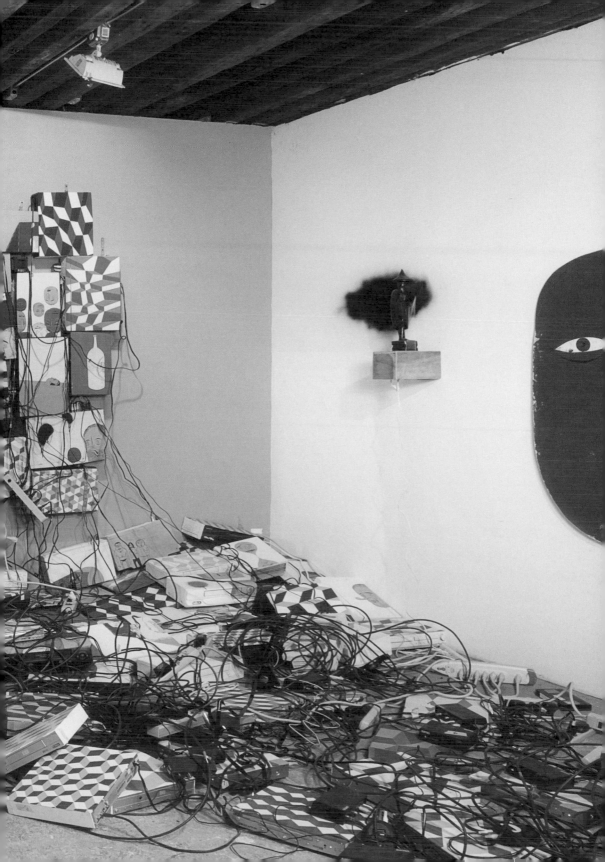

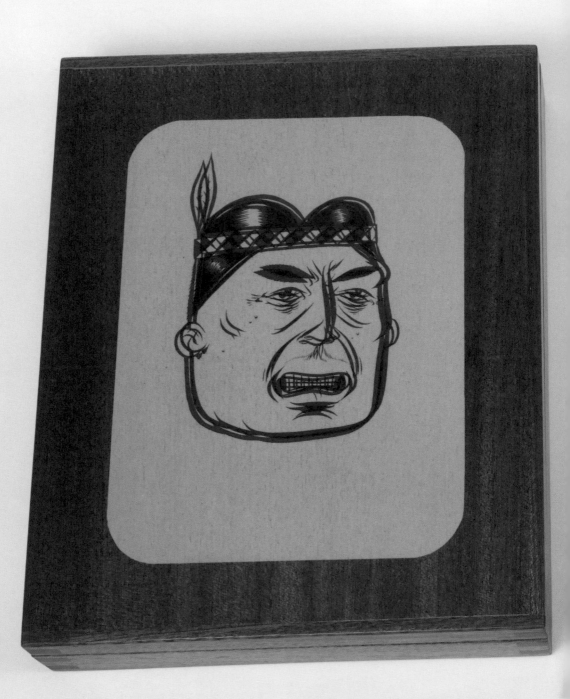

pp. 262–67: *Drypoint on Acid*, 2006; drypoint, aquatint, and acid etching; 8 x 6 1/2 in; edition of ten; collection UC Berkeley Art Museum and Pacific Film Archive: bequest of Phoebe Apperson Hearst, by exchange. Photos: Sibila Savage.

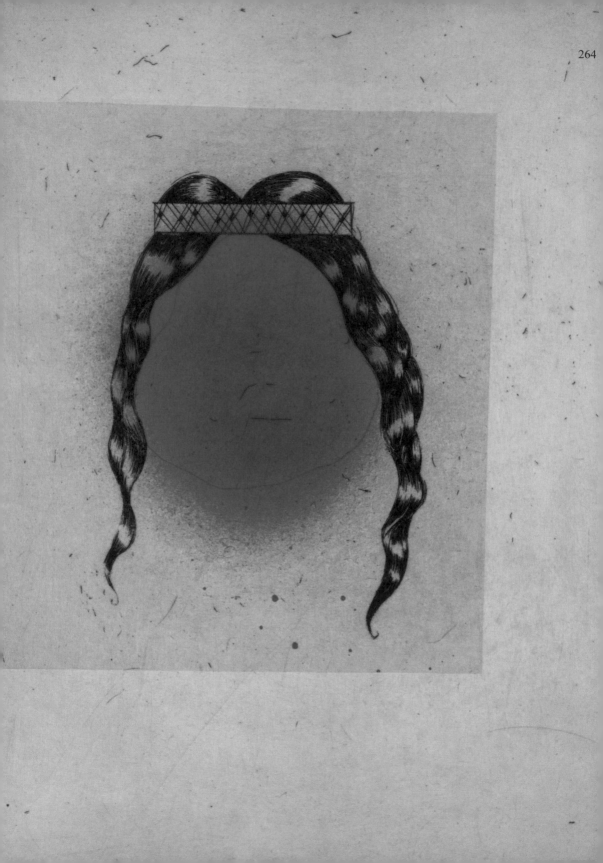

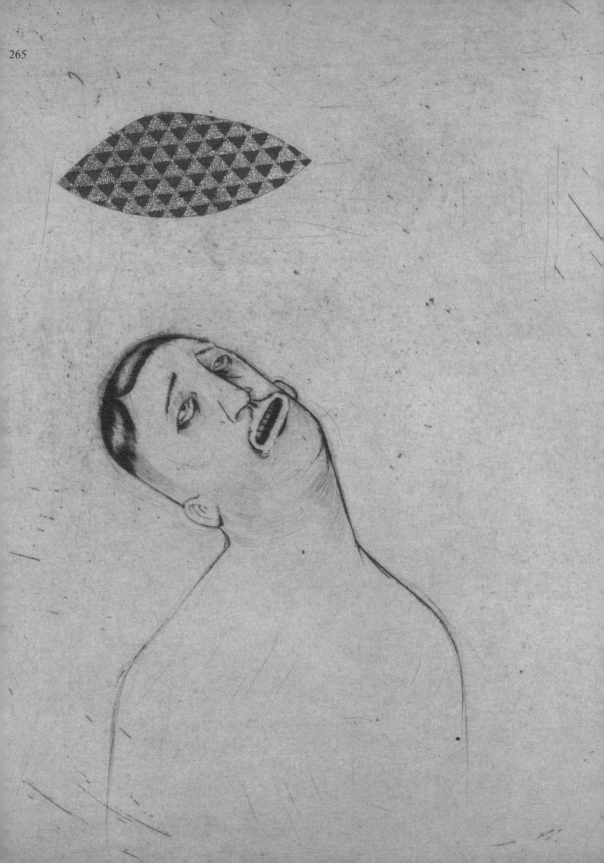

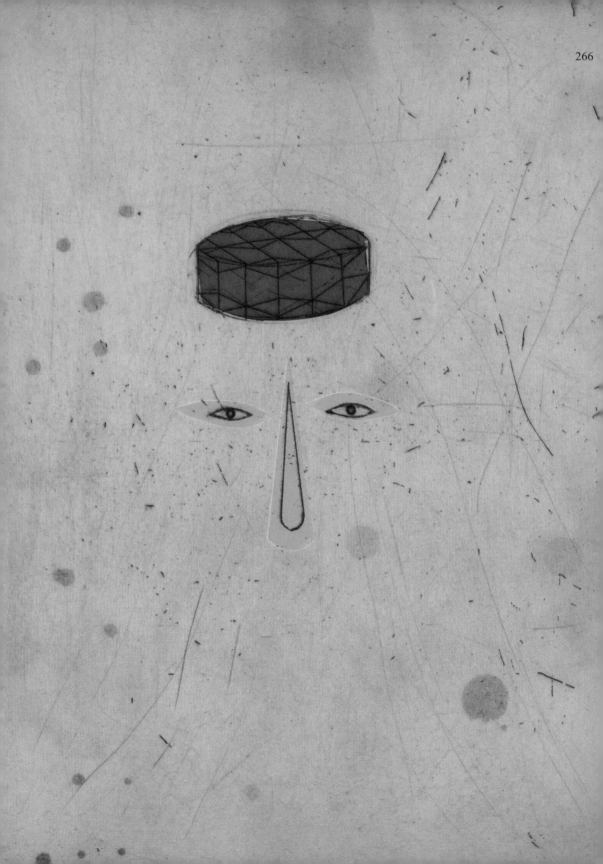

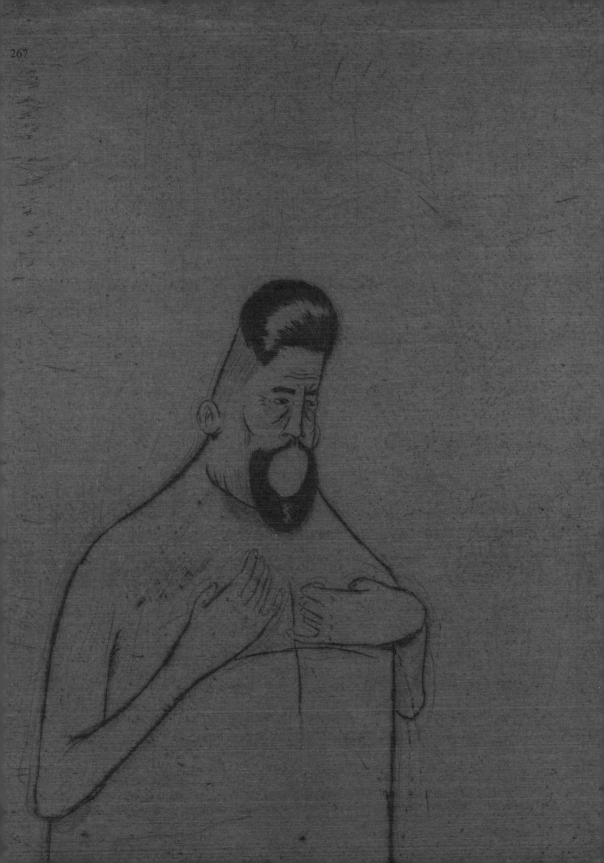

Untitled, 2006; enamel on masonry; 110 x 22 ft.; site-specific painting originally created for *Meditations in an Emergency*, October 26, 2006 – April 22, 2007, Museum of Contemporary Art, Detroit; courtesy Museum of Contemporary Art, Detroit. Photo: Mitch Cope.

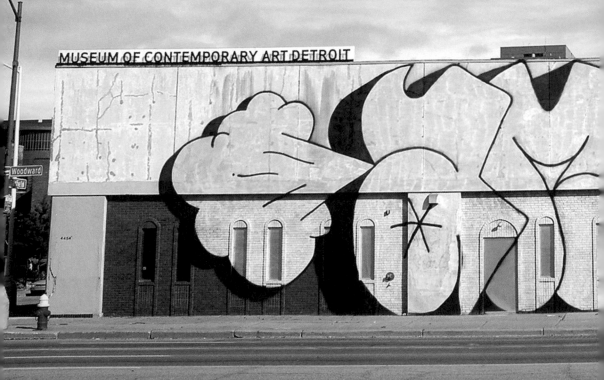

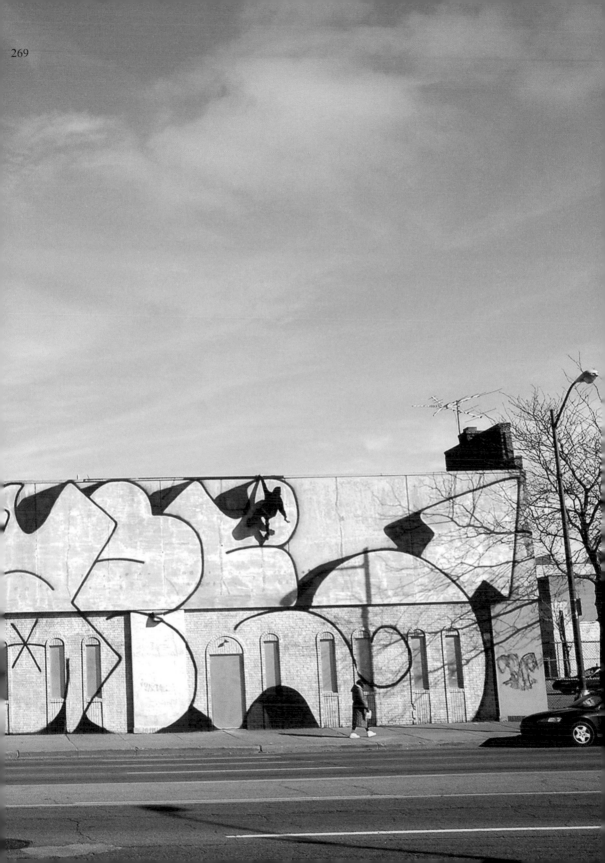

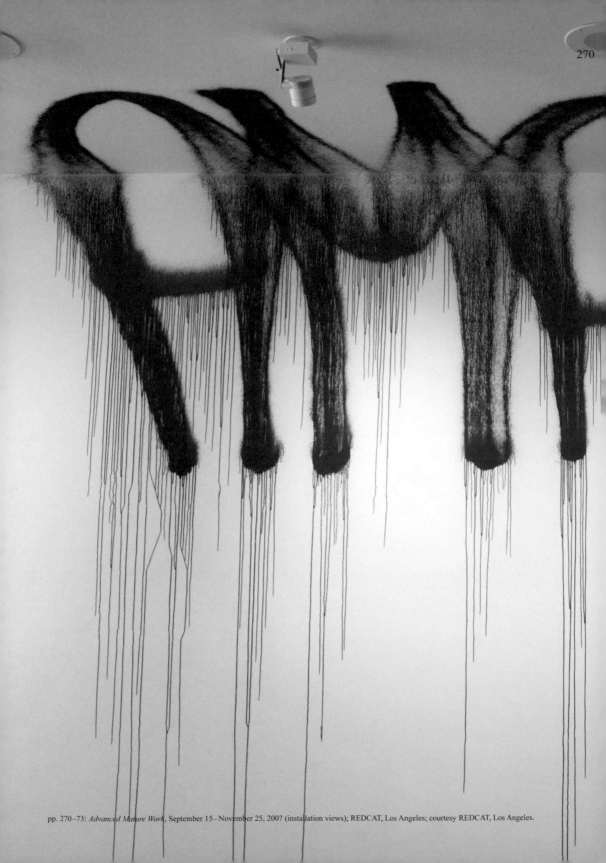

pp. 270–73: *Advanced Mature Work*, September 15–November 25, 2007 (installation views); REDCAT, Los Angeles; courtesy REDCAT, Los Angeles.

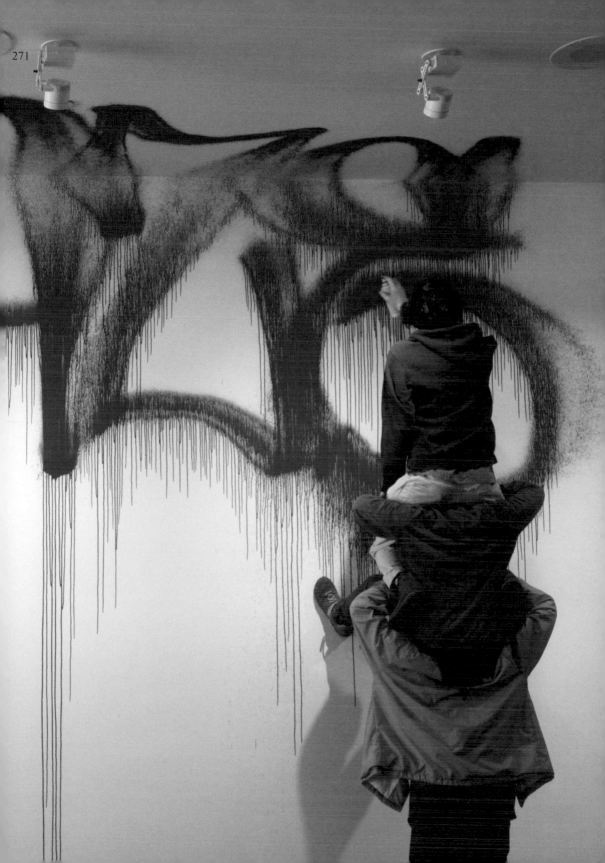

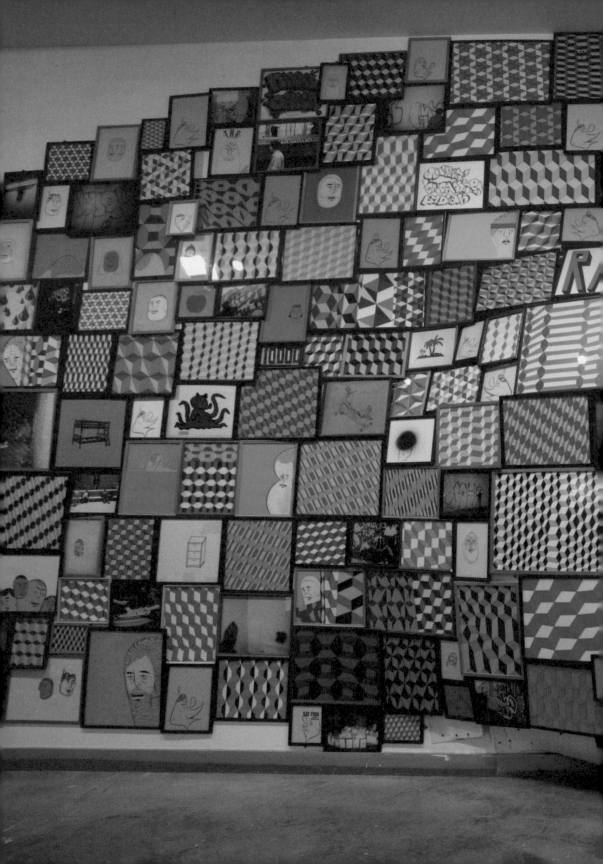

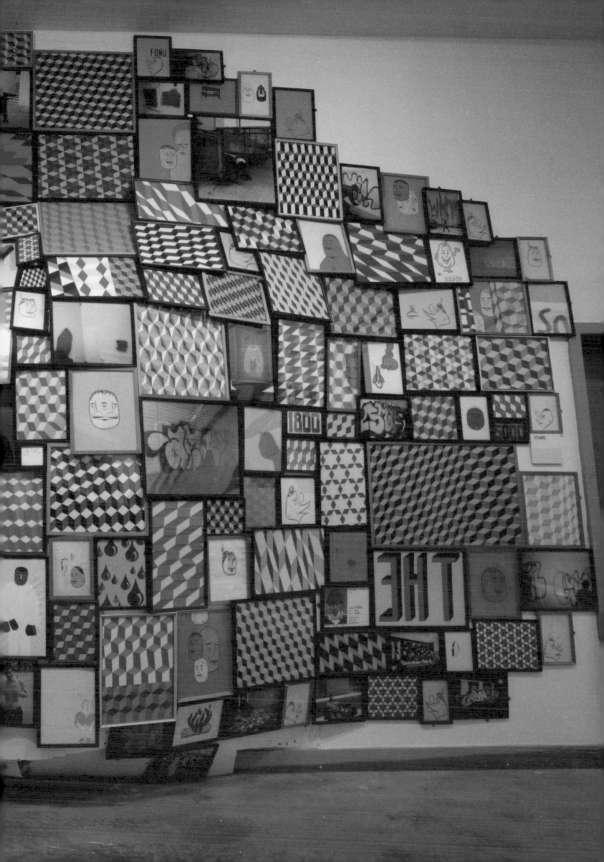

Using the same energy and frankness seen in his street works, McGee creates intricate environments within the exhibition space that are punctuated with the detritus of city excess. The seemingly disordered mass comprises chaotic clusters of photos, drawings and paintings, flickering TV screens, an upturned vehicle, metal panels, electrical cabling and glass bottles. These are exhibited alongside failing, obsolete computers displaying the animated characters of McGee's illustrated world. The sprawling installations are all individually consumed by the artist's hand-painted figures and geometric shapes and contained within elaborate, mural-painted walls.

At BALTIC, McGee will bring the elements of his varied working practices together to create an installation that will embody the spontaneity that has made him one of the most significant and respected graffiti artists to continue working since the early eighties.

From the press release for *They Don't Make This Anymore*, BALTIC Centre for Contemporary Art, 2008

pp. 275–83: *They Don't Make This Anymore*, January 21–April 27, 2008 (installation views); BALTIC Centre for Contemporary Art, Gateshead, U.K.; courtesy Barry McGee and BALTIC Centre for Contemporary Art, Gateshead, U.K. © Barry McGee. Photos: Colin Davison.

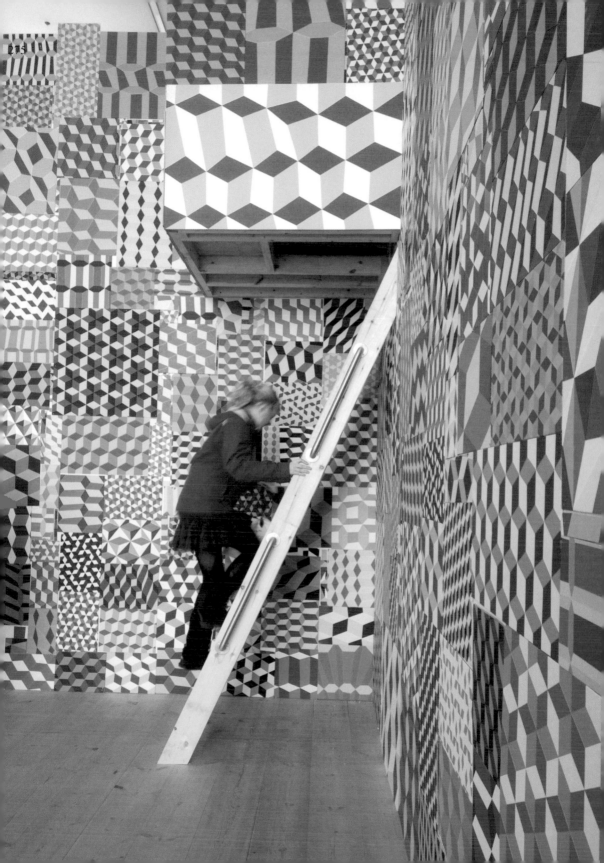

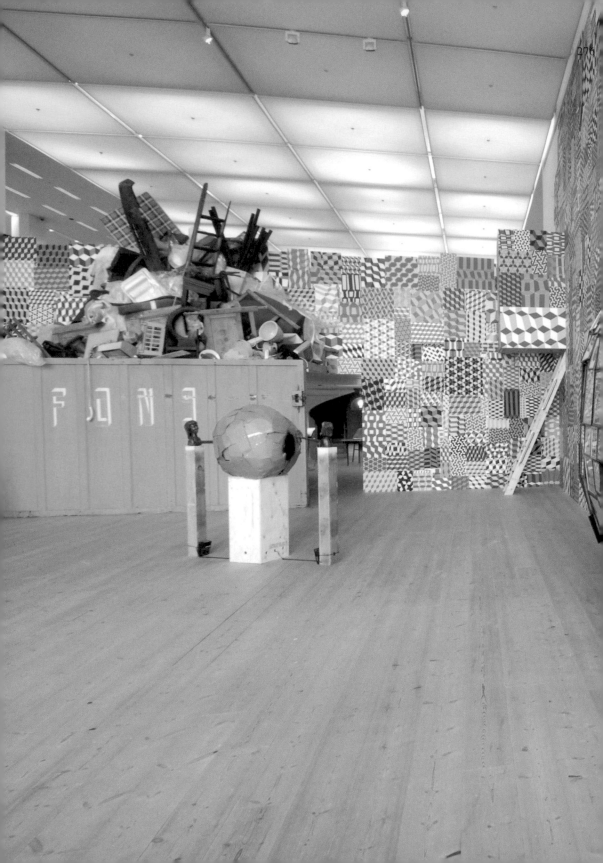

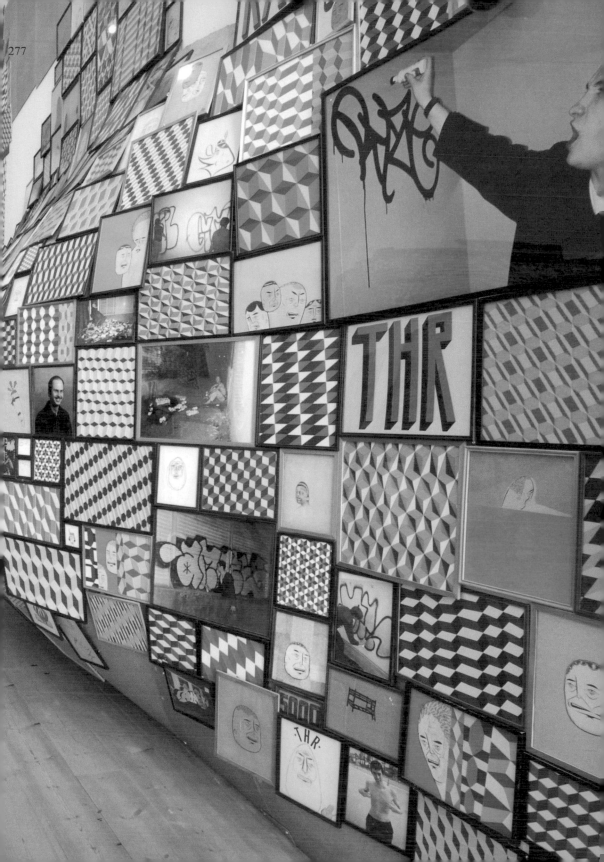

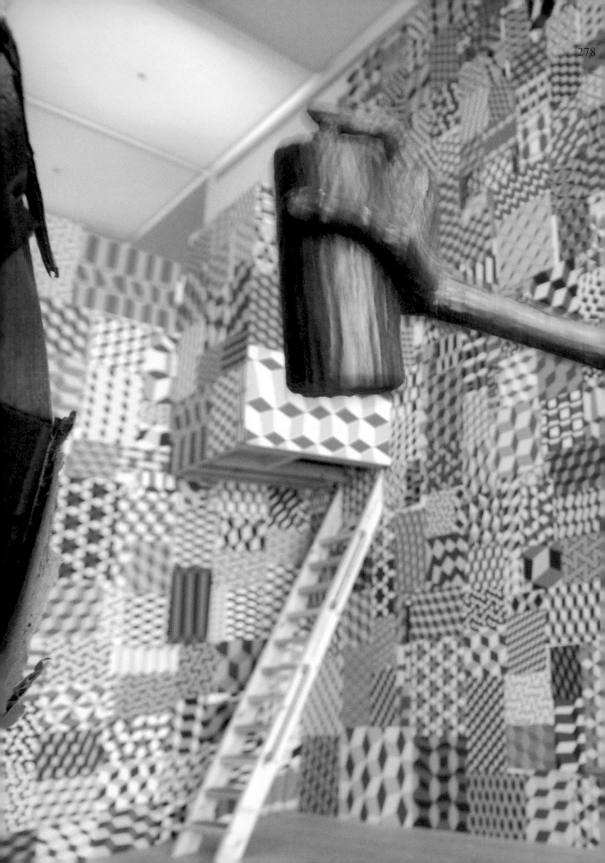

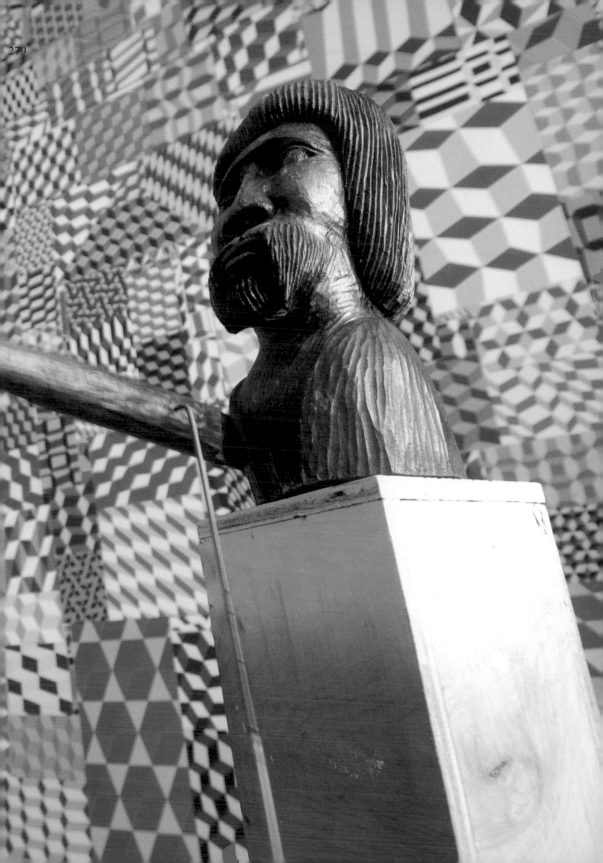

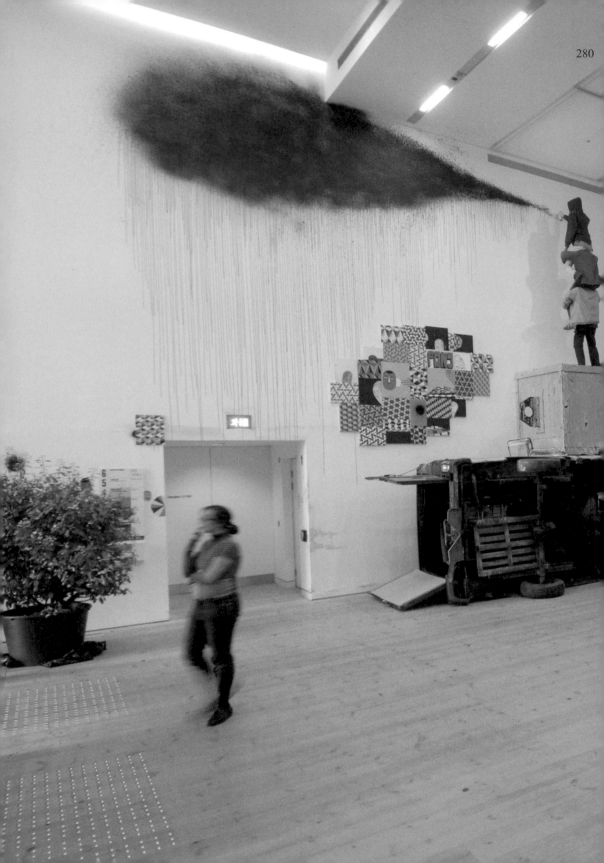

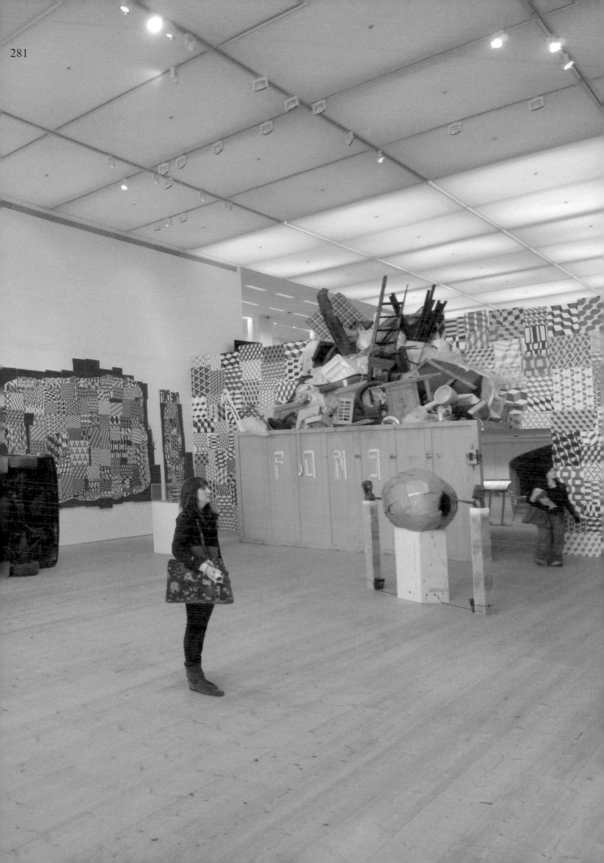

Untitled, 2006–2012; ballpoint pen on paper; 36 elements,
61 5/8 x 90 1/8 in. overall; courtesy Barry McGee.

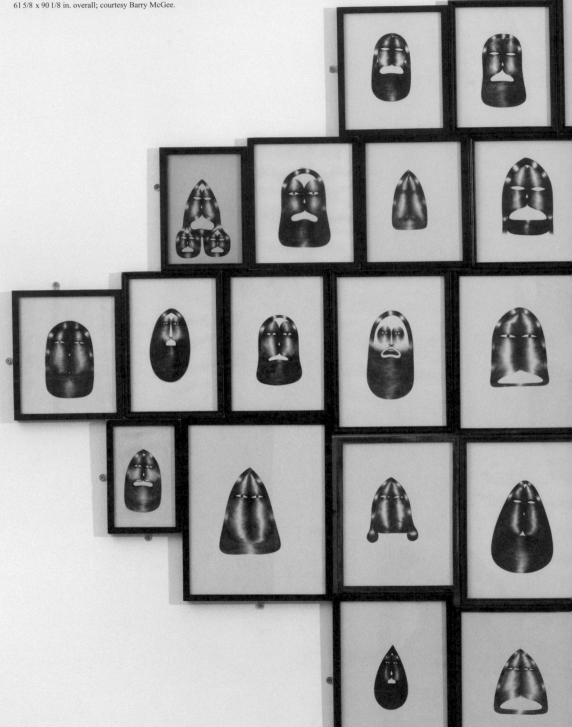

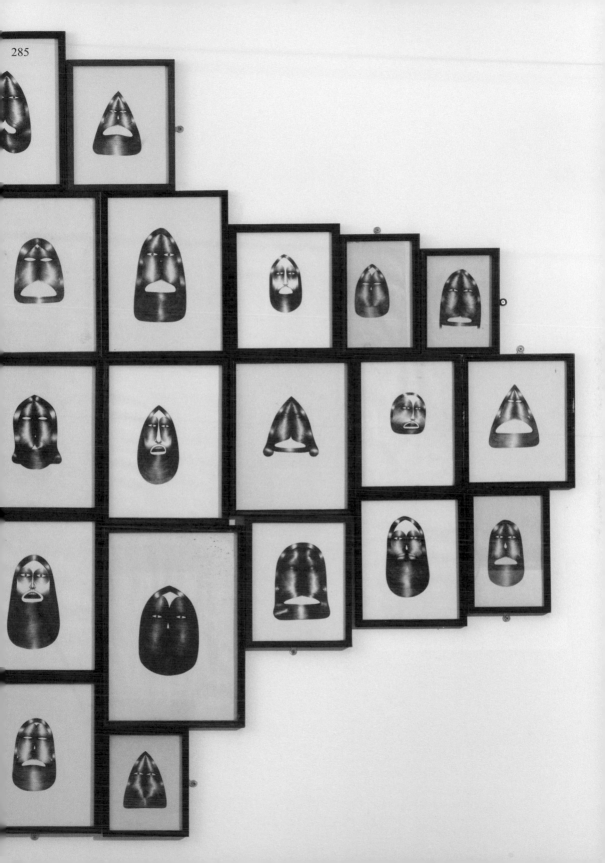

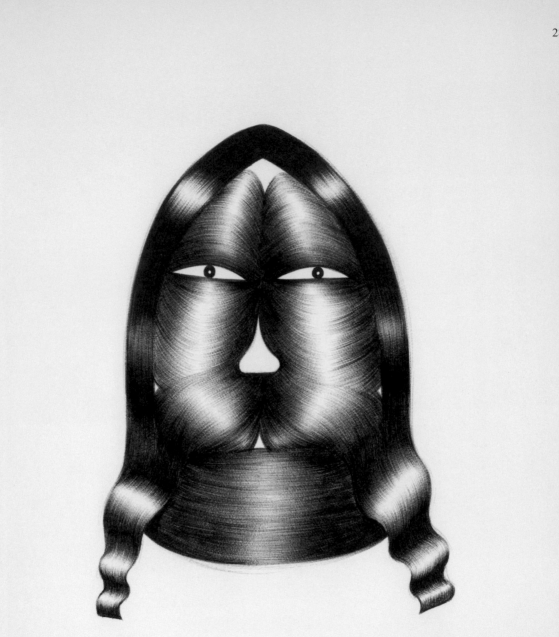

pp. 286–87: Untitled, 2008 (details); ballpoint pen and acrylic on paper; 12 1/16 x 9 9/16 and 24 1/2 x 18 1/2 in.; collection UC Berkeley Art Museum and Pacific Film Archive: bequest of Phoebe Apperson Hearst, by exchange. Photos: Sibila Savage.

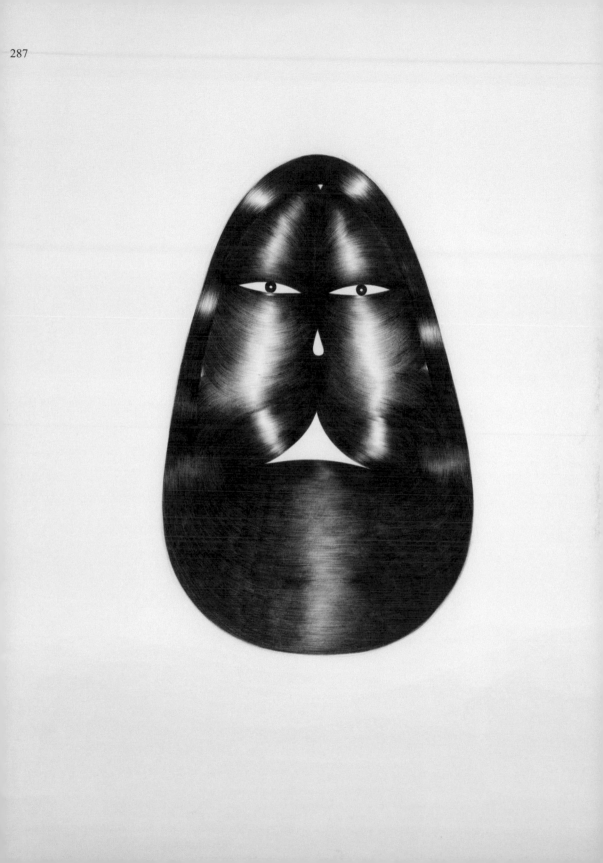

Barry McGee's playfully anarchic multimedia installations blend the transgressive and antiauthoritarian impulses of graffiti with the considered techniques of a formal artistic practice. Found, discarded, and recycled objects, over-turned vehicles, motorized figures, audio components, and video monitors exist alongside portraits, text, assemblages of framed photographs and drawings, and geometrical sections of optical color-field "wallpaper." His installations also have a degree of humorous obstinacy: a recent exhibition included a sculpture of a hand clutching a bottle of spray paint protruding from a leafy bush—comical graffiti camouflage.

Heather Pesanti, *Life on Mars: 55th Carnegie International*, exhibition catalogue, ed. Douglas Fogle (Pittsburgh: Carnegie Museum of Art, 2008), 168.

pp. 289–93: *Life on Mars: the 55th Carnegie International*, May 3, 2008–January 11, 2009 (installation views); Carnegie Museum of Art, Pittsburgh; courtesy Carnegie Museum of Art, Pittsburgh. Photos: Tom Little.

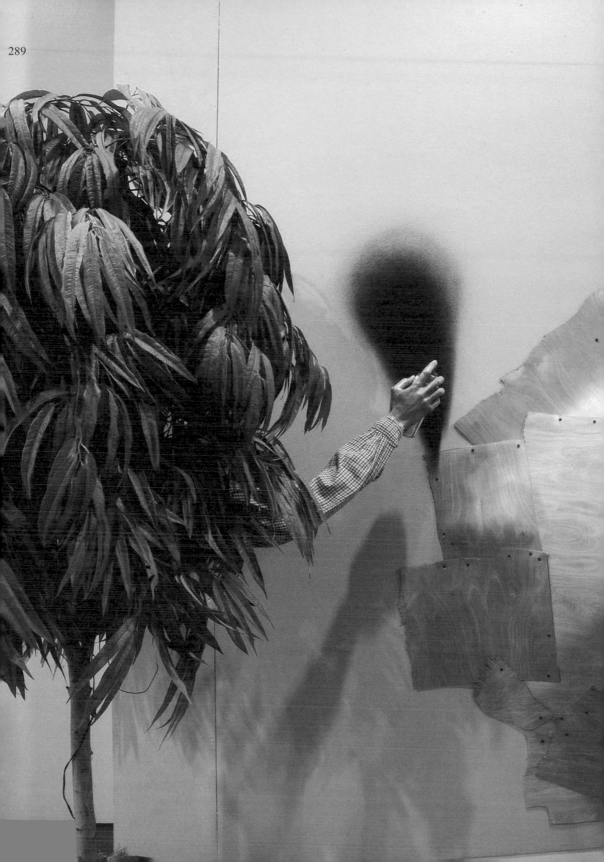

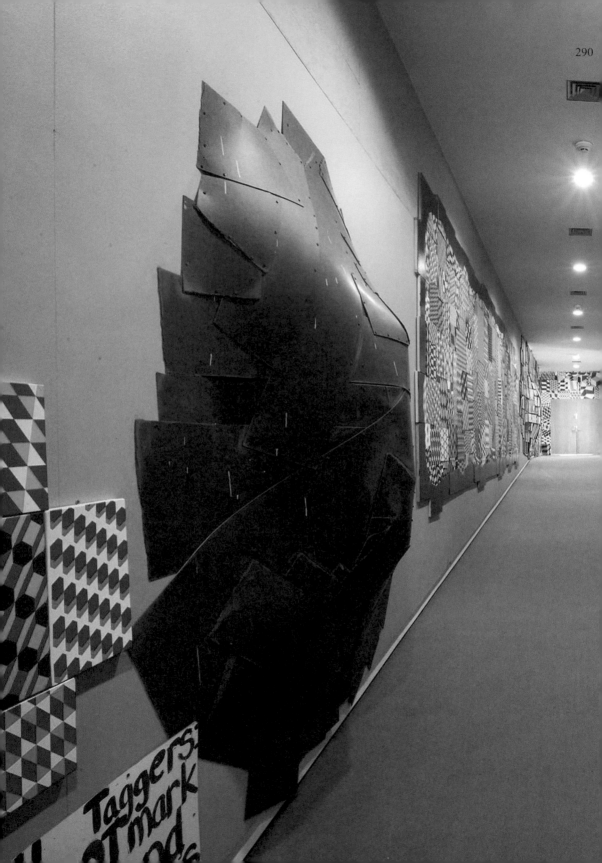

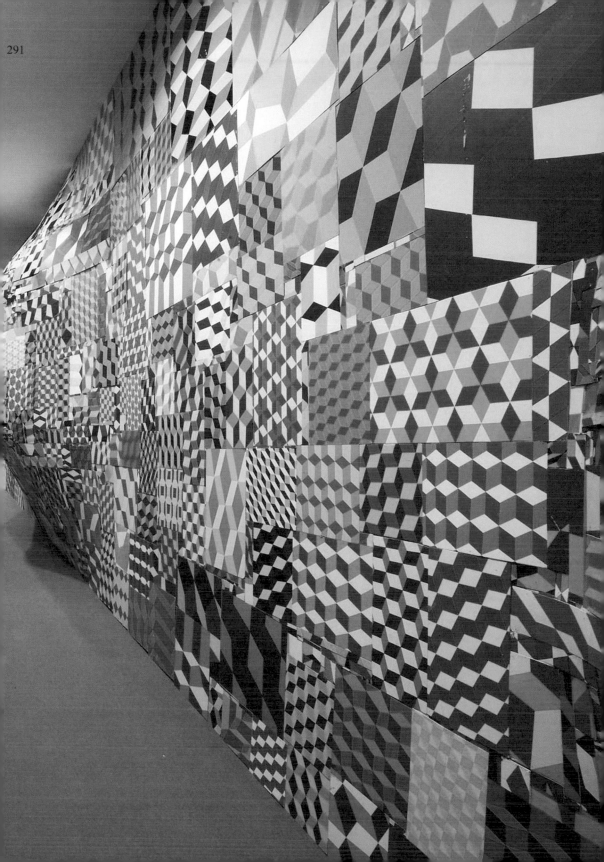

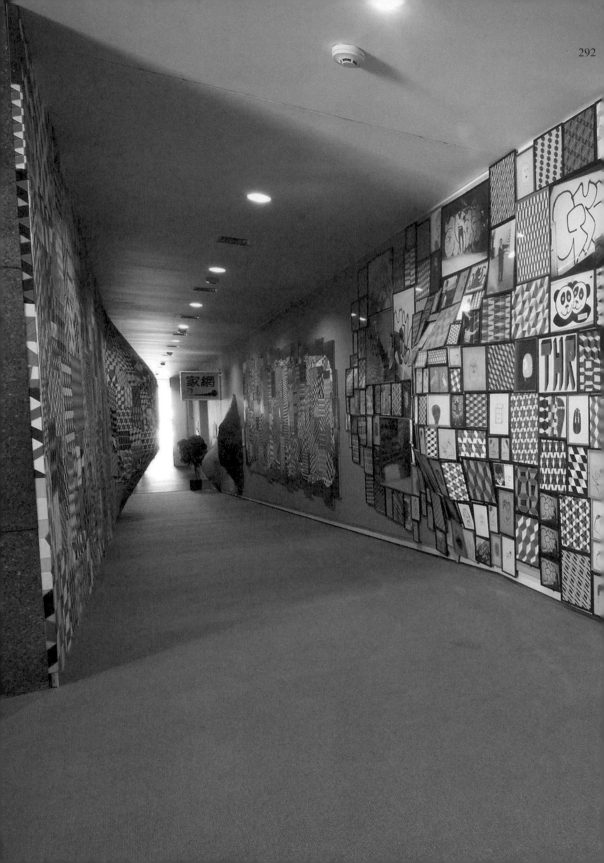

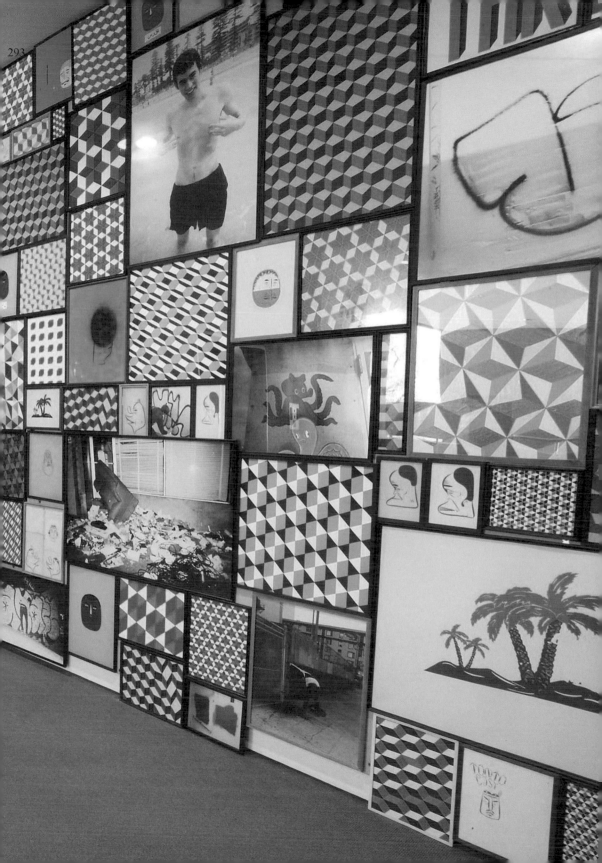

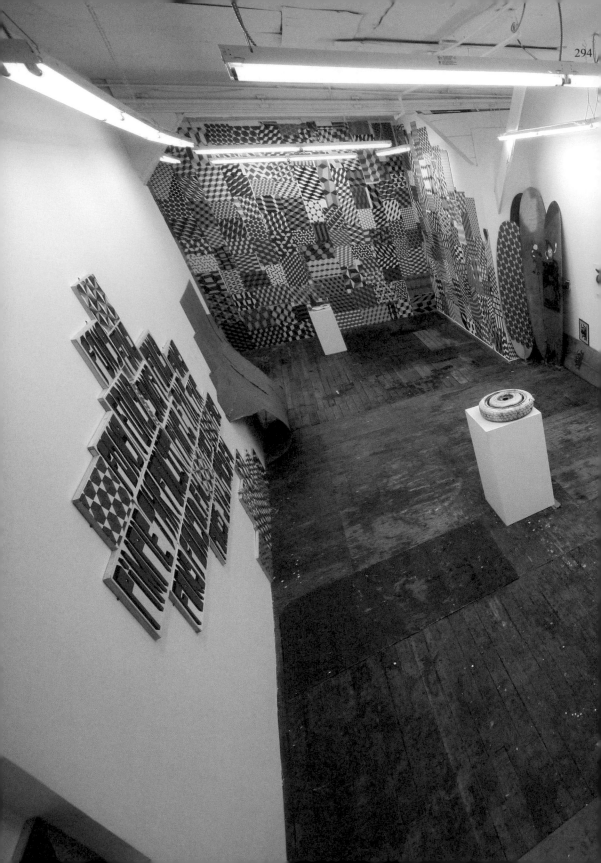

pp. 294–97: *A Moment for Reflection: New Work by Lydia Fong*, September 5–October 18, 2008 (installation views); Ratio 3, San Francisco; courtesy Ratio 3, San Francisco. Photos: Wilfred J. Jones.

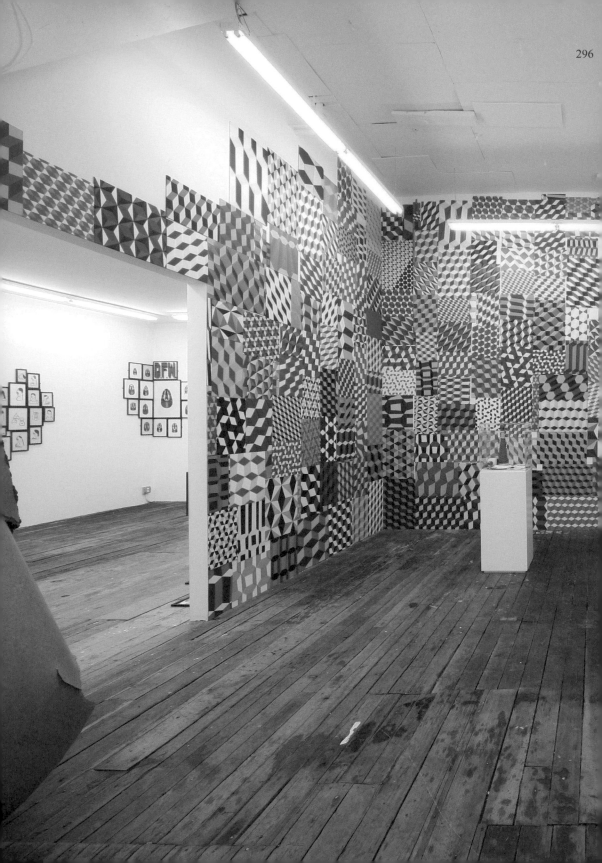

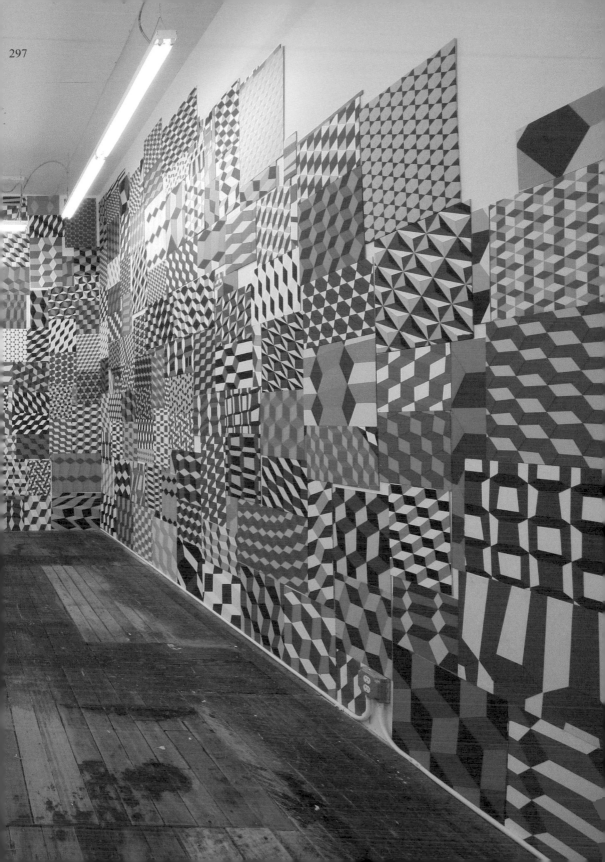

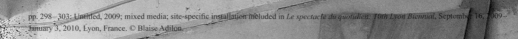

pp. 298–303: Untitled, 2009; mixed media; site-specific installation included in *Le spectacle du quotidien*, *10th Lyon Biennial*, September 16, 2009– January 3, 2010, Lyon, France. © Blaise Adilon.

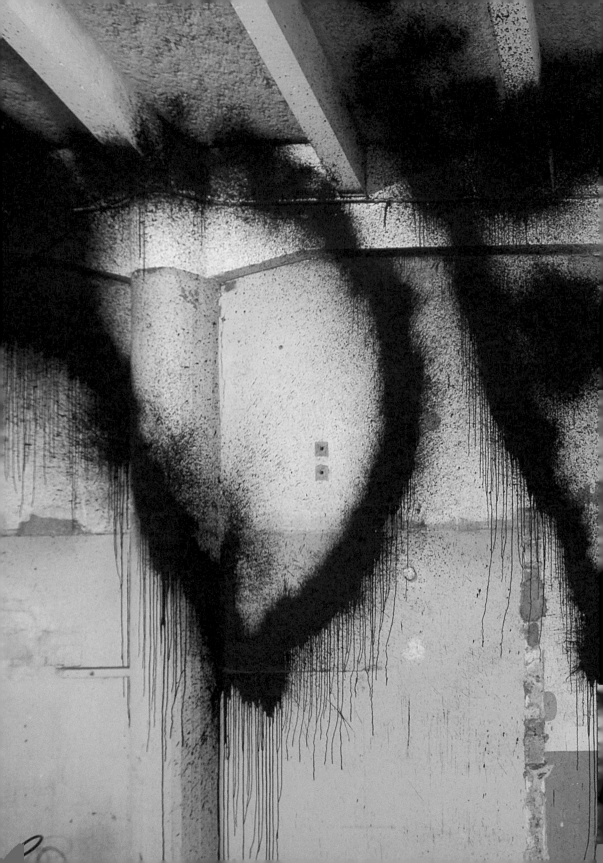

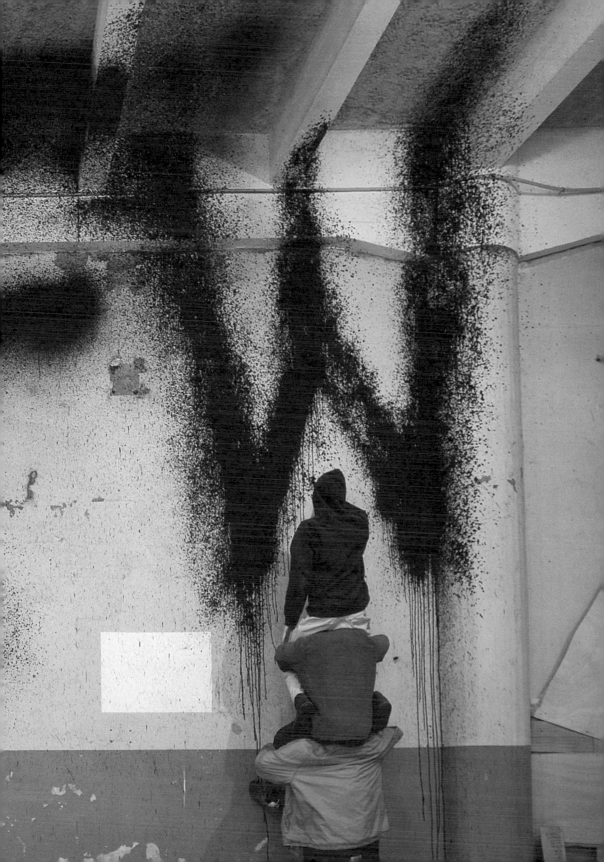

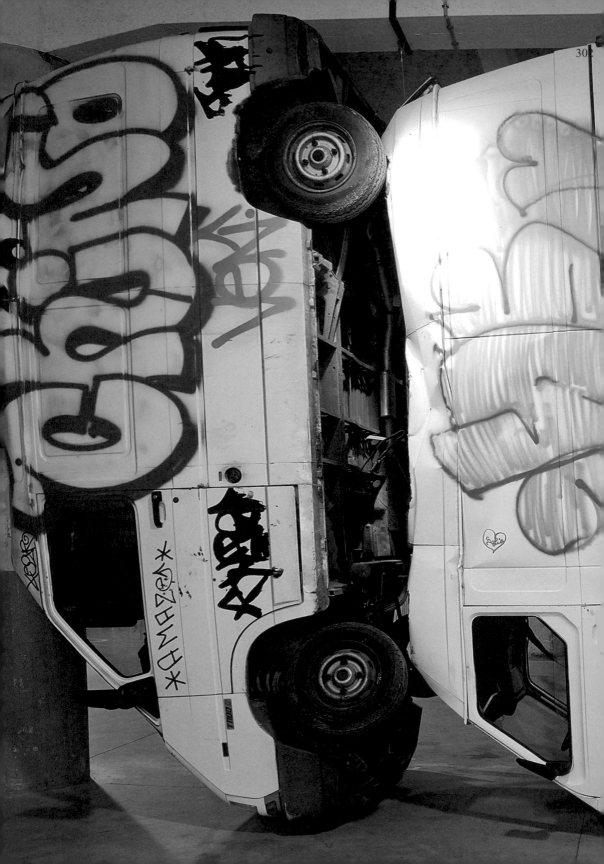

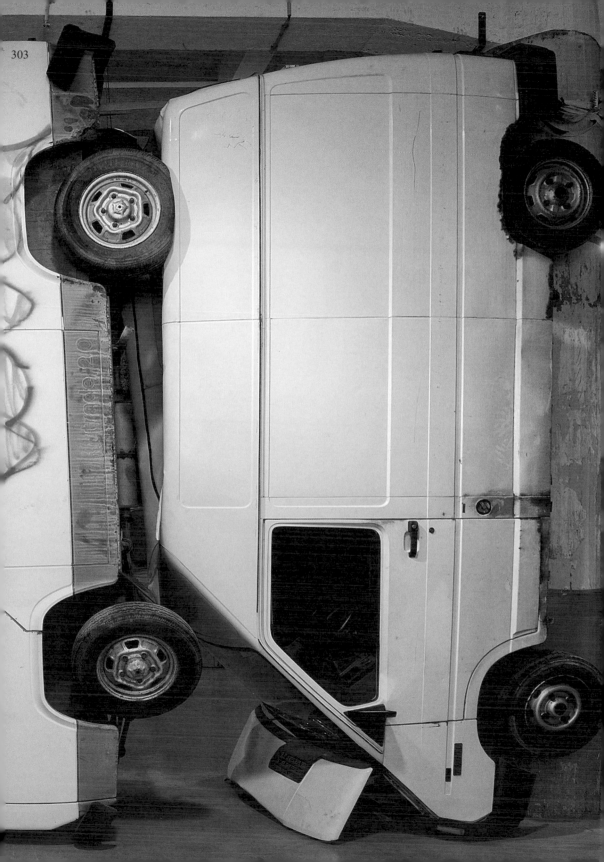

Barry McGee and Josh Lazcano: Untitled, 2009; enamel on masonry; courtesy Kathy Grayson, New York.

pp. 306–09: Untitled, 1996/2009; ink, graphite, acrylic, screenprint, and photographs on paper, frames; dimensions variable; included in *75 Years of Looking Forward: The Anniversary Show*, December 19, 2009–January 16, 2011, San Francisco Museum of Modern Art; collection San Francisco Museum of Modern Art, Ruth Nash Fund and Louis Vuitton N.A. purchase and fractional gift of Barry McGee and Ratio 3, San Francisco. Photo: Ben Blackwell.

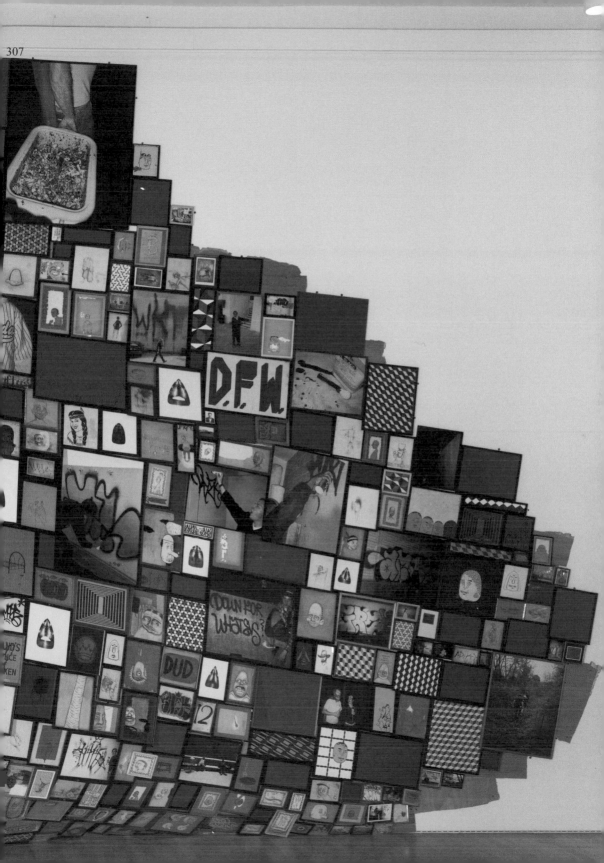

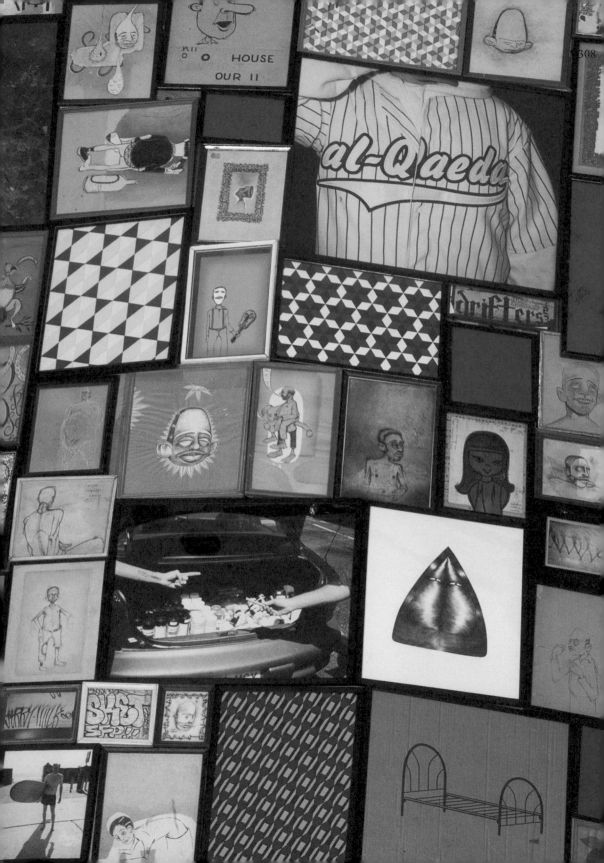

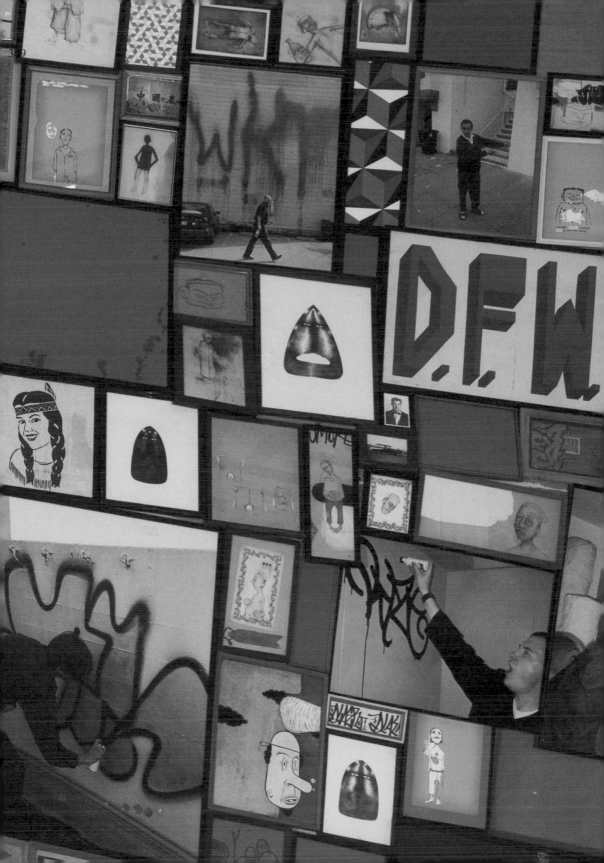

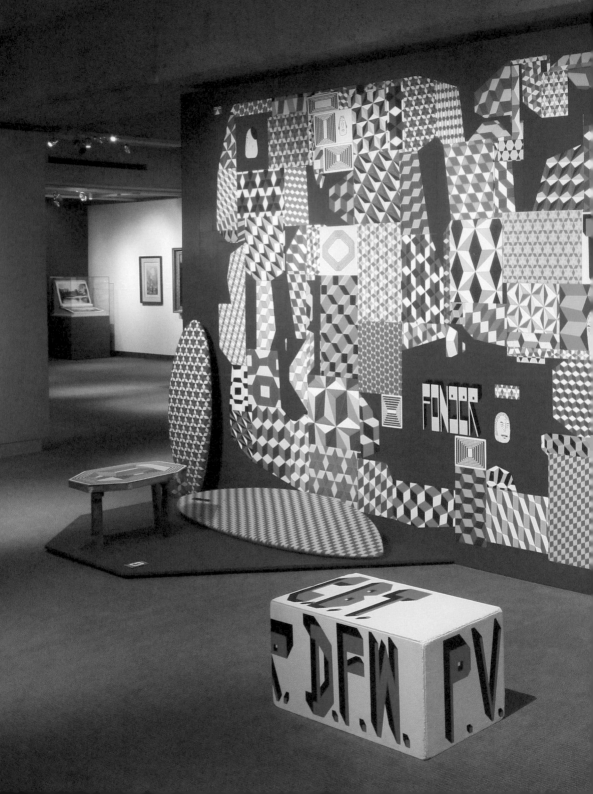

pp. 310–13: Untitled, 2010; acrylic paint on wood, fiberglass; site-specific installation for Oakland Museum of California; courtesy Ratio 3, San Francisco. Photos: Wilfred J. Jones.

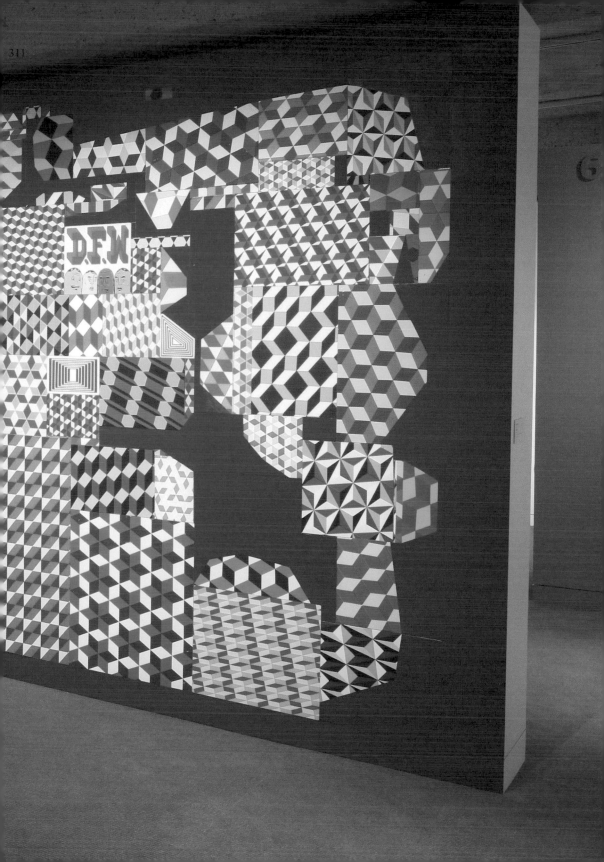

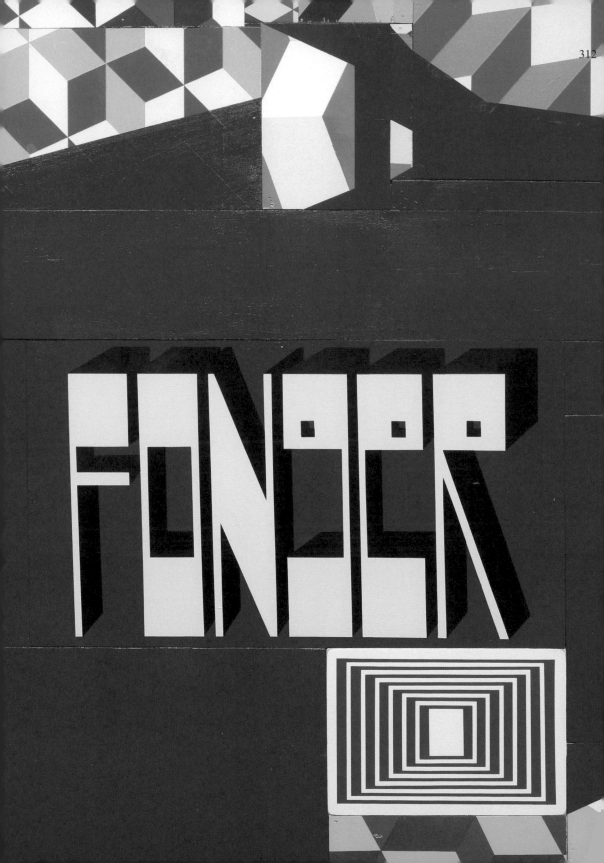

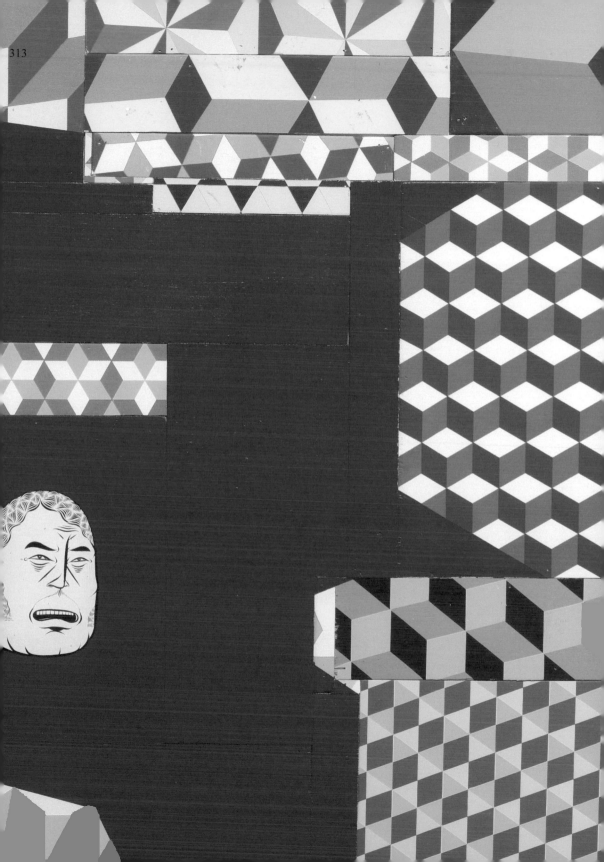

313

pp. 314–19: *Barry McGee & Clare Rojas / Leave It Alone & Together at Last*, June 19–August 2, 2010 (installation views); Bolinas Museum, Bolinas, California; courtesy Bolinas Museum, Bolinas, California.

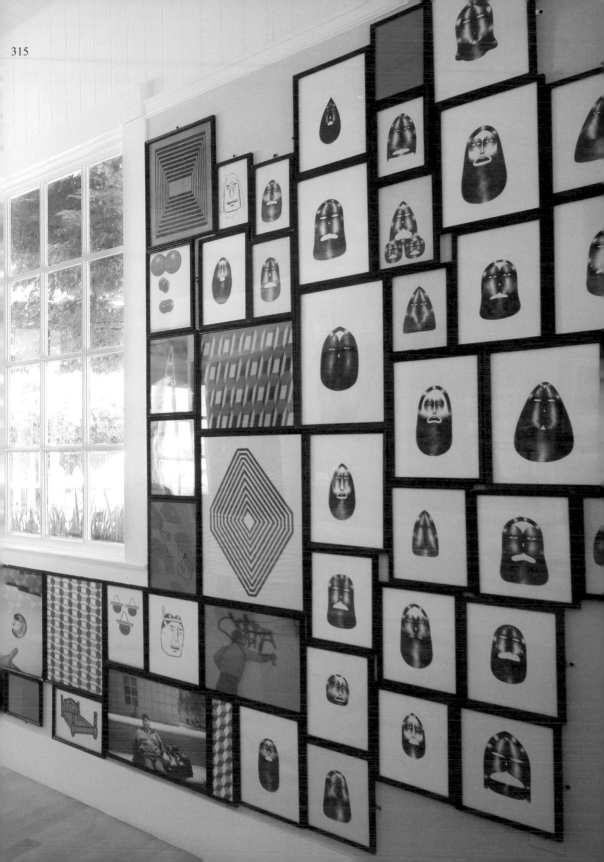

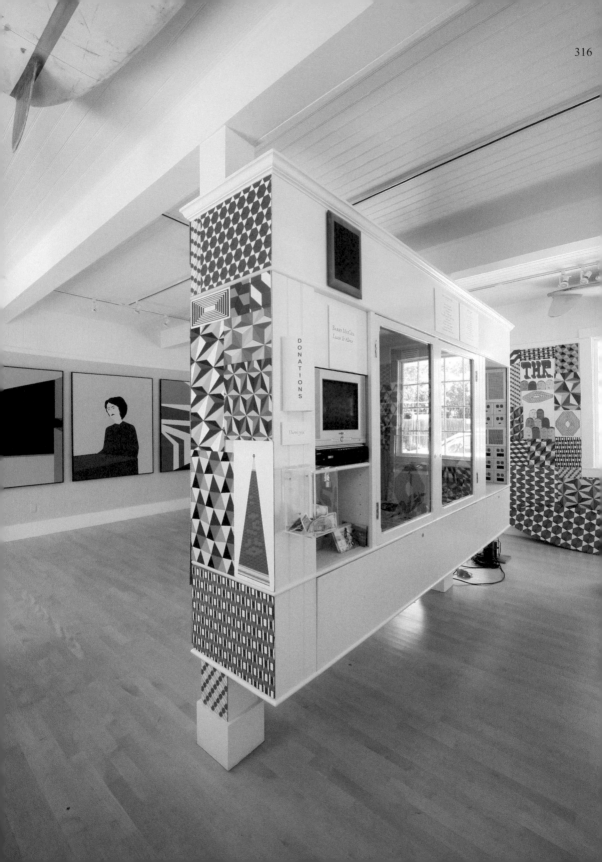

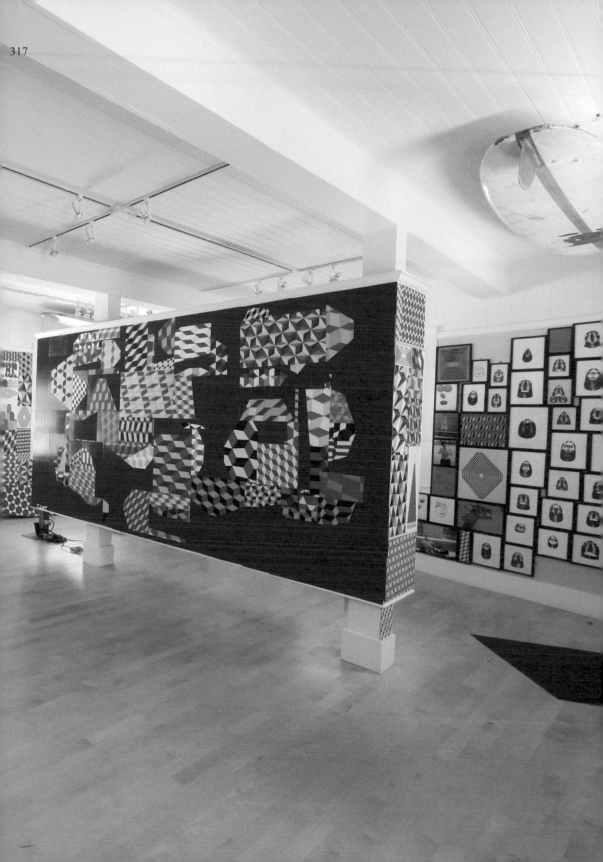

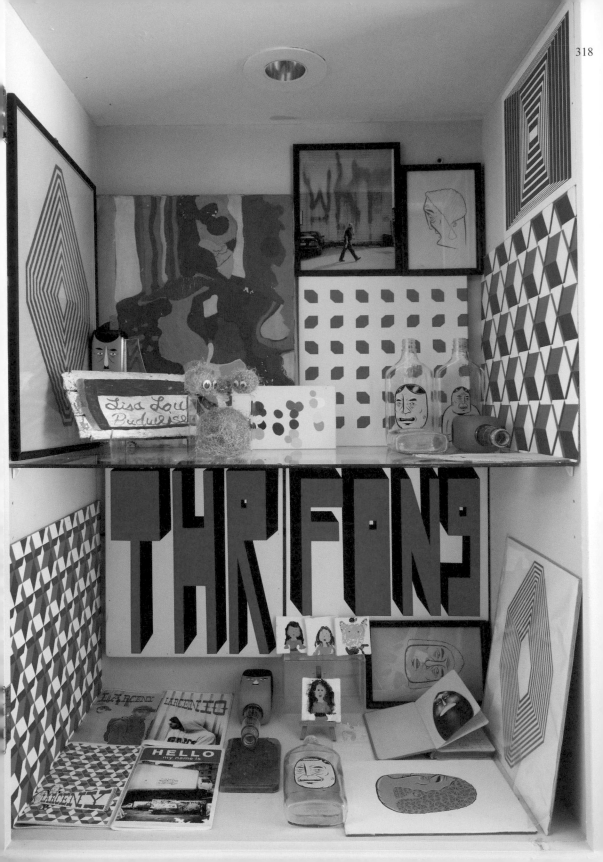

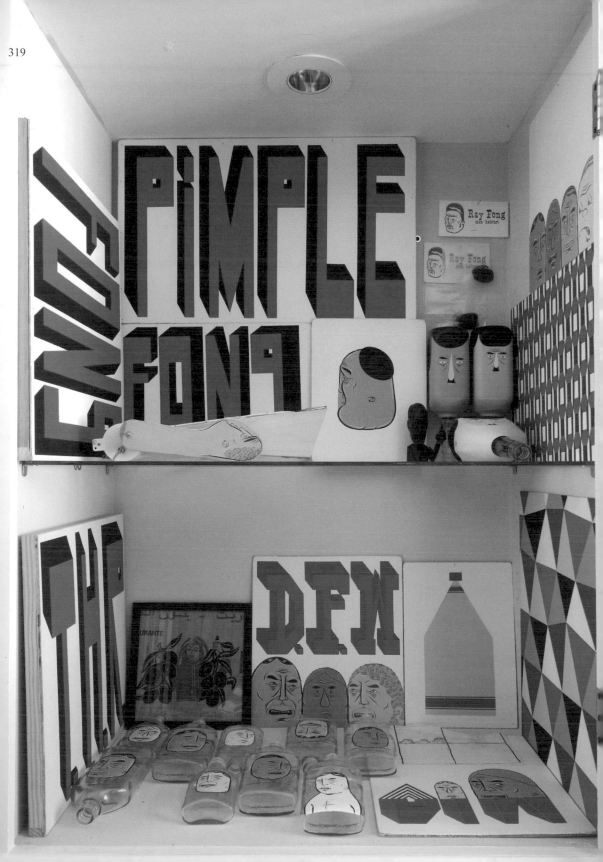

Untitled, 2010; acrylic on cardboard and wood, found photographs; site-specific installation included in *Transfer*, July 20–September 12, 2010, Brazilian Cultural Pavilion, Iburapuera Park, São Paulo; courtesy Barry McGee.

pp. 322–25: Untitled, 2010; enamel on plywood; 20 x 60 ft.; site-specific painting for Houston Street and Bowery, New York; commissioned by Tony Goldman and The Hole NYC; courtesy Kathy Grayson. Photos: Farzad Orwang.

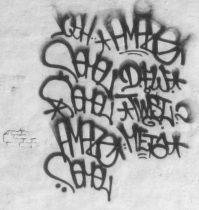

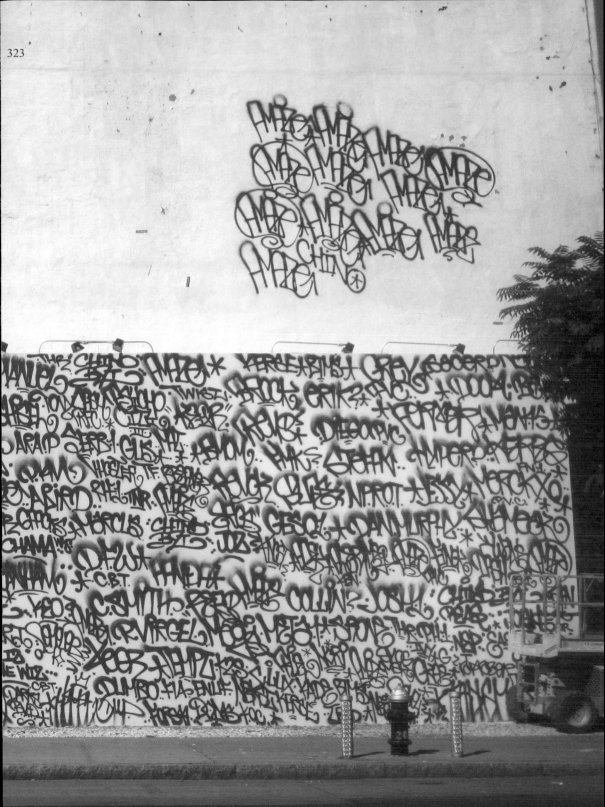

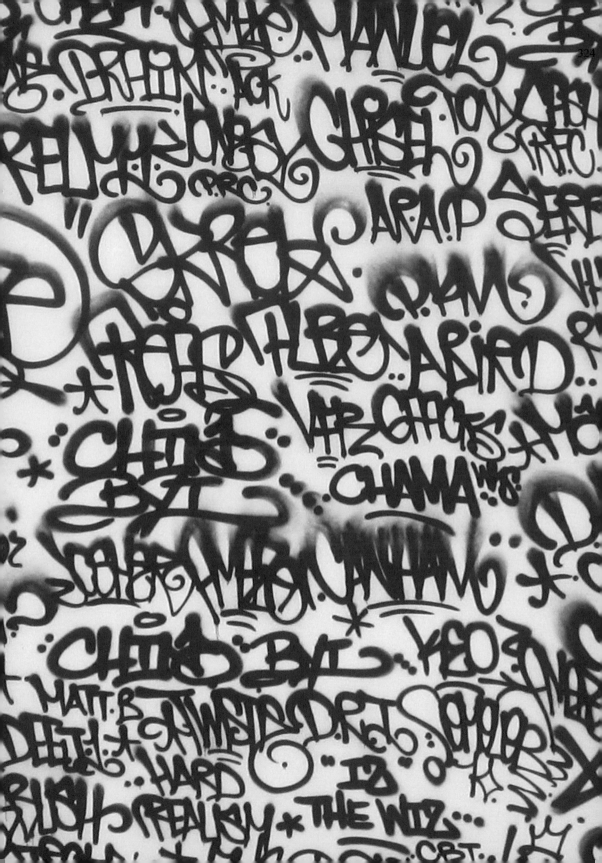

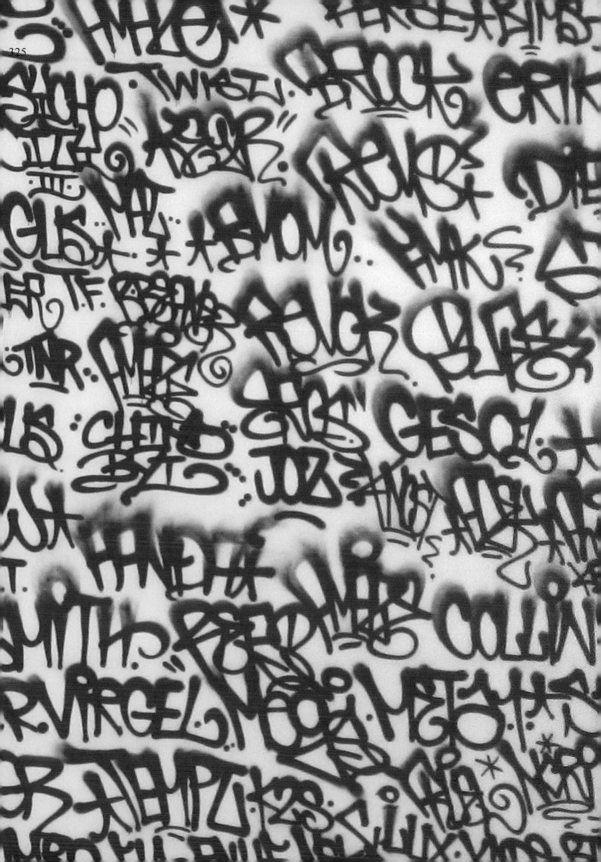

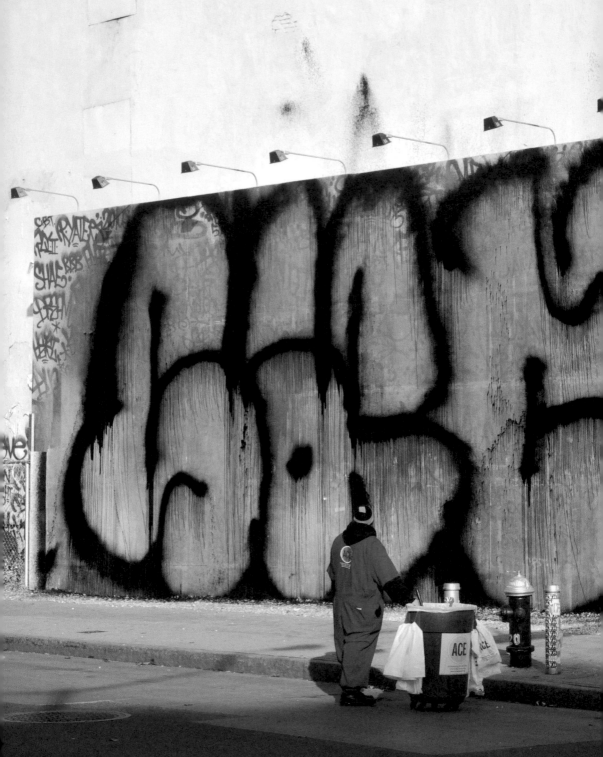

Adek BTM: Untitled, 2010; enamel on plywood; 20 x 60 ft.; site-specific repaint of Barry McGee's Houston Street and Bowery project, New York; commissioned by Barry McGee. Photo: Martha Cooper.

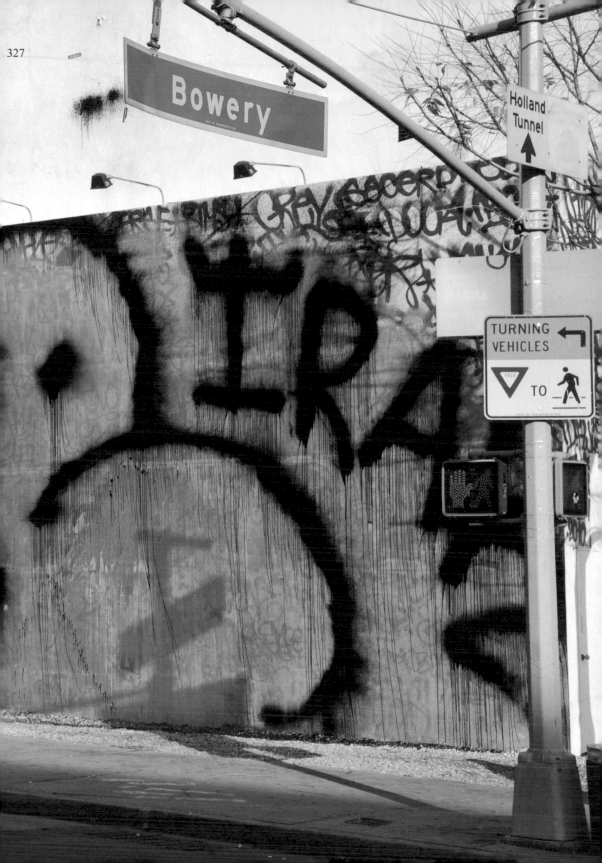

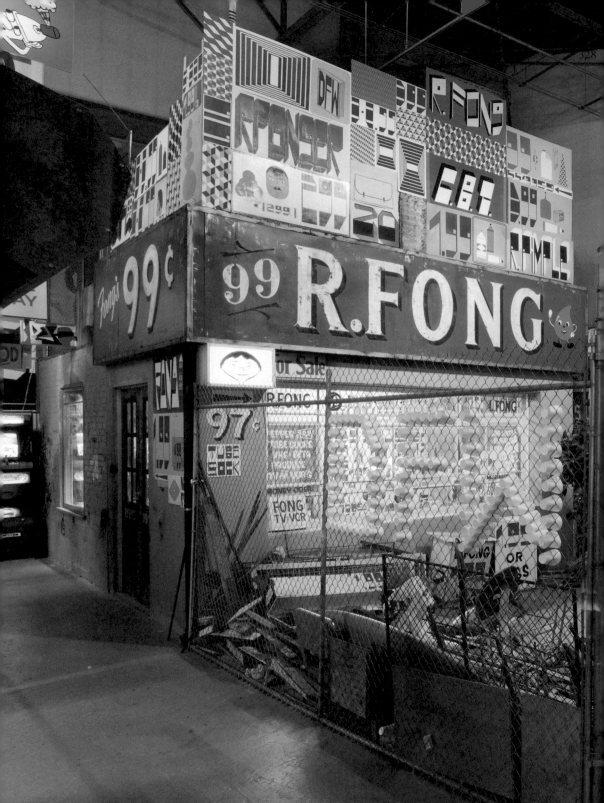

pp. 328–33: Untitled, 2011; mixed media; site-specific installation included in *Art in the Streets*, April 17–August 8, 2011, The Geffen Contemporary at The Museum of Contemporary Art, Los Angeles; courtesy The Museum of Contemporary Art, Los Angeles. Photo: Brian Forrest.

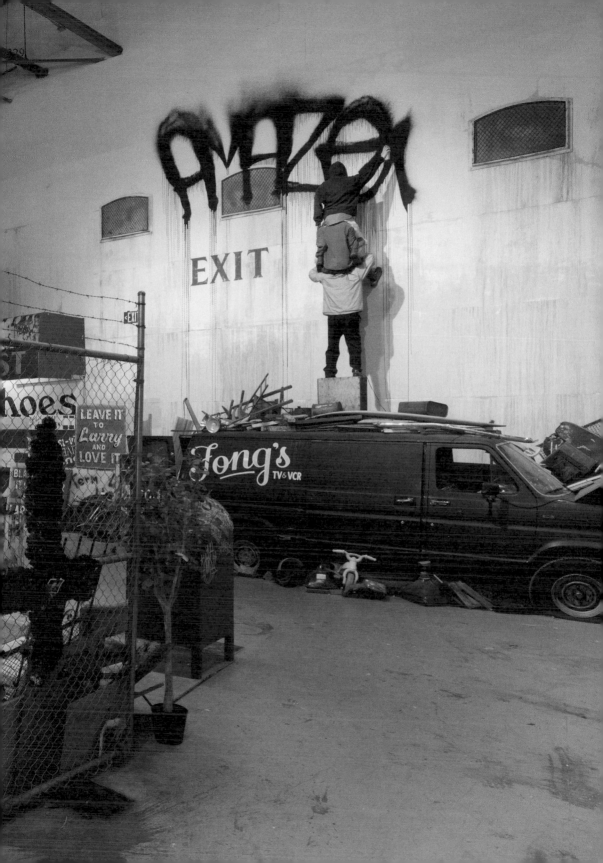

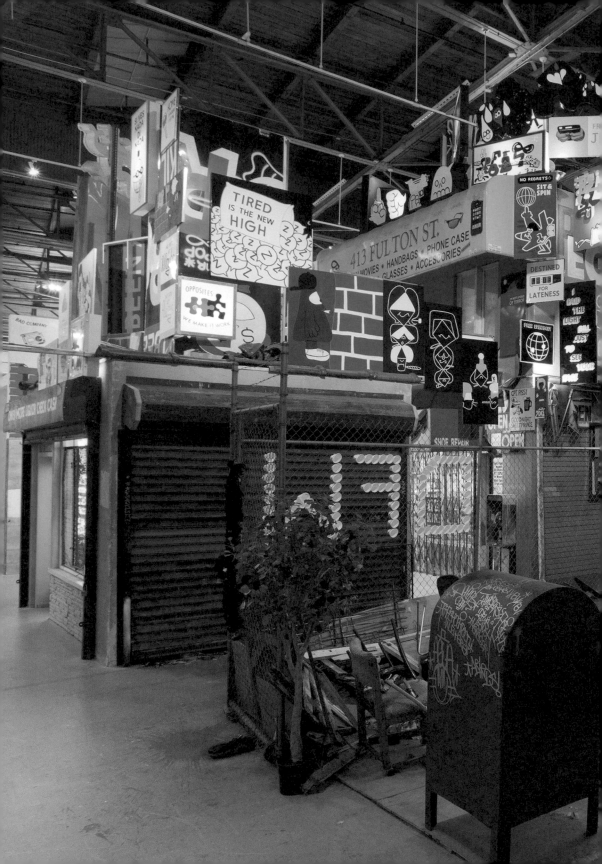

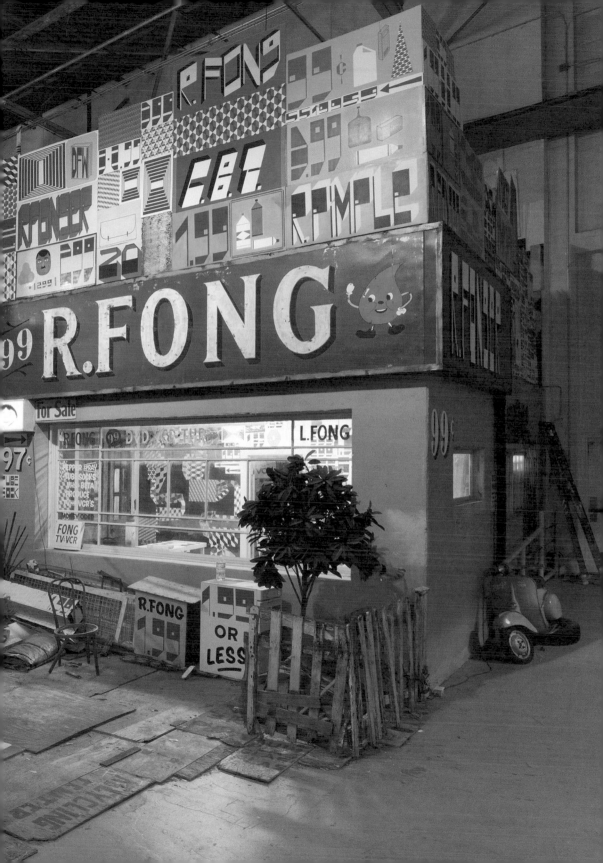

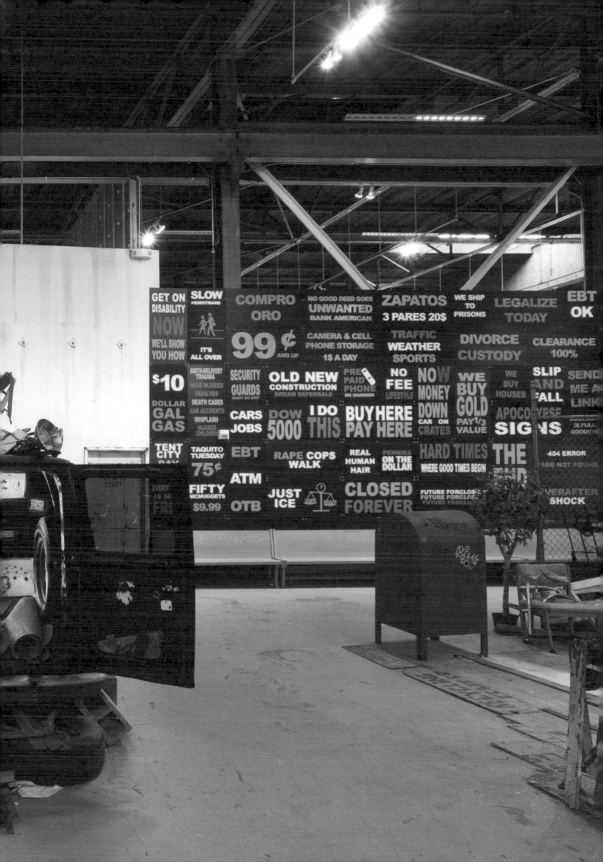

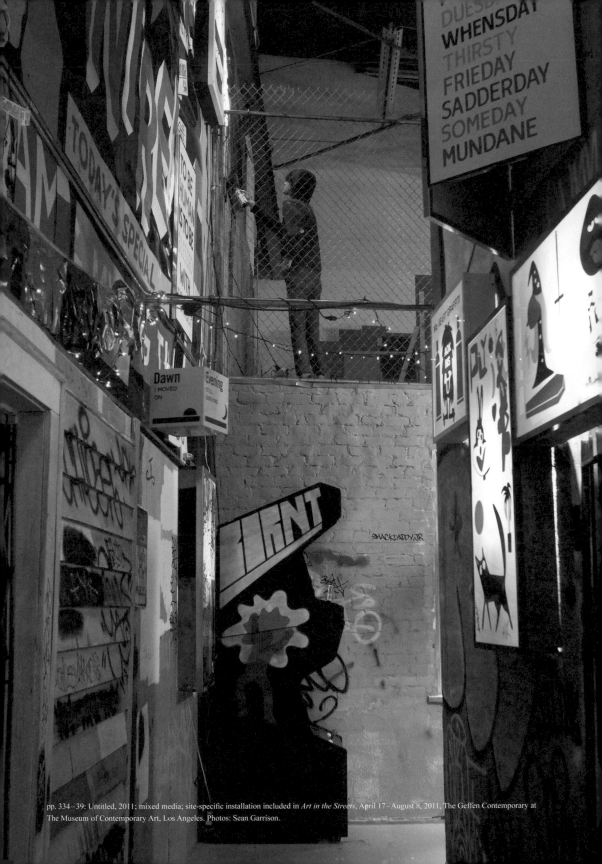

pp. 334–39: Untitled, 2011; mixed media; site-specific installation included in *Art in the Streets*, April 17–August 8, 2011, The Geffen Contemporary at The Museum of Contemporary Art, Los Angeles. Photos: Sean Garrison.

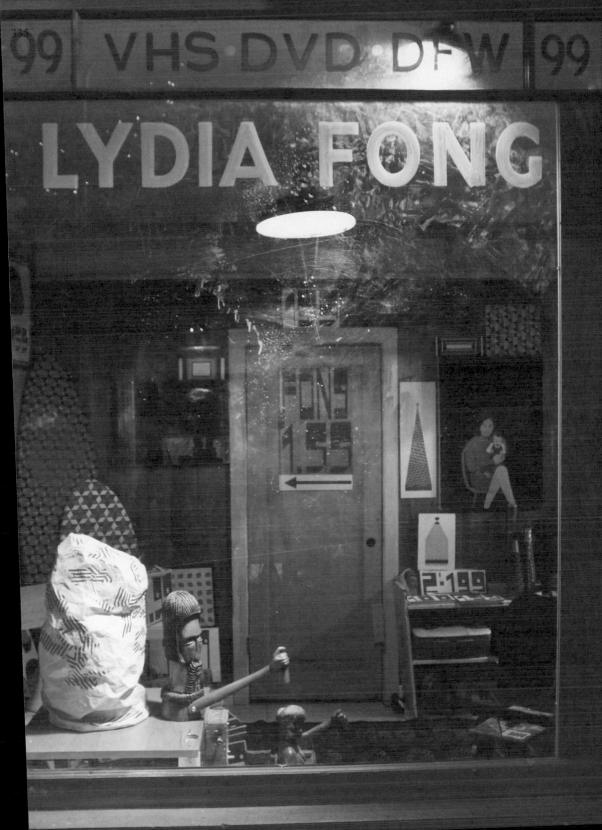

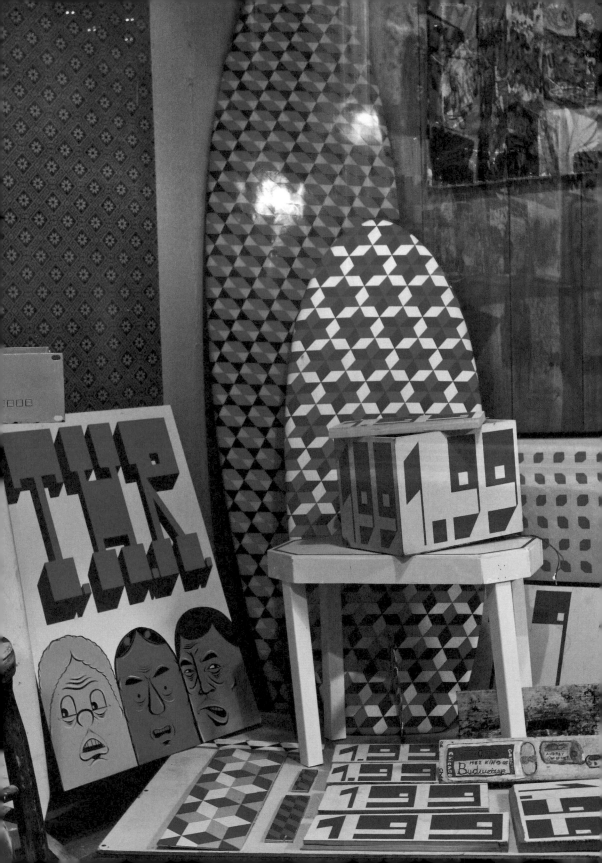

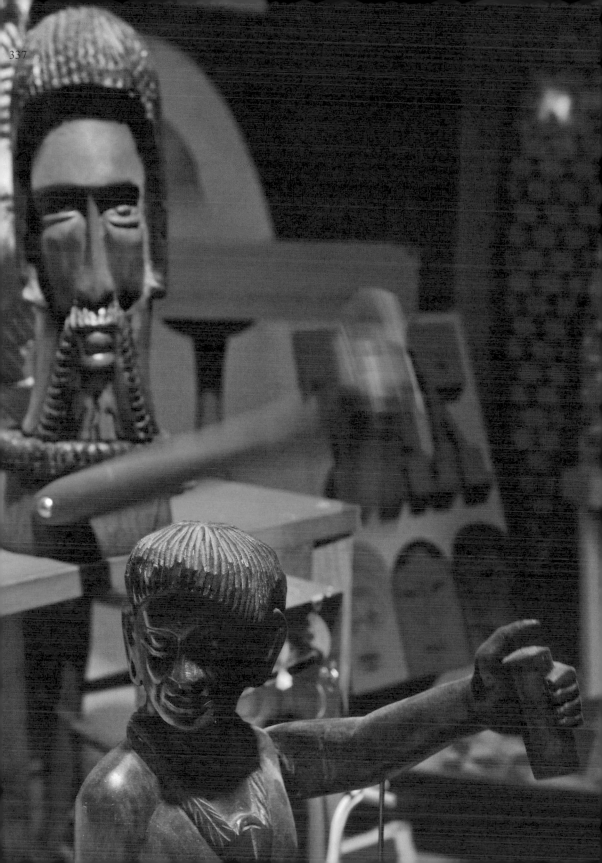

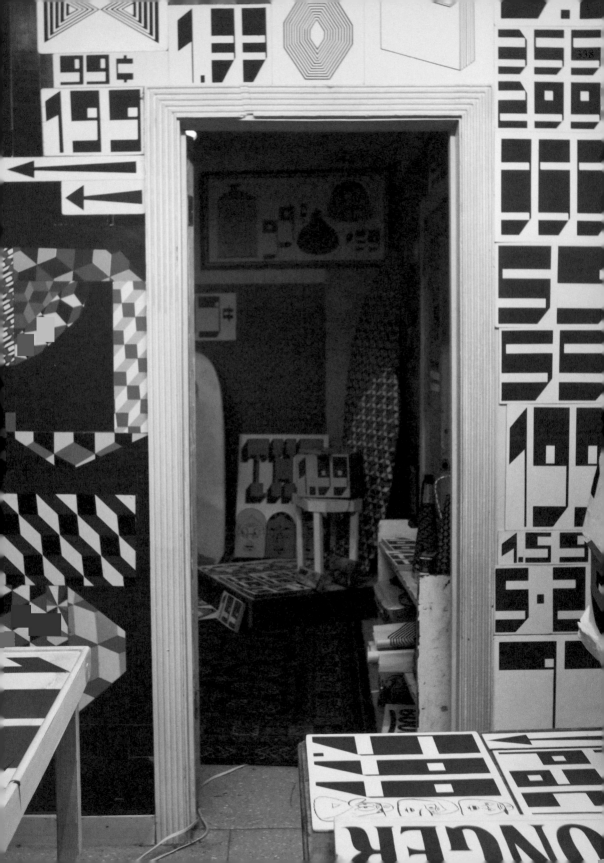

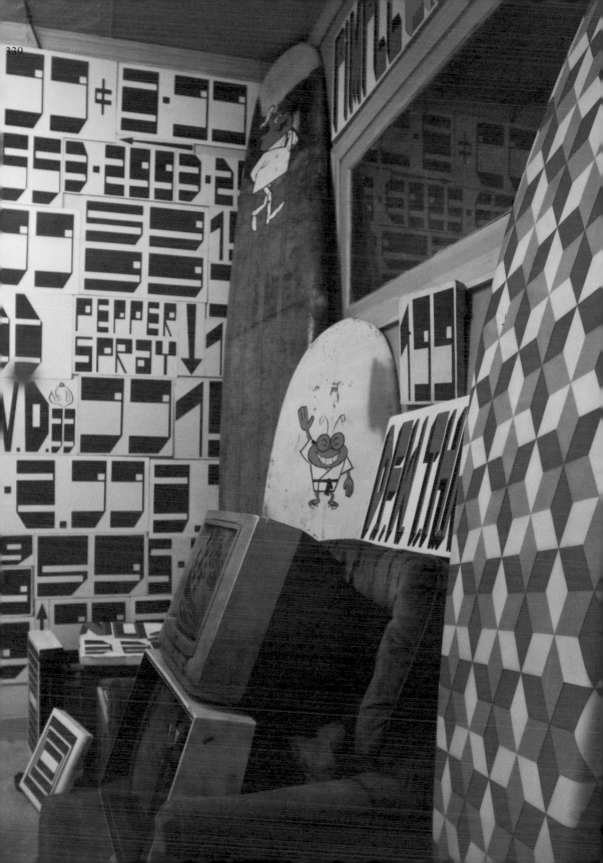

Untitled, 2011; enamel on drywall, animatronic figure; site-specific installation included in *New York Minute*, April 22–June 5, 2011, Garage Center for Contemporary Culture, Moscow; courtesy Garage Center for Contemporary Culture, Moscow, and Kathy Grayson, New York.

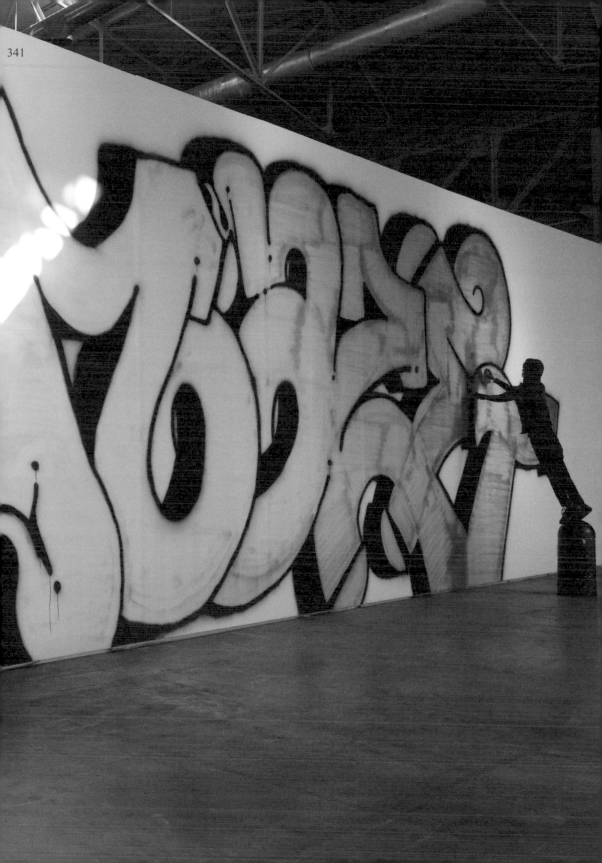

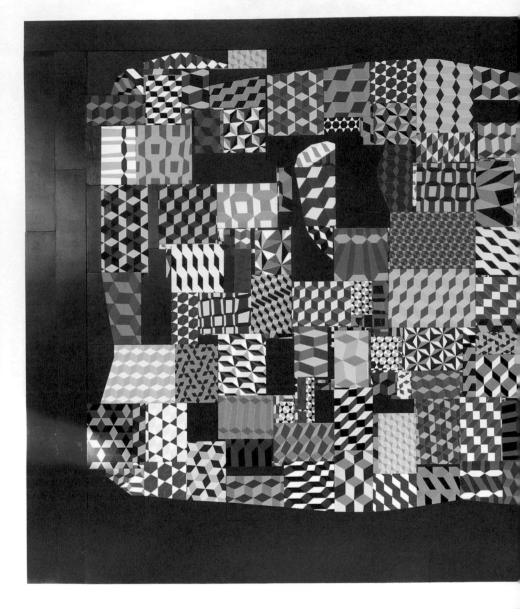

Untitled, 2011; acrylic on panels; site-specific installation included in *New York Minute*, April 22–June 5, 2011, Garage Center for Contemporary Culture, Moscow; courtesy Garage Center for Contemporary Culture, Moscow, and Kathy Grayson, New York.

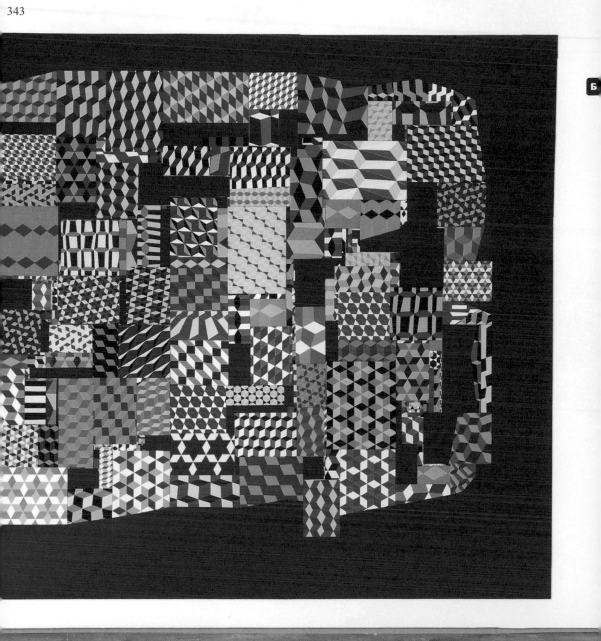

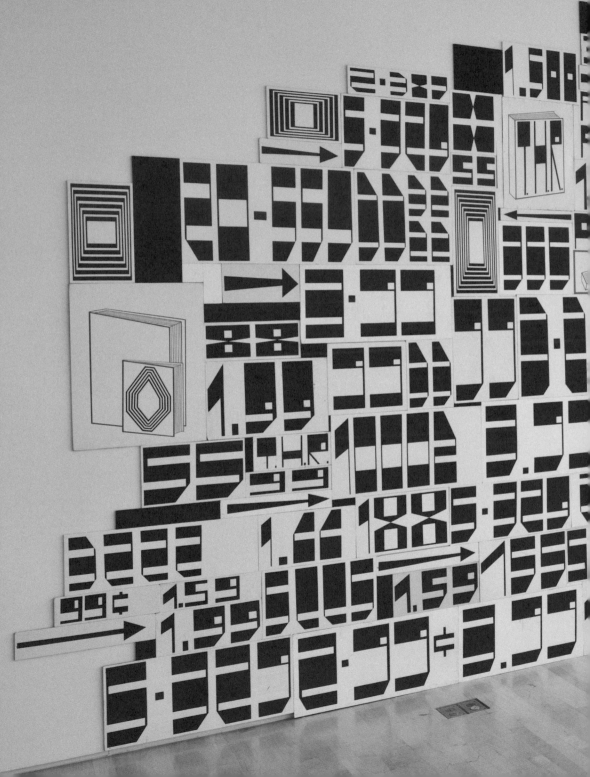

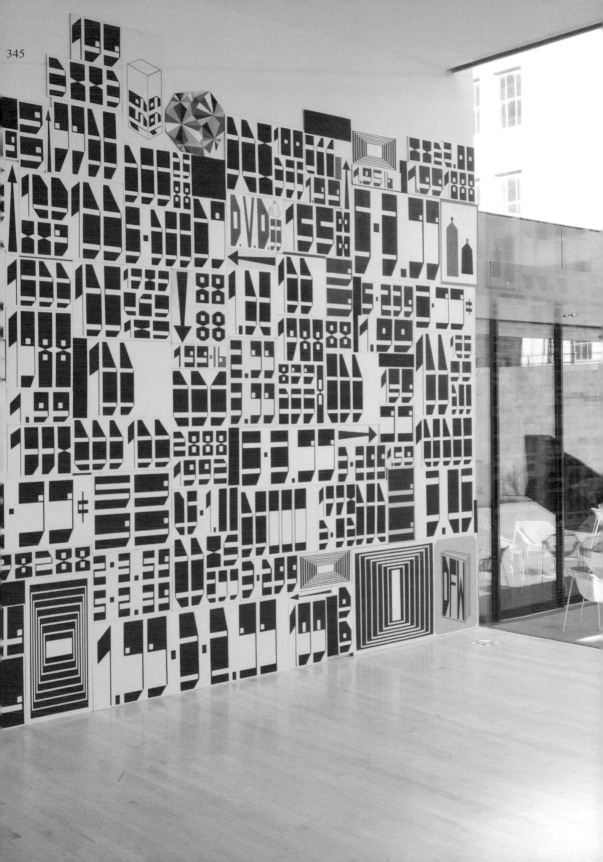

345

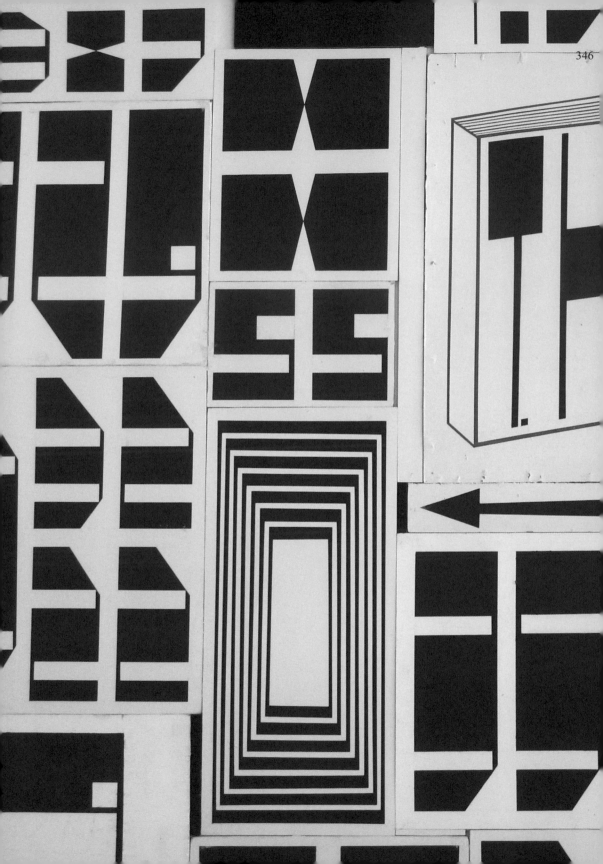

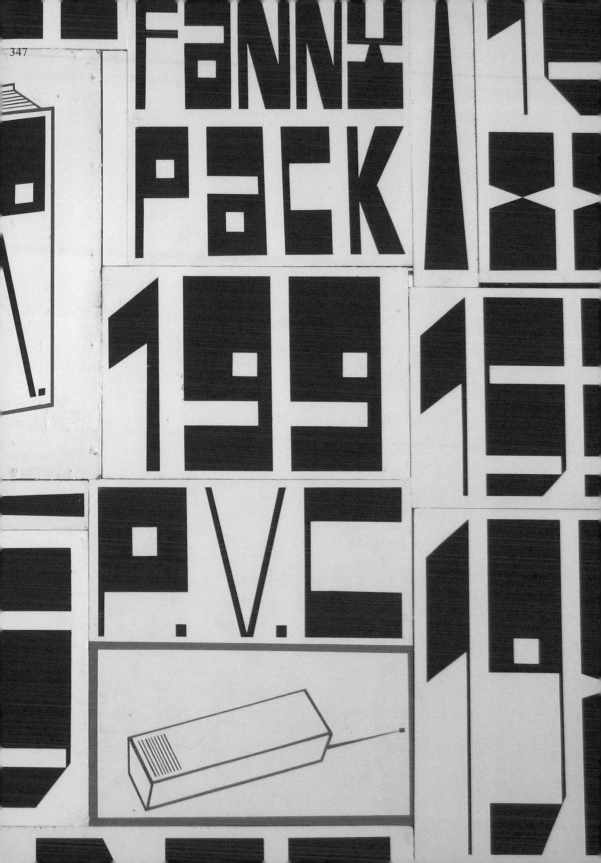

FANNY
PACK
199
P.V.C.

pp. 348–51: *Barry McGee*, May 11–June 30, 2012; PRISM, Los Angeles (installation views); courtesy a private collection, Barry McGee, and PRISM, Los Angeles. Photos: Elon Shoenholz.

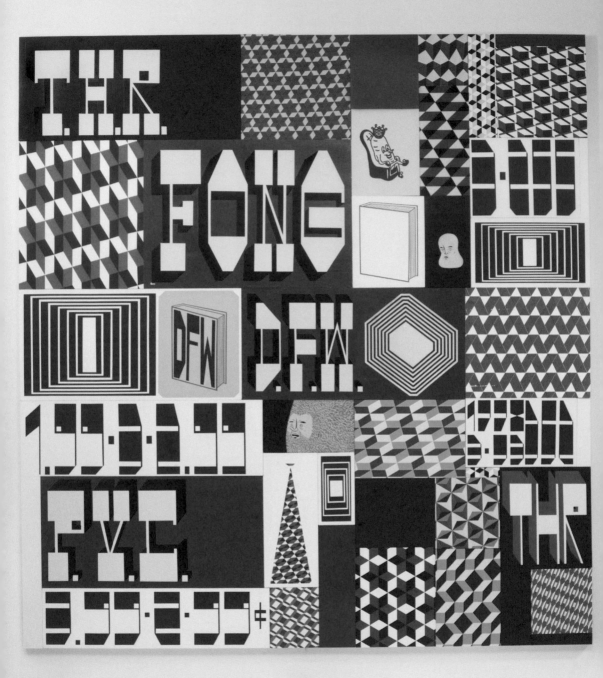

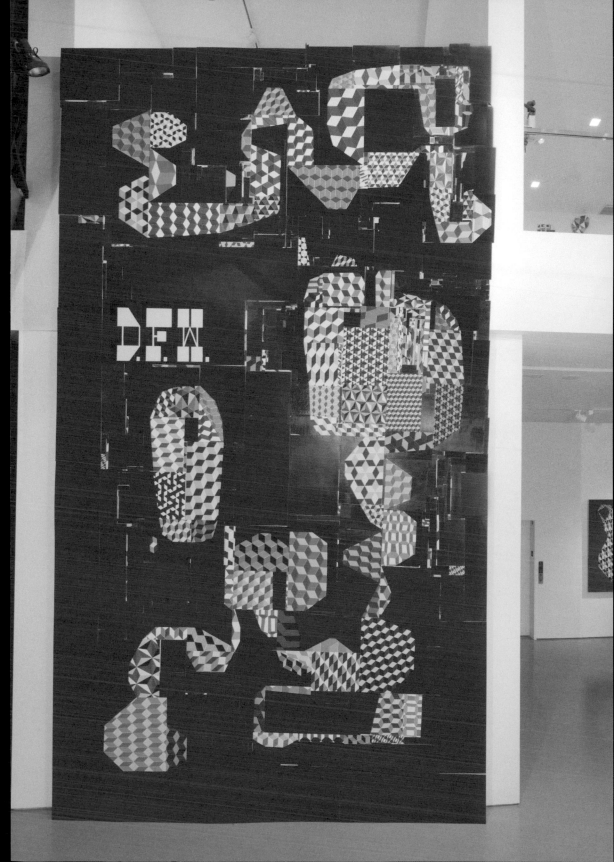

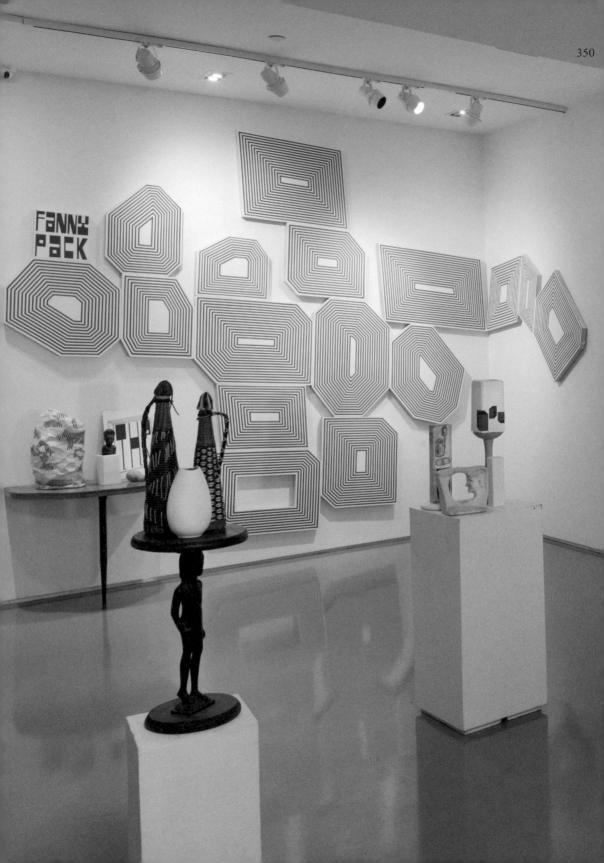

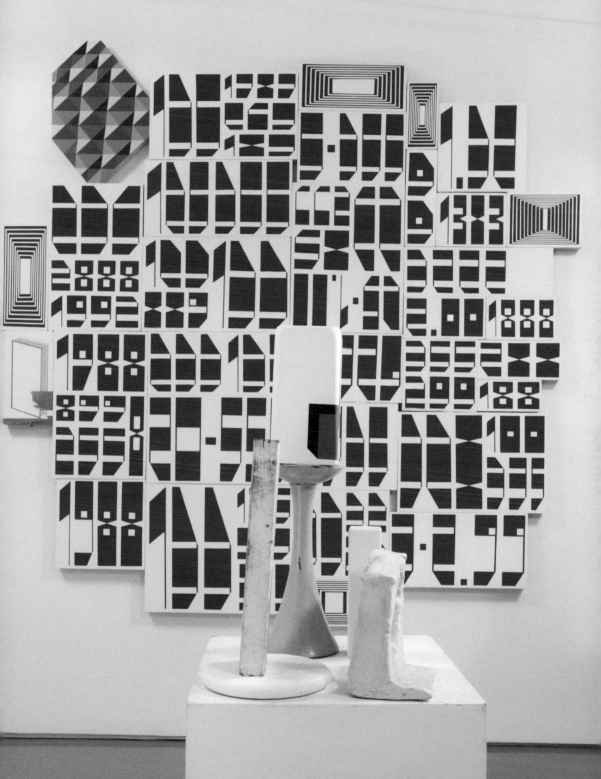

Exhibitions and Commissions

1991

3+PLAY, Southern Exposure, San Francisco (group)

Multi-Cultural Students Group, Diego Rivera Gallery, San Francisco Art Institute (group)

Wet Paint: An Entry Fee-Free Juried Exhibition of Painting Completed in 1991 by Northern California Artists, Southern Exposure, San Francisco (group)

Philip Ross, Marguerite Mack and Barry McGee, Diego Rivera Gallery, San Francisco Art Institute (group)

Wall of Resistance, Wall of Shame, University of California, Berkeley (site-specific painting)

Against the War, A.T.A. Gallery, San Francisco (group)

Luggage Store, San Francisco (site-specific painting)

1992

Mary Porter Sesnon Gallery, University of California, Santa Cruz (group)

FOLK/LORE, Luggage Store, San Francisco (group)

Yerba Buena Center for the Arts, San Francisco (site-specific painting)

Franklin Park, California Conservation Corps, San Francisco (site-specific painting)

Art in Transit Program, San Francisco Arts Commission (commission)

Life on the Water, School of the Arts, San Francisco (site-specific painting)

1993

Barry McGee, Museum Laser Segall, São Paulo (solo)

Twelve Bay Area Painters: The Eureka Fellowship Winners, San Jose Museum of Art (group)

Texture of Nature, Berkeley Art Center, Berkeley, CA (group)

La Raza Graphics Center, San Francisco (group)

1994

Barry McGee, Yerba Buena Center for the Arts, San Francisco (solo)

Clarion Alley Mural Project, San Francisco (site-specific painting)

1995

Barry McGee, Art & Design Studio/K&T Lionheart LTD, Boston (solo)

Degenerate Art, The Lab, San Francisco (group)

The Library, New Langton Arts, San Francisco (group)

Post No Bills, Acme Gallery, San Francisco (group)

Pro Arts Gallery, Oakland, CA (group)

Missed Connections, Luggage Store, San Francisco (site-specific painting)

Big Jesus Trash Can, Victoria Room, San Francisco (group)

Muni Key Stop Program, San Francisco Arts Commission (commission)

1035 Howard St., Luggage Store with Creative Work Fund, San Francisco (site-specific painting, commission)

Justice League nightclub, San Francisco (site-specific painting)

City Folk, Holly Solomon Gallery, New York (group)

1996

D-L Alvarez, Anne Appleby, Barry McGee: SECA Art Award, San Francisco Museum of Modern Art (group)

WAVEFORMS, Santa Cruz, CA (group)

Figureheads & Red Herrings, Koplin Gallery, Los Angeles (group)

Acme Custom, Acme Gallery, San Francisco (group)

Wall Drawings, The Drawing Center, New York (group)

1997

Galerie Tanya Rumpff, Haarlem, The Netherlands (group)

Drawing Today, San Francisco Museum of Modern Art (group)

Barry McGee, John Berggruen Gallery, San Francisco (solo)

Bay Area Now, Yerba Buena Center for the Arts, San Francisco (group)

The Independents, Alleged Gallery, New York (group)

1998

Art from Around the Bay, San Francisco Museum of Modern Art (group)

Creative Work Fund Project, Luggage Store, San Francisco (group)

Skatelore Expo: California Skate(board)ing Index to Concepts, Forms, and Life, Klausner Gallery, Santa Barbara Contemporary Arts Forum, Santa Barbara, CA (group)

Regards, Walker Art Center, Minneapolis (solo)

On the Wall: Selections from The Drawing Center, Forum for Contemporary Arts, Saint Louis (group)

1999
The Buddy System, Deitch Projects, New York (solo)
Hoss, Rice University Art Gallery, Houston (solo)

2000
Hammer Projects: Barry McGee, Hammer Museum,
 Los Angeles (solo)
Wall Power, Institute of Contemporary Art, Philadelphia (group)
Surf Trip, Yerba Buena Center for the Arts, San Francisco (group)
Street Market: Barry McGee, Todd James, and Stephen Powers,
 Deitch Projects, New York (group)
Point of Purchase, Parco Gallery, Tokyo (group)
Alleged Gallery, Tokyo (group)

2001
The Plateau of Humankind, Venice Biennale (group)
Un art populaire, Fondation Cartier pour l'art contemporain,
 Paris (group)
Widely Unknown, Deitch Projects, New York (group)
Holdfast, Deste Foundation Center for Contemporary Art,
 Athens (with Margaret Kilgallen)

2002
Today Pink, Fondazione Prada, Milan (solo)
Barry McGee, Gallery Paule Anglim, San Francisco (solo)
Barry McGee, Modern Art, London (solo)
Liverpool Biennale (group)
Drawing Now, Museum of Modern Art, New York (group)
No War, Luggage Store, San Francisco (group)

2003
Outerspace Hillbilly, Luggage Store, San Francisco (group)

2004
Monument to Now, The Dakis Joannou Collection,
 Athens (group)
Beautiful Losers: Contemporary Art and Street Culture,
 Yerba Buena Center for the Arts, San Francisco;
 Contemporary Arts Center, Cincinnati (group)
Barry McGee, Rose Art Museum, Brandeis University,
 Waltham, MA (solo)
The stars were aligned…, John Kaldor Projects at Metropolitan
 Meat Market, Melbourne and National Gallery of Victoria
 (solo, site-specific painting)
Smash the State, Supervisor Matt Gonzalez's office,
 San Francisco City Hall (site-specific painting)

2005
Things Are Really Getting Better, Museum Het Domein,
 Sittard, The Netherlands (solo)
One More Thing, Deitch Projects, New York (solo)
Easy Tonto, Stuart Shave/Modern Art, London (solo)
On Line, The Louisiana Museum, Copenhagen (group)

2006
We Have a Friend in Common, Nicolai Wallner Gallery,
 Copenhagen (solo)

The Art of Robert Pimple, Gallery Paule Anglim,
 San Francisco (solo)
Summer Show, Stuart Shave/Modern Art, London (group)
Spank the Monkey, BALTIC Centre for Contemporary Art,
 Gateshead, U.K. (group)
Meditations in an Emergency, Museum of Contemporary Art
 Detroit (group)

2007
EUPHORION, Pierogi Gallery, Leipzig (group)
Kinky Sex (Makes the World Go 'Round), Lizabeth Oliveria
 Gallery, Los Angeles (group)
Barry McGee, The Watari Museum of Contemporary Art,
 Tokyo (solo)
Barry McGee, Butler Gallery, Kilkenny Castle, Kilkenny,
 Ireland (solo)
Alpha, Ratio 3, San Francisco (group)
Advanced Mature Work, REDCAT, Los Angeles (solo)

2008
They Don't Make This Anymore, BALTIC Centre for
 Contemporary Art, Gateshead, U.K. (solo)
The Big Sad, Riverside Art Museum, Riverside, CA
 (with Clare Rojas)
Life on Mars: the 55th Carnegie International, Carnegie
 Museum of Art, Pittsburgh (group)
Len Lye: A Colour Box, Arcade Fine Arts, London (group)
Dripsy, Galerie Olivier Robert, Paris (group)
A Moment for Reflection: New Work by Lydia Fong, Ratio 3,
 San Francisco (solo)

2009
Galaxy: A Hundred or So Stars Visible to the Naked Eye,
 University of California, Berkeley Art Museum and Pacific
 Film Archive (group)
Barry McGee / Ed Templeton / Raymond Pettibon, Circleculture
 Gallery, Berlin (group)
Liberation upon Contact, Ratio 3, San Francisco (group)
Born in the Streets—Graffiti, Fondation Cartier pour l'art
 contemporain, Paris (group)
Lyon Biennale (group)
Mr Brown, Galleria Alessandra Bonomo, Rome (solo)
New York Minute, MACRO FUTURE, Rome (group)
mindthegap, Prism, Los Angeles (group)
75 Years of Looking Forward: The Anniversary Show,
 San Francisco Museum of Modern Art (group)

2010
*Pleasure Point: Celebrating 25 Years of Contemporary
 Collectors*, Museum of Contemporary Art San Diego (group)
The Last Night, Alice Gallery, Brussels (with HuskMitNavn)
Oakland Museum of California, Oakland, CA (commission)
Outside the Box, Hammer Museum, Los Angeles (group)
*Barry McGee & Clare Rojas / Leave It Alone & Together at
 Last*, Bolinas Museum, Bolinas, CA
Viva la Revolución: A Dialogue with the Urban Landscape,
 Museum of Contemporary Art San Diego (group)

They Knew What They Wanted, Fraenkel Gallery, San Francisco
(group)
Transfer, Brazilian Cultural Pavilion, Ibirapuera Park,
São Paulo (group)
Brush Strokes, V1 Gallery, Copenhagen (group)
Houston Street and Bowery, New York (site-specific painting)

2011
Art in the Streets, The Geffen Contemporary at the Museum
of Contemporary Art, Los Angeles (group)
New York Minute, Garage Center for Contemporary Culture,
Moscow (group)
Let's Go Bombing Tonight, V1 Gallery, Copenhagen (group)
New Work, Stuart Shave/Modern Art, London (solo)
Barry McGee, Workshop Arte Contemporanea, Venice (solo)
Sydney Laneways, Sydney (site-specific painting)
Fifty Years of Bay Area Art: The SECA Awards, San Francisco
Museum of Modern Art (commission)
Postermat, The Hole, New York (group)

2012
Paule Anglim Contemporary Arts Centre, San Francisco (group)
Stuck Up, New Bedford Art Museum, New Bedford, MA
(group)
Barry McGee, Prism, Los Angeles (solo)
Streetopia, Luggage Store, San Francisco (group)
Barry McGee, University of California, Berkeley Art Museum
and Pacific Film Archive (solo)

Awards, Grants, and Degrees

1991
B.F.A. in Painting and Printmaking, San Francisco Art Institute

1993
Lila Wallace–Readers Digest International Artist Program
Eureka Fellowship, Fleishhacker Foundation

1994
Creative Work Fund Grant

1996
SECA Award, San Francisco Museum of Modern Art

2001
ArtCouncil Grant

Publications

354

Books and Exhibition Catalogs

Baker, Alex. *Indelible Market: Barry McGee, Stephen Powers,
and Todd James*. Philadelphia: Institute of Contemporary
Art, 2000.
Barry McGee: The Buddy System. New York: Deitch Projects,
1999.
Barry McGee. Milan: Fondazione Prada, 2002.
Deitch, Jeffrey, Roger Gastman, and Aaron Rose. *Art in the
Streets*. New York: Skira Rizzoli, 2011.
Flint-Gohlke, Lucy, ed. *Barry McGee*. Waltham, MA:
Rose Art Museum of Brandeis University, 2009.
Hoptman, Laura. *Drawing Now: Eight Propositions*. New York:
Museum of Modern Art, 2002.
Hoss. Houston: Rice University Art Gallery, 1999.
McGee, Barry. *D.F.W.* Cremorne, Australia: Perks & Mini
Books, 2010.
Outerspace Hillbilly. San Francisco: Luggage Store Gallery, 2002.
Regards, Barry McGee. Minneapolis: Walker Art Center, 1998.
Rose, Aaron, and Barry McGee. *Barry McGee*. Bologna:
Damiani, 2010.
Rose, Aaron, et al. *Beautiful Losers: Contemporary Art and
Street Culture*. New York: D.A.P./Iconoclast, 2005.
Street Market. Tokyo: Little More Publishers, 2000.
Things Are Really Getting Better. Sittard, The Netherlands:
Museum Het Domein, 2005.

Reviews, Articles, and Essays

Aletti, Vince. "Top 10 of 2001." *Artforum* 40, no. 4
(December 2001).
Avgikos, Jan. "Street Market." *Artforum* 40, no. 4
(December 2001): 146.
Azkarraga, Joseba. "Punto de Mira." *La Razon*, February 10,
2006.
Baker, Alex. "Stickers, Street Markets, Fantasy Folks:
Ruminations from Philadelphia." *Tokyion* 29
(May/June 2002).
Barclay, Alison. "Just Spraying Alive." *Herald Sun*, October
26, 2004.
"Barry McGee." In *MUSAC*, Vol. II, 318–32. León, Spain:
Museo de Arte Contemporáneo de Castilla y León, 2008.
Beck, Olly. "Nightmare on Vyner Street." *The Critical Friend*
3 (2005): 6–9.
Bennett, Oliver. "The Quality of Mersey." *Observer Review*,
September 15, 2004.
Birnbaum, Daniel. "More Is Less." *Artforum* 40, no. 1
(September 2001): 55–57.
Blake, Nayland. "Barry McGee." *Interview*, February 1999,
44–46.
Bonetti, David. "On the Bright Side, the Best SECA Show in
Years." *San Francisco Examiner*, September 20, 1996.
———. "The Young at Art." *San Francisco Examiner*,
June 18, 1997.

Caniglia, Julia. "Barry McGee: Walker Art Center." *Artforum* 37, no. 4 (December 1998): 135.

Cohen, Michael. "Street Market." *Flash Art*, January/February 2001, 65.

Dauriac, Romain, and Guillaume Le Goff. "Barry McGee: Maux Urbains." *Clash Magazine* 36 (May/June 2009): 74.

"Deitch Projects." *New Yorker*, July 11, 2005, 21.

Eastman, John. "Artists of the 55th Carnegie International: Barry McGee." *Black and White*, May 30, 2008, http://blackandwhiteprogram.com/interview/barry-mcgee.

Fallah, Amir H. "Barry McGee." *Beautiful Decay*, December 2006, 90–98.

Flannigan, Eileen. "SoHo Exhibit Sparks Mental Flames." *New York Amsterdam News*, October 26–November 1, 2000.

"Gateshead: Barry McGee." *Art Newspaper*, March 2008, 53.

Gavin, F. "While No One Was Looking." *Art Review* 56 (March 2005): 64–67.

Giovannini, Stefano. "Talent Show." *Nylon*, February 2002.

Glass, A. "Barry McGee." *Art and Australia* 42, no. 3 (Autumn 2005): 439.

Heartney, Eleanor. "Speaking for Themselves." *Art in America* 90, no. 2 (February 2002): 53–55.

Helfand, Glen. "Alternative Investments." *Modern Painters*, Autumn 2002, 45–46.

———. "Barry McGee." Artforum.com, May 16, 2002.

———. "The Mission School." *San Francisco Bay Guardian*, January 12, 2002.

Heuer, Megan. "Barry McGee: One More Thing." *Brooklyn Rail*, July/August 2005.

J. L. "The Guide." *Guardian* (U.K.), September 17, 2005.

Johnson, Dominic. Review. *Frieze*, September 2005, 134–35.

Joo, Eungie. "The New Folk." *Flash Art*, May/June 2002, 124–26.

"Juicy Fruits." *Tokion*, November–December 2000.

Juxtapoz, September/October 2001, 6.

Kalm, James. "Graf 3000: Old School, New School." *NY Arts International Edition*, March 2000, 35.

Kold, Anders. "Noget tegner sig." *Louisana Magasin*, November 2005, 34.

Kuo, Michelle. "Market Index: Barry McGee." *Artforum* 46, no. 8 (April 2008): 338–39.

Lack, Jessica. "Riot on an Empty Street." *i-D*, September 2005, 284–87.

Leffingwell, Edward. "Barry McGee at Deitch Projects." *Art in America* 94, no. 2 (February 2006): 126.

"La ley de la calle se impone en ARCO, que tira de artistas urbanos, de spray y de graffity." *El Pais*, February 11, 2006.

Mandrini, Riccarda. "Street Art." *L'Uomo Vogue*, August 2002, 64.

McCormick, Carlo. "Barry McGee's Twist of Faith." *Paper*, April 1999, 33.

Mendelsohn, Adam E. Review. *Time Out New York*, July 14, 2005.

Mendelsohn, M. "Barry McGee: Deitch Projects." *ARTnews* 104, no. 9 (October 2005): 164.

Neil, J. T. D. "Barry McGee: One More Thing: Deitch Projects." *Modern Painters*, October 2005, 114–15.

Oliver, Suzanne. "Bombs Away." *The Face*, November 2001, 50.

Paynter, Andrew. "Twenty Questions with Barry McGee." *Theme*, Spring 2005, http://www.thememagazine.com/stories/barry-mcgee.

Perez, Christopher. Review. *Contemporary*, 2004.

Pheasant, Bill. "Melbourne's Meat Market a Work for Modern Art." *Australian Financial Review*, October 28, 2004, 48.

Powers, Bill. "Quiet! Dad Is Dusting His G.I. Joes." *New York Times*, December 30, 2002.

Roberts, Jo. "How's This for a Twist?" *The Age*, October 27, 2004, 73.

Safe, Georgina. "From a Different Cloth." *Weekend Australian*, October 30–31, 2004.

Sarica, Frederico. "Don't Stop: Dumbo and Barry McGee in Conversation." *Mousse*, September–November 2007, 83–85.

Scherr, Apollinaire. "Barry McGee: Off the Record." *Flash Art*, May/June 2001, 120–22.

———. "Stealing Beauty." *San Francisco Magazine*, November 1999.

Siegal, Nina. "Exhibit Becomes Opportunity for Arrest." *New York Times*, October 10, 2000.

Smith, Roberta. "Barry McGee: The Buddy System." *New York Times*, April 2, 1999.

———. "Urban Outsider Artists Evoke Society's Margins." *New York Times*, August 3, 2005.

———. "Widely Unknown." *New York Times*, December 14, 2002.

Stecyk, C. R. "One More Thing." *Juxtapoz*, Fall 2005.

———. "Some Other Small Planet." *Super X Media*, April 2000.

Subotnick, Ali. "Barry McGee: Deitch Projects." *ARTnews* 98, no. 6 (June 1999): 126.

Tansini, L. "Barry McGee: Fondazione Prada." *Sculpture*, December 2002, 82.

Tokyo Jammin', October 2000.

Torres, G. David. "The Power of Urban Art." *ABCDARCO*, February 12, 2006, 13.

Valdez, Sarah. "Street Market at Deitch Projects." *Art in America* 89, no. 12 (December 2001): 121.

Venus, Rosa. "The Artists in Their Studios." *Flaunt Magazine*, March 2000.

Virus, El Zirus. "One More Thing." *Series B*, 2006, 78–81.

Yablonsky, Linda. "Street Market." *Time Out New York*, November 2–9, 2001.

Contributors

Alex Baker is gallery director at the Fleisher/Ollman Gallery in Philadelphia. Formerly senior curator of contemporary art at the National Gallery of Victoria in Melbourne, Australia, curator of contemporary art at the Pennsylvania Academy of the Fine Arts, Philadelphia, and associate curator at the Institute of Contemporary Art, Philadelphia, he has organized exhibitions with artists including Ricky Swallow, Harrell Fletcher, Ranjani Shettar, Robert Ryman, Ellen Harvey, Barry McGee, Chris Johanson, Margaret Kilgallen, and Laylah Ali, among others.

Dena Beard is assistant curator at the University of California, Berkeley Art Museum and Pacific Film Archive. She managed MATRIX projects with D-L Alvarez, Lutz Bacher, Desirée Holman, and Silke Otto-Knapp and has worked on exhibitions with Martha Colburn, Omer Fast, Jill Magid, Ahmet Ogut, Trevor Paglen, Emily Roysdon, Tomás Saraceno, and Tris Vonna-Michell, among others. Independently, she curates projects such as the *Lending Library* exhibition series and *Taking Up Room on the Floor* for Bay Area galleries and alternative spaces.

Natasha Boas is the curator of the Museum of Craft and Folk Art in San Francisco. Since the early 1990s, she has organized exhibitions and public programs internationally for such institutions as the Centre Pompidou, the American Center in Paris, and Yerba Buena Center for the Arts in San Francisco. She is also the author of numerous publications and catalogs of contemporary art and has taught at Yale University, the San Francisco Art Institute, and the California College of the Arts.

Germano Celant has been the artistic director of Fondazione Prada, Milan, since 1995; he is also curator of the Fondazione Aldo Rossi in Milan and the Fondazione Emilio e Annabianca Vedova in Venice, and curator of art and architecture at La Triennale di Milano. He was the senior curator of contemporary art at the Solomon R. Guggenheim Museum in New York from 1989 until 2008, the curator of the Forty-Seventh Venice Biennale (1997), and the artistic supervisor for Genoa's year as European Cultural Capital in 2004. A longtime contributing editor to *Artforum* and *Interview* magazine, Celant writes regular columns for the Italian magazines *L'Espresso* and *Interni*.

Jeffrey Deitch is the director of the Museum of Contemporary Art, Los Angeles (MOCA). Prior to his appointment as director of MOCA, Deitch was a dealer in modern and contemporary art and an art critic and curator since the mid-1970s. His most ambitious exhibition was *Post Human*, which opened at the FAE Musée d'Art Contemporain in Lausanne in June 1992. He coauthored a monograph on Keith Haring, published by Rizzoli in 2008, and wrote the introduction to *Jean Michel Basquiat, 1981: The Studio of the Street*, published by Charta in 2007. Deitch opened a commercial gallery, Deitch Projects, in 1996, which produced more than 250 projects by contemporary artists.

Lawrence Rinder is director of the University of California, Berkeley Art Museum and Pacific Film Archive. He has held positions at the Museum of Modern Art, the Walker Art Center, and the Whitney Museum of American Art, where he was chief curator of the 2002 Biennial. Among the other exhibitions he has organized are *In a Different Light* (curated with Nayland Blake), *BitStreams*, *The American Effect*, and *Tim Hawkinson*. He was the founding director of the Wattis Institute for Contemporary Arts at California College of the Arts, San Francisco, where he also served as dean.

Lenders to the Exhibition

University of California,
Berkeley Art Museum
and Pacific Film Archive
Board of Trustees

Barry McGee is made possible by lead support from The Andy Warhol Foundation for the Visual Arts and presenting sponsor Citizens of Humanity.

Major support is provided by the National Endowment for the Arts, Ratio 3, Cheim and Read, the East Bay Fund for Artists at the East Bay Community Foundation, The Robert Lehman Foundation, Prism, Stuart Shave/Modern Art, and Cinelli. Additional support is provided by Rena Bransten, Gallery Paule Anglim, Jeffrey Fraenkel and Frish Brandt, Suzanne Geiss, Nion McEvoy, and the BAM/PFA Trustees.

Special thanks to Citizens of Humanity for their additional support of BAM/PFA's grade-school art experience programs.

The Andy Warhol Foundation for the Visual Arts

CITIZENS *of* HUMANITY

ART WORKS.
arts.gov

359

Opening Sequence
All photographs by Craig Costello
Front endpaper: Untitled (Safeway Tunnel), 1993; digital scan from silver gelatin negative; courtesy the artist.
p. 1: Untitled (Twist Painting, Eureka Station), 1992; digital scan from silver gelatin negative; courtesy the artist.
pp. 2–3: Untitled (Barry and Margaret), 1995; digital scan from silver gelatin negative; courtesy the artist.
pp. 4–5: Untitled (Twist Characters, Duboce Tunnel), 1993; digital scan from silver gelatin negative; courtesy the artist.
pp. 6–7: Untitled (Twist and Cypher Under Safeway), 1993; digital scan from silver gelatin negative; courtesy the artist.
pp. 8–9: Untitled (Mecca), 1994; digital scan from silver gelatin negative; courtesy the artist.
pp. 10–11: Untitled, 1994; digital scan from silver gelatin negative; courtesy of the artist.
pp. 12–13: Untitled (TMF and THR, Florida Street), 1993; digital scan from silver gelatin negative; courtesy the artist.
p. 14: Untitled (Eureka Station), 1993; digital scan from silver gelatin negative; courtesy the artist.
p. 15: Untitled (Twist Painting), 1995; digital scan from silver gelatin negative; courtesy the artist.
pp. 16–17: Untitled (Barry), 1994; digital scan from silver gelatin negative; courtesy the artist.
p. 18 and 19: Untitled (Twist Replacing Bus Shelter Poster), 1995; digital scans from silver gelatin negatives; courtesy the artist.
pp. 20–21: Untitled (Harrison Street Ledge), 1994; digital scan from silver gelatin negative; courtesy the artist.
p. 22: Untitled (Twist Tag), 1994; digital scan from silver gelatin negative; courtesy the artist.
p. 23: Untitled (Twist, Mission Street Roof), 1993; digital scan from silver gelatin negative; courtesy the artist.
pp. 24–29: Untitled, 1993; digital scan from silver gelatin negative; courtesy the artist.
pp. 30–31: Untitled (Twist), 1994; digital scan from silver gelatin negative; courtesy the artist.

Closing Sequence
Zines courtesy Barry McGee.

Published on the occasion of the exhibition *Barry McGee*

University of California, Berkeley Art Museum and
Pacific Film Archive
August 24–December 9, 2012

Institute of Contemporary Art, Boston
April 5–September 2, 2013

Published by University of California,
Berkeley Art Museum and Pacific Film Archive

Copublished and distributed by
D.A.P/Distributed Art Publishers
155 Sixth Avenue, 2nd Floor, New York, NY 10013
Tel: (212) 627-1999
Fax: (212) 627-9484

Publication Coordinator: Dena Beard
Design: Purtill Family Business
Copyediting: Juliet Clark and Nina Lewallen Hufford
Printing: The Avery Group at Shapco Printing, Inc., Minneapolis

Library of Congress Cataloging-in-Publication Data

Barry McGee / edited by Lawrence Rinder, with Dena Beard ; with texts by Alex Baker, Natasha Boas, Germano Celant, and Jeffrey Deitch.
 pages cm
 Published on the occasion of the exhibition Barry McGee, University of California, Berkeley Art Museum and Pacific Film Archive, August 24-December 9, 2012, Institute of Contemporary Art, Boston, March 1-May 19th, 2013.
 Includes bibliographical references and index.
 ISBN 978-1-935202-85-1 (alk. paper)
1. McGee, Barry, 1966---Exhibitions. I. Rinder, Lawrence, editor of compilation. II. McGee, Barry, 1966- Works. Selections. 2012. III. Berkeley Art Museum and Pacific Film Archive, host institution. IV. Institute of Contemporary Art (Boston, Mass.) host institution.
 N6537.M39652A4 2012
 709.2--dc23

 2012022667

ISBN (BAM/PFA): 978-0-9719397-0-7
ISBN (D.A.P.): 978-1-935202-85-1

THR

LARCENY

D.F.W.

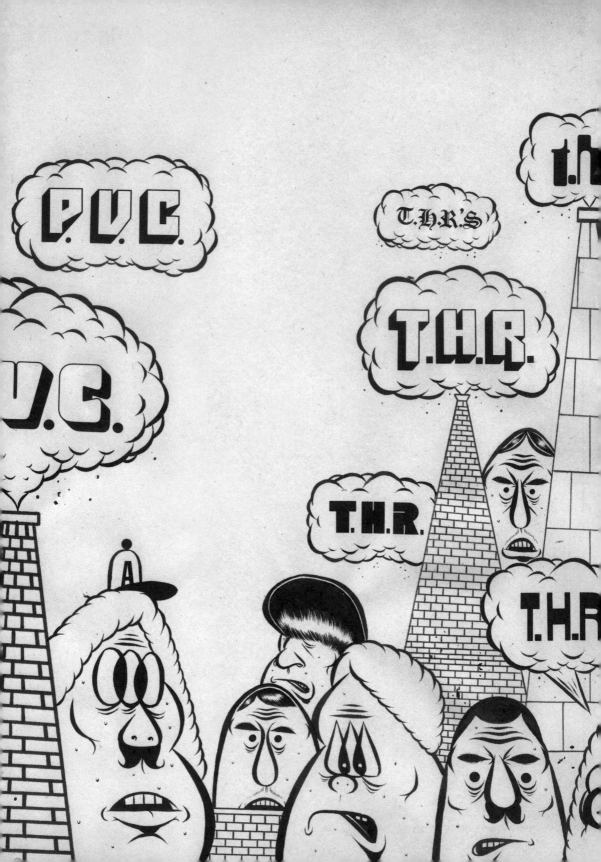